EYE
CONTACT

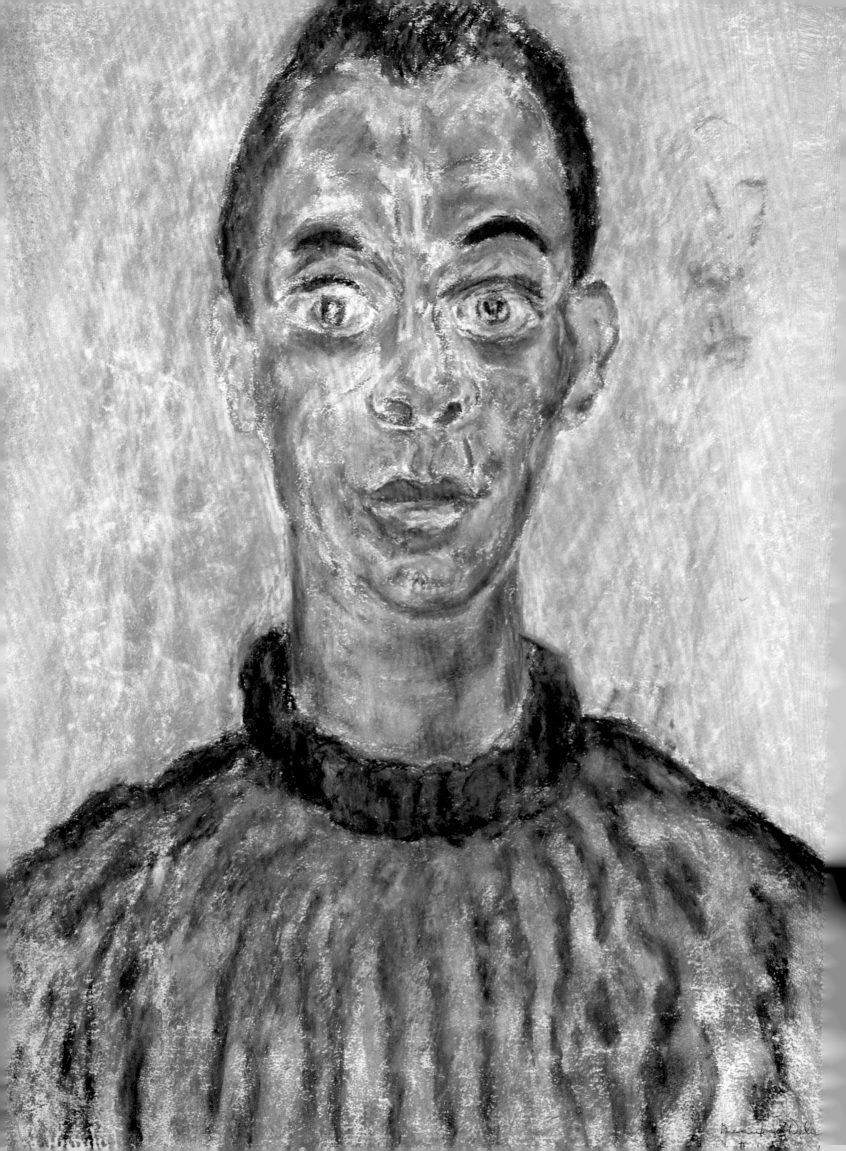

EYE
CONTACT

Modern American

Portrait Drawings

from the

National Portrait Gallery

Wendy Wick Reaves

With an essay by Bernard F. Reilly Jr.

And contributions by

Ann Prentice Wagner

Brandon Brame Fortune

Jennifer A. Greenhill

Elizabeth Mackenzie Tobey

Charles Brock

Harold Francis Pfister

Sally E. Mansfield

Dorothy Moss

LuLen Walker

Anne Collins Goodyear

Frank H. Goodyear III

Joann Moser

National Portrait Gallery, Smithsonian Institution

Washington, D.C.

in association with the University of Washington Press

Seattle and London

TOUR ITINERARY

Amon Carter Museum, Fort Worth, Texas
MAY 25–AUGUST 25, 2002

Elmhurst Art Museum, Elmhurst, Illinois
OCTOBER 4, 2002–JANUARY 5, 2003

Naples Museum of Art, Florida
FEBRUARY 14–MAY 11, 2003

Published with the assistance of the Getty Grant Program.

Library of Congress Control Number: 2002103201

Distributed by the University of Washington Press
P.O. Box 50096
Seattle, WA 91845-5096

ISBN 0-295-98267-5

Project coordinator: Dru Dowdy
Editor: Jane McAllister, Washington, D.C.
Designer: Polly Franchini, Washington, D.C.
Printer: Finlay Printing, Bloomfield, Connecticut
Bindery: Acme Bookbinding, Charlestown, Massachusetts

Cover and details:
Cover: Edna St. Vincent Millay by William Zorach (detail). Ink, charcoal, and colored pencil on paper, circa 1923. See cat. no. 12.
p. 2: James Baldwin by Beauford Delaney (detail). Pastel on paper, 1963. See cat. no. 38.
p. 7: Leo Stein by Adolf Dehn (detail). Ink on paper, circa 1925. See cat. no. 17.
p. 10: Alice B. Toklas by Pavel Tchelitchew (detail). Gouache on paper, circa 1926–28. See cat. no. 18.
p. 32: Agnes Meyer by Marius de Zayas (detail). Pastel over graphite on paper, circa 1912–13. See cat. no. 9.
p. 46: Christopher Isherwood by Don Bachardy (detail). Ink wash and graphite on paper, 1976. See cat. no. 47.

Contents

It is an odd fate to be the director of the National Portrait Gallery in an era that has over and over again declared the near death of portraiture. In fact, it might be said that the collapse of portraiture has been proclaimed from the moment more than 150 years ago that photography was introduced into our lives. Putting aside the fact that photography itself is a vibrant form of portrayal, one understands that it is the portraiture of painting, sculpture, and line that has been judged as the "invalid" of the visual arts by mainstream critics. If photography administered the first wound, then the triumph of abstraction dealt the second, near-fatal blow. In this view, the old dear survives, but barely.

Like Mark Twain, reports of the death of portraiture have been exaggerated. Indeed, this volume demonstrates a vitality of range and insight in one of portraiture's most affecting and enduring forms. It is a wonder, actually, that an examination of American portrait drawings is so late in coming, because, as Wendy Wick Reaves and Bernard Reilly establish in their two remarkable essays, virtually all the issues, all the possibilities of portraiture in our own time, are apparent in the ambitions and fate of the American portrait drawing. One can see the dance with photography, modernism, technology, and commercialism. If not the belle of the twentieth-century ball, portraiture has by no means willingly been a wallflower.

It is one of the pleasures of writing a foreword that one may only allude to what others must thoughtfully develop. In that spirit, it might be worth examining briefly what are arguably two key concepts that shape our understanding of the portrait: "likeness" and "essence." It is "likeness," of course, that most naturally suggests the impact of photography. Before its invention, what we could

know about the way an individual looked was entirely in the hands of the fine (or folk) artist. To the extent to which we needed the portrait only to provide likeness, there is no question that the coming of photography delivered more than a glancing blow to the stature of the working portraitist. But as the nineteenth century developed, makers of the painted portrait felt liberated from the need to document, and portraiture enjoyed a period of exuberance in the hands of a master such as John Singer Sargent or of probing analysis in the hands of the equally talented Thomas Eakins. What they shared was their century's belief that the essence of the person could best be determined by what he or she looked like.

That was then. In the aftermath of Freudian insight and the insistence of modernism, the attentions of the age turned from a notion of character, physical presence, and social position to one of psychological essence or "personality." The merely replicated physical self bored the abstract artist and attracted the commercial artist. But certain serious artists continued to test the possibilities of portraiture and "essence." A range of portrait strategies was unleashed—from those that tested the furthest extent of abstraction to those that introduced startling and unvarnished intimacy. Another range of responses played with "image" as a subject separate from essence, one that involved popular culture and, in time, pop art.

It is the portrait drawing that allows us to feel the pulse of these experiments in portrayals relevant to our own time. Never self-important, the portrait drawing allowed an artist to react quickly to internal needs or external demands. As a result, we find them unintimidating. We feel invited to respond, asked to make "eye contact." Invariably, in the National Portrait Gallery collection, we find many individuals

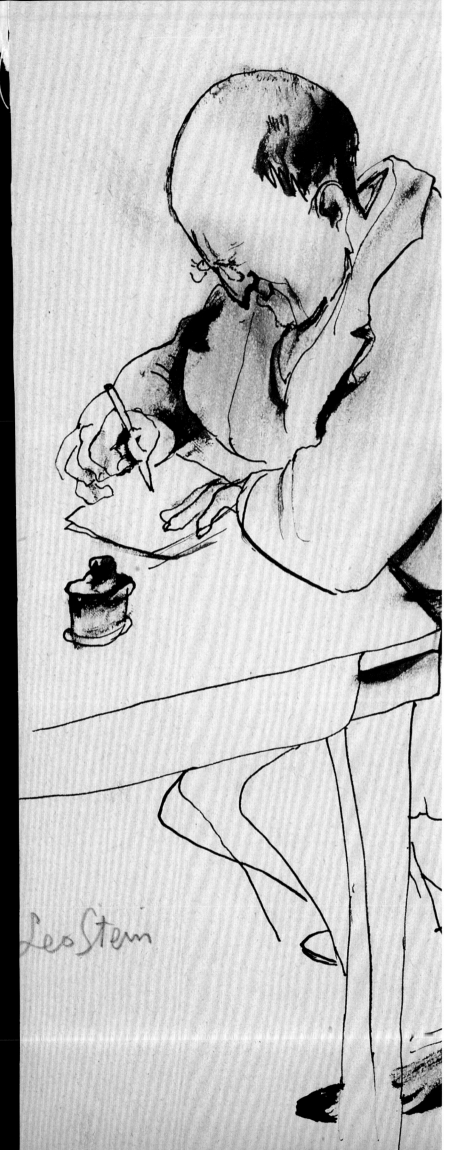

whom we know from their reputation or presence in our national life. Even if we don't know them initially, we have been provided by Wendy Wick Reaves, the indefatigable editor of this volume, and her colleagues "word portraits" of the nature and impact of these lives to measure against the drawing that captures them in most cases but hides or manipulates them in others. We understand the portrait as revelation or provocation. And we relish its vitality.

MARC PACHTER
DIRECTOR
NATIONAL PORTRAIT GALLERY

The process of selecting a group of drawings from the National Portrait Gallery's collection for a touring exhibition and catalogue has given me a renewed appreciation for the most fundamental of curatorial activities: looking again at the work of art. It matters very much, Philip Rawson pointed out in his book *Drawing,* whether an artist "has made in his drawing an arm's length sweep or a narrow pull with his fingers." His point is that drawings should be experienced at actual scale rather than be seen in a book. Further, in his opinion, that viewing requires undivided attention: one should approach a drawing, he notes, "with one's mind focused down, ready to attend to the voice of the drawing alone." Examining each work of art before us—looking harder than we had ever looked before—informed every stage of this study. From the initial selection of images through the research and writing, we learned from attending to the voice of the drawing. In the exhibition we can offer the same opportunity to others. Although we can't duplicate that experience in this book, we can share with a wider audience what we learned from the process.

Of course, there were other voices to attend to besides that of the drawing itself. Delving into the career of both artist and subject, reconstructing their interaction, examining related works, and understanding the context—social, political, psychological, or artistic—all added to our understanding. Although I thought I knew these pieces and their significance, each entry surprised me for the richness of its underlying story. Portrait-making is a human interaction, after all, open to the limitless variety of human exchange and expression.

The National Portrait Gallery, which was established by an act of Congress in 1962 and opened its doors in 1968, never set about to form a premier collection of drawings. The Gallery's early staff searched for prominent subjects, striving to build a structure of individual achievement around which to develop an historical narrative. Extraordinary drawings were a happy by-product of that approach. When I arrived at the Gallery in 1974 as the first curator of prints, drawings fell under the Department of Painting and Sculpture. When all nonphotographic works on paper were transferred to my domain in the mid-1980s, I discovered among them rare treasures: eighteenth- and nineteenth-century pastels, charcoals, pencils, and watercolors by James Sharples, John Trumbull, C. B. J. Févret de Saint-Mémin, James Barton Longacre, John Vanderlyn, and Eastman Johnson. Gradually we began to focus more on twentieth-century themes and subjects. Although we were steadily collecting portrait drawings from an era that had seemed to reject representation, we added surprisingly powerful images to our holdings.

In the process of selection, I kept returning to these twentieth-century works. Out of the boxes and bins came little-known portraits of compelling vitality, many by major artists, which accosted the viewer with their ambitions and modern sensibilities. These pictures, I concluded, warranted more in-depth research and greater exposure. Furthermore, the topic of twentieth-century portraiture in general seemed ripe for further examination. Director Marc Pachter came up with the "Eye Contact" of the exhibition title. The term implies a bold, contemporary engagement between one person and another but also a different, often challenging relationship between a work of art and its audience. Modern themes, in other words, as much as modern styles underlay the nontraditional look of these pictures.

Ferreting out connecting themes, uncovering individual stories, and summarizing what the art itself could tell us became our goals. With the timely help of a cataloging grant from the Getty Foundation, followed by a publications grant, the project was launched.

It was, from the beginning, a collaborative process. This volume would not have been possible without the dedication of a talented team: essayist Bernie Reilly and those who contributed entries—Charlie Brock, Brandon Fortune, Anne Goodyear, Frank Goodyear, Jennifer Greenhill, Sally Mansfield, Joann Moser, Dorothy Moss, Bud Pfister, Liz Tobey, Ann Wagner, and LuLen Walker. For many of us, the work of incomparable research assistant Pie Friendly filled our files before we began the entries. Paper conservators Rosemary Fallon and Emily Jacobson were also key members of the team throughout the process, contributing the glossary to this volume and enhancing our efforts to understand the medium, paper, and technique of each work of art. Exhibition and book have profited greatly from the insights and hard work of all these individuals. My own thinking about the project profited immeasurably from our shared discussions about each work of art; I have never gained more, personally or intellectually, from collaboration.

An enormous debt is owed to the exceptional colleagues who have worked with me through the years in the Prints and Drawings Department. LuLen Walker and Ann Wagner each spent a decade helping to research and build the collection. In the past two years, Ann Wagner shepherded the project through the intensive process of examination, conservation, and new photography, and Anne Goodyear, Kimberlee Staking, Kristin Smith, and Jennifer O'Keefe helped with the final preparations. Our thanks are due to photographers Rolland White and Marianne Gurley, not only for their extraordinarily fine work but also the patience with which they handled our incessant demands. We were just as bothersome to the remarkable staff of our library, especially Pat Lynagh and Barbara Insidioso, who will never admit how glad they are that our research is completed. I am grateful as well to Portrait Gallery staff Beverly Cox, Claire Kelly, Ed Myers, Dave Price, Al Elkins, Ellen Miles, and Ann Shumard. Director Marc Pachter and his predecessor Alan Fern have been outstandingly supportive of the project; and

Deputy Director Carolyn Carr has earned my undying gratitude for offering from the start a guiding hand, a sympathetic shoulder, a critical eye, and unwavering confidence. Publications Officer Dru Dowdy has been my mainstay throughout the editing and production of the book. Her hard work and extraordinary editorial skills could be cited, but I think I am more grateful for her sustaining wit. Contract editor Jane McAllister and designer Polly Franchini lent their considerable talents to the project, cheerfully conceding to absurdly compacted schedules.

Our research efforts flung a wide net outside the Gallery as well. Artists and subjects, along with their friends and family, were invariably helpful; we acknowledge particularly Don Bachardy, Lucretia Baskin, Joan Davis, Virginia Dehn, Joe Grant, Carolyn Hammer, Paul Holbrook, Mrs. Edgar F. Hubert, Barbara Meek, Bridget Moore, Darthea Speyer, Meredith Ward, Isabel Wilder, and Jamie Wyeth. Knowledgeable colleagues in museums, universities, and libraries generously shared their expertise. Although this list is regrettably limited, we want to mention especially Nancy Anderson, Ani Boyajian, Judith Brodie, Ulla Dydo, Ruth Fine, Bruce Kellner, Claudia Kidwell, Penelope Niven, Mark Rutkoski, Joyce Hill Stoner, Judy Throm, James Wechsler, and Sharon Worley. The Archives of American Art deserves special citation for its unparalleled collection and accessibility, absolutely critical for a study such as this one.

Finally, I want to acknowledge the home-front support from John Daniel, Paul, and Caroline Reaves, who contribute far more than they know to any project of mine.

WENDY WICK REAVES
CURATOR OF PRINTS AND DRAWINGS
NATIONAL PORTRAIT GALLERY

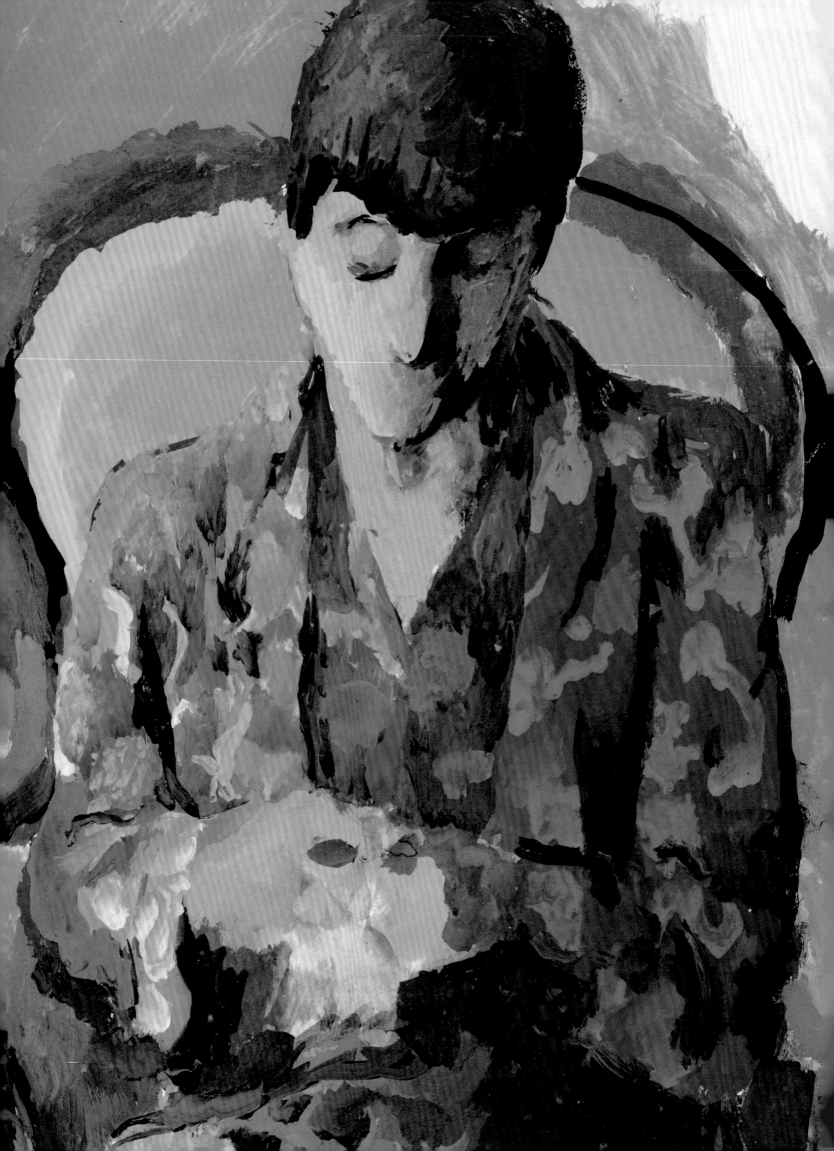

EYE CONTACT
The Tradition of Twentieth-Century Portraiture

WENDY WICK REAVES

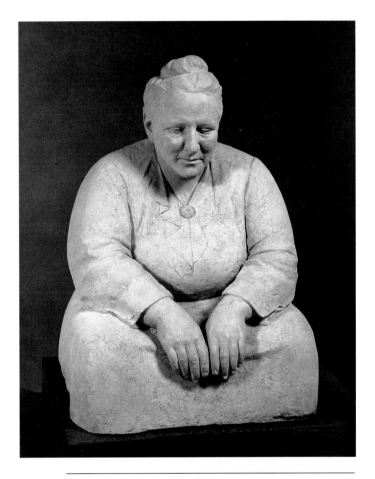

Fig. 1. *Gertrude Stein* (1874–1946) by Jo Davidson (1883–1952). Terra-cotta, 1922–23. National Portrait Gallery, Smithsonian Institution; gift of Dr. Maury Leibovitz

In the February 1923 issue of *Vanity Fair* magazine, readers were treated to a baffling contribution by Gertrude Stein titled "A Portrait of Jo Davidson." "Do you wish for he wishes for do you wish for do they wish for them," read one section of her impenetrable prose. "Does he wish for do they wish for him. Many many tickle you for them. Many many tickle you for him." Did these radical lines, with their singsong repetitions and nursery-rhyme cadence, really constitute a "portrait"? And if so, what had the word come to mean to self-consciously modern Americans? In the hands of such grand-manner stylists as John Singer Sargent and Anders Zorn, the portrait of the late nineteenth century had reached the apogee of a long tradition of posing and deportment. But within a generation, portraiture was right in the red-hot vortex of modernist experimentation.

The subject of Stein's work, Jo Davidson, was an American sculptor who had recently finished a massive seated terra-cotta sculpture of Gertrude herself [fig. 1]. He didn't know what to make of her essay on him; in fact, it contains a sly disparagement—one portion resembled a Hebrew phrase that translates "weighed in the balance and found wanting."[1] *Vanity Fair*'s audience probably missed the implications. Nonetheless, editor Frank Crowninshield, a sophisticated arbiter of new trends in literature, entertainment, and the arts, felt that this "portrait" by an "American revolutionary of prose" should be published. And he included on the page three visual images depicting Stein [fig. 2]: Davidson's sculpture, a bust by Jacques Lipchitz, and Pablo Picasso's now-famous painting reducing her countenance to totemic, masklike stylization [fig. 3]. For *Vanity Fair*'s readers, portraiture, whether literary or visual, connoted an exciting, flexible paradigm, open to a variety of modernist interpretations.

The transformation of portrait traditions was

11

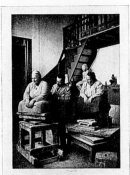

A Portrait of Jo Davidson

An American Revolutionary of Prose Sets Down Her Impressions of an American Sculptor
By GERTRUDE STEIN

VANITY FAIR

Fig. 2. *Gertrude Stein* (1874–1946) by Jo Davidson (1883–1952), Jacques Lipchitz (1891–1973), and Pablo Picasso (1881–1973). Printed illustration from *Vanity Fair*, February 1923. Library of Congress, Washington, D.C.

inspired by late-nineteenth-century artistic and scientific explorations that altered the very conception of the human figure. In reaction, the concept of portraiture began to stretch, bend, and transgress its traditional boundaries until it exploded out of them altogether. Radical new ideas for portraiture intersected with investigations of individual identity in philosophy, psychology, science, and religion. Sigmund Freud, William James, and Henri Bergson, among others, were exploring the nature of the self. Charles Darwin's theories had emphasized genetic predisposition, further undercutting established notions of consciously directed moral character. Questions about the location and identity of the self within a mechanistic world preoccupied many modernist artists and writers.[2] Portraiture at the turn of the twentieth century was negotiating dramatically new artistic and intellectual territory.

At the end of the twentieth century, however, commentators recognized a resurgence of portraiture as measured against its virtual collapse. Critics cited new conceptual concerns, a focus on role-playing and identity issues, and an artistic detachment that facilitated formalist interests. They noted fresh approaches to replicating the human personality:

serial portraiture, elaborate artifice, photographic manipulation, distortion, ambitious scale, hyperrealism, symbolic representation, and probing questions about sexuality, gender, and race. To some, new forms and ideas seemed to rise phoenixlike from portraiture's demise. "Traditional portrait painting took a beating in this century," one critic observed. Figuration, according to others, had become obsolete, or, at least, its status as a "progressive form of elite art" had been seriously undermined.[3]

What happened, then, to portraiture in the twentieth century? The ancient impulse to duplicate the human self through art didn't vanish, of course. But this logically mimetic, representational genre, after thriving for several centuries in the forefront of the arts, rode a dramatic roller coaster of reputation: first newly empowered as experimental, then stigmatized as a commercial exercise unrelated to advanced aesthetic concerns, and finally rediscovered in a new conceptual framework. The American portrait drawings of this study, often ambitious and independent works of art, can best be understood within this climate of change.

The new strategies for reconsidering and re-creating the human figure in art that emerged out of the late nineteenth century set in motion several generations of portrait making that bear a commonality, sometimes as much thematic as stylistic. In the century that followed, roughly encompassing the 1880s to the 1980s—a period that might, for ease of reference here, be called "modern" or "twentieth century"—artists recast this traditional genre. Throughout various critical reversals, progressive artists, often working outside the limelight, essayed portraiture, exploring new concepts and balancing requirements of representation with experimentation. Identifying some of the issues and opportunities that artists faced suggests a more cohesive view of figural depiction than previously thought, reflecting both the

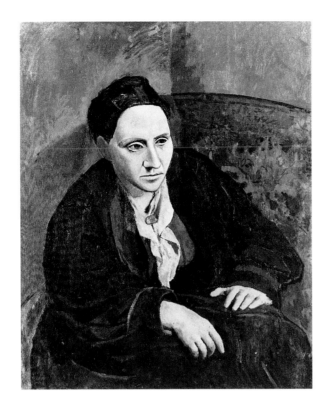

Fig. 3. *Gertrude Stein* (1874–1946) by Pablo Picasso (1881–1973). Oil on canvas, 1906. The Metropolitan Museum of Art, New York; bequest of Gertrude Stein, 1946

the page. Portrait-poems were among the subjects included in his early published volumes. His *Tulips and Chimneys* (1923) included a poem about "Buffalo Bill" Cody that he had written in 1917, upon hearing of the death of his boyhood hero.

Buffalo Bill's
defunct
 who used to
 ride a watersmooth-silver
 stallion
and break onetwothreefourfive pigeonsjustlikethat
 Jesus
he was a handsome man
 And what i want to know is
how do you like your blueeyed boy
Mister Death[5]

American composer Virgil Thomson, also inspired by Stein, began writing portraits in musical form in 1928. Thomson intended an abstraction of personality and tried to evoke the inner life rather than physical appearance or profession of his subject. Using music as a "language of feeling," he sought to bypass the literal and communicate directly to the emotions of the listener. "It was in search of such immediacy," he wrote "that I began making musical portraits as a painter works, in the model's presence."[6] The great majority of his musical portraits, mostly piano solos, were "drawn from life," with the subject sitting in front of him while he composed. The resulting pieces were "collage-like juxtapositions of idioms and styles," Anthony Tommasini has noted. "'Wrong-note' modal counterpoint, 'out of focus' hymns, dances, and diverse character pieces abound."[7] By 1954 the idea of Thomson's portraits was so ingrained in the popular mind that Charles Schultz made them the subject of a "Peanuts" cartoon. When Schroeder asks Charlie Brown to come over and sit before his piano, a notion he "learned from Virgil Thomson," Charlie

modernist concerns that reinvigorated portraiture at the beginning of the century and the roots of new conceptual approaches that emerged toward the century's end. The history of twentieth-century portraiture, in other words, may not be as fragmented and discontinuous as a reading of art criticism through the decades might indicate.

Although Gertrude Stein's enigmatic prose was seldom understood and never widely published, it was well known and highly influential among modernist writers and painters. Her experiments were inspired in part by the friendship that developed with Pablo Picasso during the many sittings for her 1906 portrait. Her portrait commentary about him, as well as one about her friend Henri Matisse, appeared in Alfred Stieglitz's magazine *Camera Work* in August 1912. Art patron Mabel Dodge printed and distributed copies of her own literary portrait by Stein and made them available at the Armory Show of 1913. Stein's "word portraits" did circulate, in other words, in intellectual circles and helped launch a minor vogue for abstract and symbolic portraiture that sought to suggest the inner essence of a personality through coded reference or emotional implication.[4]

American poet e. e. cummings, for instance, influenced by Stein and Picasso and other painters in Paris, began investigating new forms of poetry, playing with discontinuity and juxtaposition as well as spatial arrangements of words and punctuation on

13

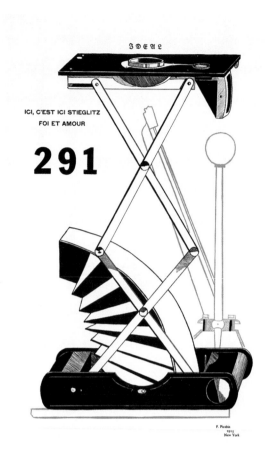

Fig. 4. *Ici, C'est Ici Stieglitz Foi Et Amour* [Alfred Stieglitz (1864–1946)] by Francis Picabia (1879–1953). Relief print on paper. Published in *291*, July–August 1915. National Portrait Gallery, Smithsonian Institution; gift of Katharine Graham

responds, "Oh, I get it. You'll try to capture my personality in music. . . . Right?" The tragicomic ending depicts Schroeder abandoning the task without a single note, unable to find enough personality in Charlie to inspire a composition.[8]

Radical notions of portraiture in prose, poetry, and music were closely tied to the work of the visual artists. Symbolists, impressionists, and postimpressionists had already probed beyond mimetic physical representation, searching for psychological truth or emotional sensation. Pablo Picasso broke even more radically with the traditions of the portrait genre. As he moved from a perceptual to a more conceptual basis for portraiture, he explored different modes for depicting the human figure, including abstract, classical, surrealist, and expressionist interpretations. When portrait making became an overtly subjective rather than objective exercise, William Rubin has pointed out, the subject's identity became highly mutable.[9] The artist, furthermore, no longer simply a recorder of character, came to play a much more self-conscious role as an interpreter of that identity. The modern artist, in other words, was "the giver, rather than the captor or preserver, of identity."[10] The door to

experimentation in the field of portraiture was thus pushed wide open.

The first American artist to offer a truly radical break with the visual portrait tradition was Mexican-born Marius de Zayas, a member of Stieglitz's avant-garde circle. In 1910, de Zayas had visited Paris, where his friendship with Picasso introduced him to cubist and primitive stylization of the figure and what he called the "pictorial equivalent of the emotion produced by nature."[11] De Zayas began to experiment with his own theory of "abstract caricature," a distorted, intensified variation on figuration. In his portrait drawing of Agnes Meyer [cat. no. 9] he represented the physical being with geometric shapes, the spiritual essence with mathematical symbols, and the life trajectory with sweeping diagonal lines. De Zayas's abstract experimentation influenced French artist Francis Picabia, who, joining de Zayas and his colleagues, created his famous series of "machine portraits" for the journal *291* [fig. 4]. By exploiting recognizable spark plugs, camera parts, gears, brakes, and lamps as symbolic referents, Picabia invented a new form of witty portrayal.

Various experiments in abstract and symbolic portraiture followed among New York artists in and around the dada circle. Marsden Hartley painted a symbolic portrait of Stein, who had recently finished a prose portrait of him. Charles Demuth created a series of "poster-portraits," which incorporate flowers, numbers, letters, and other coded symbols to probe psychological, sexual, or spiritual aspects of his subjects [fig. 5].[12] Georgia O'Keeffe, inspired by Picabia and de Zayas, made three abstract watercolors in 1917 that she intended to be portraits of photographer Paul Strand.[13] Despite these artists' often lighthearted tone, they had an ambitious agenda: they aimed for a synthesis of identity. Instead of trying to capture a likeness or a characteristic gesture, they hoped to convey a more

14

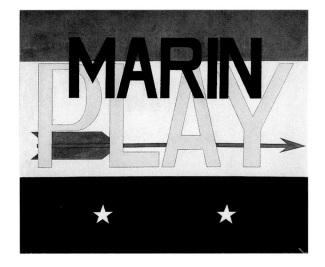

Fig. 5. *Poster Portrait: Marin* [John Marin (1870–1953)] by Charles Demuth (1883–1935). Poster paint on board, 1926. Yale Collection of American Literature, Beinecke Rare Book and Manuscript Library, Yale University, New Haven, Connecticut

profound understanding of the whole. Through abstraction they could integrate the material and the immaterial, the physical and the spiritual, re-creating the individual in all his or her complexity. Word clues, symbols, shapes, patterns, and color were all employed in an abstract summation of a subject.

Abstraction would remain a minor vogue for portraiture, but the experimental principles that underlay it would inform portraiture for the rest of the century. Modernist artists had experimented with fresh ways of representing the individual in their search for the essence. Although traditional portraitists had always sought to evoke the character of their subjects, the modernists wanted to show interior qualities that mimetic depiction could not convey. Like Stein, cummings, and Thomson, therefore, they bypassed or enhanced the literal representation in their portraits by including symbolism, humor, or expressive abstraction to bring to mind the person they knew. Many were concerned, in Edith Sitwell's words, "not only with form, but with the marrow of form."[14]

And although symbolic portraiture was set aside until its rediscovery by conceptual artists later in the century, the search for the essence of the individual, the struggle with issues of identity, and the use of various effects to add emotional or psychological content would continue. The avant-garde art movements gave artists a new stylistic vocabulary with which to convey subjective feelings. A lyrical line, an intense color contrast, or a dynamic composition, like a musical phrase or an individual word, could elicit the requisite response in the viewer. Density, rhythm, or expressionist gesture could enhance emotional or psychological nuances. Distortion, stylization, flattened space, or a simplified, abbreviated line could add not only a modern look but also an expanded meaning to figurative depiction. Such ideas influenced generations of portraitists. The graphic likenesses in

this study, therefore, bear the mark of this transformative engagement with radical new approaches.

Thematic changes, in addition to formal, aesthetic ones, also recast portraiture in the twentieth century. The presumption of static identity, as well as established traditions of pose, gesture, and deportment that had previously influenced the painting of portraits, gave way to new fashions often influenced by popular culture and the developing mass media. Previously, artists had attempted through the physical representation of a face or figure to capture the unique character of the individual they depicted. The self was a stable, definable entity. As Joanna Woodall explains it, the nineteenth-century conception of identity was a "unique, personal individuality, articulated in the face."[15] Twentieth-century portraitists, in contrast, were searching for an interior presence that was elusive and sometimes changeable, effected by circumstance or compromised by external categorizations of race, gender, age, or social class. Portraiture was often refracted by the mutability of the self into various external constructs. The subject's malleable identity opened fresh possibilities for reimagining the figure according to exterior models. The search for identity, or location of the self, was the one encompassing theme throughout modern portraiture's complex history.

The new, technologically advanced celebrity culture had a significant impact on portraiture. As information about famous people became increasingly standardized by truly national media— newsreels, recordings, motion pictures, newspaper chains, syndication services, large circulation magazines—larger-than-life public figures emerged for everyone to emulate. From then on Americans

15

consciously or subconsciously measured their own identities not only against real-life role models but also against constructed icons, created by advertisers, publicists, make-up artists, reporters, and film directors. Portraits of the famous often assumed that carefully scripted public image. The vogue for celebrity caricature between the two world wars grew directly out of the nation's new preoccupation with fame. Drawings such as Will Cotton's *Frances Perkins* [cat. no. 26] spoofed the well-known characteristics of notable figures, such as the secretary of labor's habitual tricorn hat, black dress, and pearls and her dominance in the male worlds of government and organized labor. The celebrity image was so presumed that looking beyond it became a conscious act of probing. Thomas Hart Benton's depiction of W. C. Fields [cat. no. 29], a movingly noncomic search for the man behind the character he played, is meaningful and poignant because the sitter's clownish persona was so much in the mind's eye.

Survival in the new celebrity culture meant attracting an audience, which required, above all else, the requisite compelling "personality." Rather than implying a general set of character traits, the word was used consistently during that era to connote a distinctive, attention-getting presence, what Mae West described as the "glitter that sends your little gleam across the footlights."[16] Portraitists often sought that "glitter," rather than more traditional characteristics, in searching for the essence of the individual. In the change from what historian Warren Susman called a "culture of character" to a "culture of personality," a magnetic theatricality became a highly admired and desirable trait.[17] Artists such as Al Frueh, who focused specifically on stage notables, extracted a quintessential summary of the actor and his role in his *John Barrymore* of circa 1909 [cat. no. 6]. In spare, abbreviated lines he captures the dark, handsome profile that first established the actor as a matinee idol. The brooding intensity of his portrayal

reflected the man as well as the star; the alcoholic Barrymore's personal life seemed like a dramatic performance complete with broad comic and tragic gestures.

All celebrities of the early twentieth century, not just actors, understood, consciously or instinctively, the importance of that dramatic flair. "This was the most theatrical generation in American annals," Ann Douglas has stated.[18] Intellect, knowledge, and achievement, novelist Theodore Dreiser pointed out, were not enough in the modern world; one also needed the "vital energy to apply them or the hypnotic power of attracting attention to them."[19] Performance, with all its dramatic artifice, became analogous to living life to the fullest, and portraiture of the period reflected that preoccupation. De Zayas's *Paul Haviland* [cat. no. 7], with its spotlit face and deep shadows, depicts the photographer in an awkward but dramatic staged pose. The dash and brio of the conté crayon in Harrison Fisher's *F. Scott Fitzgerald* and *Zelda Fitzgerald* [cat. nos. 19 and 20], together with the idealized lines of their faces, conjures up their soap-opera marriage, adventures, successes, and failures, all acted out in the glare of publicity. The firm facial contour and strong black-and-white patterns of William Zorach's *Edna St. Vincent Millay* [cat. no. 12] hint at the subject's commanding presence. "She asked only one thing," Douglas has stated, "expected but one safety net, and that the flimsiest and the most essential: an audience."[20] Everett Shinn, one of the most theatrically obsessed artists of his generation, depicted himself as the brooding romantic—drawing on the cliché of the artistic, bohemian soul [cat. no. 4]—and inscribed the pastel to the famous stage actress Julia Marlowe. Theatricality, personality, and adherence to new ideals of celebrity stardom became one mark of twentieth-century portraiture, in contrast to such traditional attributes as strong moral character or decorous modesty.

16

Some themes that figure largely in late-twentieth-century portraiture, such as gender and racial consciousness, appear in nascent form early in the modern era. In her watercolor self-portrait, Mary Cassatt depicted herself as a successful professional woman pursuing her career independent of male support or family [cat. no. 1]. With the light focused on her easel rather than her face, and dribbles and pools of color that dissolve form, she downplayed herself as the subject and instead emphasized her role as a progressive artist. The enormous changes in roles for women throughout the ensuing century would be reflected in the portraiture of female subjects. The bold, assured pose of Zorach's *Millay*, for example, posits a sexual and intellectual independence that reflects the poet's own emancipated generation. Charles Dana Gibson, on the other hand, whose beloved "Gibson Girl" illustrations helped define modern womanhood in the 1890s, consciously confronted evolving concepts of "manliness" in his drawing of Theodore Roosevelt for the pages of *Scribner's* [cat. no. 3]. By lengthening the torso, downplaying the spectacles, and avoiding the toothy grin, Gibson evoked the "robust and hardy qualities of body and mind" that the recently returned hero of San Juan Hill both advocated and, for many, exemplified.

Racial awareness permeates the figurative work of artists such as the German-born Winold Reiss and Jacob Lawrence. Reiss's emphasis on dignity, humanity, and creativity in his portraits of such Harlem Renaissance figures as Countee Cullen [cat. no. 16] counteracted racist notions of inferiority and engaged scientific debates about racial typologies and characteristics. Lawrence, in a later generation, used stylized, masklike faces, strong black-on-white contrasts, and powerful compositional patterning to dramatize the racial history of his subjects [cat. nos. 42 and 43]. To a greater extent than they perhaps seem to us today, Reiss's and Lawrence's pictures are all about racial identity. Locating the individual in relation to stereotyped, marginalized categories was a central, not a peripheral, concern.

Even issues of sexuality and the body, of major importance in late-twentieth-century figurative art, find some precedence in a more guarded era. Gaston Lachaise's 1920s drawing of poet Hart Crane dancing nude [cat. no. 13] is not specifically homoerotic. But as an exuberant celebration of the male body, it certainly references Crane's homosexuality. And if the drawing pays deference to the Greek *kouros* figure, its articulated musculature also evokes the body-building physical-culture movement, which aimed to return the modern male physique to an ideal epitomized by ancient Greek athletes.[21] The bulging muscles of Crane's dancing figure, like the expanded torso of Gibson's *Theodore Roosevelt*, signal a familiarity with contemporary notions of virile masculinity. Awareness of the body and the acceptance or rejection of idealized standards of beauty would become increasingly important themes for later generations.

For portrait drawings, the focus of this study, such changes were heightened by new attitudes toward works on paper. The graphic arts underwent dramatic changes in presentation, patronage, and status in the early modern period, moving from a private to a public sphere. For both the art world and an expanded general audience, the role of drawing media (including watercolor and pastel) was transformed. The emergence of drawing as an indispensable part of modern publishing established a new, critically important visibility. The perfecting of mechanical reproduction processes and an explosion of newspapers, periodicals, and illustrated books disseminated drawings far more widely than ever before. Readers grew increasingly used to seeing the drawn image. Newspaper artists conveyed rapidly sketched, newsworthy scenes to their audience. Editorial cartoons, fictional illustrations, humor

17

drawings, high-style magazine covers, and ink or charcoal portraits enhanced the rapidly growing periodical literature. Increased demand created professional draftsmen: sketch artists, graphic designers, cartoonists, and illustrators, some of whom became internationally famous. Higher visibility and handsome compensation lured many artists into the publishing industry, and the once-firm line between the fine artist and the illustrator became more fluid. High-quality drawings were now in the public sphere, no longer the exclusive province of the artist's studio or the connoisseur's portfolio.

This new positioning in the art world constituted a shift in the patronage and presentation of graphic works. For portraiture, publication produced additional layers of expectation. A privately commissioned likeness, while needing to balance the vanity of the subject with the ambitions of the artist, was still a negotiation between two people. With a published work, the artist had to consider the editor, the subject, the author or context, and the audience. Gibson's *Theodore Roosevelt*, for instance, was commissioned by *Scribner's* in 1898, just after the colonel's return from Cuba, to illustrate his memoirs, "The Rough Riders." Given Roosevelt's new fame as the acclaimed hero of the Spanish-American War, the article constituted something of a publishing coup. Unlike Gibson's usual humor drawing, this commission was newsworthy. The size of the potential audience and its familiarity with Roosevelt's exploits raised the stakes and the artist's ambitions. Gibson had to worry about the sitter's well-recognized likeness and celebrity image, but he also felt compelled to adapt his portrait to the famous author's theme. Gibson's visual image of vigorous manliness, reinforcing Roosevelt's verbal one, had a potential impact on a large audience previously unthinkable for drawings.

Works on paper, therefore, began to play an important role in the dissemination of visual ideas.

Honoré Daumier's lithographic cartoons of the mid-nineteenth century provided a precedent for such a change, but with the growth of the publication industry the potential influence of published drawings increased exponentially. The spontaneously drawn image was soon a well-integrated element of the press. Pen-and-ink social cartoons from *Life*, charcoal images from the *Masses*, the *New Yorker*'s humor drawings, *Time*'s weekly portrait cover (often a drawing in the magazine's early days), and ubiquitous charcoal and caricature likenesses on the entertainment pages of the newspapers penetrated the visual culture. Drawn images would decline in prominence after the first third of the century, increasingly replaced by photographic depictions. But far more than we realize now, drawings in the early twentieth century competed with photographs in published visual communications.

Artists were also discovering new aesthetic roles for graphic media, propelling them to more prestigious rankings in the hierarchy of the arts. For centuries drawing had been primarily an academic exercise or the artist's preparatory sketch. Although beloved by connoisseurs for their immediacy and directness, drawings had a passive, private, and minor role to play in the arts and were firmly ensconced in the lower realms of the artistic hierarchy. Late-nineteenth-century painters, particularly the French impressionists and postimpressionists, began to change the nature of drawing. Rebelling against academic rules, they prized sketching and watercolor for their plein-air portability and spontaneity. Exploiting the freedom of the quick charcoal or pencil sketch, the transparency of watercolor and wash, and the whiteness of the paper as an artistic element, they created suggestive improvisations. Drawing media, owing to their ease and directness, could capture movement, sensation, and the diffusions of memory, all much valued at the time. Artists also recognized their adaptability to formalist

experimentation. Such considerations led to drawings that were made as independent works unrelated to other media. As they became serious art rather than exercises or preparatory sketches, drawings began appearing in exhibitions. More than one-third of the works at the last of eight impressionist exhibitions in 1886 were drawings, watercolors, pastels, or prints, signaling a marked change in attitude by artists and their public.[22] Graphic media, from that point on, offered artists greater potential and expanding options.

In America, public exhibitions in museums or commercial galleries helped promote enthusiasm for drawing media. Painting exhibitions of European artists began to include pastels, watercolors, and charcoals. James McNeill Whistler's first major American exhibition in 1889 at H. Wunderlich & Co. featured thirty-six watercolors, four pencil drawings, and twenty-two pastels.[23] Knoedler Galleries mounted an exhibition of John Singer Sargent's watercolors in 1909, and the subsequent purchase of eighty-three of them by the Brooklyn Museum generated considerable publicity.[24] Traditional hierarchies of the fine arts, which had relegated drawing media to the lowest ranks, started to unravel. The formation of national or local groups to promote the so-called secondary media—including the American Watercolor Society in 1866, various etchings societies in the 1870s, and the Society of American Painters in Pastel in 1882—generated exhibitions and critical attention, encouraging interest in works on paper.[25]

Artists and commentators began to reassess these once "minor" media in light of new aesthetic criteria. Art critic Mariana Van Rensselaer wrote in *Century* magazine in 1884, "We failed to appreciate these arts [watercolors, etching, and pastels] in other days partly because they were comparatively unfamiliar to our eyes, but chiefly because we felt no desire for the expressional facilities they offer." She considered it a

sign of progress that "these minor branches" were no longer "either unfamiliar or despised."[26] A generation later, in 1911, when the widow of prominent *Century* magazine editor Richard Watson Gilder commissioned a portrait of Henry James from her friend Cecilia Beaux, the sitting resulted in a large, imposing charcoal drawing [cat. no. 8].

Even conservative academies had played a role in this process, emphasizing the need for skilled draftsmanship through required drawing classes from the antique or from life. As Theodore Stebbins has pointed out, the artist in America at the end of the nineteenth century was, for the first time, "typically a well-trained draftsman" who took drawing seriously.[27] The career of artist Everett Shinn exemplifies the new role of drawing [cat. no. 4]. Trained as a newspaper sketch artist, Shinn began working in pastels in the late 1890s when he moved to New York. The ambition to break into more lucrative magazine illustration was a motivating factor—in February 1900 he published *Harper's Weekly*'s first color reproduction—but he also discovered that the newly recognized medium of pastel could establish his artistic reputation. The same year, he exhibited forty-four of his drawings at Boussod, Valadon, and Company in New York, and the critical and commercial success of the show spurred more acclaim, exhibitions, and sales. Although Shinn would eventually turn to painting, his initial fame came as a pastel artist.

Another great impetus toward a change in status for drawings in America came from photographer Alfred Stieglitz and his pioneering "Little Galleries" at 291 Fifth Avenue. Having begun his artistic crusade by championing photography as an art form, Stieglitz refused to recognize traditional hierarchies of fine arts. "I do not see why photography, water colors, oils, sculptures, drawings, prints . . . are not of equal potential value," he once claimed. "I cannot see why one should differentiate between so-called

Fig. 6. *Nude* by Auguste Rodin (1840–1917). Pencil and watercolor, circa 1900–1908. Hope Haviland Leizear

'major' and 'minor' media. I have refused so to differentiate in all the exhibitions that I have ever held."[28] In the series of exhibitions at 291 before the 1913 Armory Show, Stieglitz, assisted from Paris by his young colleague Edward Steichen, introduced European and American modernists largely through graphic works on paper. Exhibitions at 291 featuring the work of Auguste Rodin, Henri Matisse, Henri de Toulouse-Lautrec, Pablo Picasso, and Paul Cézanne were constituted primarily of watercolors, drawings, and lithographs, and their impact was substantial.

In 1908, for instance, Stieglitz mounted an exhibition of fifty-eight drawings by Rodin. Many of these rapid, fluid contour drawings heightened with wash showed the nude model stretching, bending, or in the process of moving [fig. 6], a radical departure from the conventions of academic figure studies or posed portraiture. Even more controversial than Rodin's shorthand sketches were Matisse's drawings, watercolors, etchings, lithographs (and one oil), also shown in 1908. Mostly female nudes, these works appalled some reviewers with their immodesty, bold simplification of form, lack of finish, and expressive distortions [fig. 7].[29] Exhibitions of Cézanne's and Picasso's works were likewise debated in the press and just as revelatory for American artists. In their

own exhibitions at 291, the American artists of the Stieglitz circle, including Marius de Zayas, John Marin, Arthur Dove, Charles Demuth, and Georgia O'Keeffe, were often represented by the graphic arts, particularly watercolors, gouaches, charcoal drawings, pastels, and collages.[30]

Stieglitz and Steichen proved that once-scorned drawing media could convey new aesthetic ideas with considerable power. In portraiture, for instance, figurative drawings by Rodin and Matisse undermined notions of how a subject might be posed. Most portraits, as Richard Brilliant has pointed out, exhibit a heightened degree of self-composure appropriate to the formality of the portrait sitting.[31] But informality, these drawings implied, could be just as revealing. Julian Alden Weir posed John Twachtman sitting in a rocking chair, suggesting the intimacy of sitter and subject and their shared view of art [cat. no. 2]. In a later generation, Jamie Wyeth posed Lincoln Kirstein from the back [cat. no. 40], a tellingly quiescent stance for an impresario who spent a lot of time watching others in the creative process. Implied movement, on the other hand, could now seem as appropriate for portraiture as static posing. In the portraits of Hart Crane dancing or "Bojangles" Robinson rehearsing on stage [cat. nos. 13 and 32], elevation onto the toes or the extension of the limbs captures the sense of kinetic motion.

American art publications reproduced graphic works, disseminating their impact. Reproductions and critical essays in *Camera Work* enhanced the message-bearing impact of 291's exhibited drawings. The *Dial* magazine of the 1920s, as reconstituted by Scofield Thayer and his partner, made prominent use of drawings and prints. Planning to showcase the best in literature and the arts, the editors mixed modern with traditional works and published American art together with European. A series of articles by critic Henry McBride called "Modern Forms," for example, was illustrated with drawings by André Derain and

Fig. 7. *Nude with Bracelets* by Henri Matisse (1869–1954). Pen and ink on paper, circa 1909. The Metropolitan Museum of Art, New York; Alfred Stieglitz Collection, 1949

alternatively, took a schematic approach in his gouache and his black-ink rendering of Eva Le Gallienne [cat. no. 14 and fig. 34]. His simplified geometric forms and enlarged eyes recall Picasso's use of ancient and medieval sources for facial depiction. Every line or mark conforms to his tight stylization, heightened by areas of graphic patterning. From a later generation, Roy Lichtenstein's ink drawing of Robert Kennedy [cat. no. 45] gains meaning from its schematic concept, its cartoon stylization of the hair and face making its own irreverent statement about political campaigning and the media.

Whatever their approaches, artists were far more conscious of the abstract and symbolic effects of graphic marks upon a flat support. In much twentieth-century drawing, one senses that new, modernist relationship between the image and the paper upon which it is drawn. As John Elderfield has described it in discussing Cézanne and Matisse, artists learned to conflate the identity of the surface with that of the object portrayed.[35] Rejecting the rules of illusionistic draftsmanship, they rendered volume and mass while consciously maintaining the two-dimensionality of the sheet. The austere pencil profile of Stuart Davis's self-portrait [cat. no. 21], for instance, conveys the physicality of the head and hat but also the modernist's consciousness of line and placement on a flattened plane. Milton Avery's self-portrait [cat. no. 31] links image to surface with a dazzling pattern of hooked and hatched lines that crisscross the contours of face, modeling the features, delineating the shadows behind the head, and integrating the whole. Thirty years later, Leonard Baskin created a similar flattening of space in his portrait of Rico Lebrun [cat. no. 46] with thin lines of ink that cross over and subvert the strong profile contour, simultaneously defining the volume of the head and linking it to the two-dimensional surface. The flattened surface area no longer provided the

Vincent Van Gogh; Wyndham Lewis's drawn portrait of Ezra Pound accompanied one of Pound's poems.[32] John Marin, Charles Demuth, William Zorach, and Stuart Davis were among the Americans represented; outline drawings by Gaston Lachaise and Adolf Dehn [cat. nos. 13 and 17] are not unlike the images they submitted to the *Dial*.[33]

Artists of the late nineteenth century had invented new uses for drawing, and their ideas left a lasting legacy. The graphic media, as Nicholas Wadley has pointed out, were variously employed by impressionist and postimpressionist artists for rapid, informal sketches implying movement and sensation; for controlled schematic interpretations; or for abstract, expressive, and decorative effects.[34] Generations of American artists used drawing in similar ways. Elaine de Kooning's remarkable evocation of sound in her penciled image of saxophonist Ornette Coleman [cat. no. 41], for example, has roots in impressionist efforts to convey transient sensation through drawing as well as later experiments in the visual expression of music. Scribbled lines replacing hands and contours, smudged areas of soft pencil, and blurred erasure marks all subvert form, evoking the rhythm and improvisation of jazz. Miguel Covarrubias,

21

void in which a three-dimensional figure existed. The floating space emptied of air and gravity, seen in Baskin's *Rico Lebrun*, the claustrophobic filling up of the picture plane, seen in Philip Pearlstein's *Mark Strand* [cat. no. 50], as well as cropping, angled viewpoints and asymmetrical placement, all imply the complex interrelationship between subject and ground that had its genesis in modernist explorations.

Artists of the twentieth century were increasingly conscious of using style and technique to confer political or emotional intent, in portraiture as in other art. Graphic artists, especially, understood the meaning and symbolism of the actual marks they made on paper. Ben Shahn's *J. Robert Oppenheimer* [cat. no. 37], drawn during the atomic physicist's investigation by the FBI on charges of Communist connections, has a tortured, masklike face. But much of the impact of the drawing comes from Shahn's spiky line, which lends an unsettling, barbed-wire sharpness to the image. The fauves' exploration of the emotional impact of color inspired twentieth-century draftsmen as well as painters. Joseph Stella, in his self-portrait [cat. no. 33], creates an ambiguous flattened space through odd, juxtaposed colors. Outlining the sagging profile with a bilious yellow gouache, he brings the background forward to inhabit the same plane as the face, heightening the sense of psychological enclosure and anxiety. Harsh hues of yellow mixed with green and orange add a similar sense of psychological turmoil to Beauford Delaney's *James Baldwin* [cat. no. 38].

Ironically, portraiture, a seemingly obvious offshoot of the preoccupation with identity and the self, never settled comfortably into the modernist canon. With the ascendancy of American abstract expressionism, portraiture seemed to have lost its experimental edge. The gap between the rejection of illusionism and the portrayal of the recognizable face appeared to some artists and critics unbridgeable.

"The atmosphere of modern art seems to be not altogether favorable to portraiture," Paul Valéry wrote in 1939. "Everything now conspires to make portrait painting or drawing a rare and hazardous enterprise."[36] Looking back from 1979, Robert Rosenblum commented, "If anybody had been asked in the 1950s to check the pulse of contemporary portraiture, the diagnosis would have been gloomy. 'Moribund' might have said it discreetly." Citing the mythic, abstract worlds of Mark Rothko, Barnett Newman, and Jackson Pollock, he noted that "the prospect of any mortal, not to mention contemporary, man or woman surfacing in that lofty pictorial environment seemed slim indeed."[37]

But how dead was figuration and portraiture at mid-century? To some extent, its seeming demise reflected the preoccupations of leading critics more than the actual practice of art making. Figurative artist Ben Shahn, after all, was chosen together with abstract expressionist Willem de Kooning to represent the United States at the Venice Biennale in 1954. While portraiture and figuration certainly diminished in the 1940s and 1950s, the break with the figural tradition was complete only in the minds of some art commentators. Many artists simply endured the critical obsession with abstraction, refusing to abandon figural subject matter.[38] The explorations of the figure by such artists as Alice Neel, Fairfield Porter, Elaine de Kooning, Alex Katz, Larry Rivers, Leonard Baskin, and many others coincided with the compelling developments in abstraction that dominated the critical map. Today, their work demands an equal share of recognition, affording us a more accurate assessment of mid-century art.

Even the abstract expressionists themselves, including de Kooning, Jackson Pollock, and Theodore Roszak, for example, turned or returned to figuration for inspiration in their art. The figure for de Kooning, as Paul Cummings has pointed out, was an

Fig. 8. *De Kooning Breaks Through* [Willem de Kooning (1904–1997)] by Red Grooms (born 1937). Colored lithograph and sculpted paper, 1987. National Portrait Gallery, Smithsonian Institution; acquisition made possible by a generous grant from the James Smithson Society

endlessly complex and revitalizing challenge, a "springboard into the insights of invention."[39] Throughout the 1940s, de Kooning painted seated and standing males and females as well as incorporating figural elements into his more abstract compositions. When he started painting his controversial "Women" series in the 1950s, he was not backsliding as commentators suggested, but rather continuing to develop a long-standing relationship in his art between abstraction and the human body.

During this relatively quiescent period for portraiture, seeds were sown for reinvention. De Kooning's "Women" paintings were a dramatic reversal of accepted notions about the status of figuration, inspiring others toward new approaches to the human face and body. In 1987, Red Grooms, with punning, layered humor, made this the subject of a color lithographic paper sculpture, *De Kooning Breaks Through* [fig. 8]. The artist is shown on his bicycle ripping through the surface of one of his paintings—propelled from two dimensions to three— and transferring the woman to his handlebars. The "breakthrough" of the title also refers to smashing both the tradition of the female nude in Western art

and the seemingly inviolable aesthetic of nonfigural abstraction in his own day. In Grooms's witty deconstruction, de Kooning removes the controversial female altogether from his abstract painting while reclaiming her as personal muse. Tackling the figure, Grooms implies, had become a complicated business that required revolutionary rethinking.

A number of artists rose to the challenge that de Kooning's explorations proffered. In attempting to update figural and portrait traditions, they were inspired by abstract expressionism's energy, ambition, and large scale, even while rejecting its anti-illusionist emphasis on the creative process. Norman Geske chose the figurative tradition in recent American art as his theme for the 1968 Venice Biennale, explaining that a notion had been "bugging [him] for the past few years" that "there was something afoot among the practitioners of figurative art."[40] Something was indeed "afoot," to use his delightfully apt language of the body.[41] In 1975, *Art in America* devoted an entire issue to portraiture. In his article for the magazine, critic Gerrit Henry, while claiming that portraiture came to a "dead halt" just as American art seemed to come to its maturity after World War II, found ten artists who focused on the figure. He interviewed Alice Neel, Chuck Close, Elaine de Kooning, and Alex Katz, among others, in an attempt to understand their seemingly perverse tendency to explore a new aesthetic for portraiture. His heterogeneous group did not constitute a "school" nor a cohesive revival, he stated, but they all saw themselves as outside the conservative world of "commercial," society portraiture. Trained in avant-garde, twentieth-century traditions, these artists usually scorned commissioned work, considering likeness merely a secondary goal. They acknowledged that their images were as much about themselves and their own aesthetic explorations as biographical statements

23

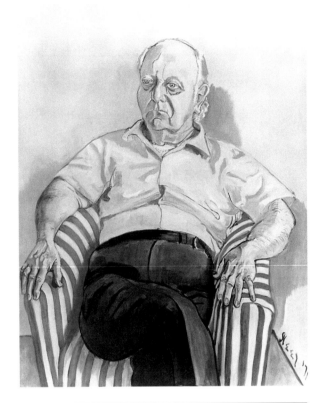

Fig. 9. *Virgil Thomson* (1896–1989) by Alice Neel
(1900–1984). Oil on canvas, 1971. National
Portrait Gallery, Smithsonian Institution

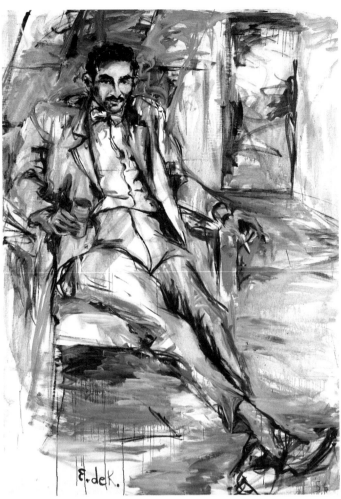

Fig. 10. *Harold Rosenberg* (1906–1978) by Elaine de
Kooning (1918–1989). Oil on canvas, 1956. National
Portrait Gallery, Smithsonian Institution

about their subjects. Portraiture for all of them was a
means to an end; they were artists, not portraitists.[42]

Alice Neel persisted in this discredited field, she
admitted to Henry, because it was a passion for her,
and she conceded an "old-fashioned" interest in the
psychoanalytic portrait. "I've always shown more
than just the surface," she noted. Surface, of course,
in such pictures as her 1971 *Virgil Thomson* [fig. 9],
was also paramount to her vision.[43] With tilted
perspective, flattened space, and Matisse-like
decorative patterning that refuses to remain in the
background, the painting reveals its modernist
sensibilities. But Neel also developed her own
contemporary look with whimsical, folklike
distortions and intense, bright lighting that washed
out colors and isolated the figure in an airless space.

For Willem's wife, Elaine de Kooning, portraiture
became an admitted "addiction."[44] Influenced by the
explosion and reconstruction of figural traditions
Willem had introduced, she applied the dynamism of
expressionist, gestural brush strokes to such portraits
as her painting of critic Harold Rosenberg [fig. 10].[45]
In her 1967 ink drawing of him [cat. no. 44],
disordered strokes rapidly drawn on paper convey a

similar vitality, evoking at the same time a sense of
strong personality.

But the evocation of personality, such a powerful
motivation for the preceding generation, struck many
artists of the late 1960s as something to consciously
avoid. Attempting to favor style over content, they
strove for detachment and the iconic import de
Kooning had achieved in his "Women" series.
Emptying portraiture of sentiment and biographical
narrative separated it from stale conventions and
allied it to a contemporary emphasis on the formal
elements of making art. These artists used
monumental scale, abstract surfaces, and imagery
appropriated from advertising, photography, and film
to distance themselves from the sitter. When Alex
Katz started making portraits, he told Henry, it was
questionable whether one could do a serious, "valid"
modern painting that was a portrait. But the

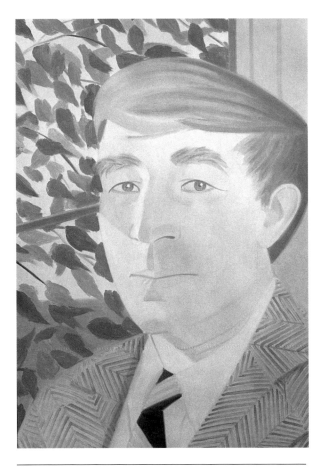

Fig. 11. *John Updike* (born 1932) by Alex Katz (born 1927). Oil on canvas, 1982. Original painting for cover of *Time*, October 18, 1982. National Portrait Gallery Smithsonian Institution; gift of *Time* magazine

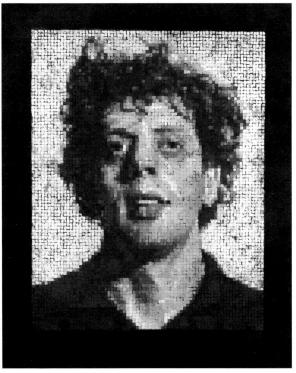

Fig. 12. *Phil III* [Philip Glass (born 1937)] by Chuck Close (born 1940). Handmade paper pulp, 1982. National Portrait Gallery, Smithsonian Institution; partial gift of Martin Peretz

challenge of "getting the expression in the eyes right" suddenly struck him as a wild, novel idea. Katz admired the impact of the huge canvases of the action painters. But he ultimately rejected their gestural technique as too mannered and overwrought. Portraiture, he claimed, added a human element that kept the painting from being too "precious" or obsessively focused on the "painter-surface."[46] He therefore channeled his formalist interests in structure, color, and composition into everyday faces and figures, subjecting them to a reductive, unsentimental refinement. In such images as *John Updike* [fig. 11], the large scale and smooth, ungestured treatment of the surface reveal his debt to billboard advertising, the movie close-up, and the media-obsessed culture of the 1960s.[47] The flat hues, abstract patterns, unexpected cropping, and impassive expressions of his massive faces further remove his portraits from the personal, creating monumental, timeless images.[48]

Chuck Close and Philip Pearlstein achieved a

similar detachment. The colossal scale of heads such as Close's molded-paper *Phil III* [fig. 12], together with its mug-shot frontality and unhierarchical assemblage of grid-patterned marks to compose the features, deflected any engagement with personality. There was no difference, Close claimed, between a background dot and one that makes an eyeball or a shirt. "They're all just a mark, without any virtuoso markmaking."[49] His emphasis on process, optical perception, and the abstract relationship of one pictorial unit to another has precedence in the ideas of Cézanne and hinted at the conceptual experimentation of generations to come. Philip Pearlstein also deemphasized personality in such portraits as his *Mark Strand* [cat. no. 50]. Using monumental scale, a close-up framing of the face and chest, a harsh, cool, bleaching light, and an emphasis on detail or texture over expression, he achieved what Hayden Herrera called an "anesthetizing psychic withdrawal" that turned subject into object.[50] Other artists eschewed traditional representations of personality by using symbolic objects or words, paired with or substituted for the portrait. Jasper Johns, Robert Rauschenberg, Jim Dine, Larry Rivers [fig. 13], and others employed symbolic or textual

25

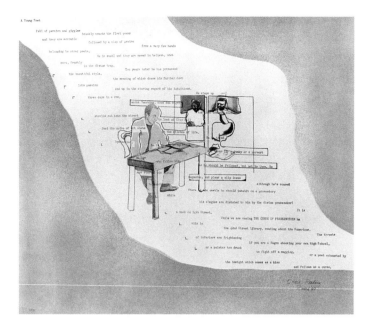

enhancements to add context, sequence, or a new form of personal narrative to the concept of portraiture.

Andy Warhol's portraits in the 1960s and 1970s incorporated many of those ideas, including larger-than-life close-up croppings, unmodeled areas of flat color, and manipulations of photographic sources. His smooth, anti-art surfaces, impersonal interpretations, and appropriation from advertising, news media, and popular culture intersected with other innovative figural depictions from his generation. Warhol's work brought portraiture unapologetically back into the media spotlight. When Warhol and realist artist Jamie Wyeth, hoping to tweak the art critics, agreed to mutual portrait sessions in 1976, the joint exhibition of their efforts at the Coe Kerr Gallery made headlines [cat. nos. 48 and 49]. "Not since Gainsborough painted 'The Blue Boy' has portraiture caused such a stir," the gallery's director declared.[51] His statement signaled the art establishment's lingering avoidance—and disdain for—portraiture at the time. But in fact, the portrait business was booming at Warhol's studio, the Factory, and elsewhere the genre was very much alive. Grace Glueck's 1983 article "Revival of the Portrait" in the *New York Times* mentions Warhol, Katz, Rivers, Pearlstein, Neel, and Elaine de Kooning, together with Jack Beal, Red Grooms, David Hockney, Alfred Leslie, George Segal, and others as successful artists particularly known for their portraits.[52] Although sometimes defensive about their choice of subject matter, artists continued to mold portrait traditions to contemporary purposes.

Some of the approaches of this generation hinted at conceptual concerns that we now recognize as postmodern. Amy Goldin addressed the "post-perceptual portrait" in a 1975 article concentrating on new approaches to self-portraiture. Six years later Carla Gottlieb, in a study of self-portraiture from Marcel Duchamp through the 1970s, identified a number of innovative devices she considered postmodern, including fragmentation, serialization, symbolic referents, punning double-entendre, and the use of photographic imagery within other media. Wendy Steiner's 1987 article on the postmodern portrait, which analyzed the work of Warhol, Rauschenberg, Close, and others, cited as characteristic: insistent repetition, the tension between the arrested moment and temporal sequence, the ambiguity between the individual and the public image or type, and self-referential stylistic artifice.[53]

All of these elements played important roles in the resurgence of experimental, conceptual figuration in the 1980s and 1990s that now suggests a distinct new era for the portrait. But we can also identify the themes that connect it to a tradition of twentieth-century portrait art. Gottlieb locates the roots of postmodern portraiture's "artistic revolution" in the work of Duchamp, Man Ray, Picabia, and their circle. Steiner relates her study to the literary portraiture of Gertrude Stein. The brief vogue for symbolic portraiture among artists of the Stieglitz and dada circles provides precedent for the allusive, nonfigural representations of later generations. From the impulses of the early modernist period, in other words, grew the experiments of mid-century artists, who in turn laid the groundwork for the conceptual portraiture of the last two decades of the century. "Identity is something we don't construct visually," one curator explained about contemporary portraiture in a 1999 article in *ARTnews*. "We construct it conceptually."[54] If so, it is the

Fig. 14. *Michael Jackson* (born 1958) by Andy Warhol (1928–1987). Synthetic polymer paint and silkscreen on canvas, 1984. Original painting for cover of *Time*, March 19, 1984. National Portrait Gallery, Smithsonian Institution; gift of *Time* magazine

culmination of a century-long process of discovery. However hidden in the shadows, a viable twentieth-century portrait tradition had been addressing issues of identity and representation right along.[55]

Looking back, then, at twentieth-century portraitists, the line between commercial and progressive portraiture does not seem as definitive as it once did. Many artists selectively incorporated innovative themes, stylistic devices, or new conventions of posing and articulating the human figure.[56] While some portraits did harken back to earlier styles, many are freighted with twentieth-century thematic or psychological concepts. Don Bachardy's *Truman Capote* [cat. no. 39] draws upon a tradition of realist pencil portraiture that goes back to Dominique Ingres, effectively us

ing the precision of the media for contouring and its smooth tonal properties for modeling. But the portrait confronts its audience in an exclusively twentieth-century manner. The artist has pushed the large-scale figure close to the picture plane in a direct, frontal pose. Instead of a traditional, hierarchical balance of features, he emphasizes the eyes to an almost surrealist degree. Despite the gentle, perhaps vulnerable, expression of the face, the result is a bold, indiscreet engagement with the viewer that evokes contemporary interpersonal relationships as well as the public's sense of ownership of its celebrity figures. Bachardy relished that "eye contact" with his sitter, which he felt "provided a real exchange of energy."[57]

As Bachardy's *Truman Capote* and *Christopher Isherwood* [cat. no. 47], Pearlstein's *Mark Strand* [cat. no. 50], Rico Lebrun's *Igor Stravinsky* [cat. no. 36], and Leonard Baskin's *Rico Lebrun* [cat. no. 46] all suggest, works on paper—also somewhat overshadowed by the reign of large abstract canvases—regained their ambition to be imposing, independent works of art in the second half of the century. In galleries and museums, works on paper

were once again integrated into retrospective exhibitions. Dealers and collectors began to recognize a salable value. These works gained prestige because the artists approached drawing media with a new respect. Bachardy found the directness of graphic media ideal for the immediate, personal experience of a life sitting. Each of his drawings, precisely dated and signed by the subject, represents a specific interaction between two personalities that records the moods and circumstances of the moment.[58] Other artists turned to graphic media for a variety of expressive effects. Drawings, Leonard Baskin argued, can be "finished self-sufficient artifacts . . . of a grand and diverse range: smashing and twittering, broad and tentative, touched with color and ponderously black on white paper." But a search for truth, not drama, underlies these effects for the draftsman. Baskin quoted his mentor Lebrun's conviction: "Drawing should be, above all, . . . a tool for understanding."[59]

Andy Warhol and Roy Lichtenstein even integrated the process of drawing into the act of picture making. Warhol, in such paintings as *Michael Jackson* [fig. 14], based his image on celebrity photographs silkscreened onto his canvases. But he frequently contradicted the "accurate" likeness by superimposing a lively, hand-drawn line over its contours. Throughout his career, Warhol subverted presumptions about originality and appropriation, hand-craftsmanship and mechanical replication. The

27

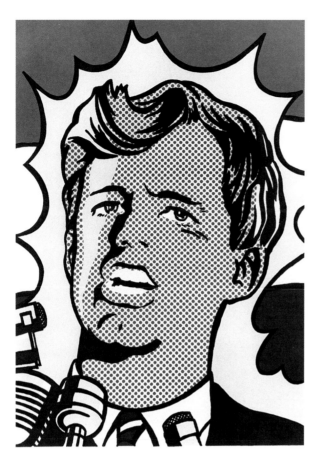

Fig. 15. *Robert F. Kennedy* (1925–1968) by Roy Lichtenstein (1923–1997). Lithograph on paper, 1968. Original illustration for cover of *Time*, May 24, 1968. National Portrait Gallery, Smithsonian Institution; gift of *Time* magazine

drawn line was a crucial element in his sly reimagining of how the artist defines art. Warhol's imposing pencil portrait of Jamie Wyeth [cat. no. 49], with its jittery zigzag superimposed on an idealized contour, reveals his hand at work without silkscreen or paint, giving us insight into his subtle manipulations.

Lichtenstein had a similar dependence on the drawn line as process, actually projecting photographic images of drawings onto canvases and then revising. It was a creative moment that he particularly enjoyed. "I like to do the drawings for the paintings, where I begin to organize the material," he claimed. "When I project it, I try to draw it again, trying not to copy the projection but to kind of resense it. . . . I redraw the position of each line. . . . I'm trying to make the drawing as powerful as possible."[60] Drawing to "preconceive" a composition, Bernice Rose has pointed out, had been discredited. Lichtenstein consciously embraced the firm contours of representational drawing as a basis of his pop appropriations.[61] Underlying such images as his Robert Kennedy lithograph [fig. 15], incorporated into a cover for *Time* magazine, was the carefully conceived linear outline [cat. no. 45] that established his aesthetic idea. From the point of view of many artists of the era, hierarchical distinctions between the graphic and fine arts were no longer relevant.

The complex histories of both portraiture and drawing since the early modern era continue to challenge us. But the effort to legitimize drawing media, the struggle to define the self, and the engagement between illusion and new techniques of figuration have yielded results that warrant more critical attention. Closer examination reveals a continuing momentum for portraiture in the twentieth century despite various critical attempts to redefine the nature of art and art making. Even while abstraction dominated the news in the art world, many artists found the potential of the figure limitless. The terrain of the human image, one such artist, Rico Lebrun, insisted, "is immense."[62] J. Robert Oppenheimer, in his volume *The Open Mind* (1955), drew parallels between the artist and the scientist in their search for innovation. "Both the man of science and the man of art," he wrote, "live at the edge of mystery, surrounded by it. Both always . . . have to do with the harmonization of what is new with what is familiar, with the balance between novelty and synthesis, with the struggle to make partial order in total chaos."[63] This defining tension lies at the heart of twentieth-century portraits.

NOTES

1. "Many many tickle you for them" is strikingly like "Mene, mene tikel u pharsim" (Elizabeth Hutton Turner, *American Artists in Paris, 1919–1929* [Ann Arbor: UMI Research Press, 1988], 78).

2. Wendy Steiner, *Exact Resemblance to Exact Resemblance: The Literary Portraiture of Gertrude Stein* (New Haven: Yale University Press, 1978), 2.

3. Cathleen McCarthy, "About Face," *Art and Antiques* 20 (Summer 1997): 56–63; Daniel Kunitz, "Changing Faces," *ARTnews* 98 (March 1999): 106–11; Terrie Sultan, "Contemporary Portraiture's Split Reference," *Art on Paper* 3 (March–April 1999): 38–42; Joanna Woodall, ed., *Portraiture: Facing the Subject* (Manchester: Manchester University Press, 1997), 7.

4. Wanda M. Corn, *The Great American Thing: Modern Art and National Identity, 1915–35* (Berkeley: University of California Press, 1999), 202–3, 223.

5. Richard S. Kennedy, *Dreams in the Mirror: A Biography of e. e. cummings* (New York: Liveright Publishing, 1980), 130. The editors of *Dial* magazine in 1924 thought enough of cummings's work to choose him for its high-profile award for "distinguished service to American letters."

6. Virgil Thomson, preface to Anthony Tommasini, *Virgil Thomson's Musical Portraits* (New York: Pendragon Press, 1986), x.

7. Tommasini, *Thomson's Musical Portraits*, 28.

8. Ibid., ix–x, 28, 22.

9. William Rubin, "Reflections of Picasso and Portraiture," in William Rubin, ed., *Picasso and Portraiture: Representation and Transformation* (New York: Museum of Modern Art, 1996), 13–14.

10. J. Kirk T. Varnedoe, introduction to *Modern Portraits: The Self and Others* (New York: Wildenstein Gallery, 1976), xiv.

11. Marius de Zayas, "Pablo Picasso," *Camera Work* 34–35 (April–July 1911): 66.

12. See Robin Jaffee Frank, *Charles Demuth, Poster Portraits, 1923–1929* (New Haven: Yale University Press, 1994); Corn, *Great American Thing*, 192–237.

13. Corn, *Great American Thing*, 383 n. 39; Ruth Fine et al., *O'Keeffe on Paper* (Washington, D.C.: National Gallery of Art and Harry N. Abrams, 2000), 47.

14. Quoted in Mervyn Levy, "? Public Image or Private Face: The Dilemma of the Portrait Painter," *Studio* 163 (February 1962): 66.

15. Woodall, ed., *Portraiture*, 6.

16. Mae West, *Goodness Had Nothing to Do with It* (Englewood Cliffs, N.J.: Prentice-Hall, 1959), 7.

17. Warren I. Susman, "Personality and the Making of Twentieth-Century Culture," in *Culture as History: The Transformation of American Society in the Twentieth Century* (New York: Pantheon, 1973), 271–85.

18. Ann Douglas, *Terrible Honesty: Mongrel Manhattan in the 1920s* (New York: Farrar, Straus and Giroux, 1995), 55.

19. "The Secret of Personality as Theodore Dreiser Reveals It," *Current Opinion* 66 (March 1919): 175–76.

20. Douglas, *Terrible Honesty*, 55.

21. Tamar Garb, *Bodies of Modernity: Figure and Flesh in Fin-de-Siècle France* (London: Thames and Hudson, 1998), 55–79.

22. Nicholas Wadley, *Impressionist and Post-Impressionist Drawing* (New York: Dutton Studio Books, 1991), 63.

23. Doreen Bolger et al., "American Pastels, 1880–1930: Revival and Revitalization," in Doreen Bolger et al., *American Pastels in the Metropolitan Museum of Art* (New York: Metropolitan Museum of Art, 1989), 15, 29 n. 75.

24. Marilyn Kushner, *The Modernist Tradition in American Watercolors, 1911–1939* (Chicago: Mary and Leigh Block Gallery, Northwestern University, 1991), 10.

25. Dianne H. Pilgrim, "The Revival of Pastels in Nineteenth-Century America: The Society of Painters in Pastel," *American Art Journal* 10 (November 1978): 43.

26. Mariana Griswold Van Rensselaer, "American Painters in Pastel," *Century* 29 (December 1884): 205, 204. For the revival of secondary drawing media, see also Pilgrim, "Revival of Pastels," 43–62; Bolger et al., *American Pastels*, 1–32; Kushner, *Modernist Tradition*, 25.

27. Theodore E. Stebbins Jr., *American Master Drawings and Watercolors: A History of Works on Paper from Colonial Times to the Present* (New York: Harper & Row, 1976), 204–5.

28. Quoted in Dorothy Norman, "From the Writings and Conversations of Alfred Stieglitz," in *Twice a Year: A Semi-Annual Journal of Literature, the Arts, and Civil Liberties* (Fall–Winter 1938): 79.

29. Anne McCauley, "Auguste Rodin, 1908 and 1910: The Eternal Feminine," and John Cauman, "Henri Matisse, 1908, 1910, and 1912: New Evidence of Life," in *Modern Art and America, Alfred Stieglitz and His New York Galleries* (Boston, New York, and London: Bulfinch Press for the National Gallery of Art, 2000), 71–81, 83–95.

30. For Stieglitz's promotion of works on paper, see also Ruth E. Fine and Elizabeth Glassman, "Thoughts Without Words: O'Keeffe in Context," in Fine et al., *O'Keeffe on Paper*, 14–36.

31. Richard Brilliant, *Portraiture* (Cambridge: Harvard University Press, 1991), 10.

32. Henry McBride, "Modern Forms: Forward," *Dial* (July 1920): 60; Henry McBride, "Modern Forms: Van Gogh in America," *Dial* (December 1920): 630; Ezra Pound, "H. S. Mauberly," *Dial* (September 1920): n.p.

33. The *Dial* collection of art was started by Scofield Thayer in order to build up a stock of art for later reproductions. Some of the works appeared not in the magazine but in the portfolio *Living Art*, published by the *Dial* in 1923. To publicize *Living Art*, Thayer arranged for an exhibition of some of the collection at the Montross Gallery from January 26 to February 14, 1924. The collection was subsequently shown in Worcester, Massachusetts, from March 5 to 30, and at Smith College in May. The portfolio and its accompanying exhibitions and catalogues were all further exposure to a collection that refused to differentiate between artistic media.

34. Wadley, *Impressionist and Post-Impressionist Drawing*, 77.

35. John Elderfield, *The Drawings of Henri Matisse* (New York: Museum of Modern Art and Thames and Hudson, 1984), 31.

36. Paul Valéry, *Art and Likeness* (1939), quoted in Paul Cummings, *The Changing Likeness: Twentieth-Century Portrait Drawings* (New York: Whitney Museum of American Art, 1986), unpaginated.

37. Robert Rosenblum, "Andy Warhol: Court Painter to the 70s," in *Andy Warhol: Portraits of the 70s* (New York: Random House with the Whitney Museum of Art, 1979), 9.

38. In her 1959 article, Eleanor C. Munro discussed a group of artists whose portraits she felt shared little in common with the commercial portraitists. She highlighted the work of Larry Rivers, Ivan Albright, Aaron Shikler, William Draper, Pietro Annigoni, Graham Sutherland, and other artists, mostly American and British. See Eleanor C. Munro, "Portraits in Our Time," *Horizon* 1 (January 1959): 95–105.

39. Paul Cummings, "The Drawings of Willem de Kooning," in Paul Cummings, Jörn Merkert, and Claire Stoullig, *Willem de Kooning: Drawings, Printings, Sculpture* (New York: W. W. Norton, 1983), 17.

40. Norman A. Geske, *Figurative Tradition in Recent American Art* (Washington, D.C.: National Collection of Fine Arts, 1968): 10.

41. Fairfield Porter's largely theoretical 1970 article "Speaking Likeness" reproduced portraiture, mostly from the 1950s and 1960s, by himself, Lucian Freud, Alberto Giacometti, Larry Rivers, Alex Katz, Elaine and Willem de Kooning, Alice Neel, and others. See Fairfield Porter, "Speaking Likeness," in *Narrative Art*, ed. Thomas B. Hess and John Ashbery (New York: Macmillan, 1970): 40–51.

42. Gerrit Henry, "The Artist and the Face: A Modern American Sampling and Ten Portraitists—Interviews/Statements: Chuck Close, Elaine de Kooning, Alex Katz, Alfred Leslie, Alice Neel, Philip Pavia, George Schneeman, George Segal, Sylvia Sleigh, Hedda Sterne," *Art in America* 63 (January–February 1975): 34–41.

43. Carolyn Kinder Carr and Ellen G. Miles, *A Brush with History: Paintings from the National Portrait Gallery* (Washington, D.C.: National Portrait Gallery, Smithsonian Institution, 2001), 56–57, 200–201.

44. Henry, "The Artist and the Face," 35.

45. Carr and Miles, *Brush with History*, 55, 188–89.

46. Henry, "The Artist and the Face," 36.

47. Carr and Miles, *Brush with History*, 57, 206–7.

48. Richard Marshall, *Alex Katz* (New York: Rizzoli and the Whitney Museum of Art, 1977), 13–22.

49. Quoted in Jacqueline Brody, "Chuck Close: Innovation Through Process," *On Paper: The Journal of Prints, Drawings, and Photographs* 2 (March–April 1998): 19.

50. Hayden Herrera, "Pearlstein: Portraits at Face Value," *Art in America* 63 (January–February 1975): 46.

51. Quoted in "At the Gallery the Crowd Was Ogling Itself," *New York Times*, January 6, 1976; *Washington Post*, May 18, 1976.

52. Grace Glueck, "Revival of the Portrait," *New York Times Magazine*, November 6, 1983, 52–57+.

53. Amy Goldin, "The Post-Perceptual Portrait," *Art in America* 63 (January–February 1975): 79–82; Carla Gottlieb, "Self-Portraiture in Postmodern Art," in *Sonderdruck aus dem Wallraf-Richartz-Jahrbuck* (Cologne: Dumont Buchverlag, 1981), 267–302; Wendy Steiner, "Postmodern Portraits," *Art Journal* 46 (1987): 173–77.

54. Kunitz, "Changing Faces," 109.

55. In his discussion of self-portraiture in the twentieth century, for example, John Yau explores how artists have resolved highly personal notions of selfhood (John Yau, "The Phoenix of the Self," *Artforum* 27 [April 1989]: 145–51).

56. Carr and Miles, *Brush with History*, 53–58.

57. Don Bachardy, *Christopher Isherwood: Last Drawings* (London and Boston: Faber and Faber, 1990): 117.

58. M. Stephen Doherty, "Don Bachardy," *American Artist* 49 (September 1985): 51–53.

59. Leonard Baskin, *Baskin, Sculpture, Drawings and Prints* (New York: George Braziller, 1970): 9; Leonard Baskin, *Iconologia* (New York: Harcourt Brace Jovanovich, 1988): 23.

60 Quoted in Milton Esterow, "Roy Lichtenstein: How Could You Be Much Luckier Than I Am?" *ARTnews* 90 (May 1991): 86.

61. Bernice Rose, *The Drawings of Roy Lichtenstein* (New York: Museum of Modern Art and Harry N. Abrams, 1987), 17.

62. Lebrun quoted in "Rico Lebrun, Artist, 63, Dead," *New York Times*, May 11, 1964.

63. J. Robert Oppenheimer, *The Open Mind* (New York: Simon and Schuster, 1955), 145.

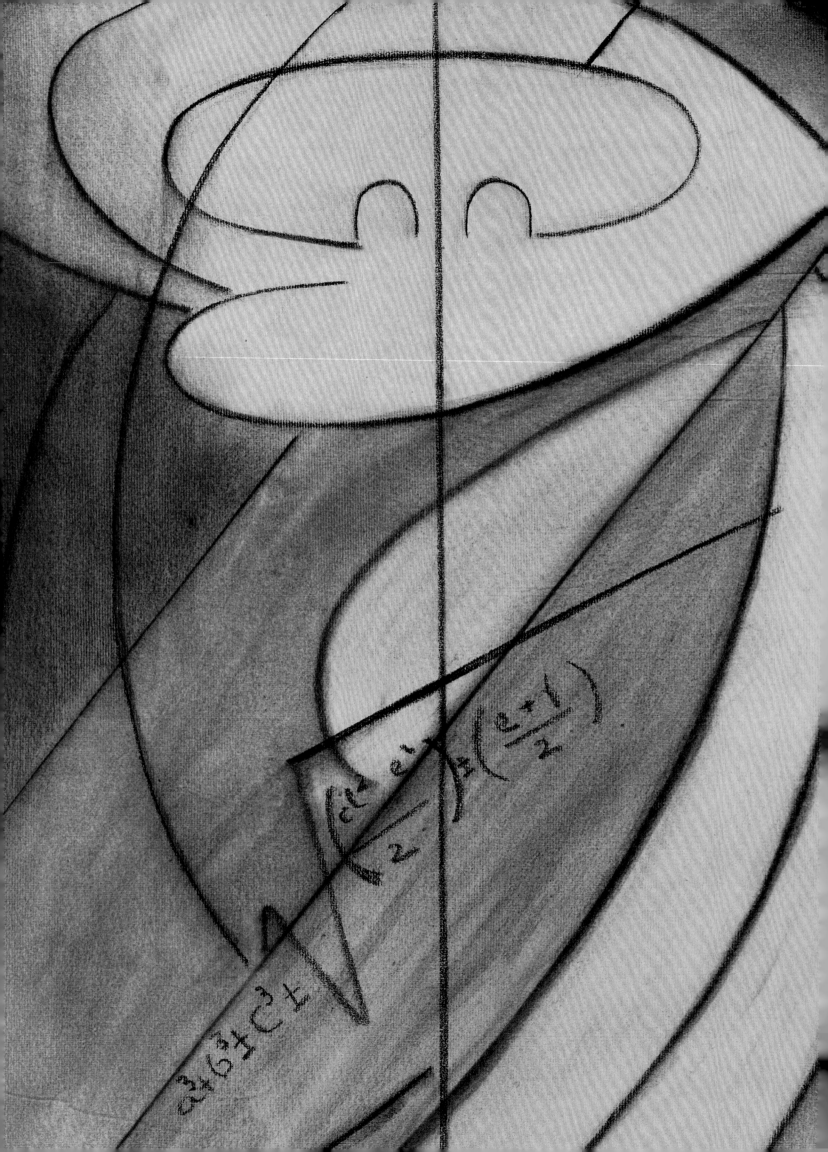

VARIETIES OF EVASION IN A CENTURY OF PUBLICITY

BERNARD F. REILLY JR.

For many of the major artistic luminaries of America's Gilded Age, portraiture was a favored idiom. In the work of John Singer Sargent [fig. 16], William Merritt Chase, Mary Cassatt, and Thomas Eakins the closing years of the nineteenth century saw a spectacular efflorescence in the formal portrait. Throughout the century portraiture had served an important social purpose. It presented for the edification of the public the exemplars of civic, social, and cultural ideals. The scientists, merchants, legislators, industrialists, artists, and others painted by Thomas Sully, John Neagle, Thomas Eakins, and their contemporaries were singled out as admirable, or at least successful, protagonists in an implied narrative of human achievement.

As represented by artists, these citizens often bore the outer markings of an inner human reality, of a discernible if not admirable spiritual or moral condition. In presenting such subjects, artists worked within a framework of accepted social and artistic conventions, and referenced a shared code of personal and civic virtue. The subject was essentially an earnest character in the drama of human existence—the common moral struggle of good against evil, and reason and order against chaos. By contrast, portraiture occupied a less conspicuous place in the oeuvres of American modernists. Among the many notable American painters of the first half of the twentieth century only a handful have created a substantial a body of work in the genre. In general, the depreciation of realism among many painters and sculptors of the early twentieth century in favor of nonrepresentational aspects of art seriously undercut the foundation of traditional portraiture, the argument that the faithful replication of the subject's appearances could convey an inner reality meaningful to the sympathetic viewer.

Certain intellectual and cultural forces of the time came to bear on portraiture as well, and altered its practice in the twentieth century. Advances in the understanding of the mind and of human motivation

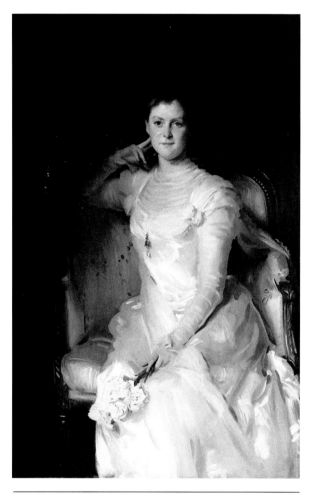

Fig. 16. *Mrs. Joshua Montgomery Sears* (1858–1935) by John Singer Sargent (1856–1925). Oil on canvas, 1899. The Museum of Fine Arts, Houston; Museum purchase with funds provided by George R. Brown in honor of his wife, Alice Pratt Brown

33

were made in the natural sciences and the new field of psychology by pioneers such as Charles Darwin and Sigmund Freud. As a result, traditional conceptions of the human personality and character were discarded for new models. Scientists and, eventually, the general public embraced a new conceptual framework through which to view the individual. New conceptual strategies played out in the media of mass communications, which emerged as a primary venue for portraiture in the first half of the twentieth century. The mass media of journalism and the press, in turn, exerted their own chemistry on portraiture, a chemistry that ultimately favored superficiality and relativism, rather than analysis, in the representation of public figures.

For portraiture, an art heavily reliant upon observation and interpretation of the individual, such new thinking posed serious challenges, which elicited a variety of responses and new strategies. These developments were particularly evident in drawings. As a relatively direct form of artistic notation, drawing reveals the mechanics of observation and manipulation with special clarity. In addition, drawing was especially suited to reproduction in the mass media of the early twentieth century, and it was in the media that many of the modern approaches to portraiture first evolved.

The scientific advances of the latter half of the nineteenth century yielded vast amounts of new data on the human mind and personality. On the basis of that information, a far more complex relationship than was previously imagined emerged between the mind and body. These advances occurred on two fronts: in the scientific analysis of the workings of the mind (psychology) and in the study of society and culture's impact upon the individual's behavior and sense of self (sociology).

Early in the nineteenth century, natural science had begun to examine the human personality in new ways. Whereas humankind had always been the central subject of Western thinking since classical times, post-Enlightenment science subjected the analysis of the mind to a more rigorous empiricism. Experimentation and observation by German scientists such as Gustav Theodor Fechner and Wilhelm Wundt yielded a great deal of understanding about the simpler neurological and mental processes of sensation, reflex, memory, and emotion. On the basis of this information, scientists and philosophers drew important conclusions about the relationship between the physiology of the brain and nervous system and human pathology and mental states.

Sigmund Freud, William James, and others of their generation applied the scientific method to analysis of the complex mental processes, with considerable success. Freud defined his results partly in the mechanistic terms of physics, based on the action of neurological energies, chief among which was the pleasure principle. But at the same time, Freud and many of his contemporaries offered a model of the human psyche wherein the complex manifestations of those energies—instinct, primal conflicts, and sexual desire—were the supreme motivating forces in the highest fields of human endeavor. For Freud, even politics and religion were arenas controlled by deep human forces.

Although Freud's theories were not universally embraced, during his lifetime the science of psychology furnished contemporary intellectuals with a far more detailed map of the inner world than had hitherto been available. Freud's research also provided useful tools with which to more precisely describe and explain human behavior. Historian Carl Schorske remarks on the enormous shadow cast by Freud's thinking on culture in turn-of-the-century Vienna:

Not only Vienna's finest writers, but its painters and psychologists, even its art historians, were preoccupied

with the problem of the nature of the individual in a disintegrating society. . . .Traditional liberal culture had centered upon rational man, whose scientific domination of nature and whose moral control of himself were expected to create the good society. In our century, rational man has had to give place to that richer, but more dangerous and mercurial creature, psychological man. This new man is not merely a rational animal, but a creature of feeling and instinct. We tend to make him the measure of all things in our culture.[1]

Research into human and animal genetics compounded the drift of scientific thought toward determinism by opening the door to explaining physical traits and psychological predispositions in hereditary terms. Gregor Mendel's experimentation with the hybridization of plants in the 1850s and 1860s helped unlock the rudimentary keys to genetic patterns affecting all life. Mid-twentieth-century findings on the power of coding embedded in microscopic particles of matter to shape the lives and fortunes of all creatures were only a logical extension of Mendel's premise.

The importance of larger societal forces in forging human personality and behavior was increasingly recognized by modern science in the late nineteenth century. Charles Darwin and other scientists gave far more weight in the shaping of human nature to man's animal beginnings. They saw the human mind not as a distinct, universal, and spiritual constant but only as the most recent stage in a process of development that had its roots in the animal kingdom.[2] The Darwinians, moreover, introduced the idea of struggle and adaptation as dynamic processes that gave form not only to human anatomy but also to the human psyche and the individual's relationship to society. Subsequently, ethnologists began to identify an expanding range of behaviors and practices common to "primitive" and

"developed" cultures alike. In explaining human character and behavior, biology and the influence of the herd loomed ever larger.

Social theorists such as Thorstein Veblen applied Darwin's findings to a broad economic and social sphere, presenting a new, more mechanistic view of human behavior and social institutions. Veblen saw the accumulation of wealth and "conspicuous consumption" as manifestations of the survivalist instinct in the "predatory phase of culture." To modern theorists, the keys to human behavior were instinct, honed through millennia of experience and struggle for survival, and the coercive forces of social interaction, rather than the internal or religious moral codes that motivated earlier exemplars.[3]

In the wake of Freud and Darwin, the conception of the individual was revised in fundamental ways. As sociologist Philip Rieff has stated, "psychological man replaced such earlier notions as political, religious, and economic man as the twentieth century's dominant self-image."[4] The findings of psychology and sociology strained the credibility of formal portraiture, its reliance upon far simpler moral narratives, and its correspondence between inner reality and outer appearances. Before the century's turn, however, complex new data only seldom found its way into portraiture. In the hands of artists John Singer Sargent and Mary Cassatt, for example, formal portraiture was more attuned to masking the inner realities of its subjects than to fathoming them, and to presenting the subject in the accepted social roles of his or her class and status: prosperous industrialist, affluent wife and mother, and so forth. The qualities of decorum, "civilization," and dignity exalted in Gilded Age portraits were incompatible with the biological and social determinism of human adaptation and behavior posited by the Darwinians; or with the primacy of instinct and unconscious drives over human behavior in the psychologists' model of the mind.[5]

35

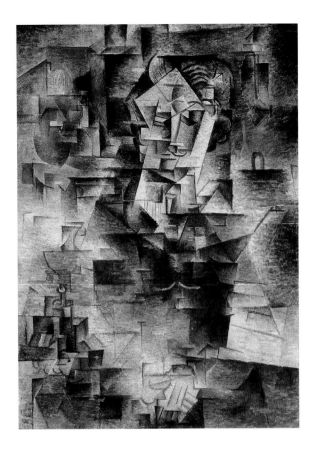

Fig. 17. *Daniel-Henry Kahnweiler* (1884–1979) by Pablo Picasso (1881–1973). Oil on canvas, 1910. The Art Institute of Chicago, Illinois; gift of Mrs. Gilbert W. Chapman in memory of Charles B. Goodspeed

Such was the state of thinking about the individual in 1891, when Oscar Wilde produced *The Picture of Dorian Gray*. In his novel Wilde used portraiture as an analogy for the discrepancy between physical appearance and moral condition. Indeed, the contradiction between the cultivated exterior and the meaner inner self became a common trope in early-twentieth-century American popular literature, from F. Scott Fitzgerald's *Great Gatsby* to Sinclair Lewis's *Babbitt*. One gets a sense of the distance portraiture had to travel between the conventions of the nineteenth century and the spiritual condition of the twentieth in Ralph Barton's circa 1925 self-portrait [cat. no. 15]. Barton was one of the cosmopolitan, "beautiful people" of the New York media world of the 1920s. In his self-portrait he shares the conventional pictorial formula for self-portraiture used by Mary Cassatt in her circa 1880 watercolor [cat. no. 1]: the artist-subject is seen in half-length, seated, and gazing directly at the viewer. But the psychological reserve imposed between the viewer and the subject in Cassatt's work is in sharp contrast with the sense of anxiety exuded by Barton. Whereas Cassatt's image implies a thoughtful, contemplative presence, Barton's portrait feels like a frank, almost confessional self-presentation that is, by contrast, unsettling.

In the face of fundamental shifts in the view of the self, twentieth-century artists sought to reinvent the genre of portraiture. In doing so, they were forced to develop new forms of argument and new uses for the medium. The traditional formal portrait as a presentation of society's exemplars had lost credibility and become an increasingly irrelevant artifact of the corporate boardroom and the historical society.

Abstraction and the emphasis on formal exploration over realistic portrayal offered the most obvious means of addressing the dilemma that this crisis of representation produced. And as a genre in which the subject was indispensable, portraiture presented an especially interesting problem to modernist painters. Led by European modernists such as Paul Cézanne, Pablo Picasso, and Henri Matisse, artists chipped away at the illusionistic conventions of pictorial representation. In his 1910 portrait of the art dealer Daniel-Henry Kahnweiler [fig. 17], Picasso had disassembled and abbreviated elements of the subject's physical appearance to a degree that renders the picture almost unrecognizable as a portrait. Here, Picasso initiated a disquisition on the problematic relationship between artist and subject that he would continue throughout his career.[6]

Experiments in "symbolic" portraiture by artists surrounding the pioneer American modernist Alfred Stieglitz also suggest a desire to loose portraiture from its traditional moorings to the physical subject. Francis Picabia and Marius de Zayas created symbolic portraits of Stieglitz and other members of the avant garde. De Zayas's 1914 portrait of Agnes Ernst Meyer [cat. no. 9] is as highly intellectualized a rendering of its subject as one could imagine. Their experiments were relatively short-lived, however, and found little acceptance among viewers outside of the small inner circle of the artists and their patrons.[7]

Even in photographic portraits, in which fidelity to appearances was traditionally paramount, modern practitioners sought alternatives to the centrality of

36

Fig. 18. *Rodin* (1840–1917), *"The Thinker,"* and *"Victor Hugo,"* by Edward Steichen (1879–1973). Photogravure, 1902. Musée Rodin, Paris

likeness. Edward Steichen's portraits of the sculptor Auguste Rodin [fig. 18] and the painter Henri Matisse relegated the artists themselves to the shadows while highlighting their artistic production as the main focus of the photographs. Similarly, some of Alfred Stieglitz's photographic portraits of Charles Demuth and Georgia O'Keeffe [fig. 19] isolated, and thus gave meaning to, certain individualizing features of the subject, like hands or breasts, over the more conventional features.

In their engagement with portraiture, de Zayas, Stieglitz, and some of their contemporaries sought to escape the idiom's traditional focus on the countenance and physical demeanor and to explore new routes to the inner self. In so doing they questioned the age-old belief that a person's external appearances mirrored the soul, an assumption that had given portraiture much of its value and meaning for Western society since antiquity. Simultaneous with the crisis of representation, the advent of the mass media boosted the role of portraiture in the visual culture. In the last quarter of the nineteenth century the American publishing industry, buoyed by rising levels of literacy and an increase in the leisure time enjoyed by the middle class, increased its output of newspapers, magazines, journals, and books to match the scale of mass production in American manufacturing. Enabled by photomechanical technology for reproducing pictorial materials, the print media created a vast new demand for illustrations and artwork, including portraits.

One of the largest circulation journals of the day was *Scribner's*. In 1899 the magazine published Theodore Roosevelt's chronicles, "The Rough Riders," in its January issue, together with a portrait of the author by Charles Dana Gibson [cat. no. 3]. In his text Roosevelt recounted the origins of the Rough Riders and told of their exploits in the recent Spanish-American War. The story's protagonists—Roosevelt's fellow officers and soldiers—are

described in terms of the conventions of manly character and virtue. The author's characterization of Dr. Leonard Wood, a leader of the expedition, is a study in elitist idealization:

> [He] combined, in a very high degree, the qualities of entire manliness with entire uprightness and cleanliness of character. It was a pleasure to deal with a man of high ideals, who scorned everything mean and base, and who also possessed those robust and hardy qualities of body and mind, for the lack of which no merely negative virtue can ever atone.[8]

Roosevelt's characterizations are as difficult to square with present-day notions of personality and character as his account is to reconcile with the squalid realities of the Spanish-American War and, increasingly, of modern warfare in general. In the war in Cuba larger factors, such as hostile environmental conditions, the political realities of Spanish imperial policy, and the power wielded by American "yellow" journalism, had as much bearing on the fortunes of the expedition as personal heroism or leadership in the field.

As one would expect, the accompanying portrait of Roosevelt was more an exercise in idealization than in character analysis. For the work, *Scribner's* editors chose not an established portrait painter but an illustrator, Charles Dana Gibson. In 1899, Gibson was the foremost among the newly emergent class of commercial illustrators who had almost single-handedly determined the aesthetic and stylistic canons of American advertising. A master draftsman and a discerning art editor, Gibson influenced a generation of advertising illustrators, such as F. X. Leyendecker, Harrison Fisher [cat. nos. 19 and 20], and James Montgomery Flagg [cat. no. 11]. In his drawings of "Gibson Girls" and the square-jawed,

Fig. 19. *Georgia O'Keeffe: A Portrait—Hand* by Alfred Stieglitz (1864–1946). Solarized palladium print, 1918. Alfred Stieglitz Collection, The Art Institute of Chicago, Illinois

Scribner's, and the roughly simultaneous emergence in several major American cities of daily newspaper Leviathans on the scale of the *Chicago Tribune* and *New York Herald,* signaled the ascent of the influence of mass-communications media in the twentieth century. The print "mass media" and the new technologies of film, sound recording, and radio broadcast had a profound impact on American culture and life in general, permeating American consciousness with the modern view of the individual. In the vast public realm served by these media, portraiture found new uses and became an important means by which the new individual was introduced to American audiences.

New subsidiary industries that served the print and broadcast media, such as teletype and wire services and news photography agencies, made possible the delivery of an unprecedented volume of information about national and world affairs. Commentators such as Walter Lippman recognized the scale and intensity of the information explosion and, in fact, saw it as a potential threat to democracy. In his 1920 book *Public Opinion,* Lippmann warned about the potentially paralyzing effect of the deluge of intelligence. He cited the inability of the average individual to absorb, let alone make sense of, the data and posited a larger role for journalism—to not only present information but also to sift and interpret it, to package it in comprehensible form. To aid in the task of managing the information flow, magazine and newspaper editors increasingly enlisted the help of illustrators and cartoonists to bring their graphic communication skills to bear. Drawings and sketches began to appear with more frequency in the journals of the day. Among them, portraits abounded.

By the end of the second decade of the twentieth century, advances in recording, film, and broadcast technology had created a mass audience for arts and letters in the United States. The preceding decades had seen the development of the means and channels

athletic young men who pursued and courted them, Gibson's pen-and-ink technique emphasized the crisp, clean lines and sharp black-and-white silhouettes of contemporary fashions.

In Theodore Roosevelt, Gibson had a challenging subject who, by evidence of photographs, hardly fit that, or any era's, masculine ideal. Even the most flattering photographic portraits of Roosevelt fail to conceal his stocky, even paunchy, stature and broad, fleshy face.[9] Like any good advertising draftsman, Gibson "repackaged" his subject, suppressing those features and the prominent, flashing teeth, bushy oversize mustache, and glaring spectacles so relished by political cartoonists of the time. The illustrator applied the contemporary, consumerist canons of dress and grooming by making his subject conform to the clean-shaven, masculine sartorial ideal that Gibson had done much to define for the era. In essence, he transformed Roosevelt into the "Gibson Man." Rather than aspire, as earlier portraitists had, to create a penetrating analysis of an individual or a timeless exemplar of character and civic virtue, Gibson was content with a superficial portrait that conformed to the stylistic look of the day. In his portrait of a national leader he embraced the values of advertising.

The success of mass-circulation magazines such as

38

with which to record and replicate performances, musical and dramatic, and to broadcast content widely and cheaply, creating lucrative markets for literature, films, and recordings of performances. The enlargement of the popular market simultaneously intensified the trend toward commodification of the arts and letters, a phenomenon that had begun in the nineteenth century with the advent of popular magazines and novels. A cultural industry created the cult of celebrity, and the literature of magazines and books that fueled it created a demand for representations of the individuals who populated the media. Hollywood and its star system were built upon the foundation of the marketability of personalities and performance, and on the symbiotic support of the mass media.[10]

In the celebrity environment a particular genre of portraiture emerged and flourished. Caricature, long an inferior cousin of traditional portraiture, was especially well adapted to the highly commercialized world of American popular culture in the twentieth century. The form emerged as a valuable tool of the mass media and a new, reductivist way of presenting the actors in American public life. The idiom had gained importance as a communications tool amid the reformist campaigns of the mass-circulation newspapers of the late nineteenth century. The collective threat that organized labor, socialism, governmental corruption, and other large forces posed to the status quo and to commerce prompted those in authority to seek more effective ways to influence the larger populace.[11] In the United States, caricature was first adopted on a sustained basis by Thomas Nast and the editors of *Harper's Weekly* in their crusade against William Marcy "Boss" Tweed and his associates in New York.[12] Caricature's appeal lay in its ability to reduce to unambiguous, even simplistic, terms the nuances and complexities of political issues and world and national affairs. Boss Tweed's famous exclamation about the power of

"them damn pictures!" to inform and persuade the illiterate was part of the dawning appreciation of the power of visual persuasion among political strategists.

Its accessibility notwithstanding, caricature is a particularly manipulative form of portraiture. Rather than probe the depths of the subject's personality, the caricaturist isolates a few telling features, and fashions from them an image of heightened expressive intensity. Caricaturists of the early twentieth century such as Miguel Covarrubias, Al Frueh, and Paolo Garretto created minimalist sketches designed to arrest the viewer's attention amidst the profusion of graphic and typographic stimuli generated by the popular press.

Through its reductive approach, caricature supplied, in a sense, the trademarks for the celebrities. The caricatures of Covarrubias and Frueh provided a mode of representation formulaic enough to be easily replicated and applied in multiple contexts such as advertisements, posters, and magazines. They were, moreover, simple enough to be readily recognizable and memorable to a broad audience. The caricaturist provided a subject a distinctive image that could enhance his or her celebrity and on which the individual could profitably trade.[13]

Covarrubias's caricature drawings of American celebrities of post–World War I New York—particularly those drawn for the *New Yorker* and *Vanity Fair* in the 1920s, and his 1925 collection of black-and-white drawings, *The Prince of Wales and Other Famous Americans*—draw from the same formal wellsprings of cubist and constructivist art and Bauhaus and other avant-garde design as the graphic and industrial designers who created trademarks and other devices of graphic identity for commerce.[14] Covarrubias's portrait, circa 1923, of the actress Eva Le Gallienne [cat. no. 14] and Al Frueh's rendering, circa 1909, of the actor John Barrymore

[cat. no. 6] replicate the key expressive features with a remarkable economy and purity of form, to an extent to which verisimilitude is often locked in a struggle with geometric abstraction. What these "stage faces" nonetheless lack is a sense of the subject's human presence, of the breathing, assertive individual portrayed.

The achievements of the caricaturists loosened portraiture from its adherence to the details of likeness, and gave other artists license to depart as well. The quick, shorthand portrait, in which a few strokes of the pen sufficed to suggest the salient characteristics of a subject, soon became a staple of literary magazines, public affairs journals, and news magazines. Editors of the *New Yorker*, founded in 1925, incorporated "vignette" portraits into the magazine's format almost from the start. Hugo Gellert's 1928 drawing of Paul Robeson [cat. no. 22] relies upon stylistic prompts that would convey to contemporary readers at a glance certain information about the subject. The portrait adopts the monumental form associated with heroes of the proletarian struggle in official Soviet art, such as Lenin, Trotsky, and others, as a way of signaling Robeson's leftist political sympathies. It also incorporates the rhythmic pattern and stylized forms typical of African art, which by the late 1920s had developed as a commonly understood code, to express his racial identity as well.

Magazines in many respects epitomized the journalistic response to modern needs. The prospectus for *Time*, the weekly news magazine founded in 1923, asserted:

> People in America are, for the most part, poorly informed. This is not the fault of the daily newspapers; they print all the news. It is not the fault of the weekly "reviews"; they adequately develop and comment on the news. To say with the facile cynic that it is the fault of the people themselves is to beg the question. People are uninformed because no publication has adapted

itself to the time which busy men are able to spend on simply keeping informed.[15]

To present events clearly and concisely for the busy professional, *Time*'s editors rigidly allotted space to clearly defined categories of news, such as the Nation, the World, and the like. This offered a way of brokering the enormous quantities of information and reducing events to those that merited the attention of the busy American professional.

Portraits had a prominent place in *Time*. Appearing on the cover of every issue, the *Time* portraits were an extension of the magazine's editorial formula. The individuals portrayed were chosen by the editors as the most significant in public life, and key to the political and economic events of the moment. The idea of temporality, enshrined in the magazine's name, pervaded *Time* from the first. Many of the earliest cover portraits were charcoal sketches, rendered in a medium that mirrored the rapid, fresh idiom of the magazine's journalism. The celebrity of the subjects of the portraits was in most instances fugitive as well. They were destined to be submerged again by the flood tide of events and supplanted seven days later by the subject of the next issue.

As *Time*'s prestige grew, the cover portrait changed in a significant way. The heyday of *Time*'s influence was the 1930s, 1940s, and 1950s, when an appearance on its cover conferred powerful recognition on the subject. During those years charcoal sketches gave way to drawings and paintings in color, which signaled the magazine's contents and editorial tone to those who would see it on the newsstand or across the aisle of their evening commuter train. With its increased impact, the editors had to be extremely deliberative to strike just the right note, a skill that became more challenging as time passed and the media-saturated public

40

Fig. 20. *J. Robert Oppenheimer* (1904–1967) by Alan Richards (lifedates unknown). *Time* cover, June 14, 1954. TimePix

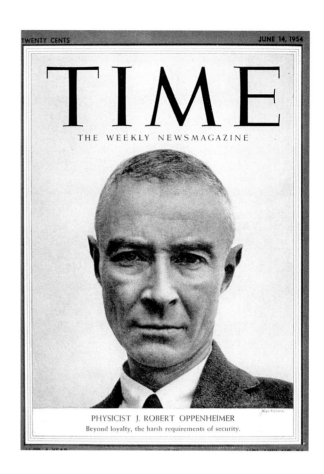

TWENTY CENTS JUNE 14, 1954

TIME

THE WEEKLY NEWSMAGAZINE

PHYSICIST J. ROBERT OPPENHEIMER
Beyond loyalty, the harsh requirements of security.

became alert to media strategies. Readers learned not only to care about the subject of the work but also to be attuned to the associations that an artist or an artist's treatment of a subject might carry.

For this newly sophisticated American public, accustomed to looking past the surface message of the medium to discern the editor's (or artist's) agenda, media outlets like *Time* acquired a kind of transparency. While *Scribner's* choice of Charles Dana Gibson to portray a national public figure would have been meaningful to audiences in 1899, in *Time* magazine the editorial agenda moved to the foreground. In Marshall McLuhan's words, the medium itself increasingly became the message.

The June 14, 1954, issue of *Time* carried a photograph by Alan Richards of J. Robert Oppenheimer [fig. 20], the distinguished nuclear physicist who had led the team that developed the first atomic bomb for the United States. One of America's most esteemed and honored scientists, Oppenheimer had recently become a highly controversial figure. In the early 1950s he expressed misgivings about the proclivity of America's postwar defense establishment to develop ever larger and more destructive nuclear devices, a viewpoint that prompted the United States secretary of defense to remove Oppenheimer from the Science Advisory Committee for the Office of Defense Mobilization and to order him to resign all connections with the federal government.

Time's editorial decision on this occasion to use a photograph instead of a painting or drawing for its cover was relatively unusual for the period. In the paranoid climate of the McCarthy era, the editors were probably playing it safe by eliminating the risk that artistic subjectivity might pose—of betraying (or being perceived as betraying) a bias, whether sympathetic or hostile, toward the subject. That reticence mirrored the careful editorial ambiguity that *Time's* editors for the most part maintained in

their coverage of the anti-Communist witch hunts. They were justifiably wary of the sensitivity of their audience to the underlying messages that the covers might convey.

Later the same year the *Nation*, a magazine positioned ideologically well to the left of *Time*, ran a lengthy essay by Waldo Frank on the Oppenheimer case.[16] In their choice of illustration the *Nation's* editors were less guarded. Accompanying Frank's essay was a portrait of Oppenheimer by Ben Shahn [fig. 21]. Shahn was actually an acquaintance of the scientist's, and like the text it illustrated, his expressionistic portrait of Oppenheimer rendered an opinionated commentary on its subject. A frequent contributor to the *Nation*, Shahn had political sympathies that were well known to the general public. In his *Nation* portrait, of which the National Portrait Gallery owns a variant from the same year [cat. no. 37], Ben Shahn adopted the stylistic conventions of expressionist graphics. As in much of his work, he used jagged, nervous lines, broken forms, and masklike features developed by earlier artists such as Ernst Ludwig Kirchner, George Grosz, and Emil Nolde in their etchings and woodcuts to signal psychological distress. The expressionist vocabulary and its associations would have been familiar to readers of the *Nation*.

41

Fig. 21. *J. Robert Oppenheimer* (1904–1967) by Ben Shahn (1898–1969). Brush and ink on paper, 1954. Original illustration for the *Nation*, September 25, 1954. The Museum of Modern Art, New York

In the 1950s and 1960s, as *Time* began to rely less on regular artists and more on commissions of well-known artists for its cover portraits, the art director's choices became more arbitrary yet more meaningful as well. By mid-century *Time*'s audience of well-educated Americans had developed a healthy skepticism toward the mass media. The propaganda campaigns of the totalitarian regimes in Nazi Germany and Stalinist Russia had demonstrated vividly the power of disinformation. Postwar critics of broadcasting and advertising such as Marshall McLuhan and Vance Packard, moreover, exposed the mechanics and manipulative practices that pervaded the American communications industry. As a result the media became increasingly transparent to its readers, and the editorial decisions connected with it more open to scrutiny.

Jacob Lawrence's portrait of Stokely Carmichael, produced for the cover of *Time* in about 1966 [cat. no. 43], suggests the self-consciousness of *Time* editors in the face of that transparency. While the portrait never actually appeared on the cover, Lawrence, true to his reputation, produced an unconventional

portrait of the Black Panther leader and activist. Instead of the fierce, provocative presence shown even in the Panthers' own pamphlets and posters, Lawrence rendered a strikingly human portrayal of Carmichael as a thoughtful, articulate man. As important to contemporary audiences as Lawrence's treatment of his subject, however, was the editors' choice of artist. The assignment of Lawrence, an African American, to portray an activist in a period of heightened racial tensions was in itself conscious and calculated casting. The decision reflected, in part, the editors' desire to afford the viewer the black perspective on events. This effort was a function, perhaps, of the increased acknowledgment by white-dominated media in the 1960s of the existence of a distinct black culture and viewpoint, and of the media's desire to accommodate and even appropriate that viewpoint. But as *Time*'s editors must have been aware, their selection of the African American artist to portray Stokely Carmichael would have been meaningful in itself to the magazine's well-educated, politically moderate, and mostly white audience.

Carmichael was considered by many, and characterized in the pages of *Time*, as a militant black-power advocate. Lawrence, on the other hand, was perceived to be a relative moderate among black artists. By the 1960s he was a widely respected senior member of the African American artistic community. Through well-known painting cycles such as "The Migration of the Negro" of 1940–41, Lawrence had earned a reputation as someone capable of presenting the history of black struggle in a monumental, historical context. Critical perception of Lawrence's work during the heyday of the Black Power movement did not associate the artist as closely with separatist or militant views as it did artists like Romare Bearden and Charles White, who explored more directly the brutality of racism and poverty in their work. While Lawrence had produced angry and explicit images of lynching and racial violence for the

New Republic in 1947 and for Langston Hughes's *One-Way Ticket,* published in 1948, his recent work, even on the more bitter episodes of African American relations, tended to underplay violence and racial divisiveness.[17]

Time's cover portraits often sent a double message to *Time* readers. By the 1960s the American public was ready for, and receptive to, the cynicism about the mass media that informed pop art. They were well prepared for the messages of Andy Warhol and Roy Lichtenstein. Unlike the artists of the first half of the twentieth century, who served the interests of the mass media, Warhol and Lichtenstein offered a vigorous critique of the media.

Andy Warhol's various media-derived images of Marilyn Monroe offer an apt appraisal of the power of media to "anoint" society's notables while simultaneously obscuring the realities of their individuality. In his 1967 screenprint of Monroe [fig. 22], garish, fluorescent colors combine with the distortion of the features to create a masklike countenance. By exaggerating the clumsy color registration typical of publications of the early "pulp" trade, Warhol created a pictorial analogy for the filtering of individual identity in their treatment of celebrity subjects. The accidents of the photomechanical production process only intensify the viewer's remove from the subject, eliminating the sense of a direct encounter that traditional portraiture tried to replicate. Warhol's *Marilyn Monroe* and other works, such as his portrait of painter-celebrity Jamie Wyeth [cat. no. 49], are in essence self-referential icons. Just as Wilde's *Dorian Gray* had exposed the complicity of art in the moral corruptness of the Edwardian era, Lichtenstein's and Warhol's portraits exposed the modern media's role in masking, and perpetuating, the superficiality of American public life.

The work of Roy Lichtenstein offers a different commentary on the pulp media. The artist produced a drawing of Robert F. Kennedy [cat. no. 45] for the cover of *Time* magazine in May 1968, a month before the aspiring presidential candidate was assassinated in Los Angeles. Incorporating the fluid, outline drawing style of the modern action comic book, Lichtenstein conveyed the romantic sense of youthful dynamism that Bobby Kennedy evoked for his followers. The drawing's clipped cropping and arrested action, reminiscent of news photographs, reference the media exposure so essential to electoral politics of the time and to which American presidential campaigns increasingly played. Kennedy's status as a media personality is further emphasized by the inclusion of a battery of microphones. Like Warhol's *Marilyn Monroe*, Roy Lichtenstein's *Robert F. Kennedy* uses the graphic conventions developed for mass production of images, and meant not for close study but for rapid and superficial reading, to produce a reflexive commentary on the idiom of fame. Both works respond in kind to the mass media and the synthetic identities they create.

The National Portrait Gallery's images of Monroe and Kennedy show how far from its traditional role portraiture had traveled in the twentieth century. In a sense, the distance between the age of Sargent, Chase, Eakins, and Cassatt and the age of Warhol and Lichtenstein was the gulf opened by a great cynicism. The questioning and eventual discarding of the traditional narratives of the human drama, prompted initially by a new scientific understanding of the personality achieved at the end of the nineteenth century, was subsequently intensified by the ethical relativism fostered by the modern mass media. The

pop artists of the 1960s acknowledged the century's abandonment of portraiture's earlier purpose of offering, in its representation of an individual, an instructive and socially useful analysis of an individual personality. For the artists of the 1960s, and for their discerning public, the moral tale of the human struggle implicit in earlier portraits had long since lost its credibility. At the same time, the quick generalizations derived in caricature and the constructed public faces presented in the mainstream press were also suspect. The art of the portrait had found its place in evading, rather than pondering, the mysteries of individuality. For many American artists near century's end, portraiture had become a commentary on itself.

NOTES

1. Carl E. Schorske, *Fin-de-Siècle Vienna: Politics and Culture* (New York: Vintage Books, 1981), 4.

2. On the new developments in psychology and sociology at the end of the nineteenth century, see Wilhelm Wundt, *Lectures on Human and Animal Psychology*, trans. Janet Creighton (London: S. Sonnenschein, 1894); Gustav T. Fechner, *Elements of Psychophysics*, trans. Helmut E. Adler (New York: Holt, Rinehart and Winston, 1966); and Daniel N. Robinson, *An Intellectual History of Psychology* (Madison: University of Wisconsin Press, 1995).

3. Thorstein Veblen, *The Theory of the Leisure Class: An Economic Study of Institutions,* Mentor Edition (New York: New American Library, 1953), 145ff.

4. Philip Rieff, *Freud: The Mind of a Moralist* (New York: Anchor Books, 1961), 391–92.

5. Compare Elizabeth Johns's discussion of Darwinist and Jamesian content in Thomas Eakins's late portraits such as *The Dean's Roll Call*, 1899 (Museum of Fine Arts, Boston), in her *Thomas Eakins: The Heroism of Modern Life* (Princeton, N.J.: Princeton University Press, 1983).

6. On Picasso's Kahnweiler portrait and the mercurial relationship between artist and sitter in Picasso's work, see William Rubin, ed., *Picasso and Portraiture: Representation and Transformation* (New York: Museum of Modern Art, 1996) and Joanna Woodall, ed., *Portraiture: Facing the Subject* (Manchester: Manchester University Press, 1997).

7. For the symbolic portraits of Picabia and de Zayas, see Wendy Wick Reaves, *Celebrity Caricature in America* (New Haven: National Portrait Gallery, Smithsonian Institution, and Yale University Press, 1998), 93–102. For the role that portraiture occupied in the Stieglitz circle, see Sarah Greenough, ed., *Modern Art and America: Alfred Stieglitz and His New York Galleries* (Washington, D.C.: National Gallery of Art and Bulfinch Press, 2000). Wanda

Corn treats the symbolic "poster portraits" of Charles Demuth, produced in the 1920s, in relation to earlier portrait production by de Zayas and the other artists of the Stieglitz circle in *The Great American Thing: Modern Art and National Identity, 1915–35* (Berkeley: University of California Press, 1999), 193–237.

8. Theodore Roosevelt, "The Rough Riders," *Scribner's* 25 (January 1899): 4ff.

9. Gibson's portrait makes an interesting comparison with the Rockwood Studio photograph of Roosevelt taken in the fall of 1899, shortly after Roosevelt was elected governor of New York and before Gibson's drawings appeared.

10. Federal legislation recognized the increased commercial value of trade in literary properties and theatrical and musical performances with the extension of copyright protection to performances, films, and recordings as well as literary and artistic works.

11. A particularly cynical contemporary polemic on the science of advertising adopted for repressive political purposes is John Keracher's *The Head-Fixing Industry* (Chicago: Proletarian Party, 1923?).

12. On Thomas Nast, see Albert Bigelow Paine, *Thomas Nast: His Period and His Pictures* (New York: Chelsea House, 1980) and William Murrell, *A History of American Graphic Humor* (New York: Whitney Museum of American Art, 1938). For a critical view of the *Harper's* campaign against the Tweed ring, see Thomas C. Leonard, *The Power of the Press: The Birth of American Political Reporting* (New York: Oxford University Press, 1986).

13. Unlike the caricatures from the political press of the earlier era, most celebrity caricatures were not designed to deride or wound their subjects. Often the opposite was the case and, as Reaves points out, some caricatures were actually welcomed by their subjects. Emily Post expressed her gratitude to *Vanity Fair* for Covarrubias's 1933 caricature of her. "Anyway, many thanks for the delicious 'publicity,'" she wrote (quoted in Reaves, *Celebrity Caricature*, 3).

14. Caricature's remarkable popularity in the United States during the 1920s and 1930s has been thoroughly chronicled in ibid.

15. Quoted in Frank Luther Mott, *History of American Magazines* (Cambridge: Harvard University Press, 1968), vol. 5, 294. Frederick S. Voss's essay in *Faces of Time: 75 Years of Time Magazine Cover Portraits* (Boston: National Portrait Gallery, Smithsonian Institution, and Bulfinch Press, 1998), is a perceptive survey of the *Time* portraits throughout the magazine's history, and discusses the growing public attention to the editorial choices regarding cover portraits.

16. Waldo Frank, "An American Tragedy: The Oppenheimer Case," *The Nation*, September 25, 1954.

17. See John Canaday's review of Lawrence's exhibition of his cycle of paintings on Harriet Tubman at the Terry Dintenfass Gallery in 1967. Quoted in Ellen Harkins Wheat, *Jacob Lawrence, American Painter* (Seattle: Seattle Art Museum and University of Washington Press, 1986), 182.

45

CATALOGUE

The catalogue is organized chronologically. In dimensions, height precedes width.

Contributors to the catalogue are:

Charles Brock	C.B.
Brandon Brame Fortune	B.B.F.
Anne Collins Goodyear	A.C.G.
Frank H. Goodyear III	F.H.G.
Jennifer A. Greenhill	J.A.G.
Sally E. Mansfield	S.E.M.
Joann Moser	J.M.
Dorothy Moss	D.M.
Harold Francis Pfister	H.F.P.
Wendy Wick Reaves	W.W.R.
Elizabeth Mackenzie Tobey	E.M.T.
Ann Prentice Wagner	A.P.W.
LuLen Walker	L.W.

Mary Cassatt
1844–1926

Self-portrait

Watercolor and gouache over graphite on paper, 33.1 x 24.6 cm (13 $^1/_{16}$ x 9 $^{11}/_{16}$ in.), circa 1880
Inscription: *recto* M. C.; *verso* P4 / 77 / W21 / 3558
NPG.76.33

Mary Cassatt's paintings and pastels of women and children give the illusion that the artist at work was invisible. Her subjects, inhabiting their intensely private domestic world, take no notice of the woman who paints them. As the subject of many of Edgar Degas's paintings and drawings, Cassatt herself appears as a lady looking at art, not as an artist creating it.[1] While Claude Monet and Auguste Renoir are familiar figures, portrayed at work in the landscape by their fellow impressionists, Cassatt remained concealed in the seclusion of private homes and gardens.

The Portrait Gallery's self-portrait is a rare painting of Cassatt as an artist. She made this informal watercolor around 1880, the year after she began exhibiting her work with the impressionists.[2] Although Cassatt's self-portrait shows her in a fashionable dark dress, she presents herself primarily as an artist rather than a society lady.[3] Cassatt struggled to be seen as a serious professional rather than someone for whom painting was a polite accomplishment.[4]

Cassatt began working toward artistic professionalism at the age of fifteen by enrolling in classes at the Pennsylvania Academy of the Fine Arts in Philadelphia. Undeterred by the concerns of her well-heeled parents, she went to Paris in 1865 to continue her studies.[5] Exhilarated to have escaped provincial America, Cassatt took advantage of every artistic opportunity open to her. In addition to her studies in Jean-Léon Gérôme's studio, she copied paintings at the Musée du Louvre and took a variety of classes in and around Paris. As a woman she was denied admission to the École des Beaux-Arts, but she had a painting accepted for the Salon of 1868.[6]

The Franco-Prussian War forced Cassatt to return to the United States in 1870. She chafed at her isolation and was desperate to sell her art to prove herself as a professional and fund continued study in Europe. A commission to copy Italian Old Master paintings allowed her to return to Europe in 1871. She worked in Italy and Spain until 1873, when she returned to Paris and established a studio.[7]

Cassatt continued to submit works to the Salon and was regularly accepted until 1876, but she became increasingly frustrated by the restrictions and prejudices of the academic art world. As a woman and an American, she felt that her status would always be inferior and insecure. In 1874 she saw pastels by Degas in the window of a Paris art dealer, and realized that modern art offered her a way out.[8] Cassatt later recalled, "The first sight of Degas['s] pictures was the turning point in my artistic life." In 1877, when the Salon refused her submissions, Degas invited her to show with the impressionists.[9] Cassatt embraced the impressionists' pure colors and open brushwork, particularly in her early years with the group. Although she preferred to paint women and children rather than brilliantly lit landscapes such as those of Monet and Renoir, her casually posed subjects and unconventionally cropped compositions reveal their own modernity.

Cassatt's association with the impressionists marked an exciting period of experimentation for her. This watercolor self-portrait shows Cassatt reinventing and reappraising her art and herself. An intense gaze anchors a composition that exemplifies the qualities of her new work. After penciling a rough initial sketch, she turned to watercolors. The touch of the artist is celebrated in strokes that emphasize color, mood, and motion over form. Calligraphic dashes of green in the right background suggest wallpaper, while the wash of rich yellow at the left evokes sunlight pouring through a window behind the artist, leaving her face largely in shadow. Cassatt focused on her role as artist: while painting, she would position herself so that light would come over her shoulder to illuminate the subject before her rather than her own features. Here, the light reflects in a zigzag of yellow dropped wetly into the pool of

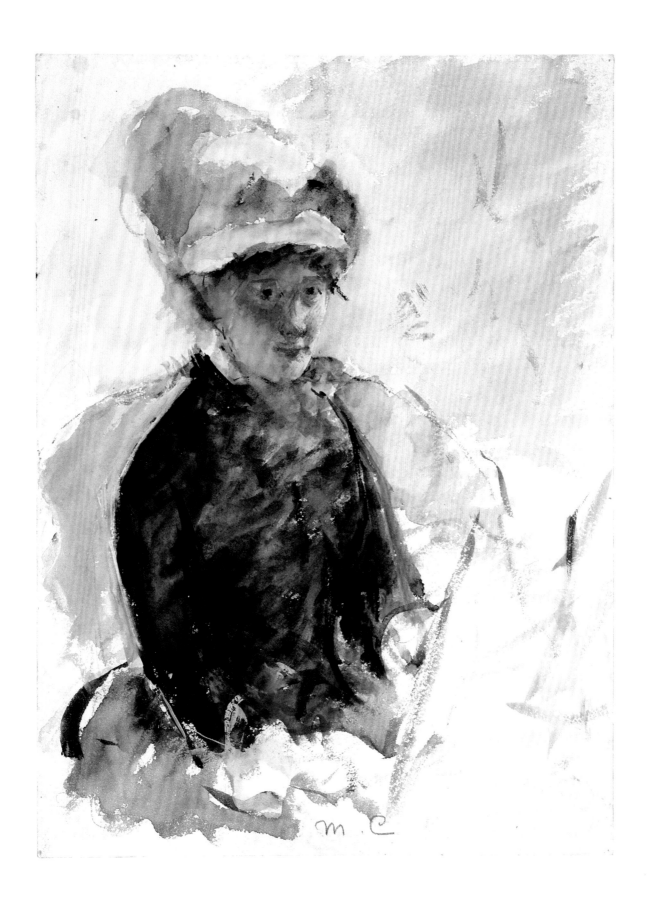

49

blue representing the arm of the overstuffed chair. Blue-gray gouache describes the other arm of the chair and also redefines Cassatt's shoulder. She painted her face in gouache, highlighting the sunlit edge of the cheek. While the gouache was still wet, she added fine strokes of shading in the favored impressionist colors of red, blue, purple, and green. Cassatt did not depict her own hands but everywhere showed evidence of their rapid work.

Degas had introduced Cassatt to the use of such graphic media as pastel, watercolor, and gouache for finished works.[10] While academic artists and even

Fig. 23. *Mary Cassatt* (1844–1926) by Edgar Degas (1834–1917). Oil on canvas, circa 1880–84. National Portrait Gallery, Smithsonian Institution; gift of the Morris and Gwendolyn Cafritz Foundation and the Regents' Major Acquisitions Fund, Smithsonian Institution

most impressionists used oils for their major works, Degas employed a variety of graphic media. Degas and Cassatt worked together closely, often turning to the same medium at the same moment.[11] Around 1879 and 1880, while Degas was creating his only pure watercolors, a series of fan-shaped paintings of dancers, Cassatt was making her most serious watercolor portraits, including this one.[12]

While Degas was the leading influence on Cassatt during this period, she saw herself as his colleague rather than his student. Her independence is clear in the comparison between her self-portrait and Degas's oil portrait of her [fig. 23], which must have been painted at about the same time and shows Cassatt in a similar dress and hat. In Degas's painting Cassatt slouches in a chair, holding a trio of carte-de-visite photographs. Her features are individualistic but irregular, and she looks bored with modeling. The indecorous posture is typical of the assertively modern women portrayed by both male and female impressionists. Cassatt's letter to dealer Paul Durand-Ruel from 1912 reveals that her self-image did not accord with Degas's painting: "I especially desire not

to leave it to my family as being me. It has artistic qualities, but is so painful and represents me as a person so repugnant that I would not wish it to be known that I posed for it. . . . I should like it to be sold abroad but without my name being attached to it."[13]

Rejecting Degas's presentation of her as an idle woman, Cassatt portrayed herself as an artist, upright and in charge. Her level, focused gaze bespeaks the demanding discipline of the self-portraitist, who must hold extremely still as she simultaneously paints and models. Both Cassatt's rapt concentration on an intellectual activity and her pursuit of a creative profession identify her as a modern woman who is to be taken seriously in the wide world outside of the parlor.[14]

Cassatt showed lingering traces of artistic convention in the refined, symmetrical rendering of her own face.[15] Around the still center, however, are the bold and colorful marks of a modern artist who breaks free of conventional prettiness. Behind the easel and below the arms her loose brushwork verges into abstraction. Cassatt was not afraid to experiment and to repaint areas that did not satisfy her, as she had not been afraid to revise her style and outlook when she left the academic art world to commit herself to modernism with the impressionists.

Cassatt's debut exhibition with the impressionists in April 1879, which presented eleven paintings, pastels, and gouaches, earned her great critical acclaim. At last, her works had begun to sell, allowing her to claim true professional status.[16] The woman who wielded a bold brush in painting this self-portrait was no longer a marginalized female American academic. She would no longer have to depend upon her parents for support or cautiously avoid offending the French academic art establishment. When Cassatt looked in the mirror in 1880, she saw a serious, successful, modern artist who joyfully seized her newfound artistic and personal freedom.[17]

A.P.W.

NOTES

1. Lucretia Giese, "A Visit to the Museum," *Bulletin of the Museum of Fine Arts Boston* 76 (1978): 43–53.

2. George T. M. Shackelford, "*Pas de deux:* Mary Cassatt and Edgar Degas," in Judith A. Barter et al., *Mary Cassatt: Modern Woman* (Chicago: Art Institute of Chicago and Harry N. Abrams, 1998), 110. Judging from its impressionist style, Cassatt almost certainly painted this self-portrait watercolor after she had been asked to join the impressionists in 1877 and before 1883. Cassatt stopped working for several months after her sister Lydia died of Bright's disease in 1882. When she resumed work in about May 1883, her style was more tightly structured. See Judith A. Barter, "Mary Cassatt: Themes, Sources, and the Modern Woman," in Barter et al., *Cassatt: Modern Woman,* 76, and the chronology, 337.

3. Shelly Foote, e-mail to Harold Francis Pfister, November 23, 2000. Cassatt could appear as a fashionable society lady rather than an artist when she chose. In a gouache self-portrait of about the same date, *Portrait of the Artist* (The Metropolitan Museum of Art, New York), Cassatt shows herself seated, wearing a white dress and gloves and a flowered hat. Her hands are folded, and she looks away from the viewer, giving no hint that the work is a self-portrait or the subject an artist.

4. Cassatt "aspired unswervingly toward professionalism and the serious work it entailed" (Linda Nochlin, "Mary Cassatt's Modernity," in *Representing Women* [New York: Thames and Hudson, 1999], 181). But Cassatt was only one of many women who strove to become professional artists. Nancy Mowll Mathews notes that "by mid-century both writing and the visual arts were promoted as viable professions for these [middle- and upper-class educated] women" (Mathews, "Mary Cassatt and the Changing Face of the 'Modern Woman' in the Impressionist Era," in *Crosscurrents in American*

Impressionism at the Turn of the Century, ed. Donald Keys and Janice Simon [Athens: Georgia Museum of Art, University of Georgia, 1996], 30).

5. Nancy Mowll Mathews, *Mary Cassatt: A Life* (New Haven: Yale University Press, 1994), 15–29.

6. Ibid., 31–48.

7. Andrew J. Walker, "Mary Cassatt's Modern Education: The United States, France, Italy, and Spain, 1860–73," in Barter et al., *Cassatt: Modern Woman,* 22; Mathews, *Cassatt: A Life,* 73–75; chronology in Barter et al., *Cassatt: Modern Woman,* 333.

8. Mathews, *Cassatt: A Life,* 104; Eleanor C. Munro, "Mary Stevenson Cassatt," in *Originals: American Women Artists* (New York: Simon & Schuster, 1979), 65.

9. Cassatt to Colonel Paine, February 28, 1915, in Nancy Mowll Mathews, ed., *Cassatt and Her Circle: Selected Letters* (New York: Abbeville, 1984), 321; Shackelford, "*Pas de deux,*" 110.

10. Ibid., 112. Degas reintroduced Cassatt to watercolor, a medium she had used as a student (Adelyn Dohme Breeskin, *Mary Cassatt: A Catalogue Raisonné of the Oils, Pastels, Watercolors, and Drawings* [Washington, D.C.: Smithsonian Institution Press, 1970], 221).

11. Shackelford, "*Pas de deux,*" 119–25.

12. Götz Adriani, *Degas: Pastels, Oil Sketches, Drawings,* trans. Alexander Lieven (New York: Abbeville, 1985), nos. 120–22. After about 1880, Cassatt used watercolor only for informal studies related to paintings (Breeskin, *Mary Cassatt,* 221–39). Among the impressionists, only Camille Pissarro worked seriously in watercolor (Horst Keller, *Watercolors and Drawings of the French Impressionists and Their Parisian Contemporaries* [New York: Harry N. Abrams, 1982], 7, 40).

13. Mathews, "Changing Face of the 'Modern Woman,'" 25–28; quoted in Nancy Mowll Mathews, ed., *Cassatt: A Retrospective* (New York: Hugh Lauter Levin Associates, 1996), 121.

14. "The female artist was often viewed in the mid-nineteenth century as the quintessential modern woman" (Mathews, "Changing Face of the 'Modern Woman,'" 28).

15. Women's faces that are very similar in shape and proportion also appear in Cassatt's oil on canvas *Women in a Loge,* 1881/82 (National Gallery of Art, Washington, D.C.), and in other works of the same period.

16. Mathews, *Cassatt: A Life,* 133–39.

17. The provenance of the Cassatt self-portrait watercolor is: Lucile Manguin, Paris; Galerie de Paris sale, 1963; A. P. Bersohn, New York; Stephen Straw Co., Newburyport, Massachusetts; National Portrait Gallery, Washington, D.C., purchased November 1, 1976.

JOHN TWACHTMAN
1853–1902

BY JULIAN ALDEN WEIR
1852–1919

Charcoal on paper, 25.2 x 20.2 cm (9^{15}/$_{16}$ x 7^{15}/$_{16}$ in.), circa 1895
Inscription: *recto* J. Alden Weir; *verso, on mount* 1" Wht Swap / 13^1/$_4$ x 15^1/$_4$ – / Leo Robinson / 1388–6th Ave. / N.Y.C.
NPG.87.236

A personally and artistically sustaining friendship united the man in the rocking chair, John Henry Twachtman, with the man who made this drawing of him, Julian Alden Weir. The portrait dates to about 1895, during an important period for the two friends and for the history of American art, when Weir and Twachtman were leaders of the American impressionist movement.

The two artists probably met during the winter of 1878–1879, when Twachtman moved from his native Cincinnati to New York and joined the Tile Club, to which Weir already belonged. Both men, fresh from art study in Europe, participated in the club's variety of bohemian antics and soon became close friends.[18] Both were also active in the Society of American Artists, a group of mainly European-trained artists who rebelled against the narrower artistic world of their American-trained elders.[19]

Yet the two men came to art from contrasting directions. Weir was born into a family of artists: his older half-brother, John Ferguson Weir, was a painter, and their father, Robert Walter Weir, was for many years the drawing instructor at the United States Military Academy in West Point, New York. Weir followed his father's academic orientation by attending, in 1870, the National Academy of Design in New York, where he took courses in drawing from casts of classical sculpture and from life. Taking the next step up the academic ladder, Weir studied in Paris with Jean-Léon Gérôme and at the École Gratuite de Dessin before enrolling at the École des Beaux-Arts in 1874. At every venue, his training reinforced the importance of proper drawing, particularly drawing the human figure.[20]

Twachtman, by contrast, came from a German immigrant family in Cincinnati. He dreamed of being a painter, but his parents preferred for him to get dependable work at the factory where his father painted window shades. However, when family friend Frank Duveneck returned from studying art in Munich, his success and confidence impressed Twachtman's parents. Duveneck subsequently taught Twachtman privately and at the McMicken School of Design in Cincinnati. Encouraged by his teacher, Twachtman used money he had saved to buy a house to instead enroll at the Royal Academy of Fine Art in Munich, where he learned to emphasize bravura brushwork over drawing.[21]

The art teacher's son and the shade painter's son somehow found common ground. Dutch seventeenth-century art and etching were the earliest of their many shared enthusiasms. Twachtman and his bride, Martha Scudder, honeymooned in Europe in 1881, and Weir and his brother John joined the couple for a sketching and etching trip through the Netherlands.[22]

From 1883 to 1885, Twachtman studied drawing in Paris while Weir painted successfully in New York. When Twachtman returned, he spent much time at Weir's farm in Branchville, Connecticut, and in 1889 bought his own farm nearby. Twachtman and Weir commuted to New York City, where they both taught at the Art Students League.[23] Those years were happy and productive for the pair, who raised their families, taught, painted, and etched in close companionship. The two formed the center of a warm and stimulating circle of artists, including William Merritt Chase, Childe Hassam, and Theodore Robinson. Hassam remembered a "Thanksgiving dinner [at Weir's house in New York City] with Weir and a turkey at one end of the oak table . . . and . . . Twachtman and another turkey at the other end."[24]

Weir's 1888 etching of Twachtman reading [fig. 24], like the Portrait Gallery's slightly later drawing of him in a rocking chair, illustrates the extraordinary sympathy between the two men. They constantly encouraged each other and exchanged artistic ideas. In a letter to Weir on December 16, 1891, Twachtman bubbled, "That was a splendid talk we had this evening and I become more convinced

53

each time I see you. I want to tell you how confident I feel. Tomorrow will be a fine day and I wish for lots of canvas and paint to go to work with."[25]

During the 1880s and 1890s, Weir and Twachtman shared their excitement about French impressionism. Their early impressionist-influenced works appeared at a two-person show at the Fifth Avenue Galleries in New York in 1889. Their mutual friend Theodore Robinson, who had studied with Claude Monet in Giverney, France, gave them direct access to this movement's ideas and techniques.[26] An exhibition at the American Art Association in 1893 compared

Fig. 24. *John H. Twachtman* (1853–1902) by Julian Alden Weir (1852–1919). Etching, 1888. Brigham Young University Museum of Art, Provo, Utah

Weir's and Twachtman's work to that of Monet and his fellow French impressionist Paul Albert Besnard. Although American critics were overwhelmed by the French artists, they recognized the originality of the Americans' poetic, tonal versions of impressionism.[27]

The Portrait Gallery's drawing of Twachtman by Weir was made during that period, when the two artists were spurring each other on in new impressionist directions. The drawing appears to date from the mid-1890s, when Weir made a series of large, softly colored paintings featuring figures in landscapes or interiors. As in those paintings, Weir placed the figure in his drawing close to the picture plane to create a dynamic silhouette stretching from the top to the bottom of the sheet. Twachtman's projecting elbows and knees, interspersed with the arms and legs of his chair, make a striking angular pattern against the almost blank background. The

strong, abstract division of space reflects the appeal that Weir and Twachtman, like the French impressionists, found in the bold, flat patterning of Japanese prints.[28]

Although at this period Weir often used ink and brush to draw in a Japanese-influenced style, his drawing of Twachtman adapts Western academic drawing techniques for impressionist purposes.[29] A soft cloud of partially erased lines shows how Weir quickly sketched in the figure, then readjusted its relationship to the page. Rather than flattening the figure in an impressionist manner, Weir skillfully foreshortened his friend's long arms and legs to create a deep space receding from Twachtman's extended right toe. Weir rubbed the edges of dark charcoal strokes to describe the rounded folds of Twachtman's pants, while crisper marks outline the heavier fabric of his jacket. Weir deftly used his eraser as a drawing tool to pick out the arms and legs of the rocking chair against the shadows under the figure.

The result of Weir's work is not a tight academic drawing but a swift, impressionistic evocation of his friend's presence. The work seems unrelated to Weir's contemporary bust-length painting of Twachtman,[30] since the emphasis is not on the barely sketched features of the face but on the lanky figure lounging in a rocking chair. Weir emphasized Twachtman's casualness by using a low viewpoint. The viewer looks up past untidily splayed toes, knees, and elbows before encountering the face with its neatly trimmed beard. It is easy to imagine the sitter engaged in hosting friends at his farm, where, as it has been described by Twachtman's biographer, "the Twachtman income and the Twachtman taste did not allow for much in the way of expense or formality. More often than not the evenings were spent in pleasant conversation before the fire, or with Mrs. Twachtman playing [piano] for the group."[31]

In 1897, Weir and Twachtman's circle of artist friends professionalized their personal ties to form the Ten American Painters. Weir was a leader among the Ten for the next two decades. Twachtman died in 1902, leaving Weir to carry on the ideas they had shared so passionately.[32]

A.P.W.

54

NOTES

18. John D. Hale, "The Life and Creative Development of John H. Twachtman" (Ph.D. diss., Ohio State University, 1957), 27, 35; Ronald G. Pisano, *The Tile Club and the Aesthetic Movement in America* (New York: Harry N. Abrams, 1999), 33–40; Doreen Bolger Burke, *J. Alden Weir: An American Impressionist* (Newark: University of Delaware Press; London: Cornwall Books, Associated University Presses, 1983), 145.

19. Lisa N. Peters, *John Henry Twachtman: An American Impressionist* (Atlanta: High Museum of Art, 1999), 32.

20. Burke, *Weir*, 16, 23–24, 36–43; Nicolai Cikovsky Jr. et al., *A Connecticut Place: Weir Farm, An American Painter's Rural Retreat* (Wilton, Conn.: Weir Farm Trust, in collaboration with the National Park Service, 2000), 16.

21. Hale, "John H. Twachtman," 10–13; Peters, *Twachtman*, 2–32; Richard J. Boyle, *John Twachtman* (New York: Watson-Guptill, 1979), 11.

22. Peters, *Twachtman*, 44, 48–51; Janet A. Flint, *J. Alden Weir: An American Printmaker, 1852–1919* (Provo, Utah: National Collection of Fine Arts, Smithsonian Institution, and Brigham Young University, 1972), 5.

23. Hale, "John H. Twachtman," 47, 68–69; Peters, *Twachtman*, 59–65; Burke, *Weir*, 87, 94.

24. Peters, *Twachtman*, 106; Hale, "John H. Twachtman," 83; quoted in Dorothy Weir Young, ed., *The Life and Letters of J. Alden Weir* (New Haven: Yale University Press, 1960), 191.

25. Flint, *J. Alden Weir*, 29; quoted in Young, ed., *Life and Letters*, 189.

26. Peters, *Twachtman*, 81; Burke, *Weir*, 88, 188.

27. Hale, "John H. Twachtman," 88–91.

28. Burke, *Weir*, 208; Doreen Bolger, "American Artists and the Japanese Print: J. Alden Weir, Theodore Robinson, and John H. Twachtman," in *American Art Around 1900: Lectures in Memory of Daniel Fraad,* ed. Doreen Bolger and Nicolai Cikovsky Jr., Studies in the History of Art 37, Center for Advanced Studies in the Visual Arts Symposium Papers 21 (Washington, D.C.: National Gallery of Art, 1990), 14–27. The Portrait Gallery's painting of Mary Cassatt by Edgar Degas [fig. 23] is an excellent example of this Japanese-inspired aesthetic.

29. Burke, *Weir*, 202.

30. *Portrait of John H. Twachtman* by Julian Alden Weir, oil on canvas, 1894, Cincinnati Art Museum, Ohio; gift of the artist. Illustrated in Boyle, *John Twachtman,* 9.

31. Hale, "John H. Twachtman," 83.

32. Burke, *Weir*, 225–28.; Patricia Jobe Pierce, *The Ten* (Hingham, Mass.: Pierce Galleries, 1976), 149.

THEODORE ROOSEVELT
1858–1919

BY CHARLES DANA GIBSON
1867–1944

Graphite and conté crayon on paper, 50.7 x 35.6 cm (19^{15}/$_{16}$ x 14 in.), 1898
Original drawing for *Scribner's* magazine, January 1899
Inscription: *verso* Jany frontispiece—plate wanted Saturday Nov. 26th if possible thing / send flat proof at once. /
full height / Keep Clean! [underlined] / 15712
NPG.73.35

In January 1899, *Scribner's* magazine featured the first of a six-part series titled "The Rough Riders" by Colonel Theodore Roosevelt, who had returned from Cuba the previous August as the undisputed hero of the Spanish-American War. The editors scored an additional coup by securing for the frontispiece this portrait by the renowned artist Charles Dana Gibson, the highest-paid illustrator in America at the time.[33] The portrait also appeared in the book version of the memoir, published by Charles Scribner's Sons later in the year.

Roosevelt's previous, varied achievements—including the publication of works of history and tales of adventures in the Dakota Territory in addition to a stint as civil service commissioner, New York police commissioner, and militant assistant secretary of the navy—had fostered his growing reputation. But his leadership of the First United States Volunteer Cavalry in decisive charges of the San Juan Heights outside of Santiago on July 1, 1898, ensured a homecoming as the most famous man in America.[34] He would win the New York governorship that November. The vice presidency would come two years later, soon to be followed, after the assassination of William McKinley, by Roosevelt's inauguration as President in 1901.

Charles Dana Gibson was reaching the peak of his international fame at the same time. After two years at the Art Students League and trips to England and France, Gibson had evolved a polished pen-and-ink style of exceptional vivacity as the featured artist of *Life* magazine. The long, elegant pen strokes of his gently satirical cartoons could limn multiple details, shadows, and textures without losing their freshness or energy.[35] Gibson's subject matter proved as compelling as his style. His most famous creation, an up-to-date American female soon dubbed the "Gibson Girl," became wildly popular in the magazines in the early 1890s and would influence styles, fashions, and manners for decades.[36]

Essentially unthreatening despite her modern impulses, his tall, proud beauty was athletic but feminine, fashionable but decorous, strong willed but winsome. Derived from various models, this idealized type descended from upper-class Anglo-Saxon stock. In an era adapting to immigration, urbanization, and changing gender roles, she had a comfortingly traditional identity despite her boldness. Although satirized for her excesses, the "Gibson Girl," embracing sports, trendsetting fashions, professional accomplishments, and a new confidence, introduced the potential of the modern woman.

The "Gibson Man" from the cartoons, who served as a foil to the more-famous young ladies, boasted an aristocratic presence and a well-muscled physique not unlike Roosevelt's in this drawing. Gibson's idealized youth was initially modeled on his friend, the handsome reporter-novelist Richard Harding Davis, whose adventurous heroes and spirited heroines paralleled the artist's own creations.[37] The dashing, flamboyant Davis played a crucial role in advancing Roosevelt's fame. The hero-seeking reporter and the publicity-minded colonel had joined forces in Cuba, and Davis's vivid dispatches firmly established Roosevelt's death-defying leadership in the war. In this drawing, Gibson drew Roosevelt with a square-jawed, robust physicality reminiscent of the athletic young men of his illustrations. While drawing on the physical characteristics of his "Gibson Man," he nonetheless went beyond his languid cartoon prototype in a clearly ambitious portrait that is unusual in his oeuvre.

For this important portrait commission, Gibson self-consciously created an image of manly valor. He avoided the two established symbols of the Roosevelt stereotype [fig. 25]: the gleaming teeth that connoted his good-humored charm and the prominent glasses that suggested his literary proclivities. Instead he focused on Roosevelt's stern military bearing. The pince-nez are drawn to blend almost invisibly into

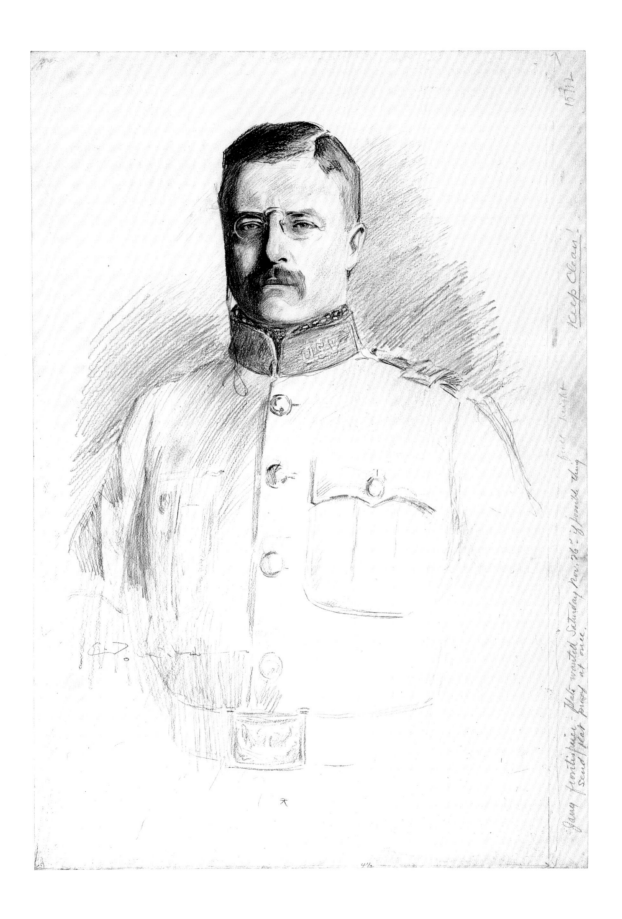

57

the face, heightening rather than obscuring the eyes. The unsmiling mouth and stiff frontal posture convey a disciplined toughness. Although Gibson featured the trademark Rough Rider kerchief at the neck and the initials of the United States volunteers on the light-colored uniform, he erased and repositioned the buttons to lengthen the torso, emphasizing the well-built upper body. Gibson also departed from his dazzling, abbreviated ink style. Only the slashing lines in the background recall his vigorous pen strokes. Using the softer effects of pencil, he chose to evoke a graphic portrait tradition

Fig. 25. *And Teddy (Roosevelt) Comes Marching Home* [Theodore Roosevelt (1858–1919)] by Eugene Zimmerman (1862–1935). Chromolithograph from *Judge*, October 22, 1898. National Portrait Gallery, Smithsonian Institution

that goes back to Dominique Ingres. Focusing on the face, which is modeled with extraordinary delicacy and a particular emphasis on the eyes, Gibson constructed the figure around it with a gradually freer and looser line toward the periphery of the sheet.

Gibson was responding in this drawing to his generation's evolving concepts of masculinity, which Roosevelt himself was helping define. After overcoming his youthful frailness through determination and strenuous exercise, Roosevelt's respect for courageous, energetic manliness lay at the heart of his psyche. Like many of his contemporaries, he worried about the emasculating effects of an over-refined civilization. A newly aggressive, masculine vigor was required, Roosevelt felt, to maintain American superiority in the world.[38] In his "Rough Riders" memoirs, he projects this conceit onto his hand-picked volunteer cavalry regiment, a mix of Ivy

League athletes, New York policemen, and Western cowboys and hunters. Despite their diverse backgrounds, Roosevelt wrote, all "possessed in common the traits of hardihood and a thirst for adventure. They were to a man born adventurers." He singled out particularly his friend, army surgeon Leonard Wood, who initially commanded the regiment until his wartime promotion. Wood's enthusiasm for athletic exertion and war with Spain had nurtured a close friendship between the two in Washington. Roosevelt wrote admiringly that Wood possessed "robust and hardy qualities of body and mind." He continued, "Like so many of the gallant fighters with whom it was later my good fortune to serve, he combined, in a very high degree, the qualities of entire manliness with entire uprightness and cleanliness of character."[39]

Roosevelt, in such writings, described the standard that he himself strove to emulate. And to many, he did seem, as Mark Sullivan described him, the "outstanding, incomparable symbol of virility in his time."[40] Gibson, who seldom drew portraits, conceptualized Roosevelt as an archetype. By changing the pen-and-ink style associated with his flippant, humorous cartoons, and by downplaying the glasses, bypassing the smile, and enlarging the torso, he tried to embody those traits of intelligence, moral character, vigor, courage, and strength that the colonel promoted. Roosevelt may not have sat for the drawing during that busy period of his career, but Gibson may have met him through Richard Harding Davis or seen him in public appearances. Gibson captured Roosevelt as if standing at attention during a patriotic commemorative ceremony, the active man in a moment of reflection, his aggressive strength checked by intellect and character. Before the campaign in Cuba began, Gibson had disdained the war-mongering of the sensationalist press, yet here he depicted Roosevelt as the war hero. Famed for redefining the feminine gender at the close of the century, Gibson essayed in this image an icon of modern manhood.

W.W.R.

33. Walt and Roger Reed, *The Illustrator in America, 1880–1980: A Century of Illustration* (New York: Society of Illustrators, 1984), 33.

34. Edmund Morris, *The Rise of Theodore Roosevelt* (New York: Coward, McCann & Geoghegan, 1979), 665.

35. Gibson was influenced by such English illustrators as George de Maurier, whom he admired and made a point of meeting when he first visited England (Fairfax Downey, *Portrait of an Era as Drawn by C. D. Gibson* [New York and London: Charles Scribner's Sons, 1936], 84–87).

36. Susan E. Meyer, *America's Great Illustrators* (New York: Harry N. Abrams, 1978), 211–12.

37. Arthur Lubow, *The Reporter Who Would Be King: A Biography of Richard Harding Davis* (New York: Charles Scribner's Sons, 1992), 2.

38. See, for example, Gail Bederman, *Manliness and Civilization: A Cultural History of Gender and Race in the United States, 1880–1917* (Chicago: University of Chicago Press, 1995), 170–215; Kristin L. Hoganson, *Fighting for American Manhood: How Gender Politics Provoked the Spanish-American and Philippine American Wars* (New Haven: Yale University Press, 1998), 143–55.

39. Theodore Roosevelt, "The Rough Riders," *Scribner's* 25 (January 1899): 13, 5–6.

40. Mark Sullivan, *Our Times: The United States, 1900–1925* (New York: Charles Scribner's Sons, 1926–35), vol. 2, 235.

EVERETT SHINN
1876–1953

SELF-PORTRAIT

Pastel on paper, 35.6 x 25.5 cm (14 x 10 1/16 in.), 1901
Inscription: Everett Shinn / To Miss Marlowe / 1901
NPG.78.219

By the time he drew this dramatically brooding 1901 self-portrait, Everett Shinn—best known as an Ashcan painter and member of the Eight—had already had his first taste of fame as a pastel artist. In 1897, Shinn, who was working as a sketch artist for the Philadelphia newspapers, had been lured to New York and the *New York World* by his friend George Luks.[41] His ambition to break into the more lucrative world of magazine illustration undoubtedly encouraged him to pursue the pastel technique, which he had first learned at the Pennsylvania Academy of the Fine Arts. Interest in this fragile, once-secondary medium was soaring at the time. Exhibitions of pastels by James McNeill Whistler, the French impressionists, and the artists of the Society of American Painters in Pastel (an organization founded in 1882) gave these drawings a new prestige. As commercial galleries and watercolor societies began featuring more pastels, critics admired the medium for its spontaneity, directness, versatility, and pure, brilliant coloration.[42]

Shinn found that the pastel technique suited his quick, facile draftsmanship and proved ideal for depicting the scenes that fascinated him: the streets, parks, docks, music halls, and theaters of New York. In the years just preceding the self-portrait, he had established himself as a successful magazine illustrator. His *Winter's Night on Broadway*, for instance, appearing in *Harper's Weekly* on February 17, 1900, was the first color reproduction in this major magazine. But Shinn's artistic reputation was growing beyond illustration. In 1899 he had begun to exhibit his pastels: five at the Pennsylvania Academy (where one was purchased by William Merritt Chase), four at the New York School of Art, two at the Saint Louis Exposition, and another five in a private exhibition at the home of Elsie de Wolfe, a well-connected actress (later famed as an interior designer and socialite) whose patronage proved crucial to Shinn's career.[43]

One de Wolfe friend, architect Stanford White, so admired the work that he arranged for Shinn's first important one-person show, an exhibition of forty-four pastels that opened at Boussod, Valadon, and Company in February 1900. "It IS a ripping show!" Shinn's friend, playwright Clyde Fitch, exulted to the artist.[44] The public and the press agreed. Thirty drawings were sold—a remarkable commercial success—and commentators, skeptical of his speedy, "careless" draftsmanship, were nonetheless impressed. "He so abounds in cleverness, in vivacity of color and of line," read one typical summation of his work, "that his most dubious sketches are forgiven."[45] After returning from a trip to London and Paris, Shinn continued to exhibit his urban scenes. Critics admired his modern subject matter— the street life and theatrical world—as well as his ability to render atmospheric change, the "million mutations of beauty we call weather, the lime-light, gaslight, sunlight, slush, cold, drip, wind, sleet, and life of this great city."[46] By 1906, A. E. Gallatin would proclaim, "Shinn is a master of the pastel; he knows thoroughly both the possibilities and the limitations of his medium. . . . And if technically his pastels are great achievements, pictorially are they also."[47]

This 1901 drawing conveys both the charm of Shinn's early pastels and the lack of definition that worried some critics. The undefined torso, for instance, if read too literally, would seem to extend his slim, dapper figure to gargantuan proportions. But Shinn's mastery and understanding of the pastel medium is already evident. His unusual approach of soaking the paper and backing board in water and drawing rapidly on the wet surface is employed here for a hard-drying, more painterly effect, in contrast to his vigorously sketched street scenes.[48] Eschewing the bright palette of the impressionist draftsmen, he adapts elegant Whistlerian tonalities of gray, black, and white. As in many of his early pastels, he accents his gentle monotones with a touch of vivid color—

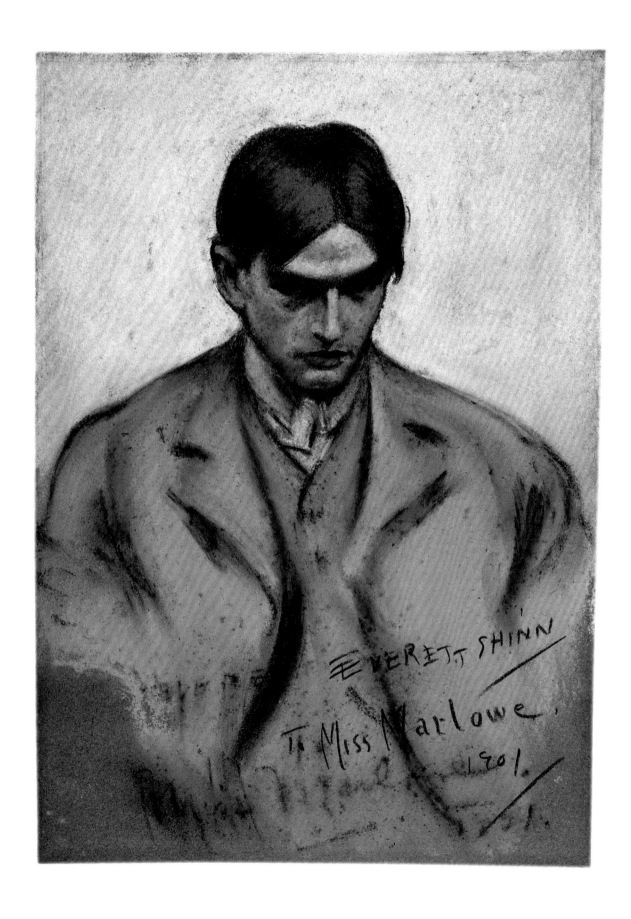

the pink cravat—thus capitalizing on the softness and the brilliance of the medium.[49] For the flesh tones of the lowered head, he effectively blends his pastels to create the strong highlight on the forehead and the heavily shadowed facial features. The riveting drama of those black eyes, staring out moodily from beneath the dark brows, eclipses any lack of definition at the periphery of the figure.

Although drawn at the brink of Shinn's first success, the self-portrait does not address his artistic ambitions nor any personal melancholy that the downturned face might at first imply. Instead, it

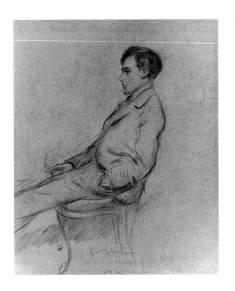

Fig. 26. *Everett Shinn* (1876–1953) by William Glackens (1870–1938). Red chalk on paper, circa 1903. Mead Art Museum, Amherst College, Massachusetts

reveals a central element of the artist's personality: his theatricality. Shinn's attraction to all aspects of the theatrical world was first nourished in Philadelphia. As a newspaper sketch artist and student at the Pennsylvania Academy, he had made friends with Luks, John Sloan, Robert Henri, and William Glackens, joining them and others in lively amateur theatricals [fig. 26]. In 1894 he debuted as James McNails Whiskers in *Twillbe*, a wildly successful lampoon of George du Maurier's best-selling novel.[50] Shinn's roommate at the time was the irrepressible Luks, once an adolescent vaudevillian and still a prankster, mimic, and gifted raconteur. In Luks, Shinn found a model of the artistic life lived at full tilt, with as much dramatic flair as possible. Several years younger than his Philadelphia friends, he eagerly absorbed the notion that wit, performance, and entertainment of all forms added a crucial vitality to art and life.

By the time he reached New York, Shinn was seriously stagestruck, as this self-portrait, inscribed to Julia Marlowe, suggests.[51] He may have met the

famous actress through Clyde Fitch or at the home of Elsie de Wolfe and Elisabeth Marbury, where prominent figures of the New York stage often gathered.[52] Shinn drew several pastels depicting Marlowe at this time, and later reminisced about observing her from backstage in a role from one of Fitch's plays: "Many nights I had stood in the wings," he recalled, "watching [her] performance."[53] In addition to such associations and his regular attendance at all types of entertainments, Shinn found that his theatrical interests led to his first murals, painted for David Belasco's Stuyvesant Theater. And he further indulged his obsession by creating a small amateur theater in his studio, where he was producer, director, playwright, actor, and set designer for his own Waverly Street Players.[54]

As a subject for art, the theatrical world would intrigue Shinn for the rest of his career. As Linda Ferber has chronicled, his pastels and paintings reveal a continued fascination with vaudeville, theater, the circus, and the ballet. Inspired by Edgar Degas, whom he greatly admired, Shinn examined performance from every angle—from audience to stage to orchestra pit.[55] All of the paintings he submitted to the seminal 1908 exhibition of the Eight explored theatrical subjects. "Everett Shinn is fond of the playhouse because of its lines and lights," one critic had noted in 1905. But the allure was more than aesthetic. Shinn had so internalized his theatrical point of view that a highly charged sense of performance pervades his entire vision of the city. Even his street scenes, Sylvia Yount has pointed out, are presented in dramatic guise as spectacles of New York life. Reacting against the "drowsiness" of American art, "that virus of ease and artificiality," Shinn had found a way to revitalize the urban scene.[56]

In Shinn's view of the modern city as an unfolding variety show, the artist had multiple roles to play: audience-observer, critic, chronicler, and, as this self-portrait makes clear, celebrity performer. In this pastel, Shinn assumes the role of brooding romantic, a conscious stereotype of the artistic soul. A certain degree of dramatic posturing, Shinn realized, was expected of the artist. "Great fun. being an artist. with temperament," he wrote to Sloan in 1908 with a sketch of himself posing with studied affectation for publicity photos.[57] Shinn's pastel self-portrait conveys the theatricality that underscored his self-perception, artistic imagination, and urban vision.

W.W.R.

NOTES

41. Useful biographical sources include Bennard B. Perlman, *The Immortal Eight: American Painting from Eakins to the Armory Show (1870–1913)* (New York: Exposition Press, 1962); Edith DeShazo, *Everett Shinn, 1876–1953* (New York: Clarkson N. Potter, 1974); and, more recently, Janay Wong, *Everett Shinn: The Spectacle of Life* (New York: Berry-Hill Galleries, 2000). The Shinn Papers, including scrapbooks and record books, are in the Archives of American Art, Smithsonian Institution, Washington, D.C. (hereafter "AAA"). Autobiographical papers, including an unfinished and unpublished autobiography, are in the Helen Farr Sloan Library, Delaware Art Museum, Wilmington (hereafter "Sloan Library"). See also Barbara C. Rand, "The Art of Everett Shinn" (Ph.D. diss., University of California, Santa Barbara, 1992).

42. The Society of American Painters in Pastel featured the work of William Merritt Chase, Robert Blum, John Henry Twachtman, J. Alden Weir, Childe Hassam, and others in four exhibitions over eight years. For the history of pastel in America, see Dianne H. Pilgrim, "The Revival of Pastels in Nineteenth-Century America: The Society of Painters in Pastel, " *American Art Journal* 10 (November 1978): 43–62, and Doreen Bolger et al., "American Pastels, 1880–1930: Revival and Revitalization," in Doreen Bolger et al., *American Pastels in the Metropolitan Museum of Art* (New York: Metropolitan Museum of Art, 1989), 1–32.

43. Linda Ferber, "Stagestruck: The Theater Subjects of Everett Shinn," in *American Art Around 1900*, ed. Bolger and Cikovsky, 52–53; Wong, *Everett Shinn*, 36–37. Elsie de Wolfe also employed Shinn to decorate the houses and apartments of her society friends.

44. Quoted in Ferber, "Stagestruck," 53.

45. "At the Academy," *Philadelphia Times*, April 17, 1900.

46. "The Heart of the Town," unidentified newspaper clipping, Shinn Papers.

47. A. E. Gallatin, "Studio-Talk," *International Studio* 30 (November 1906): 86.

48. DeShazo, *Everett Shinn*, 157. Searching for different effects, Shinn sometimes combined pastel with gouache, watercolor, or monotype.

49. Touches of bright color to enliven a black, gray, and white palette are found in many of Shinn's early pastels and may have been influenced by Whistler.

50. Perlman, *Immortal Eight*, 66–69

51. The inscription "Everett Shinn / To Miss Marlowe / 1901" is written over a seemingly identical phrase, which was at some point rubbed and obscured, but was considered important enough by either artist or recipient to reinscribe.

52. De Wolfe and Marbury, a respected theatrical agent, hosted a lively salon at their Irving Street house, which attracted notable theatrical personalities, including Marlowe, Fitch, and producer Charles Frohman; see Jane S. Smith, *Elsie de Wolfe: A Life in the High Style* (New York: Atheneum, 1982), 68–73, 76–77.

53. Shinn, unpublished auto-biography, Sloan Library; Ferber, "Stagestruck," 52–53. After de Wolfe's 1899 exhibition of Shinn's work, Clyde Fitch bought a now-unlocated pastel titled *Scene—Julia Marlowe*, which probably depicted her performing in one of his plays. Fitch's drawing was shown in the Boussod, Valadon exhibition in 1900, as were two other scenes depicting Marlowe (Ferber, "Stagestruck," n. 21).

54. DeShazo, *Everett Shinn*, 71–81.

55. Shinn, unpublished auto-biography, Sloan Library; Wong, *Everett Shinn*, 41.

56. Henri Pène Du Bois, "A Fragonard of the Present Time," *New York American*, February 22, 1905; Sylvia L. Yount, "Consuming Drama, Everett Shinn and the Spectacular City," *American Art* 6 (Fall 1992): 87–109; Everett Shinn, "Recollections of the Eight," in *The Eight* (New York: Brooklyn Museum, 1943), 11.

57. This illustrated note to Sloan, owned by the Delaware Art Museum, depicts Shinn with hat, walking stick, and cigarette posing for Gertrude Käsebier before the Eight's Macbeth Gallery exhibition.

EDWARD HOPPER
1882–1967

SELF-PORTRAIT

Charcoal on paper, 47.6 x 30.7 cm (18³/₄ x 12¹/₁₆ in.), 1903
Inscription: E Hopper Nov 1903
NPG.72.42

Edward Hopper was twenty-one years old when he completed this self-portrait in charcoal. Dressed in a jacket and a roll-neck sweater—the precursor of today's turtleneck—the figure looks back at the viewer with an expression of quiet confidence. While a strong light illuminates half of his face, dark shadows shroud the other half, an effect that both energizes the portrait and gives it an air of mystery. At the time, Hopper was a student at the New York School of Art, an institution founded and run by the celebrated American painter William Merritt Chase. Rendering this type of portrait was a standard academic exercise for young artists, and Hopper completed a number of self-portraits during the five years he was enrolled there. He did at least six in oil but executed many in other media, including charcoal, pencil, and pen and ink.[58]

In learning how to paint, sculpt, or draw, artists have long pictured themselves. When other models are lacking, the self is always available with the help of a mirror or camera. In an oil self-portrait completed in 1903 [fig. 27], the year of this charcoal drawing, Hopper portrays himself in the act of painting. With palette in one hand and his other arm raised toward an unseen canvas, the figure seems to stare at himself in a mirror. Similar in size, Hopper's many self-portraits from this period are indeed the result of his experimentation with different visual media and portraiture as an artistic genre.

The self-portrait as a subject is additionally attractive for its capacity to serve as a reflection of one's psyche. In such compositions, Hopper could probe his physical and psychological being, fulfilling his characteristically introspective nature. At the same time, the self-portraits acted as a self-fashioning device: through them, he could influence the shape of his emerging artistic identity. As a young man and an artist, Hopper in 1903 was just beginning to gain a sense of self-confidence and direction. The series of self-portraits to which this

charcoal work belongs reflects that process of maturation.

Hopper was born in Nyack, New York, a small port town on the Hudson River. The younger of two children in a comfortable middle-class family, he showed an early interest in drawing. His mother encouraged art as a pastime, often providing him with illustrated books and magazines from which to copy. In 1899, upon graduation from high school—where he received honors in drawing—Hopper longed to become an artist. Wanting to be supportive, yet anxious about their son's future, his parents agreed that he could enroll the following fall at the New York School of Illustrating. Yet, while such a program might prepare Hopper for a potential career as a commercial illustrator, it did not appeal to him.[59]

A year later, after some debate with his parents, Hopper transferred to Chase's more prestigious art school. There he began to blossom. Although Chase and Kenneth Hayes Miller were important instructors, it was the arrival of realist painter Robert Henri to the school's faculty in the fall of 1902 that most profoundly influenced Hopper. Henri's dedication to his students and his commitment to an aesthetic built upon the study of contemporary American life made him a hero to a new generation of artists. As Hopper later attested, "No single figure in recent American art has been so instrumental in setting free the hidden forces that can make of the art of this country a living expression of its character and its people." Likewise, few "have gotten as much out of their pupils, or given them so great an initial impetus as Henri."[60]

Henri encouraged his students to "depict the familiar life about them," a marked departure from traditional art educators who privileged the ideal.[61] In addition, he believed that the study of form, as opposed to the study of color or line, was crucial for aspiring artists. To direct attention to the importance of strong forms, he conducted frequent exercises in

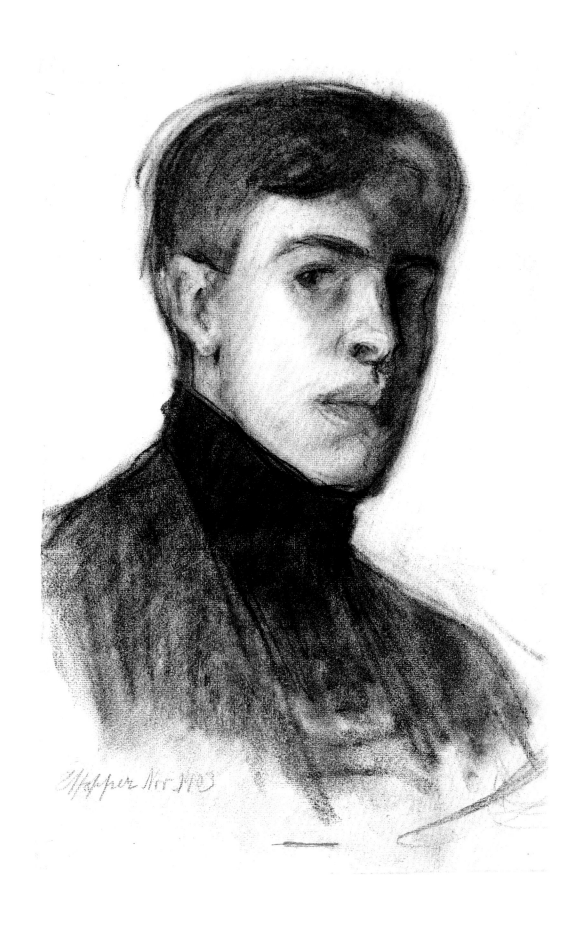

black-and-white modeling. Whereas an earlier generation used the medium of charcoal in a controlled and conventional manner, Henri pushed his students to adopt a looser, more gestural stroke. Lacking any firm contour lines and exhibiting a certain freedom in the medium's application, the Portrait Gallery's charcoal self-portrait imparts many of Henri's lessons.

At the same time, it represents Hopper's growing sense of identity. Only months before he completed the self-portrait Hopper had been awarded a scholarship in life drawing and a first prize for oil

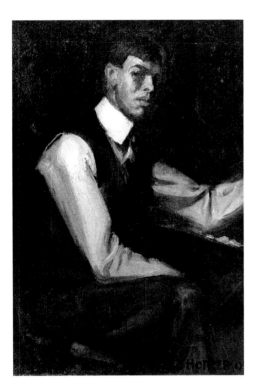

Fig. 27. *Edward Hopper* (1882–1967), self-portrait. Oil on canvas, 1903. Whitney Museum of American Art, New York; Josephine N. Hopper bequest

painting in the school's annual spring exhibition. Although described as shy and insecure as a youth, he was now considered one of the most talented students by his peers.[62] This newfound confidence is evident in his well-articulated facial expression.

Hopper's decision to figure himself in a jacket and roll-neck sweater also reveals a desire to be seen as a youthful, unpretentious, and thoroughly contemporary man. Such sweaters were commonly associated at the time with outdoor athletics such as football and cycling. In addition, they were often worn by outdoor laborers, especially fisherman.[63] An avid sailor as a youth, Hopper was perhaps trying to associate himself with such masculine pursuits. While he wears a starched white collar, vest, and tie in the oil self-portrait—articles of clothing that were typical

for artists of the period—his adoption of the more informal clothing style signals his allegiance to Henri's belief that the arts should represent all aspects of modern life.

It would be more than two decades before Hopper would gain significant public and critical attention as a realist painter, but the drawing suggests that he had come into his own as an artist and an individual by 1903. Thoroughly modern in terms of his self-representation and use of the medium, it marks the leading edge of a new tradition in the graphic arts carried forward by members of the so-called Ashcan School.[64] Furthermore, it serves as an early example of Hopper's lifelong exploration of the artist's place in American society.

Not long after his first retrospective exhibition at New York's Museum of Modern Art, Hopper had an occasion to comment on the relationship of artists to their work. He reflected as follows:

> In every artist's development the germ of the later work is always found in the earlier. The nucleus around which the artist's intellect builds his work is himself; the central ego, personality, or whatever it may be called, and this changes little from birth to death. What he was once, he always is, with slight modifications. Changing fashions in methods or subject matter alter him little or not at all.[65]

F.H.G.

58. For a complete listing of Hopper's oeuvre, see Gail Levin, *Edward Hopper: A Catalogue Raisonné* (New York: W. W. Norton, 1995).

59. For a full biographical portrait, see Gail Levin, *Edward Hopper* (New York: Alfred A. Knopf, 1996).

60. Edward Hopper, "John Sloan and the Philadelphians," *Arts* 11 (April 1927): 175–76.

61. Edward Hopper, "Edward Hopper Objects," *Art of Today* 6 (February 1935): 11.

62. Levin, *Edward Hopper*, 45.

63. See, for example, *The 1902 Edition of the Sears Roebuck Catalogue* (New York: Bounty Books, 1969), 989–91.

64. For a history of the graphic arts of the Ashcan School, see Rebecca Zurier, *Art for the Masses (1911–1917): A Radical Magazine and Its Graphics* (New Haven: Yale University Art Gallery, 1985), and Sheldon Reich, *Graphic Styles of the American Eight* (Salt Lake City: Utah Museum of Fine Arts, 1976).

65. Hopper, "Edward Hopper Objects," 11.

John Barrymore
1882–1942

By Alfred J. Frueh
1880–1968

Ink, ink wash, and graphite on illustration board, 47.8 x 22.5 cm (18 13/16 x 8 7/8 in.), circa 1909
Inscription: Frueh
Gift of the children of Al Frueh
NPG.93.161

On September 4, 1909, the twenty-seven-year-old actor John Barrymore opened as Nat Duncan in *The Fortune Hunter*, the role that catapulted him to stardom. The young man, depicted here in that role, had taken to the stage reluctantly. He had wanted to be an artist. As youngest sibling of a famous theatrical family, however—his sister Ethel, brother Lionel, father Maurice, uncle John Drew, and grandmother Louisa Lane Drew had all found success in the profession—he seemed predestined. "Acting comes easy and pays well—that's the narcotic," Barrymore later remarked.[66] Endowed with exceptional charm, a slim, athletic build, and an enviable mustache, Barrymore cut a debonair figure in the light comedies that first launched his career. His assets translated into charisma on stage despite his record for showing up drunk for rehearsals.

Most critics found Barrymore handsome and irresistible in *The Fortune Hunter*, the story of an indolent city boy who, while prowling for a provincial heiress, is transformed by small-town values. Some writers, however, doubted that Barrymore would ever go beyond comedy. "That toilsome road of the player striving for technique," Walter Eaton commented, "he has short cut. He has conquered by his charm." But the *New York Times*, while noting his "lightness and ease" and his "frank assurance," saw something beyond the surface amiability: "As he played last night there was suggested a deeper note, a sort of undercurrent of sympathy and feeling, that gave tenderness to the laughter."[67]

Ohio-born artist Al Frueh also saw something deeper—and darker—in Barrymore's theatrical talents, a latent intensity that the script hardly suggested. In addition to the handsome, heavy-browed profile that would soon become a Barrymore trademark, Frueh captured a clenched-fisted, glowering mood of desperation from the play's opening scenes, evoking not only the matinee idol of

The Fortune Hunter, but also the legendary Hamlet that Barrymore would eventually become [fig. 28].

Al Frueh—pronounced "'free as in 'free lunch'" according to the artist—was at the start of his own career at the time.[68] The young newspaper illustrator from the *St. Louis Post-Dispatch*, recently returned from his first trip to Europe, had moved to New York in the fall of 1909, and found work as a cartoonist for the *New York World*. An inveterate fan of the theater, he had started drawing caricatures in Saint Louis and developed a flair for limning famous actors on their tours through town. He would habitually sit eight rows back on one side and concentrate on a performer's characteristic poses and gestures. When he returned home, he would sketch the full-length figure from memory, painstakingly eliminating lines and honing a quintessential likeness. The abbreviated, stylized line of his portraits showed the influence of German caricature, familiar to most artists from such imported magazines as *Simplicissimus*.

Frueh's trip to Europe, particularly his visit to Paris, further refined his approach. French caricature flourished at the time in the hands of such artists as Leonetto Cappiello and Sem (Georges Goursat). Slim, elongated figures and simplified forms, together with a fun-loving irreverence toward the stylishly famous, distinguished the genre. Closely related to poster art, French caricature achieved a similar graphic impact through simplification, asymmetry, bold contours, and flat areas of color. The lessons of japonisme that had influenced the style had a profound effect on Frueh. *John Barrymore* was one of a series of theatrical figures that he drew between 1909 and 1912, after his return to New York. Often silhouetted on the page or depicted in profile, these flattened, elongated caricature drawings evoked Parisian precedents. Stylistic elements of *Barrymore*, however, such as the tall, narrow format, heavy, dark contour line, contorted pose, truncated legs, and stark, dramatic background also suggest a direct exposure

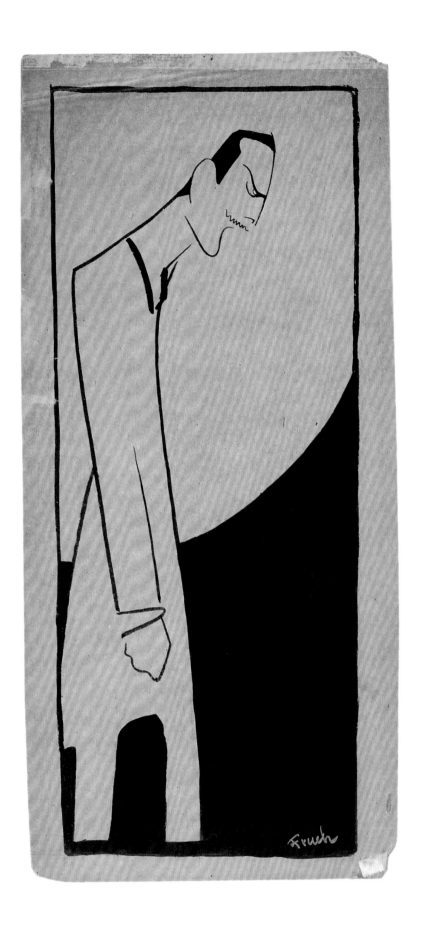

to the Japanese ukiyo-e prints he undoubtedly saw in Paris.[69]

Frueh did not make these theatrical portraits for publication—the *New York World* still featured only his cartoons—but after he left for a second trip to Europe in 1912, his friend Homer Croy showed his work to Alfred Stieglitz, who decided to mount an exhibition. The *Barrymore* drawing, along with more than fifty others, went on exhibit from November 20 to December 10, 1912, at Stieglitz's 291 galleries. Frueh received a copy of the printed brochure with Stieglitz's scribbled note: "Opened with this show.

Fig. 28. *John Barrymore* (1882–1942) by Edward Steichen (1879–1973). Gelatin silver print, 1922. National Portrait Gallery, Smithsonian Institution; acquired in memory of Agnes and Eugene Meyer through the generosity of Katharine Graham and the New York Community Trust, The Island Fund

Looks magnificent. Great success. Wish you could see it. It would please you immensely. A lot of people price'd things. Were told the things were not for sale. Hope you will publish series, the people say." Stieglitz wrote a few days later that the show was "both a popular and artistic success" and that he hoped to extend the time of the exhibition another week. Early in 1913, an expanded exhibition traveled to the J. C. Strauss Studio in Saint Louis and the H. H. Pierce Studio in Boston.[70] Critical acclaim followed. The avant-garde enjoyed Frueh's whimsical originality and his "fresh and independent point of view." Newspaper writers marveled at his abbreviated line. The *New York World*'s Henry Tyrrell tried to explain the technique: "Frueh's drawings have novelty and interest, in their extreme economy of line, which amounts practically to a pictorial short-hand. It is what the art critics call 'synthetic' drawing. That is, it summarizes a complete object or

action in a single line, curve or angle. Shading or modelling there is none."[71]

Back in New York in 1914, Frueh started translating his stage portraits into linocut prints. These, together with his drawings, children's toys, and folded-paper animals, began to be featured in exhibitions of the Society of Independent Artists. Although the artist was still young, a "kid in animal spirits," one admirer reported, "[no] other rapid-fire artist in America . . . has as much of the original Hiroshige in him as Alfred Frueh."[72] *Stage Folk*, a portfolio of his linocuts published in 1922, elicited another round of favorable reviews. In an article about the American vogue for caricature, modern art critic Willard Huntington Wright noted Frueh's preeminence:

> For sheer cleverness, diversity of talent, and ability to set down an interpretative [*sic*] likeness of a given subject, Frueh has no equal in this country. He works with a rigid economy of means, and he can construct a vivid portrait of a person with a few telling strokes. He deals in salients almost exclusively; and so keen is his observation that he is able to sum up a personality in a single feature or lineament.[73]

In the 1920s the magazines began publishing Frueh's theatrical caricatures, and by the middle of the decade Frueh had settled into what would become a long relationship with the *New Yorker*, which featured his drawings of important new plays for the next forty years.

Critics such as Tyrrell and Wright had noted that Frueh's emphasis on external summary and surface characteristics seemed less judgmental and analytical than traditional satiric portraiture. In fact, these stylized images represented a new form of celebrity caricature that pervaded the press in the era between the world wars. Frueh's portraits celebrated, rather than probed beneath, the well-known public image, tying caricature to the emerging celebrity industry. His *Barrymore* was not a satiric revelation of human weaknesses but a clever, modern reconstruction of New York's new matinee idol of 1909.

W.W.R.

66. Quoted in Michael Morrison, *John Barrymore: Shakespearean Actor* (Cambridge: Cambridge University Press, 1997), 41.

67. Walter Eaton, "Personality and the Player," *Collier's*, October 22, 1910, 17; *New York Times*, September 5, 1909.

68. For biographical sources on Frueh, see Wendy Wick Reaves, *Celebrity Caricature in America* (New Haven: National Portrait Gallery, Smithsonian Institution, and Yale University Press, 1998); Thomas P. Bruhn, *The Art of Al Frueh* (Storrs, Conn.: William Benton Museum of Art, 1983); Carlo de Fornaro, "Celebrities of the Stage in Caricature," *Arts and Decoration* 18 (December 18, 1922): 20–21, 100; Frueh Papers, AAA; *Frueh on the Theatre* (New York: New York Public Library, 1972); Mike and Nancy Frueh, *Theatre Caricatures by Al Frueh: West End Meets Broadway* (London: Theatre Museum, [1990]); Stuart W. Little, "A Half-Century of Sketching Stars," *Theatre Arts* 45 (July 1961): 60–63.

69. Frueh studied briefly with Henri Matisse while in Paris. He probably saw the exhibition of ukiyo-e prints mounted by the Musée Nationale des Arts Décoratifs in 1909. See Klaus Berger, *Japonisme in Western Painting from Whistler to Matisse* (Cambridge: Cambridge University Press, 1992), 313.

70. For 291's brochure and announcements of the Saint Louis and Boston shows, see Frueh Papers.

71. *Camera Work* 41 (January 1913): 24; Henry Tyrrell, *New York World*, January 5, 1913.

72. *New York World*, January 27, 1918.

73. Willard Huntington Wright, "America and Caricature," *Vanity Fair*, July 1922, 102. Frueh's *Barrymore* was not included in the *Stage Folk* portfolio.

PAUL HAVILAND
1880–1950

BY MARIUS DE ZAYAS
1880–1961

Charcoal on paper, 62.8 x 48 cm (24 ³/₄ x 18 ⁷/₈ in.), circa 1910
Inscription: 6
Gift of Mr. and Mrs. Harry H. Lunn Jr.
NPG.92.40

This large charcoal portrait documents the friendship of two cosmopolitan expatriates in New York who played key roles in the development of the American avant-garde in the years preceding World War I. In about 1908, Paul Haviland and Marius de Zayas each gravitated to Alfred Stieglitz's 291 galleries. Haviland—businessman, photographer, art collector, and scion of the porcelain company family from Limoges, France—had come to New York to represent his father's firm in 1901 after doing graduate work at Harvard.[74] De Zayas, born to a prominent intellectual family in Veracruz, Mexico, spoke several languages, had studied in Europe, and had published caricatures in *El Diario* in Mexico City. His family, fleeing the dictatorship of Porfirio Díaz, arrived in New York in 1907.[75] De Zayas joined a group of photographers and writers called the Vagabonds and, while drawing caricatures and cartoons for the *New York World* and other periodicals, launched into the intellectual life of the city.[76]

Haviland first visited 291 to see the exhibition of Auguste Rodin's drawings early in 1908. He was so impressed with Stieglitz that he immediately became an enthusiastic supporter of his endeavors. Just three months after their first meeting, he offered to pay the lease for the 291 galleries, and by January 1909 had started to write for the magazine *Camera Work*, eventually becoming an associate editor. He also began to develop his promising talents as a photographer, which is how de Zayas chose to depict him. The two were particularly close among Stieglitz's intimate associates, both working tirelessly to promote the cause of progressive art. Together they authored the small volume *A Study of the Modern Evolution of Plastic Expression*, published by Stieglitz in 1913, one of the first studies of modernist aesthetics in America. In 1915, together with Agnes Meyer and Francis Picabia, they launched a radically experimental new journal titled *291* and started the

Modern Gallery, hoping to reenergize the avant-garde. In a letter to de Zayas, Stieglitz praised him and Haviland for taking the initiative. Haviland's seven years of intense involvement ended abruptly in July 1915, when he returned permanently to France to help with the family company.[77]

De Zayas zealously advanced the cause of modern art, organizing exhibitions for 291, writing on cubist and African art, and introducing new concepts of abstract portraiture. He also changed the way the public and the avant-garde thought about caricature. Newspaper and magazine readers loved his lively, stylized, inked figures of the famous, drawn in an abbreviated style derived from the Parisian caricaturists. But in addition, he drew large charcoal caricatures like the image of Haviland, enveloping his elongated figures in a smoky, dense atmosphere filled with mysterious allusion. The soft focus of the Portrait Gallery's picture, as well as the dark background, limited tonal range, and use of light to emphasize the head and hands, are suggestive of the pictorialist photography that Haviland and de Zayas would have known through 291. They also evoked the charcoal "noirs" of visionary French artist Odilon Redon, which were widely admired at the turn of the century. Although de Zayas's work did not have the mystical, symbolist resonance of Redon's, it suggested a psychological synthesis more closely related to fine art than to comic ephemera. Art critic Henry Tyrrell saw little difference between "modern caricature" and "modern, 'straight' portraiture." "Both are psychological in their way of seeing a subject," he noted, "exaggerating the salient and significant features . . . and rendering the summary impression by the quickest and most arbitrary strokes." Benjamin de Casseres viewed de Zayas's type of caricature as an intellectual branch of the arts in that it examined the human condition much like a novel, poem, painting, or sculpture.[78]

The pictures had intrigued Alfred Stieglitz, who in

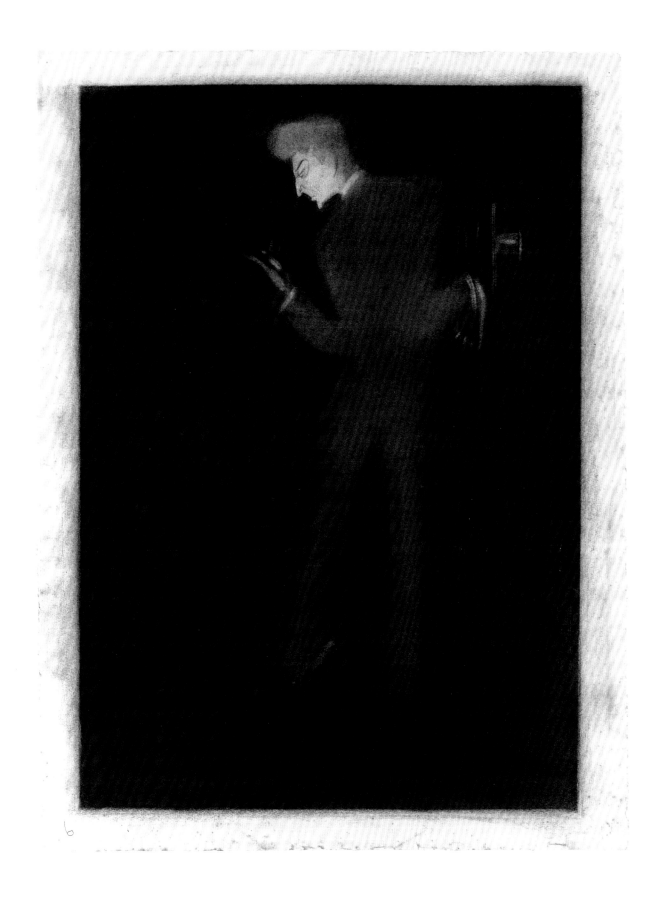

73

1907 reportedly arrived at de Zayas's studio unannounced one day. "The man asked me about what I was doing," de Zayas recalled, "'did I wish to sell or exhibit?' I replied, 'I make what you see here for myself. Just that.' 'Would you like to exhibit?' the man repeated. I said, 'No.'" Impressed by his innovative work, Stieglitz eventually mounted three exhibitions of de Zayas's caricature drawing at 291. "The limelight of caricature was thrown with a curiously subtle discrimination," Haviland wrote in *Camera Work* in April 1909, reviewing the first exhibition. The depictions were without malice, he

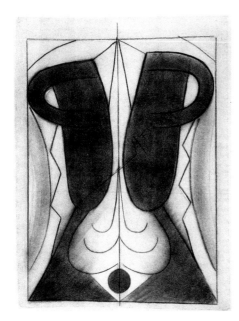

Fig. 29. *Paul Haviland* (1880–1950) by Marius de Zayas (1880–1961). Photogravure from *Camera Work*, April 1914. National Portrait Gallery, Smithsonian Institution

insisted, and no reasonable person could resent his portrayal.[79]

Haviland undoubtedly appreciated his own image. De Zayas depicted him with his camera, intent on the stopwatch held in one hand while casually gripping the shutter bulb in the other. This highly theatrical presentation was influenced by de Zayas's passion for the stage. De Zayas, who illustrated the column written by *New York Evening World* drama critic Charles Darnton, attended the theater regularly, sitting up at the front, near the powerful footlights. The low vantage point and dramatic lighting in the Haviland portrait reflect this point of view. The awkward stance is also an exaggerated back-to-the-audience pose with the profiled face and hands still clearly visible. Both de Zayas and Haviland fervently believed in the seriousness of the artistic endeavor that the picture implied despite its witty, theatrical variation on portrait conventions.

De Zayas aligned caricature with performance and celebrity. Like the popular vaudeville acts of the period, the caricatured figure had to deliver an immediate, dynamic impression. The simplification, broad exaggerations, vivid gestural poses, humor, and emphasis on personality seen here were all theatrical tools in his repertoire. Indeed, de Zayas's second exhibition at 291, in 1910, was staged as a miniature drama of the famous. In "Up and Down Fifth Avenue," he assembled dozens of small, wood-backed caricature figures on a small stage against a painted backdrop of the Plaza Hotel as if they were walking or riding down the street. Haviland was one of the many prominent New Yorkers included in the bustling scene, which one critic praised as a "panoramic motionless picture."[80]

By 1913, when he had his final exhibition at 291, de Zayas had pushed caricature into complete abstraction, inspired by his studies of cubism, futurism, and primitive art [see cat. no. 9]. Striving to represent the immaterial essence of personality, he substituted geometrical shapes and algebraic formulas as subjective "equivalents" for recognizable form. Haviland, pleased to be one of de Zayas's subjects once again [see fig. 29], wrote an article praising the new drawings in the April 1914 issue of *Camera Work*. These serious "caricatures" were among the most radically abstract pictures to be produced in America at the time. Although the complex theory behind them spawned no immediate followers, de Zayas's work (together with his and Haviland's published essays) inspired Picabia's "machine portraits" and eventually the abstract portrait experiments of the dada artists.[81]

The Haviland portrait thus represents the range of de Zayas's extraordinarily varied contributions to America art. By popularizing his abbreviated, personality-focused images in the newspapers and magazines while simultaneously raising them to the realm of serious art, he helped launch the vogue for celebrity caricature that would peak in the interwar years. Furthermore, his efforts to push figural art beyond the conventional boundaries of portraiture, as well as his and Haviland's tireless work and impassioned writing, advanced the cause of modernism in America.

W.W.R.

74. Biographical sources for Haviland include William Innes Homer, *Alfred Stieglitz and the American Avant-Garde* (Boston: New York Graphic Society, 1977); Peter Galassi, "Paul Burty Haviland, 1880–1950," *Catalogue 6 Photo-Secession* (Washington, D.C.: Lunn Gallery Graphics International, 1977): 5–11; and Colin B. Bailey, *Renoir's Portraits* (New Haven: Yale University Press, 1997): 206–8.

75. Biographical sources for de Zayas include Douglas Hyland, *Marius de Zayas: Conjuror of Souls* (Lawrence, Kans.: Spencer Museum of Art, 1981); Craig R. Bailey, "The Art of Marius de Zayas," *Arts Magazine* 53 (September 1978): 136–44; Willard Bohn, "The Abstract Vision of Marius de Zayas," *Art Bulletin* 62 (September 1980): 434–52; Marius de Zayas, "How, When, and Why Modern Art Came to New York," with introduction and notes by Francis M. Naumann, *Arts Magazine* 54 (April 1980): 96–126; Reaves, *Celebrity Caricature;* de Zayas Archive, Seville, Spain; and the Stieglitz Papers, Beinecke Rare Book and Manuscript Library, Yale University, New Haven, Connecticut (hereafter "Beinecke Library").

76. Carlo de Fornaro and Benjamin de Casseres, whom de Zayas had met through *El Diario*, were undoubtedly helpful to him in New York. De Casseres was part of the Vagabonds group, as was Theodore Dreiser.

77. Galassi, "Paul Burty Haviland," 11.

78. Henry Tyrrell, "Exhibition of Caricature by Noted Artist at Photo-Secession Galleries," *New York Evening World,* January 6, 1909; Benjamin de Casseres, "Caricature and New York," *Camera Work* 26 (April 1909): 17.

79. "Marius de Zayas: A Master of Ironical Caricature," *Current Literature* 44 (March 1908): 282–83; Dorothy Norman, *Alfred Stieglitz: An American Seer* (New York: Random House, 1973), 107; Paul Haviland, "Marius de Zayas and John Nilsen Laurvik," *Camera Work* 26 (April 1909): 37.

80. Henry Tyrrell, "De Zayas Applies Parisian Novelty to Fifth Avenue," *New York Evening World,* April 27, 1910.

81. William A. Camfield, "The Machinist Style of Francis Picabia," *Art Bulletin* 48 (September–December 1966): 310, 314; William Agee, "New York Dada, 1910–1930," in Thomas B. Hess and John Ashbery, eds., *The Avant-Garde* (New York: Macmillan, 1968), 107–8; Bohn, "Abstract Vision of Marius de Zayas," 434–52; Hyland, *Marius de Zayas,* 33–39.

Henry James
1843–1916

By Cecilia Beaux
1855–1942

Charcoal on paper, 50.6 x 38.3 cm (19^{15}/$_{16}$ x 15 1/$_{16}$ in.), 1911
Inscription: To Helena deK Gilder / Cecilia Beaux
NPG.87.248

American-born writer Henry James was an international literary and social "lion" revisiting the country of his birth and boyhood, when one of his prominent and influential American hostesses, Helena Gilder, proposed that he should sit for a portrait drawing. As a souvenir of their acquaintance, she would commission the well-regarded and socially adept fifty-six-year-old artist Cecilia Beaux, another of her talented friends.[82] If every drawing records an opportunity, the one manifested here realizes a remarkable confluence of circumstance, determination, acute instinct, and audacious skill. James, a prime trophy trapped by the social obligations of his day, certainly would have preferred to preserve his privacy. Fully aware of James's importance, Beaux, shopping for the frame she wanted, candidly confessed that it was going to be a great event for her to meet and "really know" him.[83] In the end, wholly undaunted by her aging subject's troubled personal circumstances and increasingly fragile emotional state, the ambitious Beaux demonstrated her robust talent for portraiture, exactly as she had hoped to do.

Beaux placed James's magisterial head high on the page, with diplomatic disinterest in his heavyset frame. With a few quick strokes she indicated, as unobjectionably as possible, the corpulence that increasingly discomfited and embarrassed James. She denoted the head as a matter of large planes, deftly shaded with shorter strokes of the charcoal punctuating the folds of facial flesh between the eyebrows, beneath the eyes, at the edges of a nostril and the mouth, and above the cravat. The image, as a whole, readily exemplifies what appreciative critics described as the preeminent characteristics of Beaux's best work: a direct and animated approach employing fundamental design principles with an ordered purpose untrammeled by mere conventions. In the opinion of one such source, Beaux possessed "a capacity for strength without that brutality so common to women in search of masculine qualities."[84] The drawing illustrates the technical advice she gave her art students: the importance of placing the eyes at the moment they are most interesting; not losing the first impression; looking for the large planes of shadow on the head; and, since light falls like rain, looking for places on the head that would get wet.[85]

As Beaux recalled in her diary, and later in her published autobiography, her friend Mrs. Gilder had "persuaded" James to cooperate. The day of the first sitting, the nervous artist took time to sit awhile in a park, "getting keyed up for HENRY JAMES." When he arrived, she found him "almost impossible to do. So delicate and spiritual in solid exterior." On the following day, she tried again, with better success, but still confided to her diary that she thought it was not possible "to represent the delicacy and spirituality of his mind by his physical appearing."[86]

James was struggling against a sad decline. Keenly aware of the value of his extensive social acquaintances, he was in no real position to refuse Gilder's proposal for a memento of their relationship. But he had long since been unhappy with his physical appearance. Twenty years before he agreed to sit for Beaux, he had already modestly refused the honor of being painted by no less a talent than the internationally eminent portraitist John Singer Sargent. Two years after sitting for Beaux, however, he reversed his earlier refusal when a large number of his friends offered to pay for a formal oil portrait by Sargent in celebration of his seventieth birthday, and the flattered James acquiesced [fig. 30].[87]

At the turn of the century, James's cousin, Bay Emmet, had painted a portrait of him, at age fifty-seven, that James described as shocking. He recalled the experience as having been brought

face to face . . . with every successive lost opportunity. . . . And with the steady swift movement of the ebb of

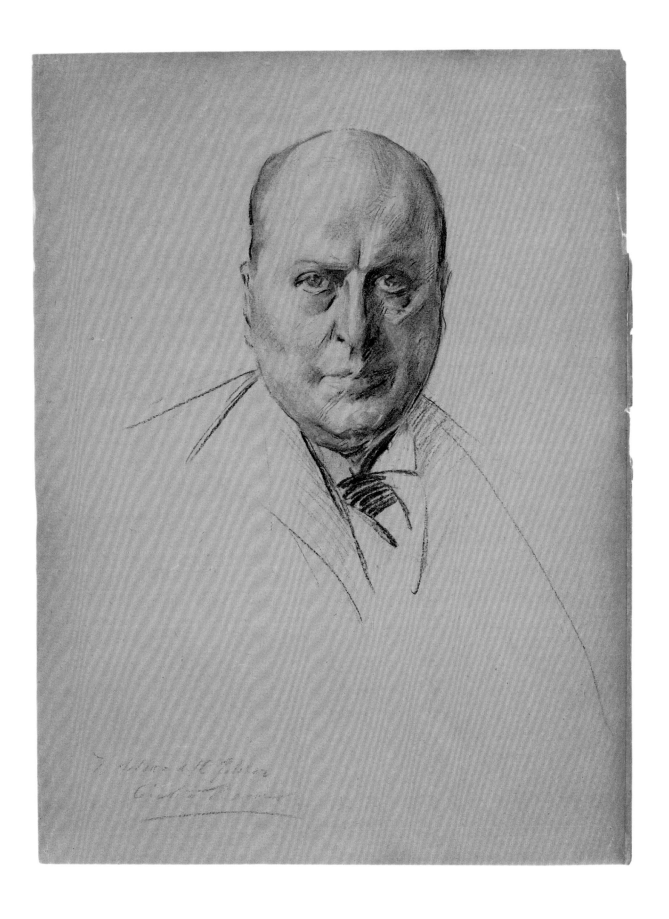

the great tide—the great tide of which one will never see the turn. The grey years gather, the arid spaces lengthen, damn them—or at any rate don't shorten; what doesn't come, doesn't and what goes *does*.[88]

A multidimensional alienation deriving partly from his experience of aging heightened the loneliness that had marked his life as an expatriate. His emotional isolation was worsened by his amazement and disappointment with America's conduct in the Spanish-American War at the end of the nineteenth century. He wrote his brother, William, that America had suddenly "ceased to be,

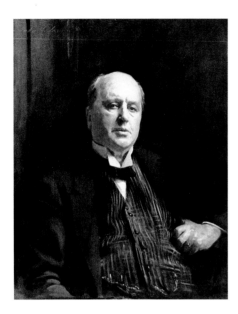

Fig. 30. *Henry James* (1843–1916) by John Singer Sargent (1856–1925). Oil on canvas, 1913. National Portrait Gallery, London

among the big nations, the one great thing that made up for our so many crudities & made us above all superior & unique—the only one with clean hands & no record of across-the-seas murder and theft."[89]

After the war, James began to experience what would become prolonged and painful dental difficulties as he labored for several years on an edition of his collected fiction. Begun with high hopes, the edition, publication of which actually marked the end of his creative life as a novelist, finally seemed to him to have been "the most expensive job" of his life. He also had problems with his heart, for which his English physicians prescribed exercise, weight loss, less isolation, and more recreation in his daily activities. One of his biographers has aptly described James's precarious emotional state in the opening decade of the new century: "When he looked into the mirror he saw an old, fat, unattractive man. Despite all his efforts, some successful, to love and be loved, he felt deeply lonely, with a strong sense of internal isolation."[90]

James fell into a serious depression early in 1910, a condition William described as a nervous breakdown "coinciding with the crisis that everyone seems to have to go thru in growing old." Humbled, he often felt, in his own words, like "a very lonesome and stranded old idiot." Repeated relapses, with fears of physical and mental disability, left him in nearly suicidal despair. When William and his wife, Alice, came to England to be with Henry, their company was welcome to the invalid bachelor who was judged "unfit to be alone." But William was then suffering with his own fatal heart condition. Henry, who felt completely dependent upon them for his own stability, returned to America with them, showing signs of improvement even as William's health deteriorated. The brothers had become so close that the prospect of William's imminent death left the wounded Henry feeling "nothing but the abject weakness of terror and grief." When it came, Henry experienced the loss of William as "so large that it was a loss of self."[91]

James wanted to return to England, to make his final crossing of the Atlantic. A relapse soon after he sat for Beaux delayed his planned sailing date, but in the summer of 1911 he again withdrew from America. Settled back in England at the outbreak of World War I, he died before the war's end.

In 1884, in an essay on the art of fiction, James had argued that the "look of things" that captures and conveys their meaning required a "solidity of specification" that it was the artist's challenge to achieve.[92] His assiduously polished prose achieved a verbal density that has challenged generations of readers. Realizing, perhaps, that Beaux's incisive draftsmanship solidly specified in the mere look of him a sense of the many truths of his situation (many of which were painful to confront privately, let alone submit for Beaux's penetrating examination), the author found it natural to evaluate the drawing on that professional, impersonal, plane. When shown the finished work, he managed to compliment, after a noticeable hesitation, the drawing's "astonishing . . . economy of means." Delighted, the triumphant Beaux was convinced, as she confided to her diary, that "He will not forget me, I am sure."[93]

H.F.P.

92. *Dictionary of National Biography,* s.v. "Henry James," 821.

93. Quoted in Cecilia Beaux, *Background with Figures* (Boston: Houghton Mifflin, 1930), 233.

82. Beaux was intensely serious about her art and devoted her entire life to it; like James, she never married. Helena deK. Gilder, the widow of *Century* magazine editor Richard Watson Gilder, had a sister in Venice who was a friend of James's. Beaux had also been a friend of James's late brother William. The idea of a quick portrait thus became something of a social inevitability. The scheme was announced during a dinner party hosted by Mrs. Gilder and attended by both the artist and the subject.

83. Beaux Diary, April 10 and 13, 1911, roll 428, frames 516–17, Cecilia Beaux Papers, AAA.

84. Royal Cortissoz, "Cecilia Beaux," *A Catalogue of an Exhibition of Paintings by Cecilia Beaux* (New York: American Academy of Arts and Letters, 1935), 7, 9; Homer St. Gaudens, "Cecilia Beaux," in *The Critic and Literary World* 47 (July 1905): 39.

85. Tara L. Tappert, "Choices: The Life and Career of Cecilia Beaux, A Professional Biography" (Ph.D. diss., George Washington University, 1990), Appendix F, "Notes Jotted Down on Criticism Day When Cecilia Beaux Came to the Portrait Class on Alternate Friday Mornings" by Elizabeth Cady Stanton.

86. Beaux Diary, April 12 and 13, 1911.

87. James cooperated in exchange for the promise that the finished work would be offered to the prestigious English National Portrait Gallery, a goal he found sufficiently worthy to justify numerous sittings for Sargent.

88. Quoted in Fred Kaplan, *Henry James: The Imagination of Genius, a Biography* (New York: William Morrow, 1992), 431.

89. Quoted in ibid., 433.

90. Quoted in ibid., 505, 516.

91. Quoted in ibid., 523–24, 531, 534.

Agnes Meyer
1887–1970

By Marius de Zayas
1880–1961

Pastel over graphite on paper, 62.1 x 47.7 cm (24 $^7/_{16}$ x 18 $^3/_4$ in.), circa 1912–13

Inscription : $a^3 + b^3 + c^3 \pm \sqrt{\left(\dfrac{d^2 + e^2}{2}\right)\left(\dfrac{e + f}{2}\right)}$

Gift of Anne Meyer
NPG.99.98

Both artist and subject of this remarkable portrait drawing were leading figures of Alfred Stieglitz's inner circle in New York when the 291 galleries on Fifth Avenue represented the height of the American avant-garde. Agnes Ernst was the *New York Sun*'s first female reporter in 1908, when she was sent to interview Stieglitz and encountered 291's "gusto for life and beauty."[94] After her marriage in 1910 to financier Eugene Meyer, she became a crucial patron for 291 and an activist for the modernist cause. Her friend Marius de Zayas, through his art, writings, exhibitions of modern artists, galleries, and influential friendships, played a role second only to Stieglitz in the promotion of avant-garde art in America from 1910 to 1915.

The Mexican-born de Zayas arrived in New York in 1907 with a cosmopolitan cultural background and began publishing cartoons and theatrical caricatures in the New York press. But he also created unusual charcoal portraits in which attenuated figures emerged from a dark, shadowy background [see cat. no. 7]. Stieglitz exhibited twenty-five of these pictures at 291 in January 1909, and critics recognized their aesthetic ambition. A second, widely acclaimed 291 exhibition in 1910 comprised a virtual caricature theater with dozens of cutout figures of New York celebrities assembled on a low, fifteen-foot-wide stage.

The Meyer drawing, however, signaled an entirely new direction for caricature and portraiture, establishing de Zayas's pioneering role as an American modernist. Arriving in Paris in the fall of 1910, he saw his first cubist picture. His fascination with the new style led him to Pablo Picasso, in whom he found a kindred spirit.[95] Picasso introduced de Zayas to African art, cubist theory, and fresh ways of translating imagery into form. Absorbing these lessons, de Zayas began writing about modern art and planning exhibitions for 291, introducing Picasso, cubism, and African art to American audiences.[96]

Picasso, he explained, developed in his art the "pictorial equivalent of the emotion produced by nature." De Zayas's own search for symbolic expression, in addition to Picasso's tutelage in modern and primitive stylization, formed the basis of his evolving theory of abstract caricature. Probably influenced by French philosopher Henri Bergson, he sought to express both the body and the spirit of an individual as well as the force that binds them together. In a March 7, 1911, letter to Stieglitz, de Zayas noted that he had started on a "new idea" and was making caricature drawings for the "philosophical collection."[97] But he still needed a "pictorial equivalent" for the spiritual or immaterial.

On a brief trip to England that fall, an object from the British Museum's ethnographical collections provided the catalyst for de Zayas's first abstract caricature. Identified as a "soul catcher," this stick with paired circles on either side reminded him of Stieglitz—both his physical appearance (he wore round glasses) and his spirit.[98] De Zayas felt that this abstract form could connote Stieglitz as a catcher of souls. In the resulting portrait, he used five pairs of rings along on a central axis to harness a primitive, spiritual energy without which modern art seemed to him sterile. Since he believed, however, that "religion today is science," he also added algebraic notations, a modern, scientific approach to symbolism. "We cannot represent materially something that is essentially immaterial," he noted, "unless we do it by the use of symbols. Mathematics are . . . the purest expression of symbolism. . . . We can represent psychological and metaphysical entities by algebraic signs and solve their problems through mathematics."[99]

The drawing of Agnes Meyer was one of a series of abstract, or "absolute," caricatures, as he called them, that de Zayas produced between the fall of 1911 and the spring of 1913.[100] It was included in his third 291 exhibit, which ran from April 8 to May 20,

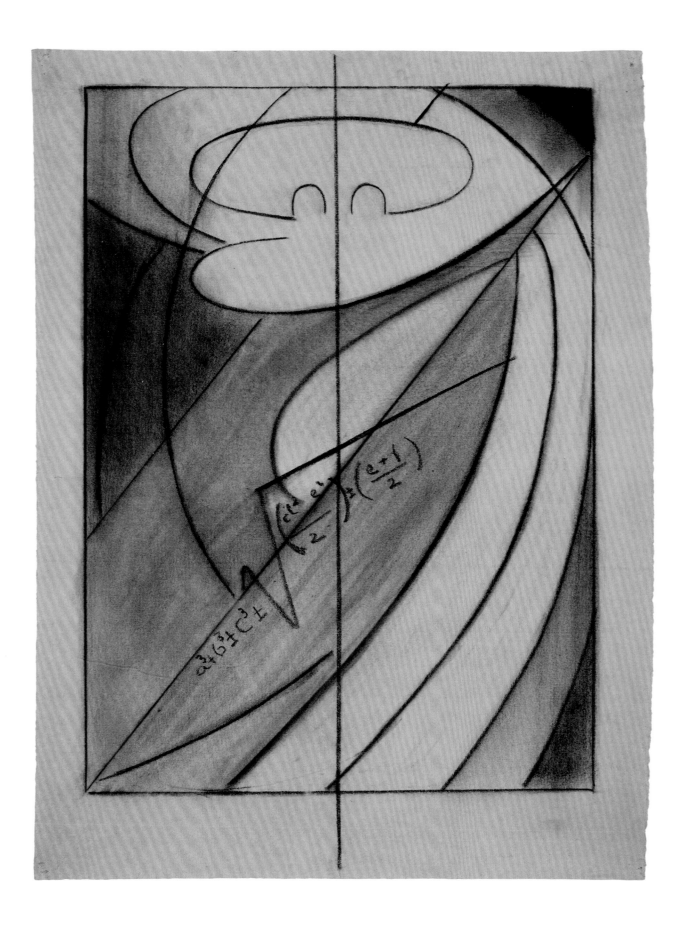

81

1913. Of the eighteen portraits shown, nine were examples of his abstract style. De Zayas explained his complex new theory in a catalogue essay reprinted in *Camera Work*. To him, the essence of an individual consisted of three segments: the spirit or soul, the physical being, and the life trajectory. "The technique of my procedure," he wrote, "consists in representing (1) the spirit of man by algebraic formulas; (2) his material self by geometrical equivalents; (3) and his initial force by trajectories within the rectangle that encloses the plastic expression and represents life."[101]

In the Meyer drawing, one of six abstracts from

Fig. 31. *Agnes Meyer* (1887–1970) by Edward Steichen (1879–1963). Platinum print, 1908. National Portrait Gallery, Smithsonian Institution; bequest of Katharine Meyer Graham

the exhibition reproduced in the April 1914 issue of *Camera Work*, geometrical forms convey the physical likeness. Comparing it with an Edward Steichen photograph of Meyer [fig. 31], ovoid shapes at the top allude to her broad brow, eyes, and prominent chin. The curved form beneath and long arcs to the right represent her breast and full-length figure in profile, an extreme reduction of his slim, elongated caricatures. Balancing these forms around a central axis gives a classical symmetry to the picture, connoting Meyer's renowned beauty. A particularly complex, abstruse mathematical formula of squared and cubed numbers symbolizes her keen intelligence, while sweeping diagonals leading upward to the right indicate Meyer's dynamic progression through life. A golden-toned paper adds warmth to the crisp geometry of the drawing.[102]

Abstraction in art, as the controversial Armory Show of 1913 had just proved, was still a radical concept in America, and de Zayas had applied it for the first time to portraiture.[103] Most New York critics

were predictably skeptical. "And now Marius de Zayas has got it," wrote one, "quite the worst case on record. By this we mean an attack of the prevailing disease for the fantastically obscure in art." Royal Cortissoz deemed it a "sort of postscript to the freakish side of the recent Armory Show," and called the abstract pictures "the disordered dreams of some Cubist mathematician." Other critics concluded that the whole idea was a joke, an elaborate spoof on cubism and futurism.[104] Arthur Jerome Eddy, however, wrote that de Zayas's portraits were "possibly the most modern expression of the human spirit." And French poet Guillaume Apollinaire noted in the *Paris-Journal* that these caricatures, "employing some very new techniques, are in accord with the art of the most audacious contemporary painters. . . . They are incredibly powerful."[105] De Zayas's abstracts especially intrigued French painter Francis Picabia, with whom he had enjoyed a mutually influential friendship in New York and Paris. Picabia, according to Stieglitz, thought that de Zayas "[had] gone ahead in the way of abstraction, of anyone in Europe or America."[106]

In 1915, Agnes Meyer and de Zayas, together with Paul Haviland, took over the leadership of the avant-garde, starting a proto-dada journal, which they named *291*. The most advanced magazine in America, it featured such radical experiments as de Zayas's "psychotypes" (made in collaboration with Meyer and Katharine Rhoades), fusing verbal and visual form into portraiture. Picabia joined in their venture. Inspired by de Zayas's symbolic representations of personality, he contributed innovative "machine portraits" of his friends. *291*'s twelve issues had a critical impact on American artists and also circulated in Paris, Zurich, and London. Meyer, de Zayas, and Haviland opened the Modern Gallery in 1915, which, though not as commercially successful as they had planned, mounted ground-breaking exhibitions of modern, pre-Columbian, and African art.[107] In later years, the energetic Meyer pursued her varied interests as a reporter, part owner of the *Washington Post*, Chinese art scholar, and promoter of social welfare causes. De Zayas stopped making caricatures around 1915 but continued through his galleries to influence artistic understanding. His picture of Meyer, a radically new concept for portraiture, documents their crucial and still underappreciated roles in the early modernist movement.

W.W.R.

NOTES

94. Agnes E. Meyer, *Out of These Roots* (Boston: Little, Brown, 1953), 68. For biographical sources on de Zayas, see cat. no. 7, n. 75.

95. De Zayas visited a Salon d'Automne exhibition in October 1910 and saw *Nu* by Jean Metzinger. He soon traced the origin of the style to Picasso. The Spanish-speaking de Zayas developed a warm friendship with Picasso (as he did with Stieglitz, and later Picabia). According to de Zayas's son, the two artists once had a square-wheeled bicycle constructed just so they could park it outside a bistro and sketch the reactions of astonished passersby (letter from Rodrigo de Zayas, November 22, 1995, National Portrait Gallery curatorial files).

96. In addition to many essays in *Camera Work*, see "The New Art in Paris," *Forum* 45 (February 1911): 180–88; *A Study of the Modern Evolution of Plastic Form*, coauthored with Paul Haviland (New York: 291, 1913), and *African Negro Art: Its Influence on Modern Art* (New York: Modern Gallery, 1916).

97. Marius de Zayas, "Pablo Picasso," *Camera Work* 34–35 (April–July 1911): 66; de Zayas to Alfred Stieglitz, Stieglitz Papers, Beinecke Library.

98. Marius de Zayas, "How, When, and Why Modern Art Came to New York," with introduction and notes by Naumann, *Arts Magazine*, 114.

99. De Zayas and Haviland, *Study . . . of Plastic Form*, 10; Marius de Zayas, "Caricature: Absolute and Relative," *Camera Work* 46 (April 1914): 19.

100. De Zayas made some additional abstract caricatures in Paris in 1914 for Apollinaire's *Les Soirées de Paris* and in New York in 1915 for the magazine *291* (Bohn, "Abstract Vision of Marius de Zayas," 439).

101. De Zayas, "Caricature: Absolute and Relative," 19–21; first printed without title in *Camera Work* 42–43 (April–July 1913): 20–22. De Zayas's theory of caricature, while highly innovative, was influenced by various European intellectual currents, as several authors have explored. In addition to the ideas of Picasso, Picabia, and Bergson, Wassily Kandinsky's interest in the spiritual essence, Umberto Boccioni's mathematical symbols (see Hyland, *Marius de Zayas*), the dynamism of the futurists, the theories of the symbolists, and positivism (see Bohn, "Abstract Vision of Marius de Zayas"), may all have contributed to de Zayas's thinking. For further analysis of de Zayas's abstract caricatures, see Willard Bohn, Douglas Hyland, and Craig R. Bailey, "The Art of Marius de Zayas," *Arts Magazine* 53 (September 1978): 136–44.

102. The golden-toned paper suggests a familiarity with the charcoals of French symbolist artist Odilon Redon. See Douglas W. Druick et al., *Odilon Redon: Prince of Dreams, 1840–1916* (Chicago: Art Institute of Chicago and Harry N. Abrams, 1994), 110–11, 252.

103. Francis M. Naumann, *New York Dada, 1915–23* (New York: Harry N. Abrams, 1994), 21.

104. The newspaper reviews were reprinted in *Camera Work* 31 (April–July 1913): 51–65.

105. Arthur Jerome Eddy, *Cubists and Post-Impressionism* (Chicago: A. C. McClurg, 1919), 219; Guillaume Apollinaire, *Paris-Journal*, July 8, 1914.

106. Stieglitz to Mr. Schumacher, April 7, 1913, Stieglitz Papers, Beinecke Library. For the collaboration between de Zayas and Picabia, see Bailey, "Art of Marius de Zayas," 144; Bohn, "Abstract Vision of Marius de Zayas," 434–35; Hyland, *Marius de Zayas*, 35–38; and William Agee, "New York Dada, 1910–30," in Hess and Ashbery, eds., *Avant-Garde*, 107–8.

107. De Zayas became director of the Modern Gallery (1915–18), which was supported by Agnes and Eugene Meyer, Haviland, and Picabia. It was succeeded by the De Zayas Gallery (1919–21). During this period de Zayas was a bridge figure between the 291 and dada circles. He became an adviser and good friend of collectors Walter and Louise Arensberg, whose evening salons brought dada artists and intellectuals together. For de Zayas's influence on the dada artists, see also Naumann, *New York Dada*, and Judith Zilczer, "Primitivism and New York Dada," *Arts Magazine* 51 (May 1977): 140–42.

Thornton Wilder
1897–1975

By Reginald Marsh
1898–1954

Charcoal on paper, 48.1 x 31.5 cm (18^{15}/$_{16}$ x 12^{3}/$_{8}$ in.), 1919
Inscription: Reginald Marsh / 1919
Gift of Isabel Wilder
NPG.87.249

In 1919, Thornton Wilder and Reginald Marsh were undergraduates at Yale. Marsh, who was disdainful of Yale's academic art courses, was contributing drawings to the *Yale Record*, the campus humor magazine, and Wilder, often neglecting his course work, was busy writing for the *Yale Literary Magazine* and seeing and reviewing plays. Both belonged to a select group of ten junior-class men known for their wit and humor, the Pundits. (A Pundit was described by one wag as a fellow who was "either clever or has something the matter.")[108] Marsh, already an accomplished illustrator, sketched this forceful and energetic charcoal portrait for his friend and fellow Pundit, "Thorny." It remained in Wilder's family until 1987, when his sister gave it to the National Portrait Gallery.

Thornton Wilder is the only writer to win the Pulitzer Prize both for plays (*Our Town*, 1938; *The Skin of Our Teeth*, 1943) and a novel (*The Bridge of San Luis Rey*, 1928). Often, his writing dealt with quintessential human themes rather than the quotidian details of life. In his later years, Wilder said: "Pride, avarice and envy are in every home. I am not interested in the ephemeral—such subjects as the adulteries of dentists. I am interested in those things that repeat and repeat in the lives of the millions."[109] Although reserved in his private life, Wilder enjoyed getting to know all sorts of people, from prizefighters to avant-garde writers to gangsters. He once noted, "On my grave they will write: 'Here lies a man who tried to be obliging.'"[110] He spent a number of years in teaching positions at the University of Chicago and Harvard, and accepted engagements to lecture whenever royalties from his writings were not sufficient to support his parents and sisters. For the most part, however, his plays, beginning with *Our Town* and including the successful musical *Hello, Dolly!* (a reworking of his play *The Matchmaker*), brought him financial stability and enabled him to spend long periods of time writing other novels and

plays. Wilder received the National Medal for Literature in 1965. When conferring the award, Lady Bird Johnson noted his widespread popularity among Americans: "You have never assumed that realism in writing means a cloying self-pity or a snappish disdain for others. You have written with an understanding, affectionate rapport with your subjects which to me is the hallmark of genuine literature."[111]

Wilder, however, was no populist. Brought up in a strict, upper-middle-class family, he was well educated, well traveled, and fluent in several languages. Such contradictions persisted throughout his life. Although he was quick to say, "I guess I was the only writer of my generation who didn't go to Paris"[112] (a reference to his sometime expatriate contemporaries, such as Ernest Hemingway and others of the "lost generation"), he did visit France, and it was in Paris that he cultivated an important friendship with Gertrude Stein, whom he first met when she lectured at the University of Chicago in 1934. Wilder was greatly influenced by Stein's avant-garde writing and ideas concerning plot and dramatic action—both *Our Town* and *The Skin of Our Teeth* owe a great deal to her influence.

Reginald Marsh, known best today for his superb drawings and illustrations and as a realist painter, focused his talents on the myriad individuals he found on the beaches of Coney Island and in the burlesque houses, movie theaters, subways, and streets of New York in the interwar years. He was raised in affluence, the son of two artists with independent means. His mother encouraged him to draw throughout his childhood, and after graduating from Yale, Marsh moved to New York, where he free-lanced for newspapers and magazines, publishing drawings and cartoons. During the early 1920s he began to study painting at the Art Students League with Kenneth Hayes Miller and joined the Whitney Studio Club, where he met Gertrude Vanderbilt

Reginald Marsh
1 9 1 9

Whitney, who would give him his first one-man show in 1924. Marsh's career path was a successful one, based on voluptuous figure paintings and prints of shop girls, sailors, vaudeville stars—and other, less exuberant and more melancholy images of New Yorkers. As he noted, making a clear distinction between his upbringing and his professional subject matter, "Well-bred people are no fun to paint."[113]

Marsh's portrait of Wilder documents a youthful friendship. It is also a telling example of his developing graphic skill. Wilder and Marsh were among the most talented members of their class at Yale. Both sought acceptance within campus groups and activities that could absorb and nurture their interests. Marsh in 1937 said of his art instruction offered at the university: "I was taught drawing from the antique and painting in still life by the pedants of the Yale Art School in a way that would make their 'old master' heroes turn in their graves. . . . It was all I could do to pass the courses."[114] Instead, he drew constantly and became the star illustrator for the *Yale Record*, where his drawings already possessed the vibrancy found in his later work. As William Benton, Marsh's editor when he drew for the *Record*, noted, "As an undergraduate he drew all the time. When he took the girls out, he drew them. Sometimes he put himself on the sofa beside one of them, only taller & snakier & more in the Brooks Bros. Model. He was short, squat, stocky like a teddy bear."[115] Through this extracurricular work for the *Record*, as well as friendship with Edmund Duffy, a roommate who would later win a Pulitzer Prize for political cartoons, Marsh developed his drawing ability.

At the time this portrait was made, Wilder and Marsh were both young men, slightly uncomfortable with traditional roles, as were many of their generation, and fascinated with new urban cultural expressions. Marsh used a form of portraiture—the quick sketch of a head with a suggestion of the shoulders—associated with nineteenth-century traditions of private portraiture and also with the sorts of portraits created for public consumption in magazines and newspapers. He invested that conventional form with a particular energy that also provides a hint of his future work as an illustrator and painter. The undulating surfaces of Wilder's face, with the carefully modulated shading within the topography of the features, are clearly suggestive of his later graphic productions. The forceful, black lines stroked behind the right side of the head, the dark contours defining the face on the left, and the dark, carefully outlined eyeglasses contribute to the drama

of the portrait. Wilder's elegant countenance—a contrast to Marsh's blunt, ruddy features—is given just a touch of youthful arrogance, particularly through the piercing gaze of the sitter and the slightly distorted undulations of the lips and chin.

Other portrait drawings from Marsh's years at Yale seem not to have survived. This sketch, so casual and yet perfectly studied, is a rare example of Marsh's early work, and an even rarer glimpse of a soon-to-be-famous playwright, playing a role through the auspices of portraiture that he had not yet filled.

B.B.F.

108. See Yale University, *History of the Class of Nineteen Hundred Twenty* [class book], 49. Both men received votes from their classmates for "Most Original"; Wilder also received votes for "Most Scholarly," "Most Entertaining," and "Most Brilliant" (453–54).

109. Quoted in "Thornton Wilder Is Dead at 78; Won 3 Pulitzers for His Work," *New York Times,* December 8, 1975. Other biographies of Wilder include Gilbert A. Harrison, *The Enthusiast: A Life of Thornton Wilder* (New York: Ticknor & Fields, 1983); Richard H. Goldstone, *Thornton Wilder: An Intimate Portrait* (New York: Saturday Review Press/Dutton, 1975); and Linda Simon, *Thornton Wilder: His Work* (Garden City, N.Y.: Doubleday, 1979).

110. Quoted in *New York Times,* December 8, 1975.

111. Lady Bird Johnson quoted in ibid.

112. Quoted in *Dictionary of Literary Biography,* s.v. "Wilder, Thornton," by Warren French. Vol. 4, *American Writers in Paris, 1920–1939,* ed. Karen Lane Rood, 414.

113. Quoted in *Dictionary of American Biography,* s.v. "Marsh, Reginald," supplement 5, 472.

114. Quoted by Lloyd Goodrich [a childhood friend of Marsh's], *Reginald Marsh* (New York: Harry N. Abrams, 1972), 20. On Marsh's early career, see also *Reginald Marsh: A Retrospective Exhibition* (Newport Beach, Calif.: Newport Harbor Museum, 1972) and Marilyn Cohen, *Reginald Marsh's New York* (New York: Whitney Museum of American Art and Dover Publications, 1983).

115. William Benton, "Reginald Marsh As I Remember Him," interview, 1955, microfilm reel 3134, William Benton Papers, AAA.

RING LARDNER
1885–1933

BY JAMES MONTGOMERY FLAGG
1877–1960

Pencil on bristol board, 33.2 x 25.5 cm (13^{1}/$_{16}$ x 10^{1}/$_{16}$ in.), circa 1922
Inscription: RING LARDNER / JAMES MONTGOMERY FLAGG
Gift of Ring Lardner Jr.
NPG.76.26

Described as a "professional humorist who sometimes smiled but almost never laughed," Ring Lardner remains a paradoxical figure who is difficult to pin down. "He is unspeakably funny," wrote one reviewer in 1925, "but there is an underlying vein of deep and poignant irony in his lightest writing which puts it far beyond the realm of the merely amusing."[116] James Montgomery Flagg's pencil portrait, which appeared in an advertisement for the writer's comic strip, "You Know Me, Al," in 1922 and later, in the artist's 1951 book *Celebrities: A Half-Century of Caricature and Portraiture*, evokes what Dorothy Parker called Lardner's "strange bitter pity." The disjunction between Lardner's sense of humor and his demeanor made an impression on Flagg, who noted Lardner's "very sad and dead-pan" face but affirmed that it revealed little of the satirist's true nature: "Ring looked like 'Lo, the Poor Indian [but was, of course] very different inside."[117]

Born into wealth in Niles, Michigan, Lardner was slow to find his calling. After dropping out of college and running through a string of odd jobs, he became a reporter in 1905 for the *South Bend Times*. From there, Lardner moved on to editorial and reporting positions at the *Chicago Inter-Ocean*, the *Chicago Examiner*, the *Sporting News* in Saint Louis, the *Boston American*, and the *Chicago Tribune*. Primarily a sportswriter, Lardner traveled with the Chicago Cubs and the White Sox between 1908 and 1913, initiating friendships with the players and picking up their way of speaking. This would serve him well when he was given his own daily column in the *Tribune* in 1913, "In the Wake of the News." Taking advantage of this intense and lucrative exper-ience to explore a range of literary forms, Lardner injected some of the talk he had learned on the ball field into his writing, perfecting the epistolary, idiomatic prose for which he is best known.

Rife with misspellings, malapropisms, and the braggadocio that was ostensibly characteristic of a small-town ball player turned big-leaguer, Lardner's "Busher's Letters" impressed George Horace Lorimer of the *Saturday Evening Post*, who published them in his magazine for four years beginning in 1914. Written by the fictional rookie White Sox player Jack Keefe to his friend Al Blanchard back home in Bedford, Indiana, the "Busher's Letters" endeared Lardner to readers hungry for an "insider's scoop" of the baseball world. Instead of deifying his players, Lardner humanized them, demonstrating what was becoming a growing trend among sportswriters generally in the 1920s. His Jack Keefe was less than role-model material; he frequently lied, performed poorly, and was quick to place blame on others for his own mistakes. Keefe nonetheless had a kind of simple charm, mostly because he was so real. "I try to write about people as real as possible," Lardner once told a friend. "[S]ome of them are naturally more likeable than others."[118]

The "Busher's Letters" made Lardner famous. Carl Van Doren called him the master of the "vernacular of the low-brows," and Virginia Woolf lauded his prose as "the best . . . that has come our way."[119] The series was published in three volumes from 1916 to 1919, the first of which, *You Know Me, Al* gave rise to the popular comic strip of 1922. Circulated to a nationwide audience by the Bell Syndicate, for which Lardner had moved to New York to write a "Weekly Letter" in 1919, the comic strip featured the writing of Lardner and the drawings of Dick Dorgan six days a week.

Although the venture brought Lardner a sizable income, it brought him little satisfaction. As Donald Elder has noted, "The comic strip was not his medium, he felt that what he was doing was flat and insipid, and he could not find enough ideas for a daily strip."[120] He gave up writing for it in 1924, the year *How to Write Short Stories*—the collection that transformed him into a major literary voice—was published. His work turned more dark and cynical

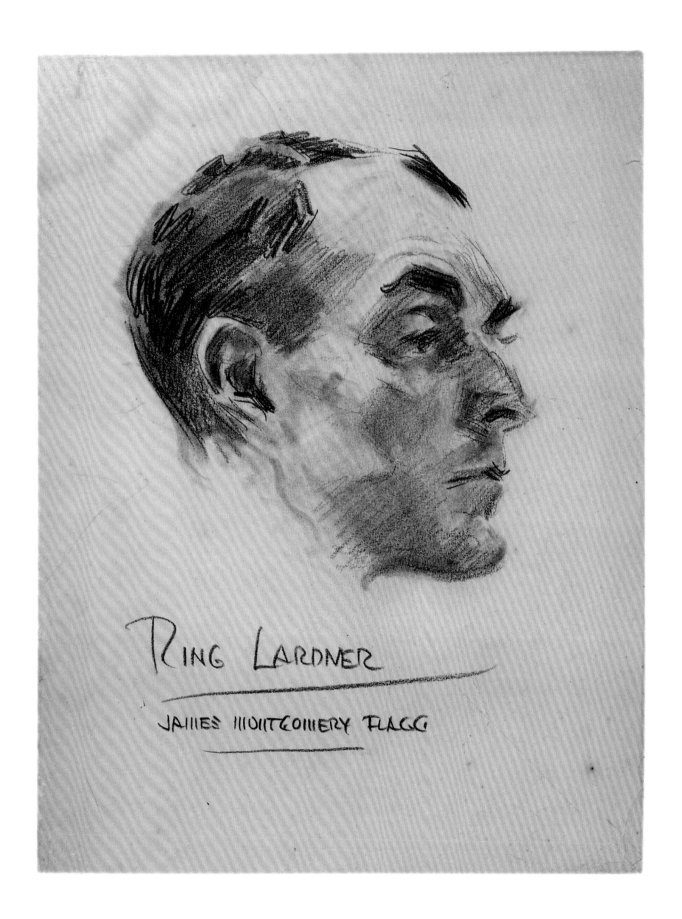

RING LARDNER

JAMES MONTGOMERY FLAGG

thereafter until his death at forty-eight in 1933. In his brief career, Lardner wrote more than 120 short stories, a number of plays, and hundreds of newspaper and magazine columns.

James Montgomery Flagg drew Lardner's portrait around the time that Lardner was approaching the height of his fame. A native New Yorker and chronicler of urban life, Flagg moved in the circles of New York's well-knowns, himself "headline copy" for most of his life. A precocious draftsman, he sold his first illustration at the age of twelve and became a regular member of the staff of *Life* magazine by the

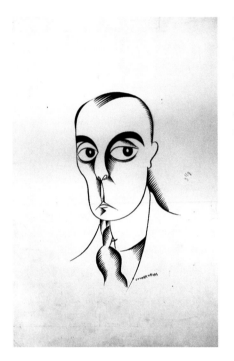

Fig. 32. *Ring Lardner* (1885–1933) by Miguel Covarrubias (1904–1957). India ink on paper, 1925. Original illustration for *Vanity Fair*, July 1925. Prints and Photographs Division, Library of Congress, Washington, D.C.

age of fourteen. He worked for all the major publications of his day—*Cosmopolitan, Good Housekeeping, Harper's Weekly*, and others— illustrating stories, designing covers, and popularizing his buxom "Flagg girl." The artist made his most substantial contribution to the arts in America during World War I with his "I Want You" poster depicting a stern Uncle Sam entreating citizens to join the armed forces. Four million copies of the poster were distributed, and it remains today the most widely known image of the period and perhaps of popular art in general.[121]

Disdainful of mechanical shortcuts, Flagg drew only from life, and only drew persons he found interesting; if approached to draw someone's portrait, the curmudgeonly artist would refuse. The Portrait Gallery's portrait was most likely, therefore, not commissioned by Lardner. Because the artist often

gave his portrait drawings to his famous sitters, Lardner undoubtedly had it in his possession and suggested that it be published as an accompaniment to his comic strip in 1922.[122]

Flagg's contemporaries praised his pencil portraits for their spontaneity and remarkable insight into his sitters' characters. "I know of no one who gets more color in black and white than does James Montgomery Flagg," wrote one commentator in the brochure for the artist's 1934 exhibition of his portrait drawings. "He has an insight into character that should be, and is, the envy of painters who have devoted their lives to portrait painting."[123] In this drawing of Lardner, Flagg exploited the properties of pencil with an impressive economy of means. First modeling the facial structure through ghostly strokes of rubbed graphite, Flagg added definition to areas such as the nose and chin through light shading with the pencil's tip. Darker, thicker lines define the writer's thin, downturned lips, eyebrows, and the crevices of his ear. His receding hairline is likewise sharply delineated, with patches—some composed of light, thin strokes, others of darker, broader lines— describing the hair on his crown.

Flagg's portrait is a striking likeness of the middle-aged Lardner, whose invariably solemn expression and heavy-lidded "owl eyes" were caricatured by Margaret Freeman in her illustrations for Lardner's mock autobiography, *The Story of a Wonder Man* (1927) and by Miguel Covarrubias in a 1925 issue of *Vanity Fair* [fig. 32].[124] Lardner's hard mouth and sharp, angular features hint at the terseness of the man who was known to be close lipped except when he was drinking. His half-closed eyes seem to cast their glance with circumspection, his expression reflecting a measure of the haughty disdain and cynicism that seeps through in his later work. Whether misunderstood or not, Lardner invariably wore this straight-faced "mask over his emotions," as his son put it.[125] Yet under this veneer was an unfailing sense of humor that injected sportswriting with a linguistic playfulness worthy of the game of sport itself.

J.A.G.

EYE CONTACT

116. Otto Friedrich, "Ring Lardner" in *American Writers: A Collection of Literary Biographies*, vol. 2, ed. Leonard Unger (New York: Charles Scribner's Sons, 1974), 418; *New York Times Book Review,* April 19, 1925, in *Dictionary of Literary Biography,* s.v. "Lardner, Ring" by Elizabeth Evans. Vol. 11, *American Humorists, 1800–1950,* ed. Stanley Trachtenberg, 243.

117. Quoted in *Dictionary of Literary Biography,* s.v. "Lardner, Ring" by Michael Oriard. Vol. 86, *American Short-Story Writers, 1910–1945,* 1st series, ed. Bobby Ellen Kimbel, 178; James Montgomery Flagg, *Celebrities: A Half-Century of Caricature and Portraiture with Comments by the Artist* (Watkins Glen, N.Y.: Century House, 1951), 48.

118. Quoted in *Dictionary of Literary Biography,* 246.

119. Carl Van Doren, *Many Minds* (New York: Alfred A. Knopf, 1926), 167, 176; quoted in Donald Elder, *Ring Lardner* (Garden City, N.Y.: Doubleday, 1956), 120.

120. Elder, *Ring Lardner,* 177.

121. For more biographical details on Flagg, see *American National Biography,* s.v. "Flagg, James Montgomery," by Robert L. Gale, ed. John A. Garraty and Mark C. Carnes, 73–74; Susan E. Meyer, *James Montgomery Flagg: A Portrait of America* (New York: Watson-Guptill, 1974); and James Montgomery Flagg, *Roses and Buckshot* (New York: G. P. Putnam's Sons, 1946).

122. Flagg, in fact, gave most of his celebrity portraits—collected in *The Well-Knowns* in 1914 and *Celebrities: A Half-Century of Caricature and Portraiture* in 1951—to his sitters, who often matched his generosity by giving them back or allowing him to borrow them for publication or exhibition. That practice might explain the inscription that was added to Lardner's portrait when it appeared in *Celebrities.* "With thanks from"

appears in cursive above "Ring Lardner" and "to" appears before the signature of the artist. Since the drawing itself, which was given to the Portrait Gallery by Ring Lardner Jr., shows no sign of the added inscription or any marks from erasure, it could be that Lardner added the inscription to a photographic reproduction that he gave to Flagg for future reproductions.

123. Leon Gordon, quoted in *Pencil Portraits by James Montgomery Flagg* (New York: Pach Bros., 1934). Brochure for an exhibition, October 30–November 10, 1934, National Portrait Gallery drawings curatorial files.

124. Ring Lardner, *The Story of a Wonder Man: Being the Autobiography of Ring Lardner* (1927; reprint, Westport, Conn.: Greenwood Press, 1975).

125. Evans writes that Lardner was "shy even with his own children, a writer who was usually taciturn unless he had been drinking." She quotes Lardner's son, Ring Lardner Jr., as saying that his father was "uneasy in crowds with a mask over his emotions and a deep-seated mistrust of face values, a cynic who felt that if something could be faked it probably was." One month before he died, however, in response to Clifton Fadiman's assertion that "no other writer has gone farther on hatred alone," Lardner wrote a friend that he was misunderstood: "I cannot remember ever having felt any bitterness or hatred toward the characters I have written about" (quoted in Evans, Lardner entry, *Dictionary of Literary Biography,* 244, 255, 246).

EDNA ST. VINCENT MILLAY
1892–1950

BY WILLIAM ZORACH
1887–1966

Ink, charcoal, and colored pencil on paper, 61.6 x 47.2 cm (24^{1}/$_{4}$ x 18^{1}/$_{2}$ in.), circa 1923
NPG.97.151

William Zorach's portrait of Edna St. Vincent Millay was published, with the image reversed, in the *Century* magazine for June 1923. It accompanied a laudatory article by Carl Van Doren on Millay's poetry, which had just earned her the Pulitzer Prize in May.[126] Zorach, who is best known today as a sculptor, had established his artistic reputation with works on canvas and on paper before making the transition to sculpture just at this time. He met Millay around 1917 or 1918, when both were working with the Provincetown Players in Greenwich Village. Zorach succeeded in conveying Millay's tiny frame and hands, her lovely features, and pensive, intelligent gaze. He hints at her unconventional, dramatic appearance through the subtly provocative opening of her loose jacket and at the intensity and charisma of her personality. Others described her in similar terms—a pale, tiny girl with bright-red bobbed hair and sea-green eyes who dominated her surroundings. Journalist Dorothy Thompson characterized her in 1922, when they were in Europe together:

> She was a little bitch, a genius, a cross between a gamin and an angel. In Budapest she had two lovers . . . both from the embassy. Keeping them apart was a *kunst*, an art. And we sharing a room. . . . She sat before the glass and combed her lovely hair, over and over. Narcissan. She really never loved anyone except herself. Very beautiful, with her little white body and her green-gold eyes. "Dotty, do you think I am a nymphomaniac?" she asked. Then she comes in a Grecian robe and reads aloud to the Ladies Club, "Such lips my lips have kissed. . . . " And what a sonnet that one was.[127]

Millay, who was born and raised in Maine, was the oldest of three sisters. Her mother, Cora, divorced their father in 1900 and supported her girls by nursing. Millay's musical talents were recognized during her childhood, and her ability with language emerged soon thereafter. In 1912 her long poem "Renascence" was selected for publication in an

anthology called *The Lyric Year*, and when published, received immediate critical acclaim. One admirer of Millay's youthful talent, Caroline B. Dow, immediately took her up, and arranged for Millay to come to New York to take classes at Barnard College in preparation for entering Vassar in the fall of 1913. At Vassar she studied literature, ancient and modern languages, and drama; she published in the college's *Miscellany* and participated in school plays, including her own production, *The Princess Marries the Page*.

The next decade was one of great literary accomplishment and enormous personal experimentation for Millay. After graduating from Vassar in 1917, Edna (or "Vincent," as she was known to family and friends) and her sister Norma moved to Greenwich Village, where they joined a bohemian group of struggling artists, writers, and reformers that included John Reed, Max Eastman, Eugene O'Neill, and Floyd Dell (editor of the *Masses*). Millay acted in productions with the Provincetown Players and wrote one play for the troupe, *Aria da Capo*. An ardent feminist, Millay wrote of her adventures in poems published in 1920 as *A Few Figs from Thistles*.[128] One of the verses for which Millay was most famous, "First Fig," was in this collection:

> My candle burns at both ends;
> It will not last the night;
> But ah, my foes, and oh, my friends—
> It gives a lovely light!

These poems, together with the increasing fame of "Renascence," and the publication of other verses in *Vanity Fair*, made Millay one of the most widely read poets of her generation. In May 1923 she was awarded the Pulitzer Prize for poetry. In Van Doren's article, illustrated by Zorach's drawing, he praises her for the "candor with which she talks of love. . . . She speaks with the voice of women, who, like men, are thrilled by the beauty of their lovers and are stung

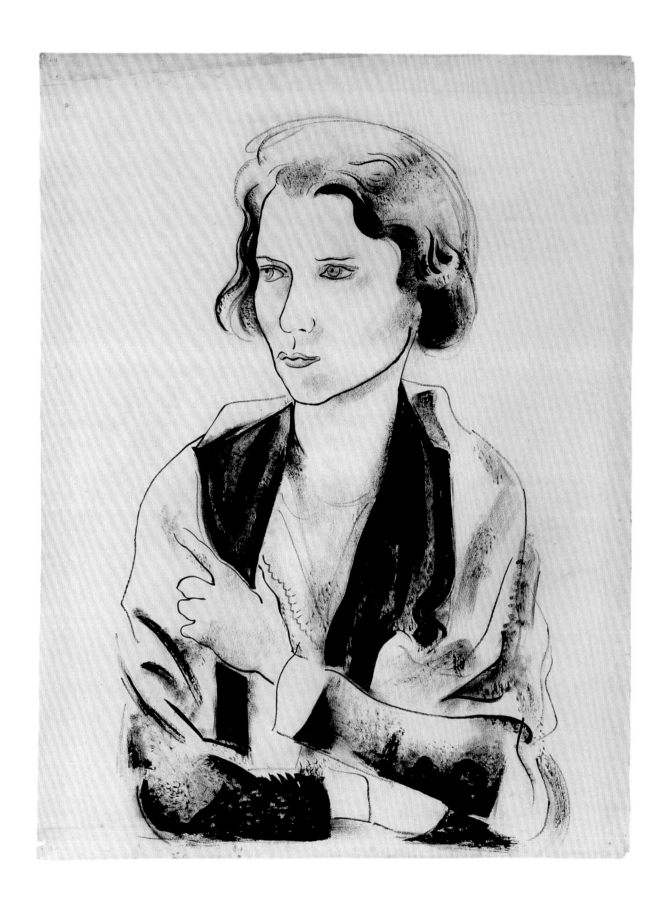

93

by desire." Just a few months earlier, after returning to New York from almost two years in Europe (funded in part by writing assignments for *Vanity Fair*), she was paired by chance with an acquaintance, Eugen Boissevain, in a game of charades. As Floyd Dell told it, "[They] had the part of two lovers. . . . They acted their parts wonderfully—so remarkably, indeed, that it was apparent to us all that it wasn't just acting. We were having the unusual privilege of seeing a man and a girl fall in love with each other violently and in public."[129] They married three months later. Boissevain was older, well-to-do, and more than willing to look after Millay. And she needed it. She suffered from long periods of ill health during their marriage and, later in life, addiction to drugs and alcohol. In 1925 they purchased a farm in Austerlitz, New York, which served as their home for the rest of their lives.

Millay's reputation continued to grow during the 1920s and 1930s, and she published major works, including a libretto for an opera, *The King's Henchman*, and several collections of poems—*The Harp-Weaver and Other Poems* (1923), *Fatal Interview: Sonnets* (1931), and *Wine from These Grapes* (1934). She died, after a fall, in October 1950, a little more than a year after her husband.[130]

William Zorach's portrait of Millay marked a period of intense creativity for both artist and sitter. Although Zorach continued to do drawings and some watercolors, he gave up painting in oils for sculpture in 1922. Born in Lithuania, he had immigrated to Ohio as a child. At thirteen, he left school and worked in factories and machine shops to help support his family. His drawing abilities, however, soon led him to work with a lithography firm. In 1908 he left Cleveland for New York, determined to be an artist, and studied at the National Academy of Design and the Art Students League. In 1909 he was able to travel to Paris. There, he worked in the conservative atelier of Jacques-Émile Blanche, but he encountered, too, some of the most avant-garde work being done in France. He also met Marguerite Thompson, a fellow artist, whom he would later marry.

In 1912, after returning to New York, William Zorach lived and worked in Greenwich Village for many years. He and his wife created sets for the Provincetown Players, first in Provincetown, Massachusetts, and later in New York. Zorach acted in some of the productions. It was through the players that he met Millay: "Most of the plays were written by the players themselves and almost everyone did some acting. Edna St. Vincent Millay and I could put on a real show at the first reading of

a play if it was one that appealed to us." Zorach also noted, in his autobiography, that he had made drawings of Millay and Eugene O'Neill (who was also involved with the players) and described Millay:

> Edna was quite a personality; a tiny little female, self-centered, adventurous where men were concerned, flirtatious and gay. A poet and not a playwright nor an actress, except in real life. In a group she was always a dominant personality. She was a prima donna who never kept an appointment, was never on time, and made everyone wait on her.[131]

Zorach actually made two portraits of Millay: this one, and another, dated to 1925 and now in the collections of the Museum of the City of New York. He also made a drawing of Millay's sister, Norma. The Portrait Gallery's drawing is the most artful. Through its sure, precise outlines and dramatic use of dark ink, Zorach evokes the economy of line found in drawings by Henri Matisse or Amedeo Modigliani and an almost oriental elegance. The essential contours of Millay's features and form are rendered with charcoal and black ink, with a thin line of yellow-colored pencil used to define her clothing. A few smudges of charcoal add volume to the essential flatness of her face, while ink and charcoal lines, with areas of deep black, create her wavy, bobbed coiffure. A subtle elongation enhances the elegance of the drawing and the general effect of introspection. Zorach's depiction calls up images of writers from centuries past—Alexander Pope, or Denis Diderot, clad in loose robes, filled with inspiration. Millay is transformed by Zorach's art from a gay, brilliant, free spirit of Greenwich Village in a fashionably unstructured suit into a female scholar and literary genius. The portrait allows us to see her in both roles.

B.B.F.

126. Carl Van Doren, "Youth and Wings, Edna St. Vincent Millay: Singer," *Century Illustrated Monthly Magazine* 106 (June 1923): 310–16.

127. Quoted in Nancy Milford, *Savage Beauty: The Life of Edna St. Vincent Millay* (New York: Random House, 2001), 228.

128. See ibid., 143–201. See, too, *Dictionary of Literary Biography*, s.v. "Millay, Edna St. Vincent" by Paula L. Hart. Vol. 45, *American Poets, 1880–1945*, 264–76.

129. Quoted in Milford, *Savage Beauty*, 250.

130. Milford's new biography, *Savage Beauty*, provides a full account of Millay's life and should be consulted especially for information about Millay's later life. See also, Anne Cheney, *Millay in Greenwich Village* (Tuscaloosa: University of Alabama Press, 1975); and Allan Ross Macdougall, ed., *Letters of Edna St. Vincent Millay* (Westport, Conn.: Greenwood Press, 1952).

131. William Zorach, *Art Is My Life: The Autobiography of William Zorach* (Cleveland and New York: World Publishing, 1967), 46, 47.

HART CRANE
1899–1932

BY GASTON LACHAISE
1882–1935

Graphite on paper, 48.3 x 30.8 cm (19 x 12⅛ in.), circa 1923
Inscription: G. Lachaise, to Hart Crane
Gift of the Lachaise Foundation
NPG.91.46

Gaston Lachaise's pencil portrait depicting Hart Crane dancing nude, clapping his hands above his head, evokes the exuberant side of the poet's personality. Crane, according to his close friend Samuel Loveman, "was the most wonderful companion, full of fun, filled with life, and at no time morbid. He had an annihilating sense of humor."[132] Born and raised in Cleveland, Ohio, Crane had moved to New York to pursue his writing while working various office jobs. He became famous for such enigmatic poems as "The Bridge," a long ode to the Brooklyn Bridge that drew heavily on mythological and historical references. Although his friends enjoyed his fun-loving nature, Crane had a dark side as well. Lonely, harassed as a homosexual, addicted to alcohol, and often insecure in his personal relationships, he battled with depression throughout his life. In 1932, Crane committed suicide by jumping off a ship.

Gaston Lachaise befriended Crane in New York in 1923, at a time when both artist and poet were contributing to the avant-garde arts journal the *Dial*.[133] Lachaise and his wife, Isabel, also encountered Crane at the artists' colony in Woodstock, New York, and became friends with the often-troubled poet.[134] Tormented by his struggle to create while making a living, Crane seemed heartened by Lachaise's success. Born and trained in Paris, Lachaise had immigrated to Boston in 1906, and in 1913 he moved to New York to work for sculptor Paul Manship.[135] There he became one of the most respected modern sculptors of the 1920s, noted especially for his figure sculpture—mainly robust female nudes. He also sculpted busts of prominent personalities such as e. e. cummings, Marianne Moore, and Lincoln Kirstein, which were reproduced in the *Dial*.

Upon returning to New York from Woodstock in January 1924, Crane wrote to the Lachaises, enclosing his poem "Interludium," which was dedicated to Lachaise's *La Montagne*, a sculpture of a reclining woman that Crane had perhaps first seen in the *Dial*'s 1923 portfolio, *Living Art*.[136] The poem described Crane's very personal reaction to the image:

. . . And blithe
Madonna, natal to thy yielding still
subsist I, wondrous as
from thy open dugs shall still the sun
again round one more fairest day.

Like a nursing child, the poem suggests, Crane drew sustenance from the artist's maternal creation. R. W. Butterfield interprets "Interludium" as celebrating not merely *La Montagne* as a work of art but the creation of life and man's participation in his own renewal. In the closing of the letter, Crane exalts the Lachaises: "Especially do I send it—because I feel it had its first thought in the dance of music, flesh and stone wherein you live always—you two!"[137]

Dance is also the dominant action of Lachaise's drawing of Crane. The artist constructed the figure using segments of calligraphic line of slightly varying width. He applied the line sparingly to mark a decisive boundary, emphasizing the subject's contour. The left arm is the only portion of the body where the boundary is drawn twice. The neat juxtaposition of line segments suggests a calculated study rather than a rapid sketch, although Lachaise desired the appearance of spontaneity in his drawing. Kirstein once described these qualities in the artist's drawing:

Though entirely in outline and very much the work of a sculptor as opposed to that of a painter, the drawings are in no way studies for sculpture. They are independent expressions in their own medium; swift, exuberant, economical and bold. They show his gifts of imaginative metamorphosis, his profound under-standing of the articulation, motive processes and capacities of the human body.[138]

The Portrait Gallery's drawing may be the first

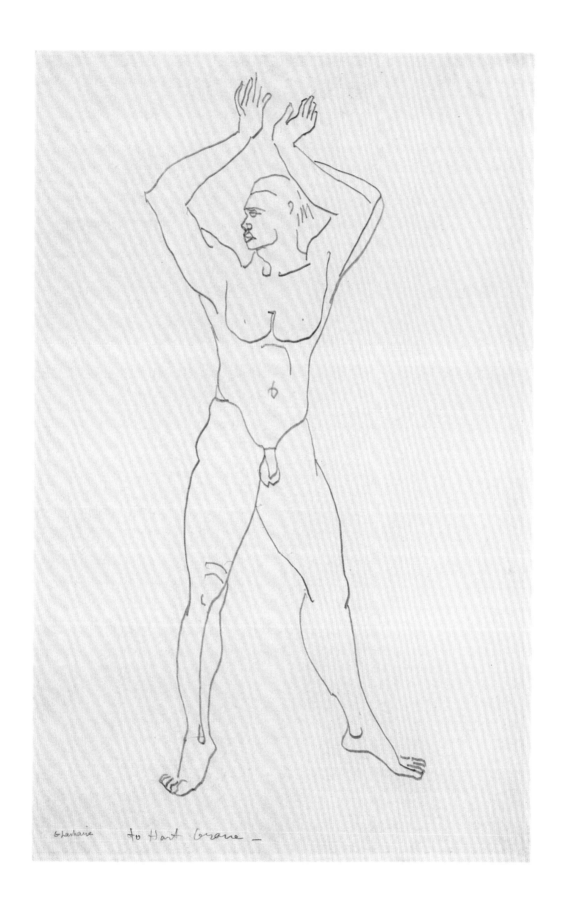

Gberhare to Hart Crane —

that Lachaise did of the male nude. Although Lachaise commented in 1928 that he "did not know and love the male figure as I do the woman," he sculpted between 1927 and 1933 no fewer than six monumental male nudes and sometimes used a pose similar to this drawing [fig. 33].[139] Lachaise shows the sitter's upper body in a nearly frontal position: the legs are shown at a slight angle, with the left leg extended outward, revealing the inner thigh and calf. The figure appears to balance his weight upon the balls of his feet, while twisting his upper body toward his right and twisting his head in profile. This

Fig. 33. *Man* by Gaston Lachaise (1882–1935). Bronze, 1930–34. Chrysler Museum of Art, Norfolk, Virginia; gift of Walter P. Chrysler Jr.

splayed-leg pose appears in several variations in Lachaise's drawings of the male nude.[140] A second, unlocated, drawing of Crane shows an almost identical stance. The facial features in the two drawings are quite similar, although in the unlocated drawing, the hairline is lower and the ear placed closer to the face. A 1928 bronze nude portrait of Gregory Slader as a baseball player shows him with legs splayed, torso turned slightly to one side, and head in profile.[141]

The enlarged thighs and articulated musculature of this drawing and the above-mentioned figures appear to be based on Greek Archaic *kouroi*, sculptures of male youths, upon which Lachaise modeled many of his male nudes.[142] The line down the middle of the right lower leg and the iliac lines of the groin mimic the sculpted lines of the New York

Kouros in the collection of the Metropolitan Museum of Art. Many of Lachaise's male nude figures possess an almost Archaic face—their slanted eyebrows, elliptical mouth, and U-shaped nose differ greatly from the heavy brow and full lips of the Crane portrait. In this drawing, the face clearly specifies an individual.

The identity of the sitter as Hart Crane and date of the drawing are supported by a letter of December 30, 1923, in which Crane describes Christmas revelries in Woodstock, which Gaston and Isabel Lachaise attended. Crane was staying at the home of friends Slater Brown (a writer) and Edwin Nagle (Isabel's son, a painter).[143] "I'm the acknowledged crack dancer everywhere now," Crane wrote, "and was even in danger for a while, of having to pose quite nude for Lachaise, which would have been rather tiresome I imagine."[144]

Many similarities exist between the facial features in this drawing and those in portrait drawings and photographs securely identified as Crane. Crane's prominent brow, full lips, and hair combed away from the forehead, so emphasized in the Lachaise portrait, are also depicted in drawings by William Sommer and by William Lescaze. Crane's profile, pronounced jawline, and sloping forehead in a 1929 photograph by Man Ray bear a striking resemblance to the head in Lachaise's drawing.[145] Whether the body accurately reflects Crane's physique is open to question. One wonders whether the body's musculature is the artist's exaggeration, and perhaps a comment on Crane's self-image. A friend once noted that, owing to the wood-chopping and the other chores undertaken during his visit, Crane "prided himself on his appearance of masculinity." Crane wrote from Woodstock, "My muscles are swelling and my blood simply glowing."[146]

The drawing remained in Lachaise's possession, perhaps kept for no other reason but that it was a reminder of his friendship with Crane. The poet's own words, written in a letter of January 12, 1924, asserting his resolve to create art, could also apply to Lachaise's drawing:

—try to imagine working for the pure love of simply making something beautiful— something that maybe can't be sold or used to help sell anything else, but that is simply a communication between man and man, a bond of understanding and human enlightenment— which is what a real work of art is.[147]

E.M.T.

132. Samuel Loveman, *Hart Crane: A Conversation with Samuel Loveman* (New York: Interim Books, 1964), 19.

133. Paul Mariani, *The Broken Tower: A Life of Hart Crane* (New York: W. W. Norton, 1999), 127. Crane's first contribution to the *Dial* was "My Grandmother's Love Letters," published in the April 1920 issue. See Nicholas Joost, *Scofield Thayer and "The Dial": An Illustrated History* (Carbondale: Southern Illinois University Press, 1964), 250–51. Lachaise's sculpture *Woman's Head* (1923, Whitney Museum of American Art, New York) appeared in the March 1923 issue of the *Dial*.

134. For an account of an incident illustrating Crane's friendship with the Lachaises, see Brom Weber, *Hart Crane: A Biographical and Critical Study: Corrected Edition* (1948; New York: Russell & Russell, 1970), 210–11.

135. Lincoln Kirstein, introduction to *Gaston Lachaise: Retrospective Exhibition* (New York: Museum of Modern Art, 1935), 7–11.

136. Carolyn Kinder Carr and Margaret C. S. Christman, *Gaston Lachaise: Portrait Sculpture* (Washington, D.C.: National Portrait Gallery, Smithsonian Institution, and Smithsonian Institution Press, 1985), 10. The letter from Hart Crane to Mr. and Mrs. Gaston Lachaise, dated January 9, 1924, is reproduced in Brom Weber, ed., *The Letters of Hart Crane, 1916–1932* (Berkeley: University of California Press, 1965), 166. The sculpture *La Montagne* was reproduced in the March 1921 issue of *Dial*. Perhaps Crane, who by that time was a contributor to the magazine, first saw Lachaise's sculpture in this edition. The poet e. e. cummings devoted several pages to discussion of it in an essay (cummings, "Gaston Lachaise," *Dial* 68 [February 1920]: 194–204).

137. Hart Crane, "Interludium," *1924* (July 1924), in Weber, *Hart Crane,*

393–94; R. W. Butterfield, *The Broken Arc: A Study of Hart Crane* (Edinburgh: Oliver & Boyd, 1969), 77–78; Hart Crane to Mr. and Mrs. Gaston Lachaise, January 9, 1924.

138. Kirstein, introduction to *Lachaise: Retrospective Exhibition,* 12. Gerald Nordland writes of Lachaise's early approach to drawing, "Lachaise retained a romantic notion of drawing throughout his life. He required a look of spontaneity and direction. If it didn't succeed it could always be discarded" (Nordland, introduction to *Gaston Lachaise (1882–1935): Sculpture and Drawings* [Los Angeles: Los Angeles County Museum of Art, 1964], 16).

139. Carr and Christman, *Lachaise,* 20; Gaston to Isabel Lachaise, 1928, in Gerald Nordland, *Gaston Lachaise: The Man and His Work* (New York: George Braziller, 1974), 41.

140. Male nude drawings are reproduced in several publications: an unillustrated 1928 work (owned at the time by the Lachaise Foundation, and possibly the Portrait Gallery's Crane image) in *Gaston Lachaise: Sculptures and Drawings* (Portland, Maine: Portland Museum of Art, 1984), cat. no. 90; a 1931 pencil sketch (present location unknown) in *Gaston Lachaise, 1882–1935: Sculpture and Drawings* (Los Angeles: Felix Landau Gallery, 1965), n.p.; another 1931 drawing (estate of Isabel Lachaise) in *Lachaise (1882–1935): Sculpture and Drawings* (Los Angeles, 1964), cat. no. 144; and an undated three-quarter-length figure (Hirshhorn Museum and Sculpture Garden, Smithsonian Institution, Washington, D.C.) in *Lachaise: Retrospective Exhibition,* cat. no. 65.

141. The unlocated drawing, last known to be in the Metropolitan Museum of Art, New York, is reproduced in Loveman, *Hart Crane,* 22. For the Slader piece, see Carr and Christman, *Lachaise,* 123. In 1985 it was owned by the estate of Lucy P. Slader.

142 . In the catalogue of a 1982 exhibition celebrating the centennial

of Lachaise's birth, Herschel B. Chipp writes of the artist's portrayal of the male nude, "So much was the nude female figure central to Lachaise's feeling and thought that his few sculptures of males suffer by comparison. They are usually standing, and one is almost certainly inspired by the Archaic Greek *kouroi* he had seen in the Metropolitan Museum of Art during his many visits to the antiquities collections." See *Gaston Lachaise: 100th Anniversary Exhibition: Sculpture and Drawings* (Palm Springs, Calif.: Palm Springs Desert Museum, 1982), 26.

143. John Unterecker, *Voyager: A Life of Hart Crane* (New York: Farrar, Strauss, and Giroux, 1969), 321–42, and Mariani, *Broken Tower,* 137–47. See also Weber, *Hart Crane,* 210.

144. Crane to Grace Hart Crane and Elizabeth Belden Hart, December 30, 1923, in Thomas S. W. Lewis, ed., *Letters of Hart Crane and His Family* (New York: Columbia University Press, 1974), 245–46.

145. The Sommer drawing dates to circa 1921–22. See "A Drawing of Crane by William Sommer," *Hart Crane Newsletter* 1 (Winter 1977): 31–33. Lescaze's drawing dates to 1921. See Langdon Hammer, "Sex and the City," review of *The Broken Tower: A Life of Hart Crane* by Paul Mariani, *New York Times Book Review,* July 18, 1999. The Man Ray photograph originally appeared in the September 1929 edition of *Vanity Fair.* It is reproduced in Vivian H. Pemberton, "The Composition of 'The Broken Tower,'" *Hart Crane Newsletter* 2 (Spring 1979): 5.

146. Loveman, *Hart Crane,* 21; Crane to Grace Hart Crane and Elizabeth Belden Hart, November 8, 1923, in Unterecker, *Voyager,* 328.

147. Crane to his father, Clarence Arthur Crane, January 12, 1924, in Weber, ed., *Letters of Hart Crane,* 170.

EVA LE GALLIENNE
1899–1991

BY MIGUEL COVARRUBIAS
1904–1957

Ink, gouache, and watercolor over graphite on paperboard, 38.1 x 25.4 cm (15 x 10 in.), circa 1923
Inscription: Covarrubias
NPG.96.66

When eighteen-year-old Mexican artist Miguel Covarrubias arrived in New York City in 1923, his youth belied his experience. He was already a syndicated caricaturist and a budding collector who had organized exhibitions of Mexican art and crafts. A well-liked prodigy, he had haunted Mexico City's theaters and cafés, meeting leading actors, artists, and intellectuals. Distinguished poet José Juan Tablada thought enough of the young man to recommend him for a government grant to travel to New York. In September 1923, soon after Covarrubias's arrival, popular novelist and critic Carl Van Vechten was asked to take a look at his drawings. "I was immediately convinced," Van Vechten wrote in a preface to the artist's first book of drawings, "that I stood in the presence of an amazing talent, if not, indeed, genius." Van Vechten knew everyone in New York's smart set and spent the afternoon on the telephone making appointments for Covarrubias with all the notables of the day.[148] One of the celebrity figures on his list was the young British-born actress Eva Le Gallienne, the subject of this drawing.

Not yet twenty-five, this brainy daughter of a British poet and a Danish journalist opened in October as Princess Alexandra in Ferenc Molnár's *The Swan*. Opening night produced a standing ovation, and the play began to break the theater's records for advance sales.[149] "Her strange beauty, her stranger repression, have never been so well matched by a part," wrote a critic for *Vogue*. Commentators recognized as well her cerebral style and extraordinary technique, honed by such role models as Eleonora Duse, Sarah Bernhardt, and Ethel Barrymore. In his drawing, Covarrubias featured not only Le Gallienne's heart-shaped face and swanlike neck but also the symbolically prominent forehead described by Ada Patterson in *Theatre* magazine. The "jutting brow," Patterson had noted, "is curiously high, remarkably broad, extraordinarily full. It is crammed with brains, which she uses." Within a few

years Le Gallienne would turn her talents away from Broadway, becoming a lifelong advocate of nonprofit repertory theater. Over the course of a long career of touring, teaching, and directing, she became one of the legends of the American stage. Even at the young age when Covarrubias sketched her, her confident reserve, intellectuality, and disinterest in the young men who pursued her marked her as a maverick in the theater's social world.[150]

After Covarrubias had drawn a couple of faces, Van Vechten invited his young protégé to lunch at the Algonquin Hotel, where "he was acclaimed at once, held, indeed, almost a reception."[151] Success followed quickly as Covarrubias translated portraits such as this one into black-and-white ink drawings for publication in the newspapers and magazines. Before the end of 1923, his concise, geometricized heads were appearing in New York newspapers, and the following January an admiring Frank Crowninshield, editor of *Vanity Fair*, first featured his work in the leading "smart" magazine of the era. The black-ink version of Le Gallienne appeared on a "Pungent Page of Character Studies" amid images of Charlie Chaplin, Alexander Woollcott, and other luminaries. Covarrubias soon became a regular feature in *Vanity Fair*'s pages. In March 1924 artist Alexander Brook included his drawings in an exhibition at the Whitney Studio Club and was surprised when the young Mexican turned out to be the star of the show, mobbed at the opening by his celebrity subjects.[152]

When Covarrubias's popular *Vanity Fair* caricatures were published by Knopf in *The Prince of Wales and Other Famous Americans* (1925), Le Gallienne was among the sixty-six figures represented [fig. 34]. According to *Life* magazine, the book "set America laughing and lifted Covarrubias to the pinnacle of United States cartoonists."[153] Spiky black lines, reminiscent of the gouges of a woodcut technique, define the geometric shapes of the Le

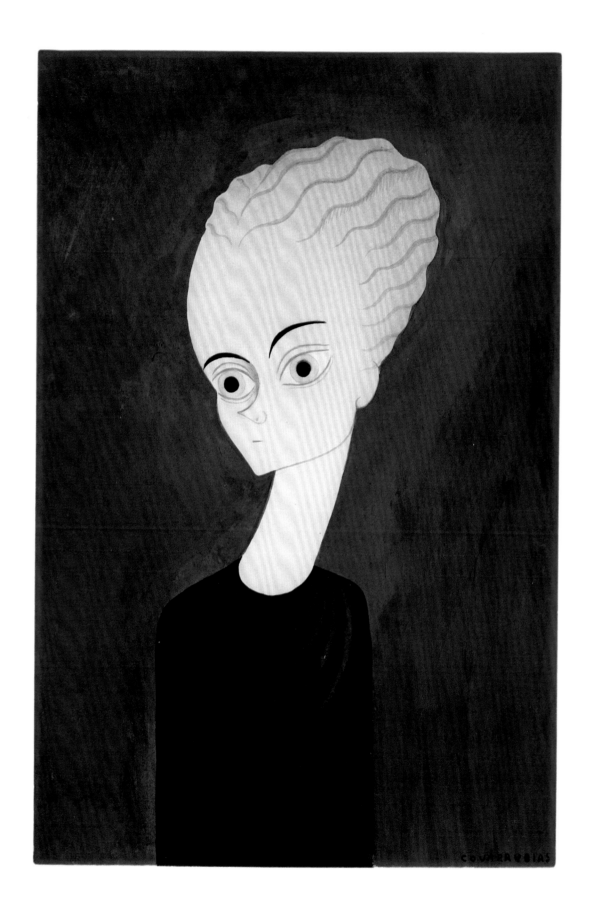

Gallienne image. In an elegant interplay of black-and-white patterning, the gathered folds of her dress splay downward from the shoulder in white lines against black, reversing the dark-on-light contrasts of her coiffed hair. The precise geometric stylization of the figure provided both the novelty and the humor. Covarrubias, Crowninshield pointed out, avoiding wild distortions and extreme abbreviations, "uses only a chemist's trace of exaggeration. . . . Our laughter derives . . . wholly and absolutely from the draftsmanship itself; from the artist's grasp of character, his clairvoyant vision, his sensitive

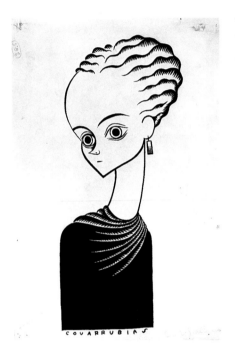

Fig. 34. *Eva Le Gallienne* (1899–1991) by Miguel Covarrubias (1904–1957). Ink on paper, 1924. Original illustration for *Vanity Fair*, January 1924. Prints and Photographs Division, Library of Congress, Washington, D.C.

misdirection of line, or his deft and almost imperceptible misplacement of muscle, shadow or plane."[154] Relying on geometrically rendered sculptural form, he translated a familiar figure into a celebrity icon, ingeniously stylized and modern.

Covarrubias's fame did not rest solely on his black-and-white reproductions, however. "One does not thoroughly know the art of Covarrubias," artist Walter Pach noted, "without seeing his originals. For he is a painter, and has the painter's relish for the beauty of the materials he works with." The gouache of Le Gallienne resonates with what Crowninshield called "rich, haunting color." The realization of sculptural form is less schematic here than in his ink drawings, but his execution seems just as unerringly precise. "There was no fumbling around either for the idea or for the method," art critic Henry McBride wrote, "but an adult assurance that was as startling as

it was pleasing." The masklike face, enlarged eyes, and smoothly arched brows recall Picasso's use of medieval facial depictions to lend a monumental quality to the image.[155] In the 1930s, Covarrubias exhibited his gouache drawings at the Art Institute of Chicago's annual international watercolor shows, winning praise from one critic for his good drawing, interesting design, and "strange, yet beautiful color."[156]

In the early 1930s, *Vanity Fair* caught up with Covarrubias's flair for color. As Condé Nast's new four-color printing plant began transforming the magazine industry, *Vanity Fair*'s editors turned to Covarrubias again for celebrity portraiture. His cover images and gently spoofing illustrations energized a magazine desperately trying to reverse declining revenues. Covarrubias's popular series, "Impossible Interviews," combining such comically disparate types as Al Capone and the chief justice or speakeasy hostess Texas Guinan and temperance advocate Ella Boule, was a featured high point of the magazine.

Vanity Fair had not monopolized Covarrubias's talents. His second acclaimed volume, titled *Negro Drawings* (1927), together with his book illustrations for Taylor Gordon, W. C. Handy, Zora Neale Hurston, and others, established him as a key illustrator of the Harlem Renaissance. He also published in the *New Yorker*, designed theater sets, painted murals, traveled widely, and made several trips to Bali with the help of a Guggenheim Foundation grant. His book *Island of Bali* (1937) won him international praise and new credentials as a serious ethnologist. In time, he and his talented wife, Rosa, would settle in Tizapán, outside Mexico City, where Miguel focused his anthropological interests on pre-Hispanic cultures and Indian art of the Americas and entertained friends from around the world.[157]

While celebrity caricature was only one of Covarrubias's varied accomplishments, his impact was critical. Under the guise of celebrity-spoofing humor, he introduced modern stylizations and color juxtapositions. Ralph Barton, reviewing the *Prince of Wales*, summarized the impact of his art, which he considered too civilized to be cruel. "They are bald and crude and devoid of nonsense," he commented about Covarrubias's drawings, "like a mountain or a baby."[158]

W.W.R.

148. Biographical information about Covarrubias comes from Adriana Williams, *Covarrubias* (Austin: University of Texas Press, 1994), unless noted otherwise. Carl Van Vechten, preface to Miguel Covarrubias, *The Prince of Wales and Other Famous Americans* (New York: Alfred A. Knopf, 1925), n.p. See also Bernard Reilly, "Miguel Covarrubias: An Introduction to His Caricatures," in Beverly J. Cox et al., *Miguel Covarrubias Caricatures* (Washington, D.C.: National Portrait Gallery, Smithsonian Institution, and Smithsonian Institution Press, 1985).

149. Helen Sheehy, *Eva Le Gallienne: A Biography* (New York: Alfred A. Knopf, 1996), 107.

150. *Vogue*, December 15, 1923, and Ada Patterson, *Theatre*, February 1924, quoted in Sheehy, *Eva Le Gallienne*, 108.

151. Van Vechten, preface to Covarrubias, *Prince of Wales*, n.p.

152. Reaves, *Celebrity Caricature*, 169–70.

153. Quoted in Williams, *Covarrubias*, 45.

154. Frank Crowninshield, introduction to Miguel Covarrubias, *Negro Drawings* (New York: Alfred A. Knopf, 1927), n.p.

155. Walter Pach, "An Artist Looks at Harlem," *New York Herald Tribune*, November 6, 1927; Crowninshield, introduction to Covarrubias, *Negro Drawings*; Henry McBride, "Ingratiating Art of Miguel Covarrubias, a Mexican Ambassador," *New York Sun*, December 24, 1927; William Rubin, ed., *Picasso and Portraiture: Representation and Transformation* (New York: Museum of Modern Art, 1996), 266.

156. Peter Hastings Falk, ed., *The Annual Exhibition Record of the Art Institute of Chicago, 1888–1950* (Madison, Conn.: Sound View Press, 1990), 237; "519 Water Colors, 125 from Abroad, in Chicago's International," *Art Digest* 10 (March 15, 1936): 15.

157. As one archaeologist pointed out, "Covarrubias would be known as one of the best-informed men of Mexican archaeology and ethnology were it not for his fame as a painter, caricaturist, and writer" (quoted in Williams, *Covarrubias*, 123).

158. Ralph Barton, "It Is to Laugh," *New York Herald Tribune*, October 25, 1925.

Ralph Barton

1891–1931

Self-portrait

Watercolor and graphite on paperboard mounted on illustration board, 37.3 x 28.3 cm (14^{11}/$_{16}$ x 11^{1}/$_{8}$ in.), circa 1925
NPG.83.170

"The human soul would be a hideous object if it were possible to lay it bare," caricaturist Ralph Barton wrote in 1926. "Men who come near to doing it go mad like Ibsen and Nietzsche. It is not the caricaturist's business to be penetrating: it is his job to put down the figure a man cuts before his fellows in his attempt to conceal the writhings of his soul."[159] Barton garnered fame and fortune following that creed. With an elegant calligraphic line, he spoofed the external veneer of the urban "smart set." In his haunting self-portrait, however, Barton comes close to revealing what he usually took pains to hide: the turmoil of the psyche. Inscribed "with apologies to Greco and God," the picture implies the artist's own mental anguish. After suffering for years from increasingly severe manic depression, Barton committed suicide in 1931 shortly before his fortieth birthday.

In a suicide note quoted widely in the press, Barton blamed his illness as the root cause of his woes. Although he felt he had not gotten "anything like full value out of [his] talent," most observers viewed his career as an unrivaled success.[160] When Bohun Lynch published his *History of Caricature* in London in 1926, he singled out Barton as the most prolific caricaturist in the United States, citing him as one who had "done much to revive the art." From the mid-1910s until 1931, editors from the major magazines besieged him for drawings. His stylish portraits of the famous were published in *Puck*, *Judge, Life, Photoplay, Harper's Bazaar, Vanity Fair*, and the *New Yorker*. Barton told Lynch that he had "gone through" so many figures from the American theater and "La Vie New-Yorkaise," that he had to wait for more subjects to be born.[161] Commissions for advertising, commercial, and comic art supplemented his income. He also illustrated novels by such popular authors as Anita Loos, Carl Van Vechten, and Honoré Balzac. Royalties from Loos's *Gentlemen Prefer Blondes* alone, Dorothy Giles

noted in a two-part article just after Barton's death, netted him $30,000. Incessant demands were met by legendary bursts of productivity. In a single, feverish week, Giles reported, Barton once finished eighty-five drawings. According to a *New Yorker* "Profiles" essay, he would occasionally work twenty-four hours without a break.[162] His constant presence in the press brought acclaim. In 1927 the French government made him a chevalier of the French Legion of Honor.

Endowed with money, charm, a series of exquisite homes in Paris and New York, and four successive, beautiful wives, including actress Carlotta Monterey (who later married Eugene O'Neill) and French composer Germaine Tailleferre, Barton maintained a life-style that he himself acknowledged was exceptionally glamorous. "The most charming, intelligent and important people I have known have liked me," he noted, "and the list of my enemies is very flattering to me."[163] Barton's circle of acquaintances constituted a rich mix of international café society from the worlds of art, literature, theater, and film. When he made a home-movie spoof of the drama *Camille* in 1926, he was able to cast Paul Robeson, Sinclair Lewis, Theodore Dreiser, Somerset Maugham, Ferenc Molnár, Clarence Darrow, Arturo Toscanini, H. L. Mencken, Charlie Chaplin, Anita Loos, Ethel Barrymore, and Dorothy Gish.[164] They were all subjects for his pen as well.

Barton's career had started modestly enough. He had little artistic training outside a brief stint at the Art Institute of Chicago and several years illustrating for his hometown Kansas City newspapers. When the renowned humor magazine *Puck* accepted an illustration in 1912, he moved to New York with his first wife and baby daughter. He shared a studio with fellow Kansas City artist Thomas Hart Benton at the Lincoln Arcade, where other soon-to-be-famous young people—William Powell, Rex Ingram, Willard Huntington Wright, Thomas Craven, and Neysa McMein among them—found cheap working

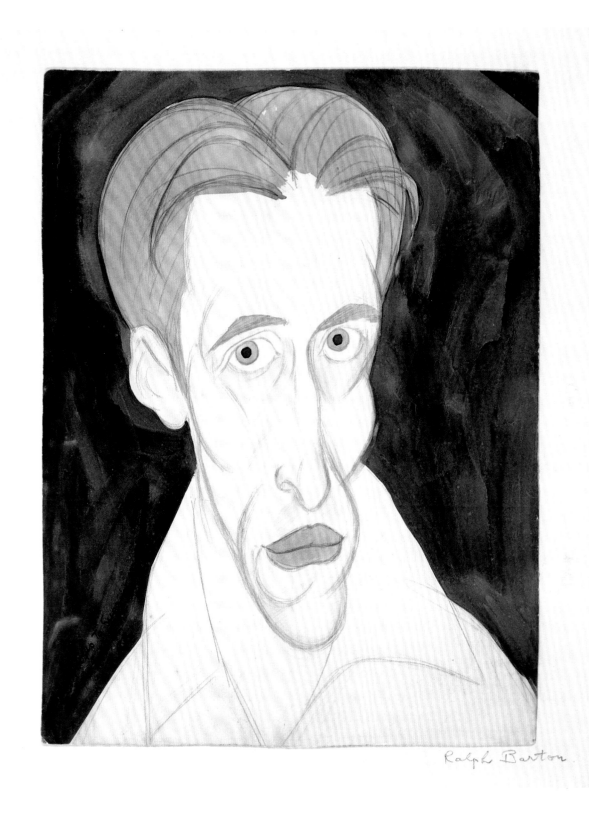

Ralph Barton

quarters. As Barton began publishing in the magazines, his evolving style revealed the process of his aesthetic self-education. One early drawing seems closely modeled on the work of English caricaturist Max Beerbohm;[165] in others, slim, elongated figures suggest such French fashion designers as Georges Lepape, Eduardo Benito, and Charles Martin. Barton was fascinated with the international modernism that was the focus of the 1913 Armory show. He fell in love with ancient art as well: the recently discovered cave paintings at Altamira, the profiles on Greek vases, and the Egyptian wing at the Metropolitan

Fig. 35. *Portrait of a Man* by El Greco (Domenikos Theotokopoulos) (1541–1614). Oil on canvas, circa 1590–1600. The Metropolitan Museum of Art, New York; purchase, Joseph Pulitzer bequest, 1924

Museum were particular interests. When he visited France, he studied the lithographs of Honoré Daumier.[166]

The influence of all these sources diminished as Barton found his own caricature style, a highly individual distortion of the face or figure. Even when drawing in black ink, Barton could add a sense of color and animation with competing linear patterns of stripes, spirals, loops, and curves. He often interwove into his pictures subtle tints, startling areas of bright color, and an intricate graphic complexity. Underlying his urbane humor and elegant sense of design was Barton's dark view of the frantic pace of contemporary life. His lines, John Updike has written, "are like wires that are all connected; his drawings give off a peculiar hum, a menace absent from the tidy lines of similar draftsmen."[167]

In 1922, Barton's growing reputation rocketed upward when his intermission curtain for the "Chauve-Souris," a popular Russian musical revue, proved to be the theatrical sensation of the season. Halfway through the opening performance, Barton's

huge caricature curtain descended and the assembled crowd found itself confronting a painted audience of fashionable "first nighters," all staring back. "The effect was electrifying," one observer recalled. The audience spent intermission identifying the 139 faces on the curtain, each individual hoping to glimpse his own image among the chosen. With only an assistant to do the "dirty work," Barton had painted the whole curtain himself, standing on a three-foot-wide bridge installed four stories above the stage of an opera house. "Surely no caricaturist," noted one critic, "ever enjoyed before so generous an exhibition!"[168] As the curtain toured around the country, magazines clamored for Barton's group caricatures—crowded scenes, alive with recognizable faces—that seemed to embody the tempo, energy, and glamour of metropolitan life. One *Vanity Fair* illustration, depicting notables dining at Hollywood's Cocoanut Grove, was even reproduced by a textile company in its Americana series of printed silks.[169]

As an inveterate museum visitor, Barton was undoubtedly aware of the Metropolitan Museum's purchase of a major work in 1924 by the Greek-born painter Domenikos Theotokopoulos, known as El Greco [fig. 35]. Made around 1590–1600, the work was originally identified as a self-portrait and may well have been the inspiration for Barton's own self-image. The two share a bust-length format, a slightly turned frontal pose, an elongated, tapering face, deep creases beside the mouth, prominent oval-shaped eyes, clothing that reaches up to the ears, and other similar attributes. In a photograph of the Bartons' living room from 1925, the self-portrait hangs with other drawings on a gold papered wall behind Ralph and Carlotta, who sit together looking at a book.[170] The grim tone of the drawing, probably made about this time, is a reminder that all was not well with Barton or his tempestuous, already-unraveling marriage.

Barton's reputation would fade as the caricature vogue ran its course. But to Dorothy Giles in 1932 this dandified artist with his exquisite sense of style, urbane humor, celebrity connections, and underlying current of anxiety symbolized the spirit of his fast-paced era. America, especially young America, she wrote, wanted "this stripling David with his pencil for a sling and his wit for a pebble. . . . He was her fortunate and golden youth, her own chosen jester."[171]

W.W.R.

159. Barton, "It Is to Laugh."

160. Quoted in *New York Times*, May 21, 1931.

161. Bohun Lynch, *A History of Caricature* (London: Faber and Gwyer, 1926), 118. The details of Barton's life and career are well covered in Bruce Kellner, *The Last Dandy: Ralph Barton, American Artist, 1891–1931* (Columbia: University of Missouri Press, 1991).

162. Dorothy Giles, "Ralph Barton—Genius Destroyed Him," *College Humor* (February 1932): 36; Charles G. Shaw, "Through the Magnifying Glass," *New Yorker*, November 5, 1927, 22.

163. Quoted in *New York Times*, May 21, 1931.

164. Kellner, *The Last Dandy*, 152–53. Chaplin was a particularly close friend and always dropped in at Barton's parties when he was in town, sometimes staying all night to talk about books, music, and art (Kenneth Lynn, *Charlie Chaplin and His Times* [New York: Simon and Schuster, 1997]: 300–301).

165. Barton's 1917 drawing of Anton Chekhov and other playwrights, *Ursa Major and Certain Particles of Cosmic Dust*, owned by the Museum of the City of New York, shows the influence of Max Beerbohm's style.

166. Dorothy Giles, "Ralph Barton—Death," *College Humor* (April 1932): 92.

167. John Updike, "A Case of Melancholia," *New Yorker*, February 20, 1989, 114, reprinted in John Updike, *Just Looking: Essays on Art* (Boston: Museum of Fine Arts, 2001), 131–53.

168. Aline Fruhauf, *Making Faces: Memoirs of a Caricaturist*, ed. Erwin Vollmer (Cabin John, Md.: Seven Locks Press, 1987), 34; Lynch, *History of Caricature*, 118; Kellner, *Last Dandy*, 79–84; Maybelle H. Klein, "The Star-studded Audience That Night Was Staring Up at . . . Itself," *Christian Science Monitor*, January 2, 1986, 34; Reaves, *Celebrity Caricature*, 136–40. The "Chauve-Souris," staged by Nikita Balieff, opened in February 1922, but Barton's curtain appeared in the summer version of the show opening on June 5, 1922 ("Chauve-Souris Anew on the Century Roof," *New York Times*, June 6, 1922). The curtain exists only as a color reproduction in the program, a copy of which was given to the National Portrait Gallery by Bruce Kellner.

169. A flapper's dress made from the silk, still showing the stains of its party-going career, is owned by the National Portrait Gallery.

170. The photograph is inscribed to a young caricaturist friend, "To Aline with our love. Carlotta Monterey Barton, Oct. 1925" (Fruhauf, *Making Faces*, 39). The self-portrait, previously dated circa 1922, is more likely to be from around 1925.

171. Giles, "Genius Destroyed Him," 36; Giles, "Death," 92, 98.

COUNTEE CULLEN
1903–1946

BY WINOLD REISS
1886–1953

Pastel on illustration board, 76.1 x 54.7 cm (29^{15}/$_{16}$ x 21^{9}/$_{16}$ in.), circa 1925
Inscription: Winold / Reiss
Gift of Lawrence A. Fleischman and Howard Garfinkle with a matching grant from the National Endowment for the Arts
NPG.72.76

"Yet do I marvel at this curious thing / to make a poet black and bid him sing!" With these words, Countee Porter Cullen identified the ambiguous position of the black artist in American society in 1925 while alluding to his own ambition to be remembered as a poet, not simply a poet of color. By the age of twenty-two, Cullen had graduated Phi Beta Kappa from New York University, won a handful of prizes for poetry, and completed his first volume of verse, *Color*.[172] Together with poets Langston Hughes, Claude McKay, and Jean Toomer, Cullen became recognized as a leading figure in the literary and artistic movement known as the Harlem Renaissance, which flourished during the 1920s. This portrait of Cullen by Winold Reiss was included in an anthology celebrating the cultural achievement of the African American community titled *The New Negro*, regarded as the manifesto of the movement itself. Its editor, Alain Locke, believed that "cultural recognition" was the key to "the further betterment of race relations."[173]

Born in Germany, Reiss studied with his father, a landscape and portrait painter, and trained at the Fine Arts Academy in Munich under Franz Von Stuck, one of the founding members of the Munich Secession. Through Von Stuck he was influenced by the Jugendstil, or "youth style," which emphasized the merging of fine and applied art forms. Further study at the School of Applied Arts in Munich enabled Reiss to work as a magazine illustrator and interior designer after immigrating to New York in 1913.[174] There he also founded the Society of Modern Art and its magazine, the *Modern Art Collector*, and lectured at the Art Students League on the modern German poster. Contrary to the prevailing opinion in America, Reiss believed in the Arts and Crafts ethos he had adopted in Munich, that fine artists should be employed in commercial design.[175]

With war looming on the horizon, Reiss had been eager to leave Europe. As a child he was enchanted by the novels of James Fenimore Cooper, and he came to the United States in a romantic quest for the "noble savage." Inspired by exhibitions of non-Western art forms, such as those in the Munich ethnographic museum, and their impact on modern art, he decided to study the indigenous populations of the New World. Reiss may have been influenced by his father, who—believing that an artist must above all be truthful to nature—had moved his young family to the German countryside in order to paint local peasant life.[176]

After six years of teaching and working as a designer in New York, Reiss was finally able to travel to Montana to paint the Blackfoot Indians with the proceeds from his free-lance work. This was followed a year later by a trip to Mexico to portray the Zapatista revolutionaries and study the ancient Aztec civilization of Tepotzolán.[177] His Native American and Mexican portraits, together with images of German and Swedish peasants, were exhibited at the Andersen Galleries in New York and later in Boston and Rochester. These exhibitions of different racial types signaled a turning point in Reiss's career. Paul Kellogg, the editor of the social-welfare journal *Survey Graphic*, subsequently approached him to illustrate a special edition of the magazine titled "Harlem: Mecca of the New Negro."[178] The Cullen portrait appeared there in black and white. The issue, selling out two complete printings, was so popular that it led to the publication of the book *The New Negro*, with Reiss's illustrations now appearing in color. While he portrayed the writers and poets who contributed to the anthology, he also included generic portraits of the urban working class, as well as expressionist designs and "phantasy" illustrations based on his study of African masks and sculpture. Hailing Reiss as a "folk-lorist of the brush and pallette," Alain Locke hoped that his illustrations would serve as a "path-breaking guide and encouragement to this new foray of the younger

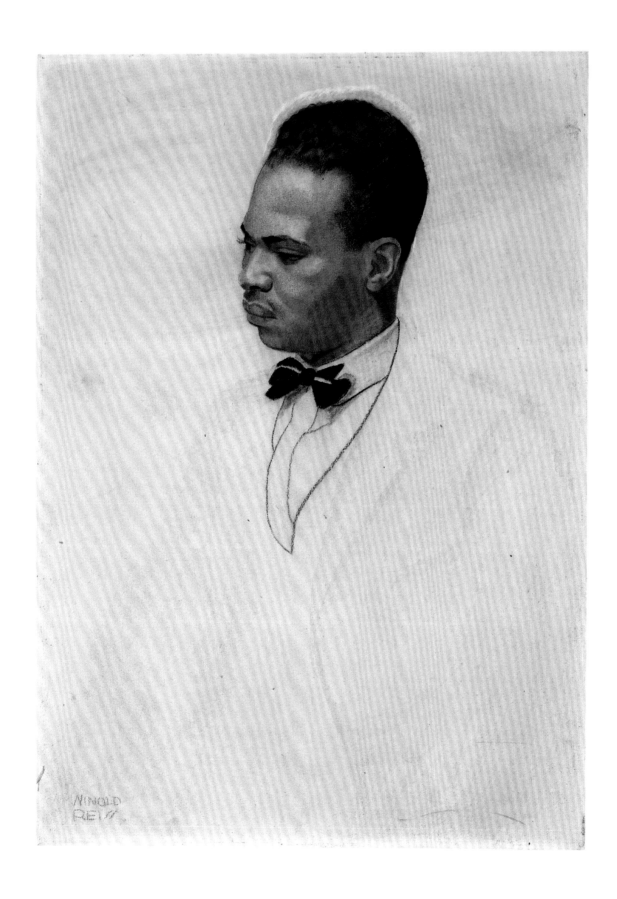

109

Negro artists."[179] In fact, Reiss inspired a number of emerging black artists, including Aaron Douglas, who became his pupil and eventually the leading artist of the Harlem Renaissance.

In the portrait of Cullen, Reiss barely suggests the torso with a few fluid lines of black pastel, allowing the body to merge with the white background while emphasizing the skin tones of the face. With his tilted head and averted glance, Cullen is shown as the sensitive, introspective poet who idolized Keats and was praised in high-society circles as a "perfect gentleman." Reiss's Harlem portraits, which also include Hughes, W. E. B. Du Bois, Locke, and Paul Robeson, are the visual highlight of *The New Negro*. Each likeness conveys the proud dignity of an accomplished individual while it reveals his or her uniqueness. Other design elements and illustrations throughout the book reflect the growing "Negritude" movement in black literature and arts, with sources in traditional African art forms. Reiss successfully captured the progressive spirit of the Harlem Renaissance through a deep respect for his subjects and their quest for a new social identity.

L.W.

EYE CONTACT

172. Published by Harper & Brothers in 1925, the book included "Yet Do I Marvel," which is one of his best-known poems. See also Gerald Early, ed., *My Soul's High Song: The Collected Writings of Countee Cullen, Voice of the Harlem Renaissance* (New York: Doubleday, 1991).

173. Steven Watson, *The Harlem Renaissance: The Hub of African-American Culture, 1920–1930* (New York: Pantheon, 1995), 28–29, and David Levering Lewis, *When Harlem Was in Vogue* (New York: Oxford University Press, 1989), 117–18, 199; Alain Locke, ed., *The New Negro* (New York: Albert and Charles Boni, 1925), 15.

174. That year he became a regular contributor to *Scribner's* magazine, designing several covers as well as some book illustrations. In 1915 he received the commission to design the interior of the Busy Lady Bakery, and in 1920 the Crillon Restaurant, both in New York.

175. Jeffrey C. Stewart, *To Color America: Portraits by Winold Reiss* (Washington, D.C.: National Portrait Gallery, Smithsonian Institution, and Smithsonian Institution Press, 1989), 28–33.

176. Ibid., 21.

177. Katherine Anne Porter, whom he met on this trip, decided to publish his drawings in her article on the Mexican Revolution in the July 1922 issue of *Century* magazine (ibid., 42).

178. Kellogg would have seen Reiss's Mexican portraits in the May 1924 issue of *Survey Graphic*, guest edited by Katherine Anne Porter.

179. Locke, *New Negro*, 420, 266.

LEO STEIN
1872–1947

BY ADOLF DEHN
1895–1968

Ink on paper, 26.5 x 20 cm (10 $^7/_{16}$ x 7 $^7/_8$ in.), circa 1925
Inscription: *recto* Leo Stein / AD; *verso* 182
NPG.92.108

Adolf Dehn's ink portrait of writer Leo Stein focuses on the physical act of creation. Stein huddles close to the rectangular edge of a table, clenching his fingers, biting his upper lip, and furrowing his brow.[180] He attacks the task of writing with an almost divinely inspired fervor; writing is more action than contemplation.

Drawing, for Dehn, was as much a physical exercise as writing was for Stein. Dehn employed a rubbed-ink technique, using his fingers to create a variety of effects. Allowing his ink line to dry partially, he then proceeded to smear it with his fingertip. Ridged marks from the fingers appear near the vicinity of Stein's ear, on the shadow adjacent to his right coat lapel, and on the body of the ink bottle. Broad areas of pale shadow, created by rubbing an inked fingertip lightly on the paper's surface, can be observed on Stein's lapel and beneath his left arm.

Dehn's portrayal of Stein in such a cramped position captures the writer's sharp intellect and critical mind. Stein was one of the first voices to champion the early modernism of Cézanne and Matisse, and later penned his vehement opposition to such later trends as cubism. In criticizing Picasso's and Braque's invention of cubism, Stein writes satirically:

> When once you know that a nose is not a nose is not a nose you can go on to discover what all the other things are not, and arrive at the conclusion that the way to build up "real" things is out of "the broken fragments of a once glorious union, of states disseevered, discordant.". . . With this kind of funny business analysis, anything can be analyzed into elements, and with this funny business synthesis any elements can be synthesized into any form. The analysis and synthesis alike are mere funny business, and it is absurd to take them seriously.[181]

The encircling position of Stein's body as well as the relatively darker tonalities of the rubbed-ink technique so focus the eye on the act of creating that we miss, at first glance, Dehn's visual joke. The chair is missing altogether. Dehn matches his subject's sharp opinions and witty prose with his own teasing omission.[182]

Dehn's intuitive understanding of his sitter's personality was based on their friendship. John Glassco recounts in his *Memoirs of Montparnasse* that in March 1928 he and Dehn were seated at a café in Paris when they were approached by Leo Stein, who presented Dehn with a photograph. Glassco notes, "The exchange was carried on with the greatest good humour. Leo Stein then raised his hat and passed on."[183] By this date at least, Dehn and Stein were already well acquainted.

Dehn was known as a lithographer. Born in Waterville, Minnesota, in 1895, he first aspired to become a cartoonist and illustrator. After attending the Minneapolis School of Art, he received a prestigious scholarship to the Art Students League in New York. He later spent time detained in a South Carolina camp for his conscientious objection to World War I. Following the war, Dehn returned to New York and switched his interests from cartooning to fine art. In his later years, he divided his work between fine and commercial art, but humor remained a defining element. Dehn published several books on technique, including *How to Draw and Print Lithographs* (1950).

Dehn's work in Europe during the 1920s suggests a dating of the drawing to sometime in that decade. As an expatriate American, Dehn divided his time between Berlin, Paris, and Vienna, executing drawings and lithographs that documented the café and club scenes of the bohemian communities of Europe, as well as engaging in good-natured satire of the foibles of the upper classes.[184]

In 1921 or 1922, Dehn met Scofield Thayer, editor of the literary magazine the *Dial,* in Vienna. Thayer began to publish Dehn's drawings, including caricatures of Stein and Thayer, in the June 1926

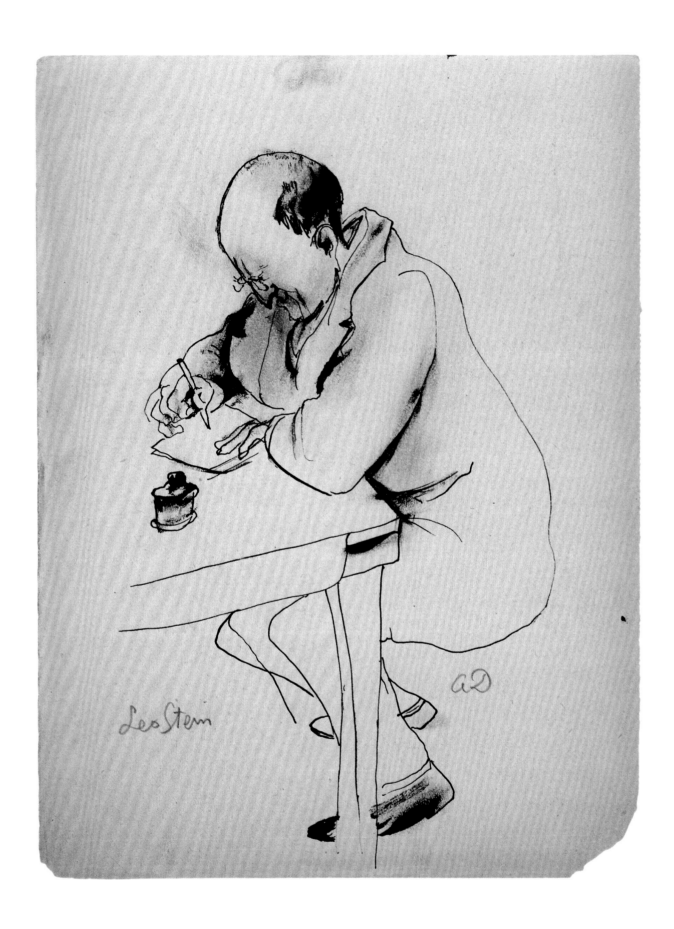

Leo Stein

113

issue.[185] Thayer also made Dehn superintendent of a *Dial* project to collect the works of avant-garde artists for publication in the magazine and in the portfolio *Living Art*. The job involved obtaining and shipping art from Berlin and Paris to the United States, and Dehn would have sought out collectors and critics such as Stein to help him accomplish his task. Dehn visited Italy at least twice during that period, in the fall of 1921 and again in 1923, when he spent five days in Florence.[186] While in Florence, it is quite possible that he visited and drew Stein at his home in nearby Settignano, working at his desk. The scalloping on the right edge of the paper indicates that the drawing was torn from the artist's sketchbook, and the small dimensions suggest that the sketchbook was easily portable.[187]

Often overshadowed by his sister, writer Gertrude Stein, Leo Stein was distinguished in his own right as a writer and art critic. Children of affluent Jewish parents who had made their fortune in the clothing business, both Stein and his sister were born in Allegheny, Pennsylvania, and later moved to Oakland, California. Leo attended Harvard and later pursued studies in biology at Johns Hopkins University in Baltimore. He moved to Paris to become a painter, a pursuit he soon abandoned, and was followed in 1903 by his sister.[188] They began collecting art, under the direction of Leo's discerning eye, amassing an enviable collection of paintings by such masters as Cézanne and Renoir, and the works of newer, avant-garde artists working in Paris, such as Matisse and Picasso in his pre-cubist days. At weekly Saturday open houses at their rue de Fleurus apartment, Leo would interpret the paintings for visitors: "People came, and so I explained, because it was my nature to explain."[189] Artist Max Weber remembered Leo's vital role at these salons. "Lengthy and involved discussions on the most recent developments . . . in art took place," he wrote, "with Leo Stein as moderator and pontiff."[190] He introduced artists and public alike to the proto-modernist innovations of Cézanne and Matisse, which paved the way for the favorable reception of the more-radical modernist trends, which Stein himself was to later denounce.

Stein and his sister never again spoke to each other after 1914. Their break was partially owing to disagreements over artistic preferences; Leo abhorred cubism, while Gertrude embraced Picasso's new style. Leo returned to the United States, and then moved to Italy in 1919, where he divided his time between Settignano and Paris for the rest of his life. Neurotic and often withdrawn, he could write undisturbed at his Italian home. He was the author of three books: *The A-B-C of Aesthetics* (1927), *Appreciation: Painting, Poetry, and Prose* (1947), and *Journey Into the Self: Being the Letters, Papers, and Journals of Leo Stein* (1950), published after his death in 1947.[191]

In his critical writings, Leo Stein asserted that each artist possessed a dominant quality in his or her work.[192] Perhaps Adolf Dehn's defining attribute was his ability to understand and capture the psychology of the people he drew. With ink and paper, Dehn conveys not only a moment—the sitter writing at a desk—but also the intensity and sharpness of Stein's words, those of one of the most important, albeit neglected, critical voices of the early twentieth century.

E.M.T.

180. This posture appears repeatedly in Dehn's work. Two examples include the 1925 drypoint *Café Table* and the 1930 lithograph *A Literary Man: Theodore Dreiser at Child's*, both reproduced in Jocelyn P. Lumsdaine and Thomas O'Sullivan, eds., *The Prints of Adolf Dehn: Catalogue Raisonné* (Saint Paul: Minnesota Historical Society Press, 1987), fig. 16, 74, and fig. 174, 116.

Although Dehn reportedly made several drawings of Leo Stein, only two have been found. According to Virginia Dehn, her late husband did "several" drawings of Stein.

181. Leo Stein, *Appreciation: Painting, Poetry and Prose* (New York: Crown, 1947), 183–84.

182. Compare Charles Dana Gibson's drawing *At the Savoy*, where a society couple are seated at a table without chairs (Edmund Vincent Gillon Jr., *The Gibson Girl and Her America: The Best Drawings of Charles Dana Gibson* [New York: Dover, 1969], 25).

183. Telephone conversation with Virginia Dehn, July 16, 1999; John Glassco, *Memoirs of Montparnasse* (New York: Oxford University Press, 1970), 14–15.

184. For biographical details on Adolf Dehn, see Richard Cox, "Adolf Dehn: The Life," in Lumsdaine and O'Sullivan, *Prints of Adolf Dehn*, 1–25.

185. The drawing of Stein, which is signed with the date 1925, is in the Dial Collection of the Metropolitan Museum of Art, New York. The caricatures accompanied Thayer's unsigned verses, titled "Leo Arrogans." Stein and Thayer had been engaged in a war of words since 1924, begun when Thayer rebuked some disparaging remarks Stein had made about Picasso. This initiated a debate on the relation of intellect and painting, about which Thayer invited Stein to contribute an essay to the *Dial*. Stein promised to write, but when no response came, Thayer jokingly published the caricatures along with the verse. Stein finally submitted two essays, "Cézanne" and "Reality," which were published in July and September 1927, after Thayer had left the *Dial* (see Nicholas Joost, *Scofield Thayer and the Dial: An Illustrated History* [Carbondale: Southern Illinois University Press, 1964], 177–79).

186. "Been here 1 day to see the wonderful Giotto frescoes [in Padua]. In Ravenna 2 days to see Byzantine mosaics. Before that in Florence 5 days." Postcard from Adolf Dehn to family members from Venice, May 7, 1923, microfilm reel 2938, Adolf and Virginia Dehn Family Papers, AAA. Dehn also visited Venice in 1936 (see letter of October 2, 1936, in reel 2938, Dehn Papers). Two drawings from this trip, *Women Praying in Apollinare Nuovo* [Ravenna] and *Students in the Borghese Gardens, Rome*, appeared in the September 1923 issue of the *Dial*.

187. Telephone conversation with Barbara Meek, August 10, 1999, of Meek Gallery, Naples, Florida, from which the drawing came to the Portrait Gallery. Meek reported that it had belonged to Virginia Dehn, widow of the artist, and that it was probably torn from a sketchbook to be given to someone.

188. Gail Stavitsky, *Gertrude Stein: The American Connection* (New York: Sid Deutsch Gallery, 1990), 1.

189. Stein, *Appreciation*, 201.

190. See Max Weber, transcript of interview conducted by Carol S. Gruber, January–March 1958, Oral History Collection, Columbia University, New York, vol. 1, pt. 1, 59, 73, and pt. 2, 243, excerpt reprinted in Stavitsky, *Gertrude Stein*, 8.

191. *Dictionary of Literary Biography*, s.v. "Stein, Leo," by Judith S. Baughman and Virgil Geddes. Vol. 4, *American Writers in Paris, 1920–1939*, ed. Karen Lane Rood, 373–74.

192. John Rewald, *Cézanne and America: Dealers, Collectors, Artists, and Critics, 1891–1921* (Princeton, N.J.: Princeton University Press, 1989), 66.

ALICE B. TOKLAS
1877–1967

BY PAVEL TCHELITCHEW
1898–1957

Gouache on paper, 50.1 x 32.5 cm (19 11/$_{16}$ x 12 13/$_{16}$ in.), circa 1926–28
Inscription: P. Tchelitchew
NPG.80.13

Pavel Tchelitchew's demure gouache portrait of Alice B. Toklas, painted during their friendship in the late 1920s, is more of a character study than a descriptive likeness. "Elegant and detached" as one contemporary described her,[193] Toklas sits in an armchair bent over her knitting, eyes downcast. Although she played a supporting role in her partnership with Gertrude Stein, managing and maintaining their famous Paris salon at 27, rue de Fleurus, according to Ernest Hemingway and others of their circle, Toklas was the engineer of a series of terminated friendships.

Toklas's modest, quiet demeanor disguised a strong will and keen critical perception. As explained by one member of their court, her influence over Gertrude's friendships was discreet but highly influential "because she drew in or rejected those who came near Gertrude, according to her own judgement."[194] Alice was the "sieve and buckler; she defended Gertrude from the bores, and most of the new people were strained through her before Gertrude had any prolonged conversation with them." Peppering them with pointed questions, it took Toklas about "three minutes" to pass judgment on someone.[195]

Comparing the two women—"one seemingly stronger and the other more frail, one affirming her genius and the other venerating it, one speaking and the other listening"—Bernard Faÿ, a friend of the composer Virgil Thomson, explained the relationship: "Only a blind man could ignore that the most vigorous one was Alice, and that Gertrude, for her behavior as much as for her work and publications, leaned on her, used her and followed her advice."[196]

Pavel Tchelitchew, the young Russian émigré, was among a series of aspiring artists who were encouraged and promoted, and subsequently rejected, by the legendary pair. From a White Russian family that fled the Bolshevik Revolution, Tchelitchew moved to Paris in 1923 with his companion, the

pianist Allen Tanner, in hopes of working with Sergei Diaghilev's Ballets Russes.

Tchelitchew became fascinated with the metaphysical concept of simultaneity of forms, drawing the human figure or only a head within the outlines of inanimate objects or shapes, creating a kind of portrait-still-life. In his portrait of Toklas, the shape of the head, devoid of ears or mouth, is conceived as a flattened oval. It was his initial fascination with this shape that led to his explorations in portraiture. As he once explained,

> An egg was the simplest form—a nose, a bottom . . . face and back, as seen from all sides—to depict all possible sides of an egg. . . . I wanted the form to be uninterrupted, to continue equally in and outwards. . . . An egg looks like a human face, too. This brought me to human heads.[197]

Perhaps inspired by Pablo Picasso's classical portraits and drawings of nudes, Tchelitchew began studying life drawing at the Académie Julian and asking friends to sit for portraits. In 1924 he exhibited a portrait of Tanner at the Galerie Pierre, which he regarded as a turning point in his career. Although Tchelitchew had found employment designing costumes for the Folies-Bergère and a local dressmaker, he began to rely on portraiture as a steady source of income.[198]

Tchelitchew's *Basket of Strawberries*, exhibited at the Salon d'Automne of 1906, had come to the attention of Gertrude Stein and Toklas. While critics took note of the work's shocking pink color, the strawberries revealed Tchelitchew's fascination with the ovoid form and its many counterparts in nature. When Stein related her interest in the painting to Jane Heap, the American publisher of *The Little Review* and a friend of Tanner's and Tchelitchew's, it was only a matter of time before a chance encounter on one of the Parisian bridges provided the perfect opportunity for them to meet.

This episode and its aftermath are reported with

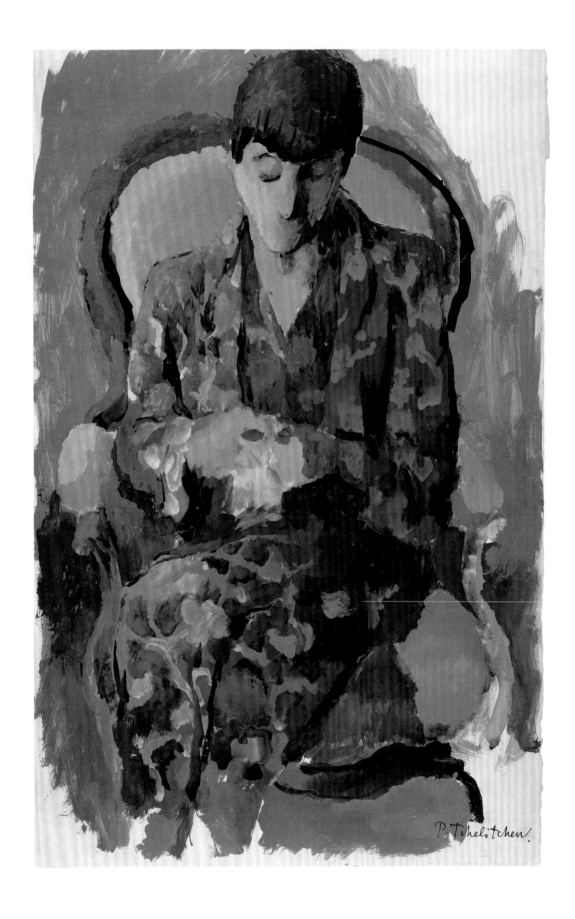

P. Tchelitchew.

117

anecdotal humor by Tchelitchew's biographer, Parker Tyler. Several days later the two women appeared at Tchelitchew's studio on Boulevard Montparnasse. For the better part of an hour they pored over everything they could find, including one male nude, which Tanner attempted to keep from them. Impressed with everything they saw, including what Toklas termed the final "peep show," they invited the two gentlemen for tea on their next free afternoon, thus inaugurating Tchelitchew's brief reign as Stein's newest protégé.

Stein and Toklas adopted Tchelitchew and Tanner,

Fig. 36. *Alice B. Toklas* (1877–1967) by Pavel Tchelitchew (1898–1957). Oil on canvas, 1927. Department of Special Collections, Charles E. Young Research Library, University of California at Los Angeles

treating them almost like spoiled household pets. They had an open invitation at the rue de Fleurus, and were invited that summer to join the women at their country home in Belley. In February 1926, Tchelitchew exhibited at the Galerie Druet with a group of friends, including the French Christian Bérard, the Russian brothers Eugene and Léonid Berman, and the Dutch Kristians Tonny, crediting the success of their show to the support of his newfound patron.

Among the group of Neo-Romantic painters, as they came to be known, Tchelitchew's work was the "most vigorous . . . the most mature and the most interesting," according to Stein. While in Belley she embarked on a series of "word portraits" of the young talents she had befriended, including Picasso,

Erik Satie, Virgil Thomson, Tanner, and Tchelitchew, in a volume titled *Dix Portraits* (1929). By the time it was published, however, she had come to the realization that although Tchelitchew had a "distinctly new creative idea," he was ultimately not the "dominating creative power" she had hoped to discover following her rift with Picasso.[199]

Toklas apparently never really liked Tchelitchew, possibly because of his self-promoting tactics, or perhaps because she was unsympathetic to the plight of Russians in general. She disapproved of his treatment of his sister, Choura, of whom Toklas was quite fond, and condemned his relationships as "cannibal." As she said of him, "Pavlik was not interested in life as he saw it, as it was. . . . He wanted to use it. . . . Pavlik was a dreadful little arriviste. . . . His attitude toward life wasn't clear. If you go into Pavlik too deeply, you'll find a weakness."[200] Gradually, Tchelitchew's work began disappearing from their salon walls, and it was only a matter of time before the friendship officially ended, his new champion becoming English poet Edith Sitwell, whom he had met through Stein and Toklas.

The remnants of their time together include a 1931 ink drawing of Stein, her head enclosed in a cube (Yale University); an unflattering 1927 oil of Toklas resembling a "sleepy vulture"[201] [fig. 36], and the Portrait Gallery's gouache portrait, originally from the artist's estate. The predominant use of blue in Toklas's dress resulted from Tchelitchew's travels from 1925 to 1927 in the south of France and Algiers, where he adopted the "indigo, Prussian blue, cerulean and cobalt"[202] he saw there, while the layering of color planes suggests the influence of Paul Cézanne. Perhaps more significantly, he memorialized the two women in his monumental masterpiece, *Phenomena* (State Tretyakov Gallery, Moscow, 1938), his personal vision of Dante's *Inferno* as a surreal amalgamation of the ills of society interspersed with malformed portraits of the artist's friends, past and present. In his peculiar tribute the illustrious pair are represented as Sitting Bull and the Knitting Maniac, in the words of Parker Tyler, seated atop a pile of discarded canvas stretchers. Although in later years he spoke highly of Stein, he seems to have remained negative toward Toklas, perhaps never forgiving her disapproval of him. In a 1951 lecture at Yale, at an exhibition of Gertrude Stein's paintings, he hoped to prove to Toklas that "painters not only paint but also can think sometimes."[203]

L.W.

193. Bravig Imbs quoted in Linda Simon, *The Biography of Alice B. Toklas* (New York: Doubleday, 1977), 136.

194. Bernard Faÿ, *Les Précieux* (Paris: Librairie Académique Perrin, 1966), 146, quoted (and translated) in ibid., 145.

195. Imbs quoted in ibid., 136.

196. Faÿ, *Les Précieux*, 145–46, quoted in ibid., 145.

197. Tchelitchew to James E. Lasry, M.D., July 11, 1956, in Lincoln Kirstein, *Tchelitchew* (Santa Fe: Twelvetrees Press, 1994), 42.

198. Kirstein, *Tchelitchew*, 33–34.

199. Gertrude Stein, *The Autobiography of Alice B. Toklas* (New York: Vintage Books, 1933; reprint, 1960), 278–79. The term "Neo-Romantic" was coined by critic Waldemar George.

200. Edward Burns, ed., *Staying on Alone: Letters of Alice B. Toklas* (New York: Liveright, 1973), 154; Parker Tyler, *The Divine Comedy of Pavel Tchelitchew* (New York: Fleet Publishing, 1967), 347.

201. Imbs quoted in James R. Mellow, *Charmed Circle: Gertrude Stein and Company* (New York: Praeger, 1974), 339.

202. James Thrall Soby, *Tchelitchew, Paintings, Drawings* (New York: Museum of Modern Art, 1942), 17.

203. Simon, *Alice B. Toklas*, 128, citing Tchelitchew's Ryerson lecture (typescript at Beinecke Library).

F. SCOTT FITZGERALD
1896–1940

BY HARRISON FISHER
1877–1934

Sanguine conté crayon and white paint on paperboard, 57.3 x 31.4 cm (22 9/16 x 12 3/8 in.), 1927
Inscription: *recto* To F. SCOTT FITZGERALD / FROM HIS FRIEND – / Harrison / Fisher; *verso* [illegible] / as other one / 1012 / 2 frs 18 X 26—8173 [illegible] / Scott Fitzgerald / Edg [illegible]
Gift of his daughter, Mrs. Scottie Smith
NPG.73.29

Handsome as the Arrow shirt man, socially ebullient, and intellectually vivacious, F. Scott Fitzgerald embodied the spirit of the Roaring Twenties. He staked his claim as the voice of his generation with his first novel, *This Side of Paradise* (1920), which he followed up with a series of short stories and important novels, including what is perhaps the most well known and representative work from the decade, *The Great Gatsby* (1925). Despite his early literary success, however, Fitzgerald was always aware of his own limitations and the fleetingness of fame. Later in his life, looking back to 1920, when he had arrived on the New York literary scene as a newly published and recently married young author, he recalled bawling "because I had everything I wanted and knew I would never be so happy again." His premonition would prove true. Fitzgerald's quick rise to prominence was matched by an equally swift decline, brought on in part by his alcoholism, free spending, and his wife Zelda's descent into schizophrenia at the close of the decade. "You remember I used to say I wanted to die at thirty," he reminded a friend the year before this portrait was made. "Well, I'm twenty-nine and the prospect is still welcome."[204]

Born in Saint Paul, Minnesota, Francis Scott Key Fitzgerald was named for the author of "The Star-Spangled Banner," an ancestor on his father's side. He entered Princeton in 1913, dropping out in 1917 to join the army with a second lieutenant's commission.[205] He began writing his first book (then called "The Romantic Egotist") while stationed in Fort Leavenworth, Kansas, and met Zelda Sayre, whom he would court relentlessly, in Montgomery, Alabama, when he was transferred there the following year. With World War I over, Fitzgerald was discharged from the army in early 1919, the same year he made his first sale to a popular journal, *The Smart Set*, and was notified that his novel had been accepted for publication by Scribner's. Finally convinced of his potential to support her leisured life-style, Zelda agreed to marry Fitzgerald in 1920. His income and reputation rose steadily during the early twenties with the publication of *The Beautiful and the Damned* (1922), *Tales of the Jazz Age* (1922), and *The Great Gatsby*.

Returning to the United States from a two-year sojourn in Paris and on the Riviera with Zelda at the end of 1926, Fitzgerald was asked to write a flapper story for a United Artists film that would feature the comedy star Constance Talmadge. Without consulting his agent, Fitzgerald jumped at the chance to go to Hollywood and tackle the genre of screenwriting. "Generally acknowledged for several years as the top American writer both seriously and, as far as prices went, popularly," he was, as he wrote to his only child, Scottie, "confident to the point of conceit" at this high point in his career. He had begun drinking heavily while in Europe, however, and was often seen behaving badly at fashionable Hollywood fêtes— barking like a dog on his hands and knees until admitted to the party of Sam Goldwyn, for example, and boiling the valuables of guests of another party in a can of tomato soup.[206] These antics tarnished Fitzgerald's reputation just as similar stunts had already put a strain on some of his closest friendships, most notably those with Ernest Hemingway and Gerald and Sara Murphy. After eight weeks of work on his screenplay *Lipstick*, Fitzgerald left Hollywood and was later informed that his script would not make it to the big screen. He was convinced that a quarrel he had had with Talmadge was the cause of its rejection. As a retaliatory snub against the town he would later call "hideous" and "a dump," he and Zelda piled the furniture of their Ambassador Hotel suite up in the middle of the room before catching the train back east, leaving their unpaid bills at the top of the heap.[207]

Fitzgerald's fair, almost angelic features bespoke none of the inner torment that his friends considered

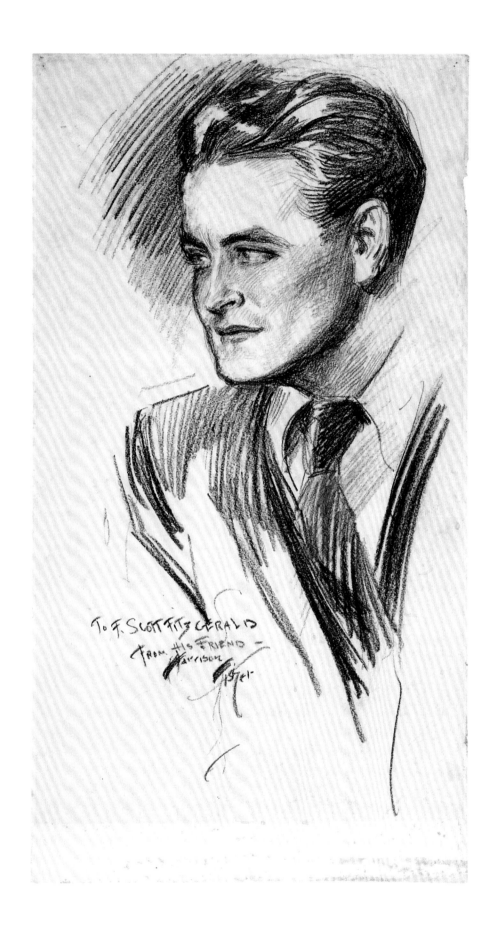

To F. Scott Fitzgerald
from His Friend –
Harrison
1921

121

to be at the root of his alcoholism and constant need for approval. When the illustrator Harrison Fisher drew Fitzgerald's portrait, probably at the same time that he drew Zelda in January 1927 [cat. no. 20], the couple's relationship was eroding, owing to Fitzgerald's infatuation with the young actress Lois Moran (who would be his model for Rosemary Hoyt in *Tender Is the Night,* 1934), and Zelda's growing envy of her husband's talent, which caused her to lash out at him in unspeakable ways. Although he was trying to hold onto his youth through his relationship with the young Moran, Fitzgerald still appears boyish at the age of thirty in Fisher's portrait.[208] With rich conté crayon, Fisher describes Fitzgerald's "very fair wavy hair . . . high forehead, excited and friendly eyes and . . . delicate long-lipped Irish mouth that, on a girl," Hemingway considered, "would have been the mouth of a beauty." It was Fitzgerald's mouth that, according to Hemingway, revealed something of the writer's disquiet: "The mouth," he wrote "worried you until you knew him and then it worried you more."[209]

Fisher, the heir to celebrated black-and-white illustrator Charles Dana Gibson, was on one of his annual visits from New York City to California when he sketched the Fitzgeralds' portraits. Making use of the new technologies in color reproduction, Fisher received commissions from every major magazine and publishing house from about 1907 until 1920, when he was at the height of his fame. His brand of American womanhood—less aloof than Gibson's, more self-possessed than Howard Chandler Christy's—graced the covers of a broad spectrum of journals, including the *Saturday Evening Post, Cosmopolitan,* and the *Ladies' Home Journal,* and appeared in innumerable product advertisements, on calendars, candy tins, and on posters spurring American citizens to support the nation's involvement in World War I. In his late career, Fisher devoted himself almost exclusively to portraiture and could claim some of the country's best, brightest, and most beautiful among his clients.

The Fitzgeralds would naturally have wanted Fisher to sketch their portraits on their arrival in Hollywood in January 1927. To be drawn by the renowned illustrator was a mark of "social success and distinction," something that Scott Fitzgerald was struggling at that point in his career to retain.[210] Fisher frequented some of the same parties as the couple and was probably as attracted to their celebrity as they were to his. He was always, moreover, looking for subjects other than women to portray, and was probably excited by the prospect of

drawing the talented and notorious writer. Perhaps because he was accustomed to sketching women, however, Fisher's portrait of Zelda is more loose and intuitive than his drawing of Scott, which seems almost timid by comparison. The lines that define the shadows of the novelist's face are softer and more careful, with white paint used as a corrective around the contours of his hair, eyes, and along the vertical line describing his forehead, right cheekbone, and chin.

Fisher inscribed the portrait, "To F. Scott Fitzgerald, From His Friend—Harrison Fisher," with his characteristic diagonal flourish through the middle of his last name. The words "His Friend" must have been an afterthought, however, as they appear lighter and awkwardly spaced. The portraits were clearly a publicity opportunity for both the artist and his famous sitters; a photograph of Fisher sketching Zelda appeared in at least two of the artist's obituaries in 1934. "His Friend" was perhaps added to the inscription to indicate Fisher's intimacy with his subject, with whom he had been photographed, together with other Hollywood luminaries, during the Fitzgeralds' two-month California stay.[211]

Fitzgerald returned to Hollywood in 1931, after Zelda's breakdown, and in 1937, when, deeply in debt, he signed a contract to write for Metro-Goldwyn-Mayer. His knowledge of the inside workings of the film studios served as the foundation for his final novel, *The Last Tycoon,* which remained unfinished at his death in 1940.

J.A.G.

204. Quoted in Matthew J. Bruccoli, *Some Sort of Epic Grandeur: The Life of F. Scott Fitzgerald* (New York and London: Harcourt Brace Jovanovich, 1981), 135; quoted in Arthur Mizener, *The Far Side of Paradise: A Biography of F. Scott Fitzgerald* (Boston: Houghton Mifflin, 1951), 201.

205. Fitzgerald had dropped out of Princeton in 1915 because of low grades and poor health, but he returned in 1916, only to leave the following year.

206. Fitzgerald to Scottie Fitzgerald [Smith], in Bruccoli, *Epic Grandeur*, 424. Jeffrey Meyers, *Scott Fitzgerald: A Biography* (New York: HarperCollins, 1994), 169, places the blame for the jewelry boiling on Scott, while James R. Mellow, *Invented Lives: F. Scott and Zelda Fitzgerald* (Boston: Houghton Mifflin, 1984), 282, writes that it was Zelda who did the boiling, collecting the ladies' purses and not their jewels.

207. In 1940 he wrote to a friend back east, "Isn't Hollywood a dump—in the human sense of the word. A hideous town, pointed up by the insulting gardens of its rich, full of the human spirit at a new low of debasement" (in Bruccoli, *Epic Grandeur*, 427).

208. Nancy Milford, *Zelda: A Biography* (New York: Harper & Row, 1970), 153–54, dates the rupture in their marriage to 1926 when, while in France, "Scott worriedly told the wife of a friend of theirs that Zelda complained of his inability to satisfy her." Zelda later accused him of being homosexual. Both accusations caused Fitzgerald immeasurable anxiety and led him to solicit the opinion of Hemingway on "the way [he] was built," an exchange famously described in Hemingway's *Moveable Feast* (1964; reprint, New York: Touchstone, 1996), 190–91. Thomas J. Stavola, *Scott Fitzgerald: Crisis in an American Identity* (New York: Barnes & Noble, 1979), 58–59, suggests that Fitzgerald's involvement with Moran stemmed from his fear of growing old.

209. Hemingway, *Moveable Feast*, 149.

210. Q. David Bowers, Ellen H. Budd, and George M. Budd, *Harrison Fisher: Identification, Descriptions, Pictures of Postcards by America's Most Famous Illustrator of Beautiful Women* (Wolfenboro, N.H.: Q. D. Bowers, 1984), 125.

211. "Pen Stilled by Death," *Los Angeles Evening Herald and Express,* January 19, 1934, National Portrait Gallery vertical files. See also *The Romantic Egoists*, ed. Matthew J. Bruccoli, Scottie Fitzgerald Smith, and Joan P. Kerr (New York: Charles Scribner's Sons, 1974), 150, 151.

ZELDA FITZGERALD
1900–1947

BY HARRISON FISHER
1877–1934

Sanguine conté crayon on paperboard, 58.4 x 36.2 cm (23 x 14¼ in.), 1927
Inscription: recto Harrison / Fisher / Los Angeles /Jan–29–1927 7990; verso 106 [illegible]
Gift of her daughter, Mrs. Scottie Smith
NPG.73.46

Recalling a visit to the Fitzgeralds' Hollywood bungalow in 1927, actress Louise Brooks commented, "What dominated the room was the blazing intelligence of Zelda's profile. It shocked me. It was the profile of a witch."[212] The sharp, angular features that made Zelda a stunning beauty when F. Scott Fitzgerald married her in 1920 are played up to great effect in this portrait by Harrison Fisher [see also cat. no. 19]. With her long neck, modern coiffure, and parted lips, Zelda looks the model of the glamorous Hollywood starlet descended from the likes of the "Gibson Girl." It would be only three years until Zelda's mental breakdown, when her beauty faded as her mind declined. If, at this early date, she could be unfavorably described as a witch with "piercing" eyes, by 1934 she would become a "living agonizing sore" in Fitzgerald's portrayal of her in *Tender Is the Night*.[213]

The daughter of a conservative judge in Montgomery, Alabama, Zelda Sayre was renowned as much for her nonconformist attitudes as for her beauty. She was known to smoke, drink, and sneak out of her bedroom window for evening outings— undisciplined behavior that earned her a throng of male admirers. When he met her while stationed with the army in Montgomery, Scott Fitzgerald found Zelda's attitude toward life, so like his own, irresistible. She was initially uncertain of his potential but finally agreed to marry him after his first novel, *This Side of Paradise* (1920), brought him critical acclaim as well as a small fortune.

The couple experienced the twenties in a haze of parties and alcohol, reveling in the extravagance and the flowering of youth culture that defined the decade. They divided their time between Europe and the United States and were central to the expatriate community of Americans living in France. When they returned to the United States in late 1926 from a two-year stay in France, Scott was asked to write a

screenplay for the comedy star Constance Talmadge. They took the train out to Hollywood in January 1927, but despite the excitement of traveling to a new place and meeting some of the country's most cherished stars, Zelda remained homesick for Paris and New York.[214]

Some of Zelda's distaste for Hollywood surely stemmed from her husband's affections for the young film star Lois Moran. The Fitzgeralds' marriage was beginning to go sour—although they would never divorce—and Scott found in Moran a kind of ambition that he felt was absent in Zelda, who wrote only sporadically for popular journals without, in Scott's mind, any real vocation of her own. Accustomed to being the center of attention in her youth, Zelda was envious of Scott's stardom and devotion to his work. His interest in the talented and accomplished Moran, whom Zelda considered "like a milkmaid" and nothing like herself, stirred her to seek out something of her own, to find a way, as Scott put it, to "be something herself."[215]

Writing, painting, and dancing became outlets for Zelda's frustrations. Determined to be "a Pavlova, nothing less," even at her late start at the age of twenty-eight, she dedicated herself to ballet with a compulsive intensity that would eventually lead to her breakdown in 1930.[216] In *Save Me the Waltz* (1932), which she wrote while institutionalized, Zelda articulated what she had hoped to gain from her endless hours of practice with Madame Lubov Egorova, the head of Sergei Diaghilev's ballet school:

> It seemed to Alabama that, reaching her goal, she would drive the devils that had driven her—that, in proving herself, she would achieve that peace which she imagined went only in surety of one's self—that she would be able, through the medium of dance, to command her emotions, to summon love or pity or happiness at will, having provided a channel through which they might flow.[217]

Dancing was therefore not only a means for Zelda to establish her identity apart from Scott and live up to his expectations, but also, she hoped, a way to rein in the "devils" that haunted her. Although she was invited to join the San Carlo Opera Ballet School in Naples, Italy, in 1929, with a solo role in *Aïda* for her debut, Zelda inexplicably declined the offer. Her artistic and literary efforts also proved disappointing. In 1934 she had an exhibition in New York of thirteen paintings and fifteen drawings, including a self-portrait [fig. 37]. Reviewers, however, seemed more interested in rediscovering a Jazz Age

Fig. 37. *Zelda Fitzgerald* (1900–1947), self-portrait. Gouache on paper, 1930s. Princeton University Library, New Jersey

personality than seriously considering her art.[218] She had even less success as a playwright.

The illustrator Harrison Fisher must have been attracted not only to Zelda's beauty but also to her enigmatic character when he sketched her and her husband in Hollywood in January 1927. Bored by the "merely pretty girls" he was continually drawing for the covers of *Cosmopolitan*, the *Ladies' Home Journal*, and other magazines, Fisher used his annual trips to California to search out the more natural, self-reliant types he found to be native to the region. While Zelda possessed the "femininity, grace, personality, and intelligence" that Fisher considered integral to the makeup of the American beauty, she did not, as he prescribed, "avoid extremes;" indeed, her disposition depended on her reverberation between opposing emotional poles.[219]

Despite her oftentimes outrageous behavior, Zelda was praised by her friends and acquaintances for her spontaneity, intellect, and dignity. Zelda's doctor considered her "brilliant," and her close friend Sara

Murphy wrote that her "dignity was *never* lost in the midst of the wildest escapades." She was uncompromisingly forthright, as when she told Scott to "stop looking for solace: there isn't any, and if there were[,] life would be a baby affair," but also had a biting sense of humor. Writing from her hospital in Switzerland, she joked to Scott that she and a "fellow maniac" prowled the streets of Geneva. Although she attacked her husband in *Save Me the Waltz*, she recognized their mutual dependency and was grateful for his enduring love for her. "I realize more completely than ever," she wrote, "how much I live in you and how sweet and good and kind you are to such a dependent appendage."[220]

Fisher's portrait of Zelda, freely drawn with broad strokes of rich conté crayon, perhaps reflects the tension he may have perceived in her personality. Emphasizing her sharp nose and chin, Fisher depicts Zelda in profile with her "hawk's eyes," as Hemingway described them, safely gazing, not directly at the viewer, but off to the right edge of the picture plane.[221] The artist pays the most attention to the structure of Zelda's face, which he carefully describes with heavy shading. This very fixed profile is surrounded by an energetic display of crisscrossing lines that seem to only vaguely conform to the contours of her upper torso. Although the looseness of Fisher's technique in this drawing corresponds to his shift away from the careful draftsmanship of his earlier work, the chaotic nature of these lines—especially when compared to the artist's controlled portrait of Scott—seem a poignant comment on her passion and perhaps even her fragile mental state. That the artist sketched Zelda out-of-doors in the region he considered to be the bastion of the healthy American woman just three years before her breakdown makes this portrait an ironic monument to her often alienated sense of self.

The Fitzgeralds kept Fisher's portraits with them all their lives. The drawings were later given to the National Portrait Gallery by the couple's only child, Scottie Smith.

J.A.G.

212. Quoted in Mellow, *Invented Lives*, 283.

213. Actress Lois Moran, quoted in Milford, *Zelda: A Biography*, 131, commented on Zelda's "very intent, piercing" eyes. F. Scott Fitzgerald, *Tender Is the Night* (1934; reprint, New York: Scribner Paperback Fiction, 1995), 183.

214. "The weather here makes me think of Paris in the Spring and I am *very* homesick for the pink lights and the trees and the gay streets," Zelda wrote to her daughter, Scottie, from Hollywood. And in another letter, she vowed "If we ever get out of here I will *never* go near another moving picture theatre or actor again. I want to be in New York where there's enough mischief for everybody—that is, if I can't be in Paris. . . . There's nothing on earth to do here but look at the view and eat" (in Milford, *Zelda: A Biography*, 128).

215. In 1927, Zelda wrote, "A young actress is like a breakfast food that many men identified with whatever they missed from life since she had no definite characteristics of her own save a slight ebullient hysteria about romance. She walked in the moon by the river. Her hair was tight about her head and she was lush and like a milkmaid" (in Meyers, *Scott Fitzgerald*, 172). For the quote of Scott Fitzgerald, see Mellow, *Invented Lives*, 337.

216. Zelda quoted in Stavola, *Scott Fitzgerald: Crisis*, 60.

217. Quoted in Milford, *Zelda: A Biography*, 141.

218. Ibid., 289–91.

219. Fisher quoted in Bowers, Budd, and Budd, *Harrison Fisher: Identification*, 50, and the *Los Angeles Examiner*, January 20, 1934, National Portrait Gallery vertical files. Fisher quoted in Tina Skinner, with price guide by Bruce Magnotti, *Harrison Fisher: Defining the American Beauty* (Atglen, Penn.:

Schiffer Publishing, 1999), 8.

220. Dr. Forel quoted in Milford, *Zelda: A Biography*, 179; Murphy quoted in Mizener, *Far Side of Paradise*, 200; Zelda quoted in Milford, *Zelda: A Biography*, 191, 189, and in Meyers, *Scott Fitzgerald*, 200.

221. Hemingway, *Moveable Feast*, 180.

STUART DAVIS
1892–1964

or

WYATT DAVIS
1906–1984

BY STUART DAVIS
1892–1964

Graphite on paper, 46.4 x 33.5 cm (18¼ x 13³⁄₁₆ in.), circa 1927
NPG.82.131

The year 1927 was one of discovery and triumph for Stuart Davis, marking the culmination of his seven years of work on a series of landscape and still-life paintings, as he gradually devised his own American version of French cubism. Late in that year, Davis nailed three ordinary American objects to a table: an electric fan, an eggbeater, and a rubber glove. He painted nothing but variations on this still life for months. The resulting "Eggbeater" paintings were the most sophisticated cubist paintings any American had yet created.[222]

But still life was not the only traditional art subject that Davis attacked in 1927. In a little-known series of pencil drawings, including the Portrait Gallery's possible self-portrait, Davis strove to formulate a modern kind of portraiture in harmony with his still lifes and landscapes.[223]

Davis's background had given him a sophisticated understanding of art from an early age. In 1909 his parents, both artists, gave him permission to leave high school to study art in New York with realist painter Robert Henri. Henri and his followers, branded the Ashcan School, shocked critics with their gritty urban subject matter and vigorous style. But the Armory Show of 1913, the first great exhibition of European modernism in the United States, revealed to Davis that even the most daring American art was dull and provincial compared with European avant-garde works. Seeing the revolutionary formal distortions of European postimpressionists, futurists, and cubists, Davis resolved that he "would quite definitely have to become a 'modern artist.'"[224] First he adopted the brilliant colors and expressive forms of the postimpressionists, then by 1921 he was ready to attempt the most advanced and controversial style at the Armory Show—cubism.

Inspired by French cubist works, Davis painted a series of tabletop still lifes. Still life gave Davis a controlled laboratory setting for experimenting with

the conception and realization of visual forms. But rather than French subjects such as fruit, books, wine glasses, and pipes, Davis painted American objects— lightbulbs, magazines, beer glasses, and Bull Durham tobacco packs. He discarded the French cubists' dark palette used to evoke the smoky rooms of Parisian café society. Instead, Davis's bright and crisply delineated cubism reflected the mass-produced products and swift pace of modern life in New York.

As Davis mastered the formal aspects of cubism, he expanded his subject matter to include cityscapes of Manhattan and harbor scenes of Gloucester, Massachusetts. But he no longer painted self-portraits as he had under the influence of Henri and Vincent Van Gogh. Only in his illustrations for such avant-garde magazines as the *Masses* and the *Dial* did the human form continue to play an important role. In about 1923, Davis wrote, "My original interest in character has waned. . . . I am interested in a new sense of space and have not yet succeeded in getting it sufficiently clear in my mind to feel at home with it."[225] In his cubist collages and gouaches in the early to mid-1920s, faces were reduced to simple symbolic ovals or polygons with or without briefly outlined features. In New Mexico in 1923, Davis painted rigid figures as angular sculptures still imprisoned within blocks of stone or wood.

With his highly abstracted "Eggbeater" series of late 1927 and early 1928, Davis found his mature conception of art, fusing cool formalism with individual passions. In 1945, looking back on that period, he stated, "You may say that everything I have done since has been based upon that eggbeater idea."[226] But at the moment of his still-life epiphany, Davis's mind was also on portraiture. Neither the French cubists nor Davis could resist the challenge of finding a modern conception of this most familiar and powerful of artistic subjects.

Around 1927, Davis made this drawing, which is either a self-portrait or a portrait of his younger

brother, Wyatt. Wyatt Davis was a professional photographer who looked much like Stuart but was slimmer.[227] The identity of the subject was apparently less important to Davis than was the form as a young, male, American face. The profile view of a young man in a tie and fedora was the portrait equivalent of Davis's strongly outlined paintings of lightbulbs and beer mugs. He suppressed individual details to gain a deeper understanding of how the eye and the mind experienced the object. The profile was ideal for Davis's purposes: it allowed him to nail down the unequivocal lines of the face without

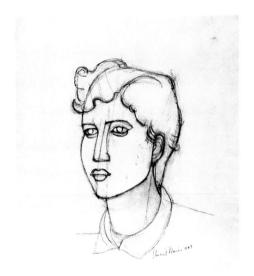

Fig. 38. *Portrait of a Woman* by Stuart Davis (1892–1964). Pencil on paper, 1927. Collection of Earl Davis

worrying about the deeper space and more complex perspective of a three-quarter or full-face view.

Davis's severely outlined portrait drawing resembles a series of neoclassical portrait drawings and paintings that Pablo Picasso made beginning in 1914, when he had established his fame as a cubist. By 1927, Davis surely knew these well-circulated linear works through exhibitions or reproductions. For the French cubists, neoclassicism offered a kind of balance to the visually fractured forms of cubism.[228] But in Davis's pure linear drawing, he searched for the underlying universal shapes of the human face so that he could convert them into his personal formal vocabulary. He made a tentative attempt at this transformation in a drawing of a woman rendered in the same heavy line but with the cheek and neck distorted into rectangular cubist planes.

By comparison with Davis's cubist works of the same year, the Portrait Gallery's profile drawing looks naturalistic. The face, however, is carefully

constructed on a geometric framework. In the two less-finished drawings from the same time, one can clearly follow Davis's process of building up each face from a combination of geometric volumes—spheres, cylinders, and polygons [fig. 38]. He would then draw a heavy outline over the structure, molding it to fit human contours but hardly masking the structure beneath. In this profile, Davis removed some of the more obvious lines of construction, but the box that became the nose is still clearly visible. As Davis polished the drawing, he adjusted the bottom line of the nose many times, gave a slight curve to the precise right angle of the shirt collar, and softened the form of the hat.

This drawing, however, is not a finished, public work. Davis's completed pieces were always meticulously neat. He stated, "The painting which shows construction lines, mistakes and successes alike, needs to be cleaned up. . . . Construction lines . . . constitute small talk which confuses the issue."[229] But of all of his portrait drawings from about 1927, this one comes closest to a finished interpretation from which Davis could have made a painting. Fleshing out the harsh geometric scaffolding, he added the rippling lines of the man's rumpled jacket and a few indications of the texture and pattern of the hat, hair, and jacket.

Davis never actually made a painting based upon this drawing. His trip to Paris in 1928 interrupted his foray into modernist portraiture, and his subsequent work was dominated by cityscapes and commercial still-life imagery. Yet he did not forget the human face. Outlines of faces show up in a number of his drawings, prints, and paintings, most frequently in the 1930s. His portrait drawings from 1927 inform these faces, whose outlines were similarly simplified although more organic. The strongest evidence of Davis's continuing interest in the human face appears in his *American Painting*, first shown in 1932.[230] It includes four schematic figures (possibly portraits of himself and friends), a large cubist face, and the geometric outline of a top-hatted man in profile. Davis tinkered with the painting in 1948 and into the 1950s, eventually completing a new version in 1956 called *Tropes de Teens*.[231] After his 1927 portrait drawings, the human face was not a major subject for Davis, but it remained an important aspect of his artistic vocabulary.

A.P.W.

222. Stuart Davis, *Stuart Davis* (New York: American Artists Group, 1945), n.p.; Brian O'Doherty, "Stuart Davis: Colonial Cubism," in *American Masters: The Voice and the Myth in Modern Art: Hopper, Davis, Pollock, De Kooning, Rothko, Rauschenberg, Wyeth, Cornell* (New York: E. P. Dutton, 1983), 67.

223. The editors of the Stuart Davis Catalogue Raisonné Project have identified three portrait drawings of women in a style very close to that of the Portrait Gallery's drawing and therefore from presumably the same period. Two of these works, including one signed by Davis and dated 1927, are in the estate of the artist. A third drawing in a more cubist form is in a private collection.

The Portrait Gallery's drawing was previously in the estate of Davis's friend Charles Allen Winter. It was found in Winter's Gloucester, Massachusetts, home after his death (Robert Schoelkopf, Robert Schoelkopf Gallery, New York City, to Robert G. Stewart, curator, National Portrait Gallery, September 15, 1982, curatorial files of the National Portrait Gallery). There is no evidence to determine whether the drawing was made in Gloucester when Davis was summering there, or in New York.

224. Davis, *Stuart Davis*, n.p.; Robert Hunter, "The Rewards and Disappointments of the Ashcan School: The Early Career of Stuart Davis," in Lowery Stokes Sims et al., *Stuart Davis: American Painter* (New York: Metropolitan Museum of Art, 1991), 31.

225. Microfilm reel 1, "1923 (?) (b) no date," Stuart Davis Papers, Fogg Art Museum, Harvard University, Cambridge, Massachusetts (quoted in Patricia Hills, *Stuart Davis* [New York: National Museum of American Art, Smithsonian Institution, and Harry N. Abrams, 1996], 67).

226. Quoted in James Johnson Sweeney, *Stuart Davis* (New York: Museum of Modern Art, 1945), 16–17.

227. If the drawing is a self-portrait, being a profile view, it must be based upon a now-lost photograph, or less likely, made through two precisely positioned mirrors that would require the artist to hold absolutely still as he simultaneously drew and modeled.

Biographical information about Wyatt Davis comes from his daughter, Joan Davis.

228. Michael C. Fitzgerald, "The Modernists' Dilemma: Neoclassicism and the Portrayal of Olga Khokhlova," in Rubin, ed., *Picasso and Portraiture*, 297–334 [see cat. no. 14, n. 155]. Picasso's fellow cubist Juan Gris made similar portrait drawings in 1920 and 1921 (Mark Rosenthal, *Juan Gris* [New York: Abbeville, 1983], 108, 151, 160).

229. September 16, 1942, Davis Papers, quoted in Karen Wilkin, "Stuart Davis and Drawing," in Wilkin and Lewis Kachur, *The Drawings of Stuart Davis: The Amazing Continuity* (New York: American Federation of Arts and Harry N. Abrams, 1992), 11.

230. Joslyn Art Museum, University of Nebraska at Omaha Collection. See Hills, *Stuart Davis*, no. 92, for the original version of the painting, from a photograph in the collection of Earl Davis, the artist's son.

231. Hirshhorn Museum and Sculpture Garden, Smithsonian Institution, Washington, D.C. (Hills, *Stuart Davis*, no. 115; Sims et al., *Stuart Davis*, 226–28; John R. Lane, *Stuart Davis: Art and Art Theory* [Brooklyn, N.Y.: Brooklyn Museum, 1978], 154–55). Lewis Kachur states that the four figures may be the artist himself, John Graham, Arshile Gorky, and possibly Willem de Kooning or Jan Matulka (Kachur, "Stuart Davis's Word-Pictures," in Sims et al., *Stuart Davis*, 101–2).

PAUL ROBESON
1898–1976

BY HUGO GELLERT
1892–1985

Lithographic crayon and graphite on paper, 38.9 x 32.3 cm (15 5/16 x 12 11/16 in.), 1928
Original drawing for the *New Yorker*, September 29, 1928
Inscription: *recto* R / HUGO / GELLERT / LINE / [illegible] / Robeson / Profile / ill; *verso* A4444 / 74 j–9 / t 1–7
NPG.88.186

Hugo Gellert originally made his drawing of singer Paul Robeson to illustrate the *New Yorker* "Profiles" article "King of Harlem" in the September 29, 1928, issue. Yet the legacy of this image endured long beyond his original intent. Not only did the portrait appear in various forms throughout the long lifetimes of both artist and sitter, but it also reflected the political views and striving for justice the men shared.

In 1928, Robeson was at the height of his popularity in both America and Europe. That year in England, he was acclaimed for his role as Joe in the musical *Show Boat*. Robeson's stirring rendition of "Ol' Man River" brought record crowds to the Drury Lane Theatre in London, and his concert programs of Negro spirituals captivated his audiences with their depth of feeling. Robeson's African American followers, the *New Yorker* author noted, felt that his influence was "greater than that of a dozen agitators because he sings their songs the way they want them sung. They hear their own voices in his spirituals: 'Sometimes I feel like a motherless chile . . .' or soaring triumphantly: 'Sometimes I feel like an eagle in the air.'"232

Gellert probably based his drawing upon a photograph of Robeson found among the artist's personal papers [fig. 39]. This same photograph illustrated the program for Robeson's first formal concert, at Copley Plaza in Boston, Massachusetts, on November 2, 1924, in which he sang many of the spirituals for which he would become famous.233 Influenced by cubist abstraction, Gellert transformed the photographic image into a highly personal interpretation. Robeson's face is fuller in the drawing than in the photograph, a typical feature of Gellert's figural style. Using the side of the lithographic crayon, Gellert drew broad, dark arcs of shading across the forehead, repeating a crescent-shaped stroke that echoes the adjacent shape of the ear. He translated Robeson's short-cropped, curly hair into

rows of a sharp zigzag pattern. Angular faceting appears throughout the face, particularly on the bridge of the nose and above the left eye. Gellert's abstraction of the photograph gives Robeson's portrait an iconic quality that reflects his growing fame yet conveys the dignity of his personality and richness of his voice.

As Gellert's drawing and the "Profiles" article suggest, Robeson was a multifaceted man, accomplished as a singer, actor, intellectual, lawyer, and athlete. Born in 1898 in Princeton, New Jersey, to the son of a former slave, he won a full scholarship to Rutgers University, where he became an accomplished football player and a Phi Beta Kappa scholar. In 1920, while at Columbia Law School, he acted in his first New York play. After graduation, Robeson joined a New York law firm, but when a white secretary refused to take his dictation, he decided to leave the profession and pursue acting. Playwright Eugene O'Neill cast Robeson in leading roles in *All God's Chillun Got Wings* (1924) and the revival of *The Emperor Jones* (1925).234 The former, a new drama about an interracial couple, provoked protests and threats from racist groups that nearly prevented the company from performing. In the 1930s, Robeson acted the role of Othello to critical acclaim on stage and on screen, and performed in numerous motion pictures, including *The Emperor Jones, Song of Freedom,* and *Proud Valley.*

But Robeson's political activism was controversial. In 1928 he was invited to the British House of Commons, where he met several left-wing Labour Party members.235 Robeson reflected later in life that it was in Britain that he became acquainted with the struggles of the working man, the efforts of organized labor, and Socialist politics.236 Starting in the 1930s, Robeson lent his voice to a variety of issues involving political, racial, and social injustice. Dismayed by the racial prejudice in his own country, he played a prominent role in civil rights. He

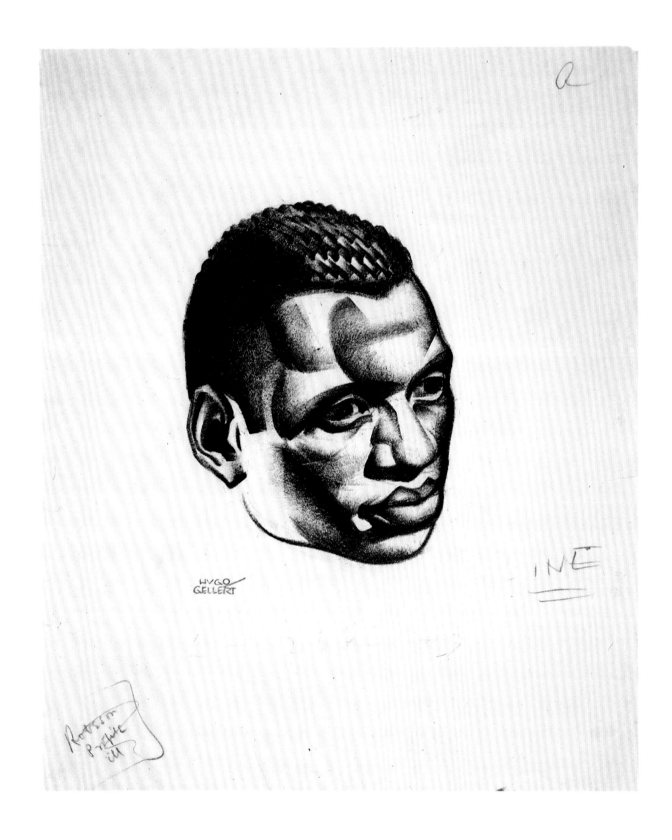

HVGO
GELLERT

LINE

championed labor unions and was a staunch anti-Fascist. Robeson visited the Soviet Union for the first of several visits in 1934.[237] He was impressed by the equal treatment given to blacks in the USSR. "Here[,] I am not a Negro, but a human being," said Robeson of his Soviet experience.[238]

Hugo Gellert shared many of Robeson's left-wing political views and felt that his art could be used to advance social change. Born in Hungary in 1892, Gellert immigrated in 1907 to New York. He learned lithography, designed theater and movie posters, and contributed illustrations to the Socialist paper *Elöre*.

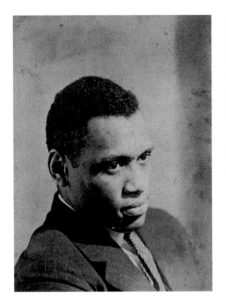

Fig. 39. *Paul Robeson* (1898–1976) by an unidentified photographer. Gelatin silver print, circa 1924. Hugo Gellert Papers, Archives of American Art, Smithsonian Institution

Trained at the Cooper Union School of Art and the National Academy of Design, he also studied briefly, in 1914, at the Académie Julian in Paris. World War I prompted his return to the United States, where he became a contributor to the left-wing journal the *Masses* and its successor, the *New Masses*. Gellert supported himself by accepting commissions from more mainstream publications such as the *New Yorker* and the *New York Times*. But in the 1920s, as a member of the New York John Reed Club and other organizations, he worked actively to address such social issues as racism, labor strife, and anti-Fascism. In 1928, Gellert painted his first labor mural and in 1937 organized an AFL-CIO labor union, the Mural Artists Guild. He illustrated an edition of Karl Marx's treatise on Socialism, *Capital in Lithographs* (1933), and wrote and illustrated *Comrade Gulliver* (1935), criticizing his country's racism and economic disparity.[239]

In 1952 Robeson was a guest speaker at a celebration of Gellert's fortieth anniversary as a professional artist.[240] Influenced perhaps by their similar politics, Gellert revisited his 1928 portrait of Robeson at least twice during his career. In the 1939 New York World's Fair, for which Gellert painted a mural and served as the chairman of the Artists Coordinating Committee, he included in the "American Art Today" exhibition what seems to have been a photolithographic print, in reverse, of his original Robeson drawing.[241] Much later, in 1972, the still-active octogenarian artist incorporated the image into a mural of famous Americans for Hillcrest High School in Jamaica, New York. Long before, Robeson's controversial political views had seriously hampered his musical and stage career, provoking repeated scrutiny from the House Un-American Activities Committee and causing the State Department to revoke his passport for eight years. The school board objected to Gellert's inclusion of Robeson in the mural, citing an ordinance banning portraits of living individuals in public buildings. Gellert lobbied the mayor of New York about the mural. "Paul Robeson is very ill (an outcome of the bitter battles for the welfare of his people)," he wrote. "Please, Mr. Mayor, favor this deserving man and great artist—let me include his image in my work." In the end, Gellert won his fight and painted Robeson's portrait into the mural. The original drawing remained in his possession throughout his life.[242]

During their respective long careers, both Gellert and Robeson revived material from the past, recasting it within a new context. When singing on behalf of social justice, Paul Robeson often reprised his performance of "Ol' Man River" from *Show Boat*. But instead of Oscar Hammerstein's sorrowful lyric "I'm tired of livin' and feared of dyin'," his powerful voice would proclaim, "I will keep fighting until I'm dying."[243] These resonant words embody the work of both Robeson and Gellert, artists who lived the conviction that art has the power to enact social change.

E.M.T.

232. Mildred Gilman, "Profiles: King of Harlem," *New Yorker*, September 29, 1928, 29.

233. Gellert scholar James Wechsler recalled seeing this photograph in the Hugo Gellert Papers, AAA. The program "Paul Robeson, Baritone" is in the Paul Robeson Papers, Bender Library, American University, Washington, D.C., microfilm 364, reel 2, frame 592 (original documents in the Schomburg Center for Research in Black Culture, New York Public Library, New York). The photograph also appears in the 1930 biography written by Robeson's wife. See Eslanda Goode Robeson, *Paul Robeson, Negro* (London: Victor Gollancz, 1930).

234. According to Wechsler, Gellert drew several program covers for Provincetown Players' productions in which Robeson acted.

235. Ron Ramdin, *Paul Robeson: The Man and His Mission* (London: Peter Owen, 1987), 57–59. On this visit, Robeson met Indian Member of Parliament Shapurji Saklatvala, who later became Robeson's friend and ten years later was a prominent Communist leader.

236. Paul Robeson, *Here I Stand* (1958; Boston: Beacon Press, 1971), 48. For more on Robeson's involvement in labor struggles, see Mark D. Naison, "Paul Robeson and the American Labor Movement," in Jeffrey C. Stewart, ed., *Paul Robeson: Artist and Citizen* (New Brunswick, N.J.: Rutgers University Press, 1998), 179–81.

237. Naison, "Paul Robeson," 179; David Levering Lewis, "Paul Robeson and the USSR," in Stewart, *Paul Robeson*, 217.

238. Quoted in Martin B. Duberman, *Paul Robeson* (New York: Alfred A. Knopf, 1988), 190.

239. Hugo Gellert Memorial Committee, *Hugo Gellert (1892–1985): People's Artist* (New York: n.p., 1986), 2; Hugo Gellert, *Comrade Gulliver* (New York: G. P. Putnam's Sons, 1935), 10.

240. *Hugo Gellert: People's Artist*, 7. In 1953, Robeson was a "guest speaker at [the] 40th anniversary of his [Gellert's] career." A letter of September 17, 1954, from [?eak] Zoltan and Michael Gold of the Hungarian Word, Inc., asks Robeson for his sponsorship of a "large affair to honor Hugo Gellert" (microfilm 364, reel 5, frame 44, Paul Robeson Papers). Unless these two sources discuss different events, it appears that the first source lists an incorrect date.

241. The lithograph is reproduced in *American Art Today: New York World's Fair* (Poughkeepsie, N.Y.: Apollo, 1987), 273; Hugo Gellert, "Hugo Gellert—Style and Tenacity," *Daily World* (New York), May 19, 1973, 5; and Johnny Woods, "'American Art Today': A High Point of Artistic Activity," *Daily World* (New York), September 4, 1975, 8. The caption in the latter source reads: "Gellert's lithograph of Paul Robeson was purchased and presented to the Birmingham, Alabama Public Library. He [Gellert] hopes it is still in existence." The lithograph's present location is unknown.

242. Gellert, "Hugo Gellert—Style and Tenacity," 7. The Portrait Gallery obtained the drawing in 1988 from the gallery handling Gellert's estate.

243. Robeson's first documented use of these revised lyrics occurred at a rally of December 19, 1937, in support of Democratic Spain. Lenwood G. Davis, *A Paul Robeson Handbook* (Kearney, Nebr.: Morris Publishing, 1998), 19.

Theodore Roszak
1907–1981

Self-portrait

Graphite on paper, 31.6 x 24 cm (12 $^{7}/_{16}$ x 9 $^{7}/_{16}$ in.), 1932
Inscription: *recto* T. Roszak / 1932; *verso* T Roszak. 1932
NPG.89.26

A disconcerting face gazes from this drawing—at once close and distant, warm and cold, classic and modern. Theodore Roszak drew this self-portrait in 1932, at a moment when he was moving between extremes of artistic tradition and modernity. The young Roszak had begun as a realist depicting the traditional folk characters of his family's Polish background. But between 1929 and 1931, a fifteen-month fellowship in Europe transformed him. Roszak later recalled "It was Europe that first introduced me to the great modern movement, so that going to Europe and seeing these things was a kind of strange and wonderful experience. . . . There was an overall absorption of many, many things, an infinite variety of surprises."[244] Overwhelmed by his rapid survey of art from Raphael to Giorgio de Chirico to Pablo Picasso, in 1932 he was questioning and reshaping many aspects of himself as a man and an artist.

Roszak had spent most of the 1920s studying and teaching at the Art Institute of Chicago. After his European sojourn the artist married Florence Sapir, a graduate student who became an English teacher. In 1931 a Tiffany Foundation Fellowship allowed the pair to join an artists' colony in Oyster Bay, Long Island. In 1932 they moved to Staten Island, where they lived for two years.[245] At the same time that he was transforming from midwesterner to New Yorker and from single to married, Roszak in his art gradually left behind realism and painting itself to become a constructivist sculptor. He explored his new self-image in a variety of paintings and drawings during the early thirties.

These self-portraits objectify tensions and confusions in Roszak's mind and art. For a time he agonized over the respective roles of visual art and music in his life. In several paintings and drawings Roszak portrayed himself as a musician playing the violin or the accordion, yet the very creation of the works as self-portraits shows his commitment to

visual art. While Roszak's identity as a musician soon disappeared from his art, the precise lines of the instruments remained as part of the artist's fascination with geometry.

The central struggle Roszak faced in the early thirties was between his twin allegiances to modernist geometry and the traditionally rendered human form. Even while Roszak was still in Europe in 1930, his consuming love of geometry boldly invaded the figurative world of his self-portraits. In an oil self-portrait, the artist grasps a triangle, protractor, and caliper [fig. 40].[246] Forms like those of his later constructions appear on a chessboard as frighteningly rocket- or bomblike game pieces, ready for the artist to deploy.

The opposition of the human and geometric fought itself out in a variety of sculptures, drawings, and paintings of the early thirties, in which antithetical forms wrestle and dance together. In cubist-influenced images, cylinders, strings, and sound holes violate the heads of serene women. In a plaster relief of 1933, *Musical Elements as Architectural Forms* (now destroyed), a welter of organic and mechanical forces collided as strings stretched over an open heart and a giant nose merged with a twisting tower. Such confusion found resolution in the mid-thirties when Roszak's gleaming constructivist sculptures emerged, clean and triumphant. They arose from the smooth geometric forms of balloons, zeppelins, and other modern machines.

As the geometry of Roszak's 1930 self-portrait came to dominate his abstract work, its image of the artist carried over to the others that Roszak made soon after his return to the United States. The 1932 drawing paraphrases in less extreme form the elongated head, exaggerated and distorted perspective, asymmetrical eyes, and striped shirt. But the drawing is unique among the 1930s self-portraits in including no references to Roszak as musician or

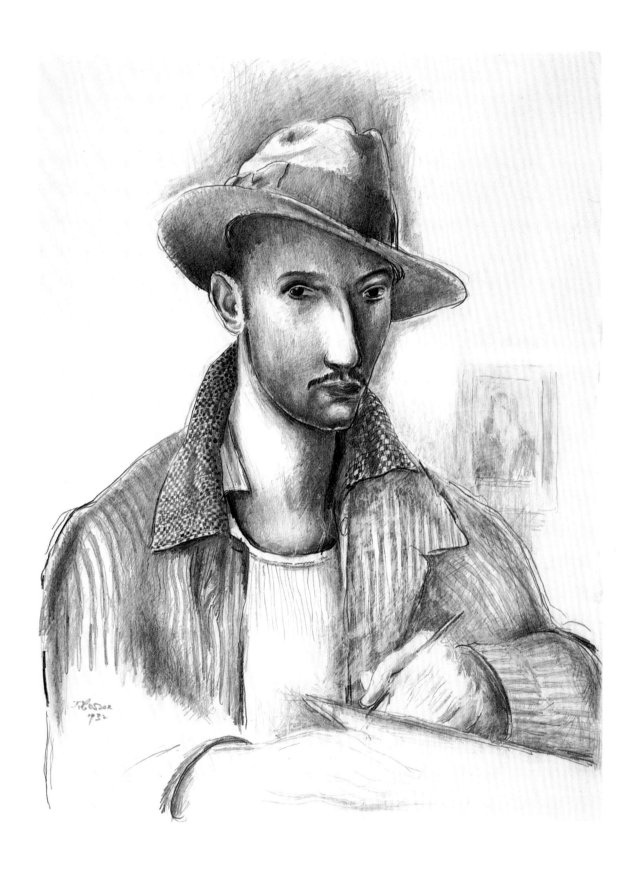

137

master of geometry. He called drawing "a cutting out, a sorting out, process."[247] In this drawing, Roszak cut out the progression of outside interests seen in other images, to resolve his self-image into his central, enduring identity as an artist, and more specifically, as a master draftsman.

Drawing had always been the wellspring of Roszak's art. In the late twenties, Roszak had taught drawing at the Art Institute of Chicago. As he planned his constructivist sculptures in the 1930s and early 1940s, his ideas flowed first onto paper. After World War II, Roszak's sculptural style, materials,

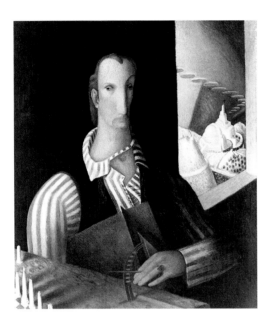

Fig. 40. *Theodore Roszak* (1907–1981), self-portrait. Oil on canvas, 1930. Collection of Xavier Simon

and subjects transformed utterly as he began the turbulent welded metal sculptures for which he remains best known. Yet his reliance on drawing to conceive his works remained. In 1956, Roszak said of his art, "It begins . . . with drawings."[248]

Roszak was a superior craftsman not only in his drawings but also in every medium he attempted. His characteristic care and skill shaped this drawing.[249] He achieved the subtle shading not by quickly smearing the pencil, but rather by applying countless strokes of pencil to create luminous tones. The smooth modeling evokes the precisely modulated surfaces of his sculptures.

Roszak originally placed the drawing hand higher in the composition and to the left of its current position, and the lapel on that side was turned forward. He then changed his mind and erased a large area of the image before carefully redrawing it. It seems fitting that an artist in the midst of re-creating his approach to art would revise the picture

of his drawing hand. During this transitional phase of his life, Roszak had one artistic eye trained on the past and one on the future. The features of this self-portrait retain some of the sleekness of Roszak's early drawings and lithographs depicting Eastern European folk characters. The simplified volumetric forms of artist's face, neck, and torso here also recall the figural style of artists Roszak had imitated before his European sojourn, the American Ashcan School members George Bellows, Leon Kroll, and Eugene Speicher. However, the distorted perspective that shifts the odd eyes in space and the strange shirt collars that change patterns, piercing and interweaving with each other, reflect surrealism and cubism.[250]

Between his traditional past and the radical, modernist future he envisioned, Roszak found an enjoyable present and drew it with loving accuracy. Photographs of the artist in the early thirties posing with his sculptures show him in the same felt hat and thin mustache that he drew here. The years in Staten Island were intensely productive, satisfying, and happy despite the deprivations the Roszaks shared with so many Americans during the Great Depression.[251] The framed picture in the background, possibly a painting of a woman, may make affectionate reference to the many times Roszak painted his wife during this period.

Roszak's warm human content seems profoundly at odds with the immaculate geometric constructions the artist would devote himself to for the next decade and a half. Yet the apparent contradiction is deceiving, for the human figure remained at the center of his art.[252] Roszak made several series of paintings, such as "Man Sewing" and "Mechanical Man," in which machine and man are gradually subsumed into a single harmonious being. No matter how cold and mechanical they may seem, the attenuated vertical forms of his constructions always contain an underlying allegiance to the upright human form. His machines never lose contact with their human creators. Even the violent, abstract sculptures that Roszak later made in reaction to World War II derive from the human form in the ways that they stand and move. In 1932, Roszak was still groping for his identity as an artist and a man amid a welter of artistic ideas. But in his self-portrait drawing of that year, he reasserted those things of which he remained sure: his identity as artist, draftsman, husband, and human being.

A.P.W.

244. Douglas Dreishpoon, *Theodore Roszak: Paintings and Drawings from the Thirties* (New York: Hirschl & Adler Galleries, 1989), 11–13, 15–20; quoted in James H. Elliott, "Interview with Theodore Roszak," February 13, 1956, transcript, microfilm reel N69–81, 9–10, Theodore Roszak Papers, AAA.

245. Howard E. Wooden, *Theodore Roszak: The Early Works, 1929–1943* (Wichita, Kansas: Wichita Art Museum, 1986), 11; Joan Marter, *Theodore Roszak: The Drawings* (New York: Drawing Society and University of Washington Press, 1992), 14; Dreishpoon, *Paintings and Drawings from the Thirties*, 27.

246. Dreishpoon, *Paintings and Drawings from the Thirties*, 20.

247. Quoted in Belle Krasne, "A Theodore Roszak Profile," *Art Digest* 27 (October 15, 1952): 9.

248. Quoted in Howard Griffin, "Totems in Steel," *ARTnews* 55 (October 1956): 34.

249. H. H. Arnason, *Theodore Roszak* (Minneapolis and New York: Walker Art Center, in collaboration with the Whitney Museum of American Art, 1956), 18. There are many stray scratches in the surface of the paper, but they were apparently inflicted on the drawing after the artist had completed it.

250. Dreishpoon, *Paintings and Drawings from the Thirties*, 17. Dreishpoon notes, "Though few in number, Roszak's Cubist paintings and drawings show a firm understanding of Cubism's spatial dynamics, compositional layering, and diverse content" (p. 24).

251. Ibid., 27.

252. Douglas Scott Dreishpoon, *Theodore J. Roszak (1907–1981): Painting and Sculpture* (Ann Arbor, Mich.: University Microfilms, 1993), 1–2.

FRITZ KREISLER
1875–1962

BY PAOLO GARRETTO
1903–1989

Collage of airbrushed gouache and crayon on wood laminate and illustration board, 30.8 x 23.8 cm (12 1/8 x 9 3/8 in.), 1933
Original illustration for *Vanity Fair*, March 1934
Inscription: *recto* GAR / RETTO / 33; *verso* Kreisler / Drawing by Garretto 1530 / Referring Brokaw to [illegible] / Vanity Fair 357 / 8898
Stamp: MADE IN FRANCE / [illegible]
NPG.89.159

Paolo Garretto's witty depiction of Fritz Kreisler is an aptly disembodied portrait for a musician whose fame rests as much on sound recordings as on his physical stage presence. The Viennese-born violinist's international reputation was well established in the first decade of the century, particularly in America, where extended tours fueled an enthusiastic popular following. But his 1910 contract with the Victor Phonograph Company launched a previously unimaginable degree of exposure and renown.[253] Like Metropolitan Opera tenor Enrico Caruso, Kreisler's musicianship was ideally suited to the fledgling gramophone industry. Critics exulted over the warmth and sweetness of his tone. His own compositions were beloved for their assertive melodies and dancelike rhythms. Frankly sentimental and unafraid of emotional effects, Kreisler provoked a response in his listeners that few could match. By the outbreak of World War I, he was one of the most admired and highest-paid musicians of the era, and Americans, according to his first biographer, "took him to their heart as few nations did."[254]

Although Kreisler was ostracized in the United States during the war years, by 1920 he was a full-fledged celebrity once again. His concerts were oversubscribed, his records sold in unprecedented numbers, and the press covered his every move and word.[255] Variously called a king, a giant, or a god of the violin world, Kreisler had reached a pinnacle of fame acknowledged in a *Vanity Fair* page titled *Olympians of the Musical Sphere* [fig. 41].[256] The collage of Kreiser appeared in this pantheon together with images of Arturo Toscanini, Ignace Paderewski, and Igor Stravinsky.

All four portraits were made by the Italian-born artist Paolo Garretto. In his art studies, first in Milan and then in Rome, where his family had moved in 1921, Garretto had become fascinated with cubism and futurism.[257] In Rome he befriended Filippo Tommasco Marinetti, Fortunato Depero, and Giacomo Balla, absorbing these futurist artists' rejection of traditional approaches. "We were all conscious," he later wrote Steven Heller, of "pushing and trying to change something or everything." Inspired by Balla and Depero, he began experimenting with collage. He was especially enchanted, he remembered, by Depero's "unexpected creations" and use of unusual materials.[258] At the Café Aragno, where many intellectuals gathered, Garretto drew caricatures of his friends, which journalist Orio Vergani had published in the local papers.[259] Marinetti encouraged Garretto to move to Paris, where he would have more opportunities to publish his work in color. With the appearance in 1927 of four of his caricatures in the London *Graphic*—one of the "Great Eight" British journals to which all illustrators aspired—Garretto began a successful international career in advertising and illustration. Based in Paris, he published hundreds of caricatures in the London press and designed advertising campaigns throughout Europe.

Garretto's portraits retained a sense of layered assemblage inspired by his early contacts with the Italian futurists. The Kreisler collage is cut from a thin piece of wood veneer; other portraits are drawn with such sharp, precise edges that they look like scissored cutouts floating against their bright backgrounds. His work reveals an even greater stylistic affinity, however, with art deco Paris. Arriving there shortly after the 1925 Exhibition Internationale des Arts Décoratifs et Industriels Modernes which, years later, gave the name "art deco" to an amalgam of styles, Garretto encountered some of the poster artists who helped define its aesthetic. He was even briefly associated with the Alliance Graphique, an advertising agency founded by A. M. Cassandre (Adolphe Mouron). Cassandre, together with Paul Colin, Charles Loupot, and Jean Carlu, dominated the high-style advertising world, drawing inspiration from advanced art movements of the time.[260]

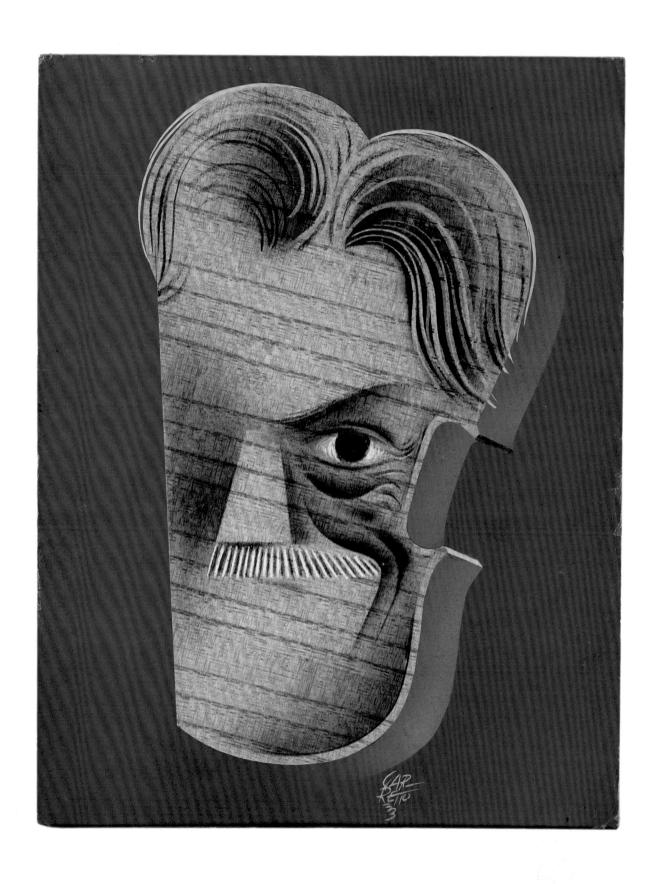

141

The Kreisler collage reflects the design principles of the poster artists, with its strong colors, smooth surfaces, and abbreviated, geometric stylization. Like Carlu, Garretto used airbrush, a photographer's retouching tool newly discovered by Bauhaus designers, which sprayed a light film of pigment with machinelike precision. Airbrush produced in this image a dense, even background blue, smooth tonal gradations, and no sign of the artist's touch, qualities undoubtedly appealing to an artist with a technical bent and training in architecture and engineering.[261] Garretto's powerful musical symbol also has

Fig. 41. *Olympians of the Musical Sphere* by Paolo Garretto (1903–1989). Printed illustration from *Vanity Fair*, March 1934. Library of the National Portrait Gallery and the Smithsonian American Art Museum, Washington, D.C.

surrealist undertones reminiscent of Carlu, and a witty ingenuity similar in spirit to Cassandre's posters. Alan Fern has called the emblematic French poster a "translation of surrealist imagery into advertising design." Garretto applied similar principles to portraiture, moderating the impact of his one-eyed, anthropomorphic symbol through celebratory humor. "Under his hands," Orio Vergani noted, "persons become moving puppets, in an atmosphere that no longer smells of typography or of paper, pen and inkstand. . . . [His] drawings might really be called . . . marvelous surrealistic toys for adults."[262]

The editors of *Vanity Fair*, great proponents of sophisticated caricature, inevitably noticed Garretto's sleek, stylish mockeries. They had clipped his work from the London *Graphic* of December 1927 and had

no doubt seen his caricatures in the *Philadelphia Ledger* and the *New York Sunday World* in the late 1920s. *Vanity Fair*, in the early 1930s, was facing declining revenues and looking for innovation. A new emphasis on color caricature, the staff decided, would complement their new Bauhaus-inspired graphic design as well as spotlight Condé Nast's state-of-the-art, four-color printing plant and the magazine's increasingly global perspective. In October 1930, editor Clare Boothe Brokaw wrote Garretto that the editors were "very impressed" with his cartoon of Mahatma Gandhi in the August issue of *Fortune* and would be glad to consider publishing his caricatures. When Garretto did not immediately respond, she wrote more insistently in December: "We are indeed anxious to see your work, and if there is something we can use, are anxious to do so in a forthcoming issue." Garretto sailed for New York, initiating a close relationship with *Vanity Fair*.[263] Together with Miguel Covarrubias and Will Cotton, he joined the trio of artists who designed many of the striking covers and color caricatures of the 1930s.[264] Although he remained in Paris, he visited frequently, also selling advertising designs to such agencies as J. Walter Thompson and N. W. Ayer and pictures and covers to *Fortune, Harper's Bazaar, Vogue*, and the *New Yorker*.

However playful the mood, the surrealist undertones of Garretto's collage are strikingly effective. The conflation between the performer and his instrument was particularly appropriate to Kreisler's impact on his audience. Many commentators described the subconscious merger of the man and the music that his playing provoked. Isaac Stern recalled, "In every Kreisler performance that I heard, it was inevitable that in its course there came moments of pure magic, moments where one could forget one was sitting in a concert hall listening to a man performing on an instrument." Violinist Nathan Milstein described Kreisler's art as hypnotic; Yehudi Menuhin recalled being "enchanted by his playing. It was so human, so human."[265] Such qualities explain why Kreisler, who became an American citizen in 1943, remained a celebrated performer until 1950. Garretto, on the other hand, had a disappointing career after the war, as periodicals turned to more photographic illustration. But in the 1930s, his ingenious adaptation of poster aesthetics made a significant impact on American graphic design, and his art deco caricatures added a new epigrammatic approach to portraiture.

W.W.R.

NOTES

253. Amy Biancolli, *Fritz Kreisler: Love's Sorrow, Love's Joy* (Portland, Ore.: Amadeus Press, 1998), 71.

254. David Ewen, *Musicians Since 1900: Performers in Concert and Opera* (New York: H. W. Wilson, 1978), 423; "Fritz Kreisler Dies Here at 86; Violinist Composed 200 Works," *New York Times,* January 30, 1962; Louis P. Lochner, *Fritz Kreisler* (New York: Macmillan, 1950), 71–72.

255. Biancolli, *Fritz Kreisler,* 158–59.

256. See, for example, Helen L. Kaufmann and Eva Hansl, *Artists in Music of Today* (New York: Grosset & Dunlap, 1933), 65; "Olympians of the Musical Sphere," *Vanity Fair,* March 1934, 37. The *Vanity Fair* caption read: "To Kreisler, technique may mean less than spirit, but his dexterity is still the despair of his many imitators."

257. Garretto, the son of a professor, was born in Naples and as a child spent four years in America, where his father pursued his research for an Italian history of the United States. The principal biographical source for Garretto is Steven Heller, "Paolo Garretto: A Reconsideration," *Print* 44 (May–June 1990): 66–75ff. Heller corresponded extensively with Garretto before the artist's death in 1989 (Paolo Garretto Papers, Steven Heller). See also "The Painter Garretto," *Gebrauchsgraphic* 12 (June 1935): 16–23, and Gianni Mazzocchi and Renzo Trionfera, *The Paolo Garretto Story* (Milan: Editoriale Domus, 1983) (in Italian).

258. Garretto to Heller, September 20, 1988, Garretto Papers.

259. Spurred by his hatred of Communism, Garretto also became briefly involved with Fascism in the early 1920s. For one year he even served as part of Mussolini's personal honor guard, but he soon regretted this youthful indiscretion. His father managed to get him discharged from military duty, and he returned to art school and the making of satiric portraits (Heller, "Paolo Garretto," 73).

260. Patricia Frantz Kery, *Art Deco Graphics* (New York: Harry N. Abrams, 1986), 58–62.

261. Elyce Wakerman, *Air Powered: The Art of the Airbrush* (New York: Random House, 1979), 42.

262. Alan Fern, *Word and Image* (New York: Museum of Modern Art, 1968), 61; Orio Vergani, "Paolo Garretto," *Graphis* 20 (1947): 292–95.

263. Heller, "Paolo Garretto," 75. For Garretto's caricatures in *Vanity Fair,* see Reaves, *Celebrity Caricature,* 224–33. Garretto, who had met art director Mehemed Agha in Berlin when he worked for *Vogue,* considered him a close friend. He also socialized with Condé Nast in Paris and New York, thought Frank Crowninshield a "kind and most comprehensive editor," and fondly recalled the "beautiful and bright, intelligent" Clare Boothe Brokaw (Garretto to Heller, undated, Garretto Papers).

264. A short biographical piece titled "Fascist Artist," published in the magazine in 1934, came back to haunt him, however. Like Kreisler during World War I, he was shunned in the United States during the war years. *Harper's Bazaar* canceled a contract for the twelve covers of 1940, and he was eventually imprisoned and deported. He fared poorly in Europe as well, viewed as "suspect" by the Italians, Germans, and French ("Fascist Artist," *Vanity Fair,* August 1934, 9; Heller, "Paolo Garretto," 162–64).

265. Quoted in "The Kreisler Career," *Saturday Review,* February 24, 1962, 48, 47; Menuhin quoted in Biancolli, *Fritz Kreisler,* 275.

JOHN STEINBECK
1902–1968

BY JAMES FITZGERALD
1899–1971

Charcoal on paper, 61 x 48.2 cm (24 x 19 in.), 1935
Inscription: James Fitzgerald '35
Gift of Mr. and Mrs. Edgar F. Hubert
NPG.72.99

The self-possessed completeness of James Fitzgerald's drawing exemplifies his principled insistence on avoiding distraction or anything that might interfere with the immediate experience of his work. Fitzgerald had little interest in, or patience for, artistic criticism. Many of his paintings are neither signed nor dated.[266] That he signed and dated this portrait of John Steinbeck may indicate that he valued it shrewdly for the unusual prominence of his subject as well as its aesthetic quality.

In 1935, Steinbeck was on the verge of the critical success that would eventually distinguish him as one of America's foremost authors.[267] He and Fitzgerald had both gravitated to the circle of artists, writers, and assorted intellectuals who gathered around the charismatic figure of Edward ("Doc") Ricketts, a marine biologist of wide-ranging interests. Ricketts established and directed the Pacific Biological Laboratories, a research facility located in Monterey, California's so-called Cannery Row, which became the group's customary gathering place in the years before World War II.

A Boston-born painter, Fitzgerald arrived in California at the age of thirty in early 1929 with sufficient personal funds to purchase some land and build a combination house-studio in Monterey. Remote and controlling by nature, he may always have seemed something of an outsider to other members of the Ricketts circle.[268] A few years older than Steinbeck, he had served in the Marines shortly before the end of World War I. After being discharged, he studied art for four years at the Massachusetts Normal Art School (later known as the Massachusetts College of Art), sometimes signing on for voyages to Newfoundland's Grand Banks with commercial fishermen out of Gloucester and exploring the warmer, more distant waters of the Caribbean as well. After art school, he headed for Alaska, a trip that ended in California, where he decided to stay indefinitely. The artistic and natural environment of Monterey nurtured him. Between periodic driving trips back east, he read widely, particularly favoring oriental philosophy and art, and developed interests in acting and the violin. He also began to produce and exhibit watercolors, many of which were inspired by his love of the sea; local critics noticed the work favorably.

On a late winter visit to Vermont sometime around 1934, he happened on a snow-covered stream. *Snow, Ice and Water*, the landscape that resulted, remained a personal favorite. Representing what has been described as a turning point in his work, it reflects his studies in Asian thought in the notion of dynamic natural forces balanced against stillness. Fitzgerald typically painted landscapes "on site." But in this case, having experienced the scene, he waited until the following morning to paint it, preferring to reduce and abstract its details as an exercise in visual and philosophical memory. In later works he would again concentrate his attention in direct observation of his subject so powerfully as to arrive at a "state of heightened awareness" in which he hoped to "absorb" its essence. Later, in the studio, a finished work would emerge.[269] Although Fitzgerald is believed to have attempted portraiture rarely, he may well have brought to this drawing of Steinbeck the same quality of vision that crystallized on the bank of that Vermont stream.

In a notebook of jottings, collected from various sources, which incorporate his philosophy of painting, Fitzgerald wrote that the "effectiveness" of representational work derived from a "successful fusion" of the objective matter with "formal suppositions which are the province of the particular art." "Pure form to the detriment of representational fidelity—or representational fidelity to the detriment of pure form—both are aesthetically mistaken."[270] In this drawing, the reduction in the use of the monochromatic black for the large and active shape of Steinbeck's pullover echoes the dramatic use of

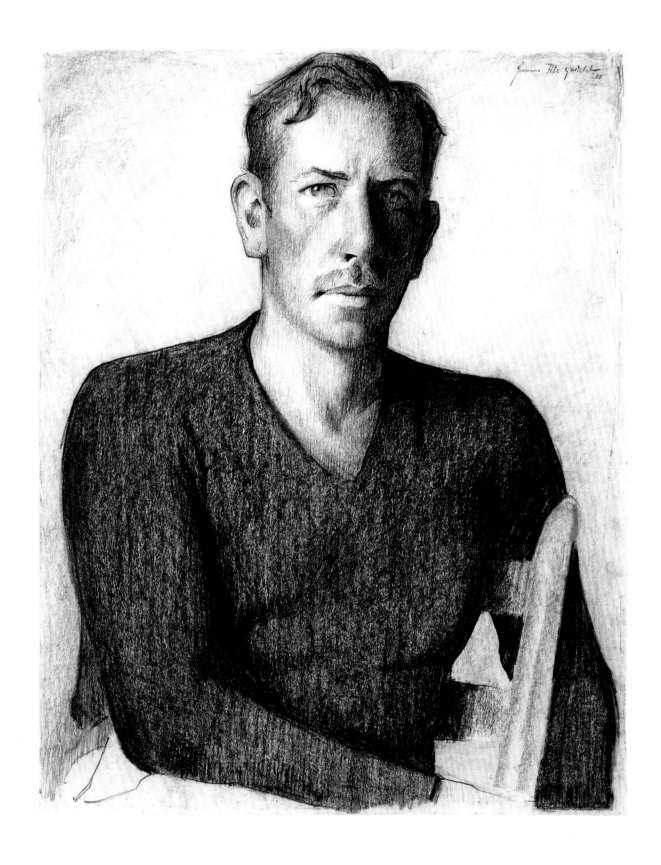

145

monochrome in several other works by Fitzgerald. The complex shape of the shirt dominates the lower half of the page and balances the detailed modulations of Steinbeck's neck, face, and head at the top. Within its contours, the shirt darkens beneath the shadow of the head and neck, where Steinbeck's left shoulder recedes from the picture plane, suggesting the three-dimensional volume of his upper left arm behind the back of the simple chair. A tension emerges between flattened plane and rounding volumes, form-dissolving light and form-giving shadow, physical solids and spatial voids, representation and abstraction.

The portrait might have been posed for on a particular evening, but it could just as easily have been the result of cumulative, intense observation over the course of the often-troubled acquaintance between the two men, with Fitzgerald fascinated and challenged by the power of Steinbeck's authentically creative personality. Friends said that draftsman and subject were prone to disagreements, often heated, which may have stemmed from a rivalry for Ricketts's favor. Steinbeck's personal life was in the kind of flux that probably left little patience for the eccentricities of Fitzgerald's, or anyone else's, evolving talents.

At the time the drawing was done, Steinbeck's parents had both succumbed to illnesses they had suffered for many years. Their lingering deaths had seized Steinbeck's spirit, challenged his will and ability to concentrate on his writing, and evoked deep speculations on the nature of life. In November 1933, working on *Tortilla Flat,* Steinbeck described it as a "very jolly" book, which struck him as a "direct rebellion against all the sorrow" that accumulated during his parents' long illnesses. As his parents suffered their "slow disintegration," Steinbeck felt he was simultaneously "losing a sense of self" and undergoing a spiritual toughening he needed to continue to work (which he came to recognize as a necessary pleasure).[271] He wrote a friend that in "this . . . deadly time . . . all my wanderings have taken a stream-like force." His focus brought a kind of simplification in which he claimed to have found not solace but joy: "Our life has been uprooted of course, but that doesn't matter if I can find my escape in work." He may have hoped to find the primal key to his own survival in reducing his life to creativity. "As long as we can eat and write more books, that's really all I require. . . . If you demand little from life you limit its ability to strike at you and you can say what you wish about it."[272]

Whatever their disagreements, Fitzgerald and Steinbeck shared some fundamental attitudes toward their work and fears of the threats to their creative freedom that could all too easily snatch artistic disaster from popular and critical success. Fitzgerald avoided publicity and never attempted to promote his work in conventionally commercial fashion, although when Steinbeck knew him he was enjoying a growing reputation from exhibitions in California, New York, and London. For his part, Steinbeck claimed to be mistrusting of popularity: "It has ruined everyone I know." When *Tortilla Flat* was awarded a prize, he declined to accept it in person: "This is the first and God willing the last prize I shall ever win. The whole early part of my life was poisoned with egotism, . . . with self-consciousness."[273]

While Steinbeck is not likely to have shared such thoughts with Fitzgerald, the artist would easily have understood them. For him, too, the creative act was its own reward. In Steinbeck, Fitzgerald the philosophical fisherman surely recognized that he had somehow managed to hook a native California specimen of unusual quality, an elusive being who would aggressively test the strength of his draftsman's tackle and the quickness of his artistic skills with unadorned force. But Fitzgerald, soon to make his home in the East, took with him this rare portrait, a signed and dated trophy of a special California acquaintance.

H.F.P.

266. "As time progressed, he gradually came to feel that his real reward—that which linked him temporarily to all that is enduring—lay in the very act of painting. Exhibitions and thoughts about 'success' distracted him from his ultimate purpose. Appreciation for his paintings over time, he believed, would find its own level in a natural manner" (Calvin Hennig, *By Land and Sea: The Quest of James Fitzgerald* [Portland, Maine: Portland Museum of Art, 1992], 11); "Possibly to discourage 'academic chaps' and others who might attempt to classify his works, Fitzgerald dated only three or four paintings" (David J. Gibson, "A Painter of Importance," *Northeastern University Alumni Magazine* 15 [October 1989]: 23).

267. *Tortilla Flat* (1935) won a general literature Gold Medal from the Commonwealth Club of California; *Of Mice and Men* (1937) won the same; *The Grapes of Wrath* (1939) was awarded that medal and the Pulitzer Prize in 1940. In 1962, Steinbeck was awarded the Nobel Prize for literature.

268. Calvin Hennig, *James Fitzgerald* (Rockland, Maine: William A. Farnsworth Library and Art Museum, 1934), 39

269. Ibid., 9–10.

270. Transcribed from the artist's notebook; filed with "Recollections of the Artist James Fitzgerald," gallery talk by Anne Hubert, March 15, 1987, for the New Britain Museum of American Art, Connecticut, AAA.

271. Steinbeck to Edith Wagner, November 23, 1933, 89–90; Steinbeck to Carl Wilhelmson, August 9, 1933, 87. The letters by Steinbeck cited here and below are from Elaine Steinbeck and Robert Wallsten, eds., *Steinbeck, A Life in Letters* (New York: Viking, 1975).

272. Steinbeck to Carlton A. Sheffield, June 21, 1933, 97; Steinbeck to Carl Wilhelmson, August 9, 1933, 88; Steinbeck to Edith Wagner, November 23, 1933, 90.

273. Gibson, "A Painter of Importance," 20; Steinbeck to Elizabeth Otis, June 13, 1935, 111–12; Steinbeck to Joseph Henry Jackson, 1935, 119.

FRANCES PERKINS
1880–1965

BY WILLIAM HENRY COTTON
1880–1958

Pastel on illustration board, 48.3 x 37.6 cm (19 x 14³/₄ in.), circa 1935
Inscription: *recto* W. Cotton / 9 3/4"; *verso* VF 2227 / 126
NPG.87.219

In his pastel of Frances Perkins, Will Cotton muses playfully on gender contrasts and the position of a professional woman in a man's world. When President Franklin Roosevelt appointed Perkins secretary of labor in 1933, she became the first female in American history to hold a cabinet post. But Perkins, who insisted on retaining her maiden name after her marriage in 1913, had been breaking barriers all her life. Her education at Mount Holyoke, social work experiences in Chicago and Philadelphia, and a master's degree from Columbia University established her interest in social justice. From the beginning of her professional life in New York City, she had lobbied city and state government for her primary issues: industrial safety, minimum wages, maximum hours, workman's compensation, child labor restrictions, and general rights for the working class. Governor Al Smith invited Perkins to become a commissioner of the state's Labor Department. Roosevelt, as his successor, appointed her industrial commissioner, responsible for administering the department. The state's energetic response to ensuing economic crises helped establish Roosevelt's platform for his presidential bid. Serving in the cabinet throughout Roosevelt's presidency, Perkins became a leading author and advocate of New Deal legislation and developed a strengthened and vital Department of Labor.

The clothing and accessories in Cotton's drawing, including the tricorn hat, black dress or suit, string of pearls, and minimal makeup, was a costume Perkins herself contrived to appear less threatening and more persuasive [fig. 42]. She "dressed as carefully as any actress," one biographer has noted. Perkins determined at an early age that men tended to associate women in political life with maternal models. "That's the way to get things done," she concluded. "So behave, so dress and so comport yourself that you remind them subconsciously of their mothers."[274] Her own mother had convinced

her at age twelve that the tricorn hat suited her broad face and sharply pointing chin.[275] The simple, matronly black clothing and pearls struck a note of professional formality that suited this intensely private public figure. "Many good and intelligent women," she felt, "do dress in ways that are very attractive and pretty, but don't particularly invite confidence in their common sense, integrity or sense of justice."[276] In time the costume became a uniform, so persistently a part of her public image that reporters wondered if the ubiquitous tricorn hats had been designed by her own Bureau of Standards. But Perkins used her image to good effect, constructing a look of concerned competence that avoided both the muscled authority of male officialdom and the nonprofessional allure of overt femininity.

Pastel artist Will Cotton saw the comic side of Perkins's public persona. The Rhode Island–born artist had trained at the Cowles Art School in Boston and the Académie Julian in Paris, won a number of prizes and exhibited his paintings at prominent museums and galleries around the country. He made his name primarily as a portraitist and, later in life, as a mural painter who decorated a number of New York theaters. But in 1926 his first-place award in the Lewis Prizes for Caricature at the Pennsylvania Academy of the Fine Arts launched his additional specialty of portrait lampoons.[277] Cotton was soon exhibiting his caricatures to New Yorkers at the Ehrich Galleries and to summer crowds in Newport, Rhode Island.[278] In 1927 his pastels were included in the Art Institute of Chicago's prestigious international watercolor exhibition. The "clever take-offs by Mr. Cotton," one Chicago newspaper opined, "were among the best of the offerings." Cotton's increasingly popular caricatures appeared in five of the annual exhibitions over the next ten years, and in 1937 he was one of three featured artists of the Chicago show.[279]

The remarkable blended tonalities of Cotton's

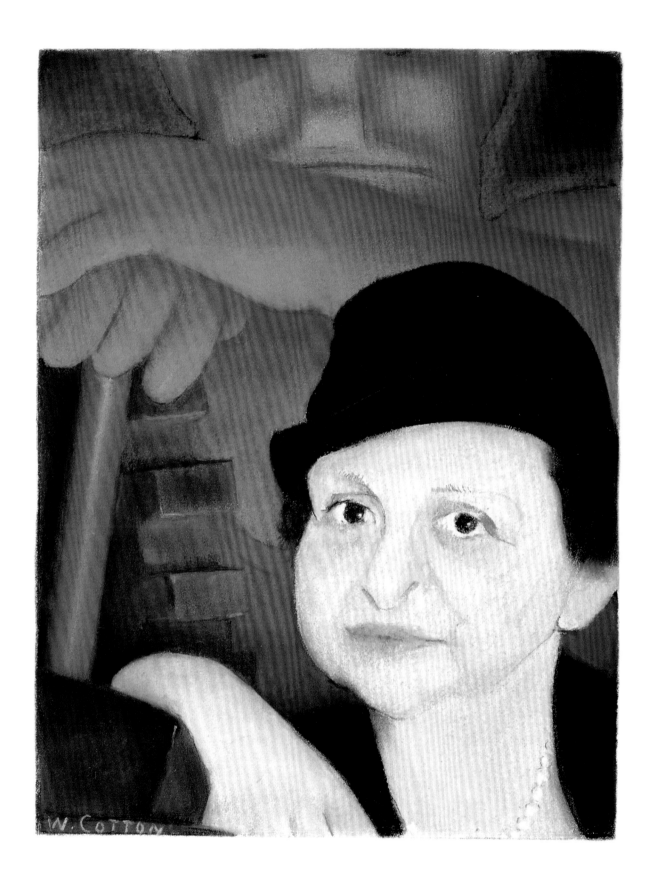

149

pastels, which here range from brilliant blue to rich, glowing terra-cotta to delicate, lavender-tinged flesh tones, undoubtedly added to his appeal. The editors of *Vanity Fair*, searching for artists to highlight their new color-printing technology, did not fail to notice. In 1931, after the success of his first few monthly contributions, the magazine began to feature a full-page Cotton frontispiece in each issue, a dazzling blast of color for an audience used to monochromatic magazines with a few garish advertisements. By May 1932, *Vanity Fair* advertised Cotton as a contributor, together with sportswriter Paul Gallico and theater

Fig. 42. *Frances Perkins* (1880–1965) by Maurice Constant (1895–1968). Photograph, circa 1939–45. Prints and Photographs Division, Library of Congress, Washington, D.C.

critic George Jean Nathan, on a page promoting subscriptions.[280] The following October, the editors selected Cotton for their own "Hall of Fame" nominations. The caption cited his multiple roles as a founder of the National Portrait Painters Association, muralist for five theaters, playwright of a current Broadway satire, and a preeminent caricaturist, whose portraits were "models of polite causticity."[281] Although Cotton also contributed to the *New Yorker* and other magazines, his *Vanity Fair* portraits, beautifully reproduced in color, established his reputation. The Perkins pastel was drawn for, but never published, in the magazine.[282]

Although many artists had learned from the fauves and various color theorists the expressive capacities of complementary and contrasting hues, Cotton was more conscious than most of the symbolic and comic potential of color. In this drawing he plays with gender differentiation through composition and color. He places Perkins's face in the lower half of the sheet to suggest a diminutive female

stature and uses delicate shades—ivory flesh tones, luminous pearls, and pale lipstick—to heighten her femininity. Actually, Perkins considered herself tall for a woman at five feet five inches; she was olive-complexioned and wore little makeup.[283] But by emphasizing her gender, Cotton underscored the contrast to the looming figure above her, a huge, square-shouldered, geometricized laborer, reminiscent of the iconic working man of 1930s mural art. Cotton used the earthy brown of the skin and metallic gray hues of the mallet and cogwheel (pre- and post-industrial symbols of labor) to enhance the strong masculine overtones. But Perkins, unintimidated, drapes her hand casually against the machinery, her steady, confident gaze establishing her competence. Cotton emphasized her dark eyes, her most striking, and to some formidable, feature. (AFL President William Green once complained about the unnerving effect of being fixed by those "basilisk eyes.")[284] In Cotton's depiction, "Madam Secretary" is not only entirely at home in this realm of men and machines but is dominant.

Cotton also includes hints of controversy, however, to which Perkins was no stranger. Her appointment had been opposed by some labor leaders, and her twelve years as secretary, filled with labor-management strife and crippling strikes, left her open to criticism. Perkins's attempts to mediate caused some congressional opponents to suspect her of Communist sympathies. The mallet, suggestive of the hammer and sickle, and the glimpses of the laborer's red shirt on either side of her face (subtly linked to her through the tonalities of her lipstick) are unmistakable symbolic references. Perkins's refusal to deport Harry Bridges, radical head of the longshoreman's union, after a general strike in San Francisco in 1934, had infuriated the House Un-American Activities Committee. Ultimately, in 1939, Perkins had to defend herself against J. Parnell Thomas's resolution to impeach her. Cotton's portrait, probably made in the mid-1930s, could have been rejected by *Vanity Fair* because of controversy. But this mild spoof of Perkins's carefully negotiated stance between male and female stereotypes was more likely a commissioned piece left unpublished when the magazine folded in 1936. Cotton's work was never so well showcased afterward, and his popular reputation began to fade. But he was a "colorist of the first order," according to one contemporary; a better artist than Max Beerbohm, according to another, with a wit "equally stylish and literate."[285]

W.W.R.

274. Quoted in George Whitney Martin, *Madam Secretary, Frances Perkins* (Boston: Houghton Mifflin, 1976), 146.

275. Ibid., 5.

276. Quoted in ibid., 147.

277. *Catalogue of the Twenty-Fifth Annual Philadelphia Water Color Exhibition, and the Twenty-Sixth Annual Exhibition of Miniatures* (Philadelphia: Pennsylvania Academy of the Fine Arts, 1927), 9.

278. The Ehrich Galleries exhibited Cotton's series of caricatures of famous authors; see *Chicago Evening Post*, April 6, 1926; "Coolidge 'Play Boy' in Newport Picture: William Cotton So Depicts Him," *New York Times*, August 21, 1927.

279. *Chicago Daily Tribune*, June 12, 1927; Cotton also exhibited his pastel caricatures at the watercolor exhibitions of 1928, 1931, 1932, and 1937; see Peter Hastings Falk, ed., *The Annual Exhibition Record of the Art Institute of Chicago, 1888–1950* (Madison, Conn.: Sound View Press, 1990), 235–36; "Water Color Exhibition," *Bulletin of the Art Institute of Chicago* (March 1937): 50, 58.

280. "Who's Who in Vanity Fair," *Vanity Fair*, May 1932, 6.

281. "We Nominate for the Hall of Fame," *Vanity Fair*, October 1932, 37. See also "Will Cotton, 77, Dead," *New York Times*, January 6, 1958.

282. Reaves, *Celebrity Caricature*, 211–24, 242–43, 246. The pencil inscription "VF" on the verso of the drawing indicates that it was a *Vanity Fair* commission. The drawing remained in the artist's possession and was ultimately auctioned from his widow's estate.

283. Lillian Holmen Mohr, *Frances Perkins: "That Woman in FDR's Cabinet!"* ([Great Barrington, Mass.]: North River Press, 1979), 14.

284. Quoted in ibid., 14, 117, 173.

285. "Bored with Borah," *Vanity Fair*, February 1933, 9 (although this reader, whose letter was published on the editorial page, admired Cotton as a colorist, he complained that the artist was too kind to the obstinate, bellowing Senator Borah); "Beerbohm and Cotton," *Saturday Review*, July 29, 1939.

OLIVER HARDY
1892–1957

BY JOSEPH GRANT
born 1908

Graphite on paper, 24.1 x 30.5 cm ($9^1/_2$ x 12 in.), circa 1935
NPG.96.99

The striking relationship between Joe Grant's drawing of Oliver Hardy for the Disney Studio and Albrecht Dürer's engraving *Knight, Death, and Devil* [fig. 43] signals the complex aesthetic evolution of animation art during its golden age in the 1930s and early 1940s. Walt Disney greatly expanded his animation studio in the mid-1930s and set up an art school under Donald W. Graham. His newly hired staff, often trained artists rather than experienced animators, studied drawing, motion analysis, and a variety of artistic sources in their search for new ways to express movement through line. "A drawing principle is a drawing principle," Graham once stated. "If it works in a Rubens, it must work in Donald Duck."[286] Joe Grant was considered "more sophisticated, aesthetically" than others at the studio, and despite the comic exaggeration of his Hardy drawing, it conveys a sense of equestrian monumentality that could have been inspired by such precedents as a Dürer print.[287] Disney, in a 1935 interview, commented on the diversity of the animators' sources, citing as examples great master paintings, modern magazine illustrations, movies, and advertising. "We tapped the world for material," Grant said of a later project.[288]

Disney had first noticed Grant's work in the pages of the *Los Angeles Record*, where the young artist, under contract to Metro-Goldwyn-Mayer, was publishing caricatures of film stars.[289] In 1932, when Disney was preparing a brief film sequence featuring nominees for the Academy Awards parading through "Storyland," his animators were instructed to imitate Grant's newspaper caricatures of the stars. The success of his award nominees sequence inspired Disney to produce an animated cartoon featuring Hollywood celebrities. He hired Grant, the son of an art editor for the Hearst papers, to create cartoon versions of the film-world elite for the 1933 short, "Mickey's Gala Premiere." Soon afterward, Grant came to work full time at Disney. He became a "story man" rather than an animator at the studio, developing ideas, making inspirational drawings, and designing the look and personality of many cartoon characters.

The Hardy drawing was made for "Mickey's Polo Team," a cartoon that grew out of the Disney brothers' passion for Hollywood's new fad.[290] Walt and Roy joined the fashionable polo games hosted by Will Rogers at his "ranch" in Rustic Canyon, recruited a team from the studio, hired a coach, and bought their own polo ponies. When Disney asked Grant to draw Jack Holt playing polo, the artist suggested pairing the actor with a matching steed that would look and move like his rider.[291] Disney loved the idea, and the cartoon developed from there. A frenzied match would pit the celebrity team of Will Rogers, Oliver Hardy, Stan Laurel, and Harpo Marx against Mickey Mouse, the Big Bad Wolf, Goofy, and Donald Duck.[292] After Rogers's death in 1935 in an airplane crash, the studio substituted Charlie Chaplin, and the work continued. In the stands, Shirley Temple sits with the Three Little Pigs, W. C. Fields hobnobs with Greta Garbo and Harold Lloyd, and other recognizable luminaries cheer the players. *Variety* took the unusual step of reviewing the cartoon, mentioning its box-office potential, "raucous and ribald" antics, and some "fine satiric moments" in the spoofing of the stars.[293]

Grant's Hardy drawing is on animation paper with punched peg holes at the bottom to keep the sheet in register. But it is not an animation drawing—one of the sequential pencil renderings that record the characters' incremental movements and are then traced onto the cels, inked, and photographed in the final stage of production. Instead, it is a model drawing designed as a prototype for the team of animators to copy. Grant made four model drawings of the principal celebrity characters in the film, each posed in static profile on his pony (or, in Marx's case, his ostrich).[294] Unlike the animators, who implied a

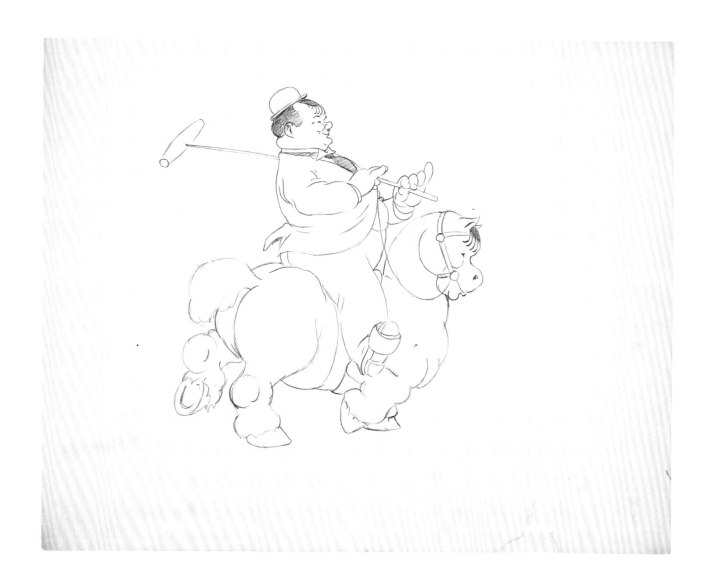

sense of movement on every sheet, Grant's purpose in these drawings was to design the animated versions of the celebrities, honing their familiar (even clichéd) traits, inventing not only how they would look but how they might move and react. Clothing, shapes, proportions, characteristic gestures, expressions, and personality are all succinctly designated in one carefully drafted image.

Grant's model drawing of Oliver Hardy hints at many of the ensuing celebrity jokes and antics of the cartoon. The actor, born Novell Hardy, was half of the beloved Laurel and Hardy duo that launched, in

Fig. 43. *Knight, Death, and Devil,* by Albrecht Dürer (1471–1528). Engraving, 1513. National Gallery of Art, Washington, D.C.; gift of W. G. Russell Allen

1926, a series of Hal Roach comedies. Playing physically contrasting, slow-witted, and endearing anti-heroes beset by the comic frustrations of everyday life, they reached international fame in more than a hundred films.[295] Grant established the central characteristic of Hardy and his pony—their considerable bulk—by conceiving of the drawing as a series of circular forms. Starting with the pony's head, sketched over a still-visible penciled circle, the shape is echoed in the pony's flanks and joints as well as Hardy's hat, stomach, buttocks, nose, cheek, and chin.

Grant added depth to the characterization with other, more subtle, Hardy traits. The extended little finger was a screen character trait that Hardy had adapted from memories of an aunt drinking tea in his polite southern childhood.[296] The gesture adds to a sense of overall refinement and graceful agility, qualities that Hardy brought to his roles in delightful contrast to his enormous girth and usually humiliating circumstances. In the drawing, it is reinforced by the dainty movement of the pony's feet. Even the slim, elongated polo mallet contributes

to the sense of genteel delicacy. In addition, Hardy's cherubic expression implies the basic amiability of his character. Despite the childlike fiddling with his tie when he was thwarted and his trademark stare of frustration at the camera, Hardy's gentle, lovable nature was a key component of his screen persona. The principal purpose of the model drawing was to specify the ever-present derby hat, details of clothing, and basic shape of the character for others to copy. In his elegantly drafted rendition, Grant succeeded in infusing his image with subtleties of humor and personality that distinguished Hardy both on screen and off.

Although animation was a highly collaborative process, Grant's influence grew to the point where, according to animators Frank Thomas and Ollie Johnson, he was "the studio authority on the design and appearance of nearly everything that moved on the screen." By the mid-1930s, they noted, no character model sheet was official until it bore the "O.K. J. G." signature of approval. Eventually, in 1937, Disney asked him to start a Character Model Department, where he and his artists made sketches of new characters being considered.[297] Grant worked on *Fantasia, Snow White, Bambi, Dumbo,* and other classics, and his taste, Thomas and Johnson felt, helped identify the Disney style of the period. Although Grant left the studio in 1949 to pursue other projects, including his own greeting-card company, the industry later recognized his achievements. In 1985 he received an Annie Award for lifetime achievement in animation, followed by a Disney Legends Award in 1992.[298] In an even-greater tribute, Disney hired him back in 1987, and Grant has since contributed in various ways to such films as *Beauty and the Beast, Aladdin, The Lion King,* and *Pocahontas.*

Animation had its own inherent requirements. Curved lines, for instance, were faster to draw and created a smoother flow of movement.[299] Figures were generally reduced to rounded, infant-proportioned forms. Since the cartoons were seen not just by children but by adults in the movie theaters, such principles inevitably influenced other art forms. Critics fiercely debated whether the Disney aesthetic, dubbed "sentimental modernism" by one scholar, was "art," but exhibitions of animation drawings appeared in prestigious museums as early as the 1930s.[300] The drawings and cartoons from Disney's studio, more sophisticated than their humor implies, had a considerable impact on the visual culture of the era.

W.W.R.

NOTES

286. Quoted in John Canemaker, introduction to Walt Disney Productions, *Treasures of Disney Animation Art* (New York: Abbeville, 1982), 18.

287. Michael Barrier, *Hollywood Cartoons: American Animation in Its Golden Age* (New York: Oxford University Press, 1999), 256.

288. Steven Watts, *The Magic Kingdom: Walt Disney and the American Way of Life* (Boston: Houghton, Mifflin, 1997), 110; quoted in Martin Krause and Linda Witkowski, *Walt Disney's* Snow White and the Seven Dwarfs: *An Art in Its Making* (New York: Hyperion, 1994), 26.

289. Grant's biographical sources include the author's telephone and in-person interviews with the artist between April 1993 and November 1999; Barrier, *Hollywood Cartoons*; Jim Keeshan, "Don't Take Him for Granted," *Animation Magazine: The Animation Authority* (May 1999): 78–82; David Seidman, "A 'Toon Man for the Ages," *Los Angeles Record*, January 19, 1995; and "Joe Grant," *Program, 14th Annual Annie Awards* (Los Angeles: ASIFA/Hollywood, 1985).

290. "Mickey's Polo Team," which opened on January 4, 1936, was the first Mickey Mouse cartoon in color.

291. Telephone interview with Joe Grant, November 1999.

292. The watercolor backgrounds were based on Rogers's Rustic Canyon ranch.

293. "Mickey's Polo Team," *Variety*, February 12, 1936.

294. In a telephone interview in November 1999, Grant acknowledged that he made the four drawings. All are now owned by the National Portrait Gallery.

295. Biographical sources for Oliver Hardy include John McCabe, *Babe: The Life of Oliver Hardy* (Secaucus, N.J.: Citadel Press, 1989) and Randy Skretvedt, *Laurel and Hardy: The Magic Behind the Movies* (Beverly Hills, Calif.: Moonstone Press, 1987).

296. Skretvedt, *Laurel and Hardy*, 22.

297. Barrier, *Hollywood Cartoons*, 256; Frank Thomas and Ollie Johnson, *Disney Animation: The Illusion of Life* (New York: Abbeville, 1981), 208–9. According to Barrier, Disney wrote in late 1935, "We should try to develop models of [cartoon] characters that express more actual personalities, or caricatures of personalities. . . . I think we should utilize the talent of *Joe Grant* for the making of the models." The Character Model Department eventually included three sculptors, whose clay figures helped animators visualize the characters.

298. *Program, 14th Annual Annie Awards.* The Annie Awards were given by ASIFA Hollywood, the American branch of L'Association Internationale du Film d'Animation.

299. Barrier, *Hollywood Cartoons*, 19–20, 74.

300. Watts, *The Magic Kingdom*, 101–31. According to Watts, the Art Institute of Chicago mounted an exhibition of Disney drawings in December 1933; it was followed during the decade by exhibitions at the Fogg Art Museum, Cambridge, Massachusetts; the Los Angeles County Museum of Art; and the Metropolitan Museum of Art, New York.

VAN WYCK BROOKS
1886–1963

BY JOHN STEUART CURRY
1897–1946

Sanguine conté crayon on paper, 47 x 30.8 cm (18$\frac{1}{2}$ x 12$\frac{1}{8}$ in.), 1936
Inscription: *recto* Van Wyck Brooks / 1936 / John Steuart Curry; *verso* Not for sale
NPG.99.7

Beginning in the 1920s, directly following World War I, the quiet villages and bucolic countryside of Connecticut drew a remarkable number of writers and other artists away from New York City. Many of these "exurbanites" settled in Westport, although they continued to conduct business and influence culture in the city. Writer, literary critic, and historian Van Wyck Brooks, pictured here, notes in his autobiography that at various times Westport was home to such writers as F. Scott Fitzgerald and Sinclair Lewis, poet Robert Frost, and artists Arthur Dove, Everett Shinn, Maurice Prendergast, and John Steuart Curry.[301]

Brooks had moved to Westport in 1920, in the vanguard, having established himself as a voice for a group of young intellectuals who felt that American culture lacked an organic centrality. His 1918 essay "On Creating a Usable Past" called for a reevaluation of the American past, divorced from current academic modes. For the creative mind, he wrote, "The present is a void because the past that survives in the common mind of the present is a past without living value. But is this the only possible past? If we need another past so badly, is it inconceivable that we might discover one, or that we might even invent one?" The literary historian would approach the subject from the point of view of the creative impulse, mapping tendencies and challenges, creating a "sense of brotherhood in effort and in aspiration which is the best promise of a national culture."[302]

Early years in Westport were successful for Brooks. He received an award for his achievements from the *Dial* in 1924, and contributed to and edited *Seven Arts* (1917) and the *Freeman* (1920–24). As he sought to create a centered culture, he published *The Ordeal of Mark Twain* (1920) and *The Pilgrimage of Henry James* (1925). In these studies he analyzed the fatal flaw in each man's work—the cost of staying within American culture for Twain, of abandoning it for James. Brooks was to pay his own price in

attempting to formulate a usable past. While working on *The Life of Emerson*, he suffered a mental breakdown and later described the years between 1925 and 1931 as a "season in hell."[303] Finally, in 1932, the book was published. In a change of attitude, Emerson is viewed as achieving a positive synthesis of the antithetical dilemmas of Twain and James. Answering his own call of 1918, Brooks set out to establish the living American tradition that he had felt was lacking to artists. His five-volume *Makers and Finders: A History of the Writer in America, 1800–1915* (1936–52) was his answer, and for the volume *The Flowering of New England,* Brooks won the 1936 Pulitzer Prize for history.

When John Steuart Curry portrayed him in that same year, Brooks was a man at the height of his powers who had found purpose. In rich sanguine conté crayon Curry presents a strongly modeled head, reinforcing the lines of cheekbones, jaw, and nose. His firm hand conveys the strength of Brooks's character. The focus of the eyes, slightly raised and gazing into the distance, gives Brooks a pensive look. With the body only sketchily suggested, the viewer focuses on the face and personality of the man. A related pencil drawing, also in the collection of the National Portrait Gallery [fig. 44], shows Brooks in the setting of his study, surrounded by his books and desk, posed with crossed legs and folded hands. Probably preliminary to the more resolved portrait, it includes a second, smaller study of Brooks's head, a step in the process of the distillation of a personality best represented simply and finally in this strong but carefully characterized head in conté crayon.

The purpose of the drawing remains obscure. Curry did few painted portraits. Brooks recalled the drawing in the context of the frescoes Curry did for Westport's Bedford Junior High School (now King's Highway School) in 1934. Placed in the auditorium to either side of the stage, *Comedy* and *Tragedy* included such local Westporters as writer Sherwood

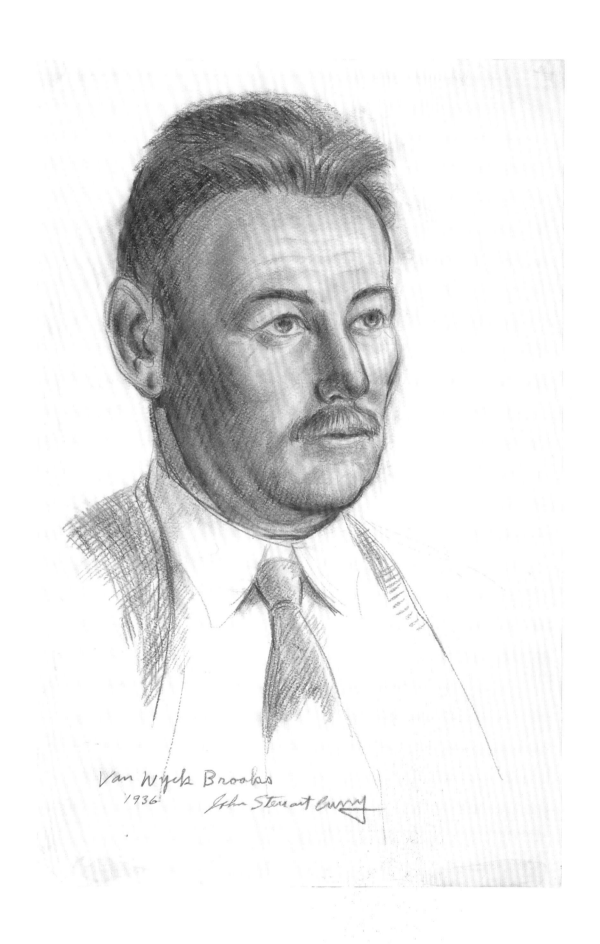

Van Wyck Brooks
1936 John Steuart Curry

Anderson, sculptor James Earle Fraser, Shakespearean actors Moffit and Winifred Johnson, creator of the Kewpie doll (and sculptor) Rose O'Neil, and Curry and his new wife, Kathleen.[304] Clearly Curry drew many of his neighbors. Brooks himself recalled only, "Of me he made a red-chalk portrait drawing that gave me the look of a Mexican border bandit."[305]

In fact, Brooks and Curry had much in common beyond living in Westport. As Brooks was concerned with recovering America's literary heritage, Curry was concerned with creating a truly indigenous American art divorced from European modernism.

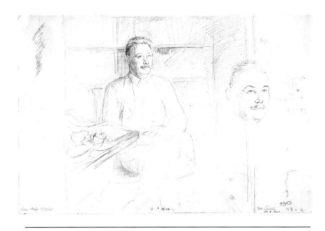

Fig. 44. *Van Wyck Brooks* (1886–1963) by John Steuart Curry (1897–1946). Graphite on paper, 1936. National Portrait Gallery, Smithsonian Institution

Categorized with Thomas Hart Benton and Grant Wood as one of the foremost regionalist painters of the American scene, Curry maintained, "My sole interest and conception of subject matter deals with American life, its spirit and its actualities."[306] Born on a farm in Dunavant, Kansas, Curry began drawing at an early age. Instead of finishing high school, he briefly entered the Kansas City Art Institute and went on to the Art Institute of Chicago. After a semester at college, Curry moved to Tenafly, New Jersey, to begin work as an illustrator under the tutelage of Harvey Dunn. Having achieved a measure of success, he bought a studio and settled in Westport in 1924.

For Curry as well as for Brooks, the Westport years were crucial and formative. While working with neighbor James Daugherty on a mural for the Philadelphia Sesquicentennial Exposition, Curry felt his limitations as an illustrator. Daugherty recommended study in Paris, and with the financial support of Westporter Seward Prosser, Curry was

able to make the trip. He studied assiduously at the Russian Academy of Basil Schoukhaeff, making anatomical studies and drawing from the model. At the Musée du Louvre he copied and studied the works of Rubens, Courbet, Daumier, and Delacroix. After a brief stop in London, Curry returned to Westport and began to paint. In 1928 he exhibited *Baptism in Kansas* at the Corcoran Gallery of Art in Washington, D.C., to public acclaim, and received a two-year stipend from Mrs. Harry Payne Whitney. He continued work on Kansan subjects and in 1930 exhibited at the Whitney Studio Club and had his first one-person show at the Ferargil Gallery in New York, to positive critical reviews. The Whitney Museum of American Art in New York bought *Baptism in Kansas*, *Kansas Stockman*, and several watercolors. By the time Curry made his portrait of Brooks, he had been appointed to teach at the Cooper Union School of Art and the Art Students League, had a painting purchased by the Metropolitan Museum of Art, received second prize at the Carnegie International in Pittsburgh, and had completed two murals for the Department of Justice building in Washington, D.C., and two more for the nearby Norwalk High School.[307]

For Curry as for Brooks, 1936 was an important year. He was appointed the first Artist in Residence for the College of Agriculture at the University of Wisconsin. In December he and his wife moved to Madison, returning to the Midwest that, in the opinion of art critics and even *Time* magazine, he embodied.

S.E.M.

301. Van Wyck Brooks, *An Autobiography* (New York: E. P. Dutton, 1965), 253–60, 362–78.

302. Van Wyck Brooks, "On Creating a Usable Past," *Dial* (April 11, 1918): 339, 341.

303. Brooks, *Autobiography*, 435.

304. The murals were a gift from Curry to the town. He asked only that they pay for supplies and provide an assistant. It was truly a labor of love, since Kathleen recalled in a 1990 interview with Robert F. Brown (for the Archives of American Art) that the young man, Lewis Rubenstein, was a "shiftless, idle creature" who made John's life difficult because he refused to get up early to prepare the wall, so that John often worked past midnight (cassette tape 1, side 1, John Steuart Curry Papers, AAA).

305. Brooks, *Autobiography*, 363. The drawings remained in Curry's possession and were acquired by the Portrait Gallery from the estate.

306. Curry, in a speech given January 19, 1937, on becoming Artist in Residence at the University of Wisconsin, excerpted in *A Retrospective Exhibition of Works by John Steuart Curry* (Syracuse, N.Y.: Joe and Emily Lowe Art Center, Syracuse University, 1956), n.p.

307. The first two murals are *Westward Movement* and *Justice Defeating Mob Violence*; the second two (made for a New Deal Public Works of Art Project) are *Ancient Chemistry* and *Modern Hat Industry*.

W. C. Fields
1879–1946

By Thomas Hart Benton
1889–1975

Graphite on paper, 35.6 x 27.6 cm (14 x 10 $^7/_8$ in.), 1937
Inscription: *recto* Benton / 2 My favorite stars / G878; *verso* D–1216 22 / W. C. Fields
NPG.98.34

At the time this portrait was drawn in 1937, W. C. Fields remarked "This is my second time on earth. It's all borrowed time that I am living on. . . . What I've gone through and come out of by a narrow squeak has certainly made me appreciate living, something I never did before." Serious words for a great comedic actor, but in 1936–37 the gravely ill Fields had seen the "fellow in the bright nightgown"[308]—his vision of death—waiting to take him away, right at the height of success.

Born William Claude Dukenfield in Philadelphia, Fields had little schooling and a tough childhood, having left home at an early age, forced to live rough and on his own. An accomplished juggler (and pool player) at age thirteen, he worked in an Atlantic City amusement park juggling—and also drowning (and being rescued) to draw crowds when business was slow. He published *The Magician's Handbook: A Complete Encyclopedia* in 1901. By 1913 he had appeared in the Winter Palace, Berlin; the Folies-Bergère, Paris (on the same bill as Charlie Chaplin and Maurice Chevalier); the Palace and the Hippodrome, London; the Orpheum, Vienna; and in Dresden and Prague, and had given a command performance at Buckingham Palace before King Edward VII (on the same occasion as Sarah Bernhardt). When the outbreak of World War I made touring impossible, Fields joined the Ziegfeld Follies in New York and gradually became one of the biggest names on Broadway. He made his first silent film in 1915 and starred in his first play, the musical comedy *Poppy*, in 1923. Fields made a number of silent films, including a version of *Poppy*, and appeared in his first sound film, the short subject *A Golf Specialist*, in 1930. He copyrighted several of his comedy sketches.

In 1931, Fields decided to move west to Hollywood and in November played a comically pivotal role in *Her Majesty, Love*, his first sound feature. He went on to make thirty-seven films for Paramount, including four short subjects for producer Mack Sennett that Fields both starred in and wrote. In a rare serious role he played a classic Mr. Micawber in David O. Selznick's *David Copperfield* in 1935. Marking his arrival at the top was the filming the following year of a sound version of *Poppy*. But Fields became too ill to work and appears in little more than a quarter of the footage, which made extensive use of a double.[309] Years of physical neglect, the abuse of alcohol and his own constitution, the added agony of a broken vertebra and tail bone, and a host of other ailments led to a collapse, pneumonia, an oxygen tent, and unconsciousness. Fields was in the hospital for months, but against all odds, he began to recover.

In January 1937, Fields was asked to contribute to a radio program honoring the twenty-fifth anniversary of Adolph Zukor's founding of Paramount. Fields had to broadcast from his sickbed but was such a success that in May he was invited to join Edgar Bergen and Charlie McCarthy on the *Chase and Sanborn Hour*. Fields excelled in this new medium, which suited his distinctive voice, acerbic tone, jaundiced view of humanity, irreverent and iconoclastic attitude, and wide-ranging and creative vocabulary. He became a household name and personality, eventually writing his own sketches and starring in Lux Radio Theatre's presentation of *Poppy* (produced by Cecil B. De Mille). Although Fields would go on to make some of his most famous films for Universal—including *You Can't Cheat an Honest Man* (1939), *My Little Chickadee* with Mae West and *The Bank Dick* (both 1940), and *Never Give a Sucker an Even Break* (1941)—before dying on Christmas Day 1946, it was at this most vulnerable point in his life and career that he met Thomas Hart Benton.

Benton and Fields had a number of characteristics in common. They were both outspoken, skeptical, and irreverent individualists who liked a good drink. In his portrait, Benton does not show us the conman or anti-hero that Fields portrayed [see fig. 45], but

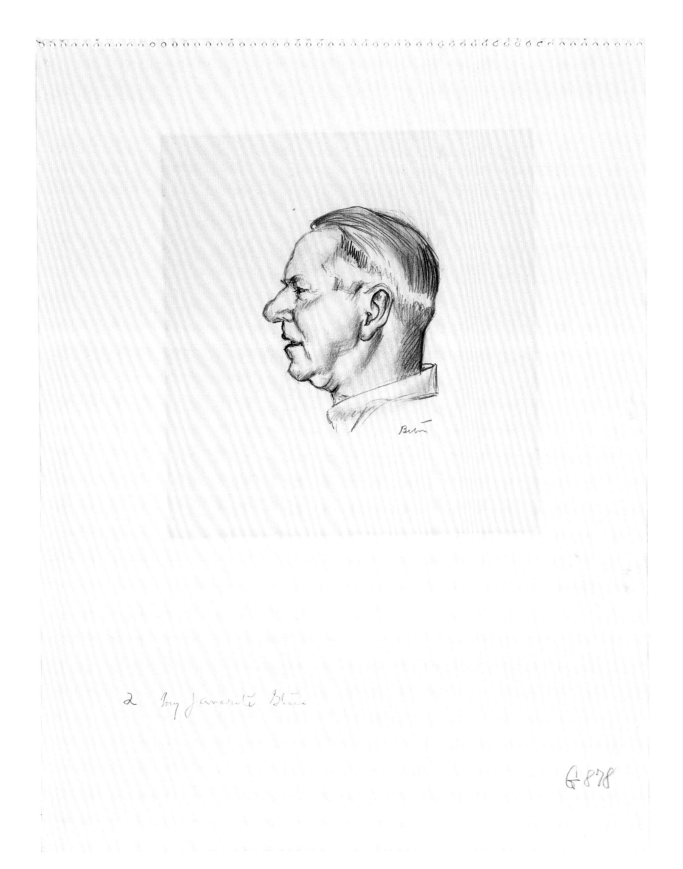

2 Tory Jamaroto Blair

G878

rather the very human actor himself. Finely and sensitively drawn, this profile (possibly chosen to highlight the famous nose) presents an aging figure with thinning hair. The squinting eyes with their crinkly lines and the parted lips give a sense of animation and gentle humor, while the reinforced outline lends a strength of character. The man, and the affection with which he is drawn, appear genuine.

Known primarily as a muralist and regionalist painter of the American scene (together with John Steuart Curry and Grant Wood), Benton was also a prolific draftsman and recorder of American life. His

Fig. 45. *W. C. Fields* (1879–1946) by Harry Warnecke (1900–1984). Color carbro print, circa 1936. National Portrait Gallery, Smithsonian Institution; gift of Elsie M. Warnecke

trip to Hollywood was on a commission from *Life* magazine, to produce a painting to be published in a full-color, two-page spread. This was not Benton's first job for *Life*. In July 1937 he had been sent to Michigan to cover a series of sit-down strikes and Fourth of July rallies. No stranger to reportage, he had in 1935 published drawings of the Hauptmann trial for the Lindbergh kidnapping in the *New York World Telegram* (January 3), and the February 14, 1937, issue of the *Kansas City Star* included six of his sketches of flooding in southwestern Missouri. Nor was Benton new to the film industry. From 1914 to 1917 he worked for his friend (former sculptor and later movie director) Rex Ingram in the early Fox studio in Fort Lee, New Jersey, painting scenes and finding willing models among the actors to pose for portraits.[310]

In Hollywood, Benton assembled a series of forty drawings of four types: "Hollywood Notes" or "Candid Camera," including gossipy vignettes and gathering places of the famous; "My Favorite Stars,"

including the portraits of W. C. Fields, Eddie Cantor,[311] and others; examinations of the steps involved in making a movie, such as "Set Designing" and "Prop Department"; and the business end of the business—scenes of Fox's top producer's office, conferences, and projections rooms.[312] Back home in Kansas City he used his sketches as episodes in his painting, which centered on a rather scantily clad blonde. *Life* rejected the painting, possibly as too sexy for its general audience. The magazine also did not accept the series of drawings that presented Hollywood as an industry with workers, much like the industries and workers that Benton had included in his paintings and murals. In its May 3, 1937, issue, *Life* did a feature article titled "Hollywood Is a Wonderful Place." Full of glitzy photographs of glamorous stars, mansions, expensive cars, and cute chorus girls, it was very unlike Benton's vision.

Disappointed at the rejection, Benton entered the painting *Hollywood* in the Carnegie Institute's annual exhibition, where it won a prize, and so ended up being reproduced in *Life* after all, late in 1938. To salvage something from the trip, Benton began to write a book around the drawings, with a personal account of his month's visit. Titled "Hollywood Journey," it never extended beyond page twelve but provides an interesting glimpse of Benton's experience. He reports that "Hollywood is different. But it is not qualitatively different from a great deal that is very American" and goes on to describe people at work in an industry. Noting that "the moving picture Art is predominantly an economically conditioned Art," he goes on to explain how things are done: with a boss, yes men, and advertising as driving forces. Benton's view of Hollywood remained cynical. As he had told a *Life* staffer about his painting, "I know it doesn't make sense. Nothing in Hollywood does"[313]—an opinion shared by W. C. Fields who, when asked if he had ever had the D.T.'s, answered, "I don't know. It's hard to tell where Hollywood ends and the D.T.'s begin."[314]

S.E.M.

162

308. Quoted in Charles Darnton, "Mr. Fields Wins by a NOSE!" *Screen Book Magazine* (November 1937): 34; quoted in Simon Louvish, *Man on the Flying Trapeze: The Life of W. C. Fields* (New York: W. W. Norton, 1997), 399.

309. William K. Everson, *The Art of W. C. Fields* (London: George Allen and Unwin, 1967), 149.

310. Thomas Hart Benton, interview with Paul Cummings, July 23, 1973, transcript 16, Thomas Hart Benton Papers, AAA, courtesy of the Benton Testamentary Trust; and Benton, *An American in Art: A Professional and Technical Autobiography* (Lawrence: University Press of Kansas, 1969), 34–35.

311. Also owned by the National Portrait Gallery (NPG.98.28).

312. Karal Ann Marling, *Tom Benton and His Drawings* (Columbia: University of Missouri Press, 1985), 95–96.

313. Benton's tone was sardonic throughout the piece: "A story" he wrote, "I soon learned was something to wrap about personalities who were either in the movie lots pay or available for its pay and that the genius of a story lay not in what it told about life, but in what it offered as opportunity for dragging in all the variety of currently advertised acting talent within" (Benton Papers, 1906–1975, Benton Testamentary Trust, AAA, microfilm reel 2327, frames 267–78); quoted in Marling, *Tom Benton,* 94.

314. Quoted in Wes D. Gehring, *W. C. Fields, A BioBibliography* (Westport, Conn.: Greenwood Press, 1984), 91.

Victor Hammer
1882–1967

Self-portrait

Silverpoint, graphite, and watercolor on prepared paper, 45.9 x 36 cm (18^1/$_{16}$ x 14^3/$_{16}$ in.), circa 1937
Inscription: V. H.
Gift of Carolyn Reading Hammer
NPG.89.59

In this silverpoint drawing, Austrian-born Victor Hammer portrays himself in the tradition of early Italian Renaissance artists' self-portraits. Hammer stares out at his audience, his face in three-quarter view, holding the attribute of his trade—in this case, a book. He is a craftsman, dressed in his work smock, presenting the finished product of his labor.[315] Also, in the working method of Renaissance artists, Hammer executed the silverpoint drawing as a study for a 1937 tempera on panel painting [fig. 46], which was owned by his widow, Carolyn Reading Hammer, until her death.[316]

In this medium, the artist must apply a silver stylus to a prepared ground. Although Hammer, according to his wife, used commercially available silverpoint papers later in his career, here he applied a ground of rabbitskin glue and Chinese white. He then executed a preparatory sketch in pencil, which he then drew over with the silver stylus. According to Bruce Weber, Hammer apparently floated the surface of the drawing in water to dissolve some of the ground, thus allowing him to spread silver with a brush in certain areas. He finished the drawing by applying watercolor to the face and hands and darkened the smock and other shadowed areas with Chinese ink.[317]

Silverpoint creates an extremely fine, delicate line that is gray when initially applied to the paper but turns brown as it tarnishes. When viewed at an angle, the silver has a reflective quality that imparts a shimmering luster to the line. These qualities spurred a revival of interest in silverpoint in the 1920s among European and American artists who admired Renaissance draftsmanship, including such American practitioners as Pavel Tchelitchew and Joseph Stella.[318]

Victor Hammer, a Renaissance man in several respects, received his artistic training at the Academy of Fine Arts in his native city of Vienna, where he served a brief term in the late 1930s as professor.

Accomplished as a painter, Hammer was also a printmaker,[319] typographer, writer, musician, architect, sculptor, and silversmith. In this circa 1937 silverpoint, however, Hammer emphasized his skills as a bookbinder and printer. His interest in bookbinding extends as far back as 1910, and it is during his years in Florence, Italy, from 1922 to 1933 that Hammer launched his career as a printer, with the assistance of patron Edgar Kaufman.[320]

In the late 1920s, Hammer hired a local carpenter to construct two wooden printing presses after a nineteenth-century reconstruction of a fifteenth-century press in the Biblioteca Laurenziana in Florence. In 1930–31, using hand-cut Uncial type, Hammer and a workshop of assistants began printing John Milton's *Samson Agonistes* under the Stamperia del Santuccio imprint.[321] Hammer brought both printing presses with him to Vienna when he left Florence in 1933.[322]

With the help of friends, Hammer in 1939 was able to secretly leave Austria for America, where he taught until 1948 at Wells College in Aurora, New York. At that time, he left Wells for Transylvania University in Lexington, Kentucky, where he continued printing under the mark of the Stamperia del Santuccio. Hammer, who died in 1967, is still considered one of the foremost American printers and typographers of the twentieth century.

Several rectilinear forms appear sketched faintly behind Hammer in his self-portrait drawing. Two parallel horizontal lines appear level with his left shoulder, perhaps the outline of a handle, suggesting that Hammer may have initially intended to portray himself in front of his Florentine press. In his left hand, Hammer holds a bone folder, a pointed tool used for folding paper, smoothing surfaces after gluing, and delineating details in leather tooling. On the left appears a cup, and on the right is a tool with a balled handle, possibly an agate burnisher or an awl used for polishing leather. The cup may hold water or

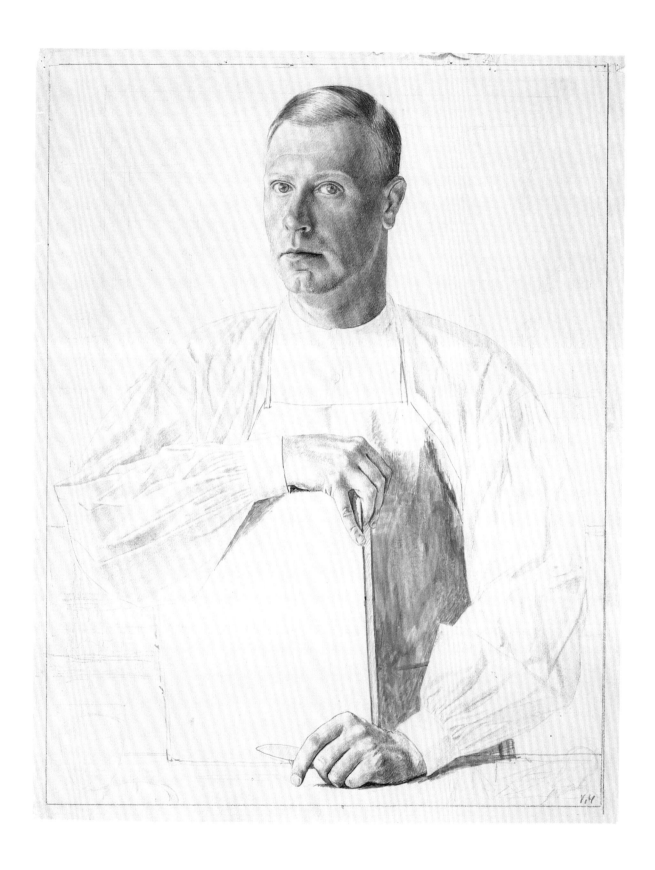

165

adhesive.[323] It is significant that Hammer shows himself at the final stage of book production— completing its binding—thus implying his mastery of all of its individual stages.

Around the perimeter of the drawing, Hammer drew a dark pencil border, which functions as a frame. "For the classic work of art, the 'frame' is the primary requisite," Hammer once wrote. "It need not be symmetrical or even tangible, but it must be visible."[324] Despite its finished quality, however, the silverpoint also functions as a preparatory study for the unfinished painted self-portrait [fig. 46]. Hammer

Of course behind every one of my paintings is a definite geometrical (abstract, cubistic, or what not) design: Claude Berger said, one could think about Mondrian seeing my paintings. But how sweet it is to tell a story, tell it in those cold, geometrical terms of which the Listener (or Onlooker in my case) is not aware: I am engrossed in the abstract design. . . . Why shouldn't I paint a portrait as if it were a triangle, and at the same time give a Likeness? [328]

E.M.T.

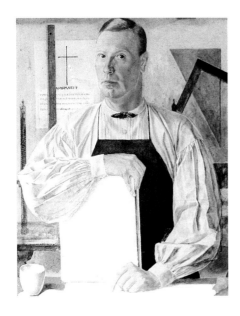

Fig. 46. *Victor Hammer* (1882–1967), self-portrait. Tempera on panel, 1937. Estate of Carolyn Reading Hammer

included many of the details from the drawing in the painting, for instance, the barely sketched rule and triangle in the background. The triangle adds a prominent geometric element to the painting. But Hammer also made significant changes in the tempera on panel portrait, replacing the printing press with a sewing frame used in the binding process.[325] The tall press would have obscured the inscription, which Hammer added to the upper left-hand corner of the painting.[326]

Rather than follow the modern painting styles of his contemporaries, Hammer looked to the past throughout his oeuvre; he painted portraits and religious and mythological subjects in tempera on panel in the style of the early Renaissance. As a Renaissance artist might do, Hammer divides his composition of the silverpoint drawing into a fore-, middle-, and background; he even sketches a squared line above the cup as a perspective aid.[327] Yet Hammer's emulation of traditional composition did not preclude a modernist sensibility. In a letter of 1948, Hammer wrote of his painting:

315. Hammer, as an artist, saw in himself a craftsman. Using a Renaissance and classical literary form, he wrote a lengthy autobiographic dialogue in which a Craftsman (himself) and a Patron (Edgar Kaufmann Sr.) discuss with one another various aspects of artistic production. See Victor Hammer, "On the Persons and of the Argument of the Dialogue," in Carolyn Hammer, ed., *Victor Hammer: An Artist's Testament* (Lexington, Ky.: Anvil Press, 1988), 117–89.

316. Edgar Kaufmann Jr., son of Hammer's patron, was apprenticed to Hammer for three years in Florence during the early 1930s. He describes how his teacher instructed him to make preparatory sketches in silverpoint: "First, some techniques had to be acquired; how to choose suitable paper, how to dampen and stretch it evenly over a board, using glue freshly cooked up. Then came the matte gesso ground, mixed and applied to receive the delicate markings of the point" (Kauffman, "With Victor in Florence," in Hammer, *Victor Hammer*, 17). According to Carolyn Hammer, Victor completed this self-portrait while teaching at the Schule für freie und strenge Künste at Grundlsee in Austria, an institution founded by Anna Mautner and himself.

317. Bruce Weber, *The Fine Line: Drawing with Silver in America* (West Palm Beach, Fla.: Norton Gallery of Art, 1985), 24.

318. Ibid., 19–29.

319. The National Portrait Gallery owns a mezzotint self-portrait (NPG.89.60) that dates to 1925.

320. Joseph Graves, *Victor Hammer: Calligrapher, Punch-Cutter, and Printer* (Charlottesville: Bibliographical Society of the University of Virginia, 1954), 5.

321. Ibid., 5–6. Hammer preferred using the Uncial type and created a new typeface by cutting the punches for the American Uncial (John Rothenstein, *Victor Hammer: Author and Craftsman* [Boston: David R. Godine, 1978], 32, and Harry Duncan, "My Master Victor Hammer," *Doors of Perception: Essays in Book Typography* [Austin: W. Thomas Taylor, 1983], 65–82).

322. Hammer's press was named for the statue of the small saint that stood outside of the entrance to his house, known as the Villa Santuccio, on the Via San Leonardo in Florence. For more information on Hammer's years in Florence, see Susanna Ragionieri, "Victor Hammer a Firenze," *Artista* (1991): 48–63. Before his move to the Via San Leonardo, Hammer and his family lived in Settignano at the Casa di Boccaccio outside of Florence, where they were neighbors of the renowned Renaissance art historian Bernard Berenson. It was Berenson who had suggested Milton's *Samson Agonistes* for printing this first book from the press.

According to Carolyn Hammer, the second Florentine press was in storage during World War II, and after the war was brought to this country, where it is now at the King Library Press at the University of Kentucky. The first Florentine press is now in the Gutenberg Museum in Eltville am Main.

323. Laura S. Young, *Bookbinding & Conservation by Hand: A Working Guide* (New York: R. R. Bowker, 1981), 19–22. Rosemary Fallon, paper conservator at the National Portrait Gallery, identifies the tool in Hammer's hand as a bone folder.

A similar cup appears in the foreground of the tempera and oil on panel self-portrait *Man in Black Robe*, 1928, owned by the National Portrait Gallery.

324. Victor Hammer, "On Classic Art," in Hammer, *Victor Hammer*, 205.

325. Reverend Paul Holbrook and Carolyn Hammer to Elizabeth Tobey, August 25, 1999.

326. According to Carolyn Hammer, the inscription, which is difficult to decipher, may be a passage from Goethe.

327. Hammer expresses his compositional strategy for self-portraits in a 1936 writing: "Underneath at the base of the picture, in the foundation, the forms pile up; one overlaps the other, and carefully led, the eye feels its way along the objects up into the at times confined, at times indefinite far distance of the horizon. Within the center of all the smaller forms stands a mighty mountain, in the middle heights its forms begin to stand out individually against the sky; and its peak, two fold in the self-portraits, stands directly against air or clouds." (Victor Hammer, "Victor Hammer: Rüchschau, Gegenwart und Ausblick," *Zweiter Band der Bucherreihe, Österreichische Blätter* [Graz: Schmidt-Dengler, 1936], trans. Dudley Zopp and the Gerhard Probsts and reproduced in Hammer, *Victor Hammer*, 22).

328. Victor Hammer to Mrs. Strain Biesel, April 21, 1948 (University of Chicago Renaissance Society Papers, microfilm reel 2403, AAA. Also reproduced in Ulrich Middeldorf, "Victor Hammer on His Art" in *Exhibition of the Recent Work of Victor Hammer in the Lexington Public Library, June 10–July 1, 1950* [Lexington, Ky.: Transylvania College, 1950]).

Milton Avery
1885–1965

Self-portrait

Ink on paper; closed 45.8 x 30.6 cm (18^1/$_{16}$ x 12^1/$_{16}$ in.), opened 45.8 x 60.8 cm (18^1/$_{16}$ x 23^{15}/$_{16}$ in.), 1938
Inscription: Milton Avery
NPG.86.65

This drawing of a man thoughtfully smoking a pipe is on the front of a carelessly folded piece of paper, while inside the folded page and on the back are lively scenes of seascapes [fig. 47a], views of a little girl drawing and sipping a tall drink, and a picture of a man with a furry mustache and glasses [fig. 47b]. The man with the pipe is Milton Avery, the little girl is his daughter March, and the man with the mustache is probably just a stranger who happened by. When Avery made this self-portrait in 1938, he was emerging as a masterful American painter. But while Avery is known as a colorist, this black-and-white drawing highlights other key aspects of his work: his frequent exploration of his own features, his fascination with line and texture, his affectionate habit of drawing his family and friends, and his sense of humor.

Avery's art began seriously, however. He enrolled in a lettering class at the Connecticut League of Art Students in Hartford in 1905, hoping that the skill would help him to support his widowed mother and siblings. When the class was canceled, Avery transferred into a life-drawing class. Although art did not provide the financial returns he had hoped for, for many years he continued to take art classes while working at factory and file-clerk positions. He painted academic portraits and landscapes inspired by American impressionism but, isolated, remained utterly ignorant of the movements of postimpressionism, futurism, and cubism, which rocked the worlds of American and European art.[329]

In 1924, Avery spent the summer in the popular artists' retreat in Gloucester, Massachusetts, where he met and fell in love with Sally Michel, a young artist from New York City. The next year Avery moved to New York to be near her, and they married in 1926. In the city's museums and galleries, Avery suddenly encountered a stunning array of American and European modernist art. He was captivated by the bright colors of French artists Henri Matisse, Raoul Dufy, André Derain, Pierre Bonnard, and Édouard Vuillard.[330] From these and a variety of other European and American modernists, Avery learned to use both color and line abstractly and freely. The dark colors and roughly defined forms that characterized his early modernist paintings gradually transformed over the next several years into brighter, complexly layered colors and strongly outlined, flat forms.

Avery's wife supported him in his explorations of modernism, working as an illustrator so that her husband could devote himself to his art. The Portrait Gallery's self-portrait is only one among a stream of casual yet striking drawings that the Averys created. The pair attended life classes at the Art Students League almost every evening.[331] When the Averys moved to Greenwich Village in 1938, they began their own cooperative for evening figure-drawing sessions. Avery's modernist paintings attracted few buyers as he began to show regularly, but a flock of young followers came to draw and paint with this quiet man who was bold enough to contradict the dominant 1930s realist trend of the American-scene painters. Avery's most devoted followers included Mark Rothko, Adolph Gottlieb, and Barnett Newman, who would be leaders of the abstract expressionist movement, which dominated the next generation of American art.[332] This excited circle of young painters stayed late into the night to talk after the sessions, but Avery said little. He preferred to interact with his friends and family through his art. "Why talk when you can paint?" he asked.[333]

Avery "often did several sketches before his first cup of coffee in the morning."[334] Much praised as a colorist, he was perhaps equally absorbed by linear effects. In this drawing, Avery made quiet statements about himself, his family life, and his process of drawing. The interplay of freely running lines evokes textures ranging from the artist's thinning hair to his warm sweater. Avery arranged areas of crosshatching so that when the drawing is viewed from a distance,

169

the planes of the artist's face appear solidly constructed, defined by light flooding his face from one side, which leaves his eyes and half of his face in soft shadow. This clear structure reflects the artist's background in academic portraiture. But viewed in detail, the drawing shows the artist's hand at work as each line loops toward the next. The open areas of hatching and crosshatching recall Matisse's delight in linear pattern. Avery often drew lines into wet paint with the end of his brush. He said, "I never thought of being interested in pattern, but my work has always stressed it."[335] Avery's use of line and pattern

Fig. 47a and b. Interior and back of Milton Avery self-portrait. Ink on paper, 1938. National Portrait Gallery, Smithsonian Institution

ranges from comic, as in the caterpillar mustache and dotted whiskers of a passing stranger, to lyrical, in the sweep of a young girl's hair. Racing to record the vibrant world of people in motion around him, Avery's line became loose and quick. Such drawings are a visual journal, showing us Avery's life day by day and person by person.[336]

His daughter, March, shown here at the age of six

in multiple views, was one of his favorite subjects. As soon as she was old enough to hold a pencil, she began to participate in the family culture of art alongside her parents and their friends. Avery frequently depicted March absorbed in creating art, as we see her in this drawing. As Avery's wife recalled, "[March and I] were always there, ready to be the source of a new arrangement of colors and forms; ready to personalize a landscape. . . . I was the prime target as subject; standing at the easel or bent over the drawing board."[337]

During the late 1920s and the 1930s, Avery and his family, often accompanied by Rothko, Gottlieb, and Newman, spent the summers at various retreats around New England. As they did in New York, the Averys and their friends documented their summer trips in many paintings and drawings of beaches and fields, often including familiar figures reclining or sketching.[338] Avery made this self-portrait drawing during the summer of 1938, when the family traveled to the Gaspé Peninsula in Quebec, where they rented a cabin for two months at Rivière-au-Renard.[339] The Gaspé landscape appears in paintings made in 1939 and 1940. On this sheet, a tiny seascape sketch in a rectangular framework suggests a possible canvas. Nearby is a sketch of a nude figure standing on the beach of the Gaspé.

For Avery, self-portraiture was a kind of touchstone, always there for him when he was at loose ends artistically. His wife recalled that he said to her more than once, "I don't know what to paint today. . . . I guess I'll just paint myself."[340] The Portrait Gallery's drawing focuses on Avery as the gentle father figure, as he was both for his own family and for the excited young artists who gathered around him. A 1933 painting and a 1936 etching that Avery made of his protégé Mark Rothko reflect the quiet, pipe-smoking pose of this self-portrait.[341]

In the drawing, Avery included all of his favorite artistic subjects: the nude, portraits of loved ones, landscapes, familial figure studies, comic caricatures, and even still lifes, if we count March's drinking glass and ink bottles. Avery gathered all of these motifs around his self-portrait on a single sheet of paper, making a broadly encompassing portrait of himself as father and artist. On the same surface where he made sketches of seascape and nude, Avery drew his own left hand reaching out toward his daughter, as through his art he reached out toward his family, his friends, and the rest of the world.

A.P.W.

NOTES

329. Barbara Haskell, *Milton Avery* (New York: Whitney Museum of Art and Harper & Row, 1982), 19.

330. Robert Hobbs, *Milton Avery* (New York: Hudson Hills, 1990), 3; Haskell, *Milton Avery*, 25–37.

331. Burt Chernow, *The Drawings of Milton Avery* (New York: Taplinger, 1984), n.p.; Haskell, *Milton Avery*, 26–29. For information on Sally Michel, see Robert Hobbs, "Sally Michel: The Other Avery," *Woman's Art Journal* 8 (Fall 1987/Winter 1988): 3–14.

332. James E. B. Breslin, *Mark Rothko: A Biography* (Chicago: University of Chicago Press, 1993); Lawrence Alloway and Mary Davis MacNaughton, *Adolph Gottlieb: A Retrospective* (New York: Adolph and Esther Gottlieb Foundation and Arts Publisher, 1981); Barnett Newman, "Milton Avery," in *Barnett Newman: Selected Writings and Interviews*, ed. John P. O'Neill (New York: Alfred A. Knopf, 1990), 77–80.

333. Chernow, *Drawings of Avery*; quoted in Haskell, *Milton Avery*, 13.

334. Chernow, *Drawings of Avery*.

335. Quoted in Chris Ritter, "A Milton Avery Profile," *Art Digest* 27 (December 1, 1952): 12.

336. Haskell, *Milton Avery*, 30.

337. March Avery grew up to be an artist; see *March Avery: Selected Works, 1974–1994* (Fairfield, Conn.: Thomas J. Walsh Art Gallery, Fairfield University, 1994); quoted in *Milton Avery: My Wife Sally, My Daughter March* (New York: Grace Borgenicht Gallery, 1989), n.p.

338. Chernow, *Drawings of Avery*, nos. 35–39, are by Avery; Haskell, *Milton Avery*, nos. 37 and 38, are by Rothko and Gottlieb.

339. Haskell, *Milton Avery*, 60, 188–89; Sally Michel Avery to Bridget Barber, National Portrait Gallery, September 16, 1987, National Portrait Gallery curatorial files.

340. Quoted in Gertrude Grace Sill, "The Face in the Mirror: What Do These American Artists See in Themselves?" *Connoisseur*, July 1986, 47.

341. The 1933 painting of Mark Rothko by Milton Avery is at the Museum of Art, Rhode Island School of Design, Providence. The 1936 etching of Rothko by Avery is owned by other collections as well as the National Portrait Gallery.

Bill ("Bojangles") Robinson
1878–1949

By Al Hirschfeld
born 1903

Ink on illustration board, 32.7 x 54.1 cm (12⁷/₈ x 21³/₈ in.), 1939
Original drawing for the *New York Herald Tribune*, March 19, 1939
Inscription: 7 3/4" / BILL ROBINSON (DANCING MIKADO) NAT KARSON (DESIGNER) HASSARD SHORT (DIRECTOR) / AT A REHEARSAL OF "THE HOT MIKADO"
NPG.94.117

"The Agile Bill Robinson Turns on the Heat at a Rehearsal of 'The Hot Mikado,'" the *New York Herald Tribune* proclaimed on March 19, 1939, in its caption for this image by caricaturist Al Hirschfeld. The artist, now famed for his elegantly abbreviated figures for the *New York Times*, created for this illustration a highly complex drawing that had more to do with music, dance, film, and graphic design than with comic portraiture.

The Hot Mikado, a swing version of Gilbert and Sullivan's operetta, featured the renowned sixty-year-old tap dancer affectionately known as Bojangles. Fresh from a series of hit films with Shirley Temple, Luther Bill Robinson, according to the *New York Daily Mirror*, once again "set the stage ablaze."[342] In another review, drama critic Brooks Atkinson acclaimed him as a great man "in black dancing shoes and a black derby hanging on one ear. . . . He struts. He taps sharply and lightly . . . and he gleams at the audience with the gusto that has crowded New York with his friends."[343] With his smooth, natural dancing style and ebullient vitality, Bojangles had worked his way up to the national vaudeville circuit, the Broadway stage, radio, and major studio films, breaching racial barriers all along the way. He was pronounced by some, James Weldon Johnson noted in 1930, as the "greatest tap-dancer in the world." A tireless performer, Robinson wore out twenty to thirty pairs of custom-made, split-clog shoes in a year and was considered the highest-paid black entertainer in the world. He taught tap to New York debutantes, gave thousands of benefit performances, and was dubbed the honorary "Mayor of Harlem."[344]

Al Hirschfeld played the drums throughout his life, and the love of percussive rhythm that he shared with Robinson pervades his image, particularly in the strong, repetitive white arcs of the seat backs located suggestively beneath the dancer's tapping feet. But Hirschfeld brought to this drawing other cultural

influences as well. Although he studied briefly at the National Academy of Design in New York, he also worked in the fledgling film industry in his early years, starting in the art department at the Goldwyn studios and ending up, at age eighteen, as the art director for Selznick Pictures.[345] This early exposure explains elements of the drawing that are strikingly cinematic; the elongated horizontal shape, the low viewpoint, and the bright white background call to mind the lighted screen. The equally sharp focus on the faces of Bojangles, designer Nat Karson, and director Hassard Short, in contrast to the sketchy details of the figures lounging on the stage, suggest movie close-ups and long shots rather than the steadily graduated focus of the theater. And the stretches and bends of the dancing star suggest a freeze-frame movie still of energetic movement.

Sharing a studio with Mexican-born caricaturist Miguel Covarrubias in New York in 1924 undoubtedly inspired Hirschfeld's interest in stylized figural drawing. In fact, the central figure of Robinson in this image seems almost a tribute to his friend, with whom he enjoyed frequent visits to the nightclubs of Harlem. The sharp, spiky shading of the face appeared in Covarrubias's ink drawings for *Vanity Fair* [see figs. 32 and 34] and the elongated arms, enlarged hands, and exaggerated bends were all characteristic of the loose-limbed figures Covarrubias drew for his volume *Negro Drawings* (1927) [fig. 48]. Hirschfeld's own caricature career started in 1926 after several months spent studying art in Paris. Attending the New York theater one day with his friend the press agent Dick Maney, he scribbled a sketch of French actor Sacha Guitry. Maney, impressed, urged him to produce a cleaned-up version to show to a friend at the *New York Herald Tribune*. Published on December 26, that illustration launched a twenty-year working relationship with the *Tribune*. Hirschfeld's legendary association with the *New York Times* began shortly afterward when

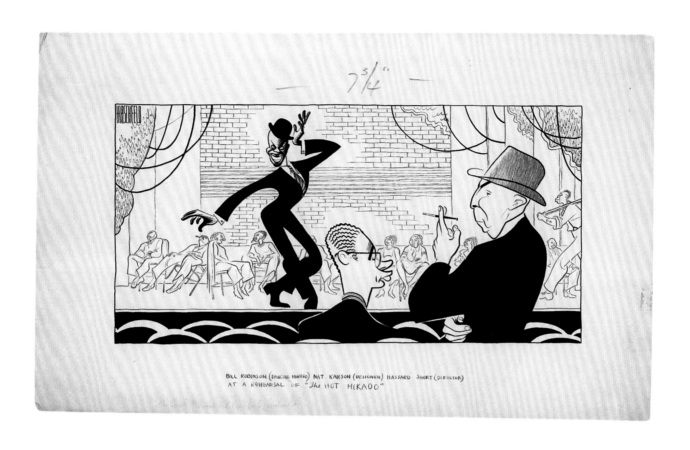

BILL ROBINSON (DANCING MIKADO) NAT KARSON (DESIGNER) HASSARD SHORT (DIRECTOR)
AT A REHEARSAL OF "The HOT MIKADO"

his drawing of Scottish vaudevillian Harry Lauder was published on January 22, 1928. But before his agreement with the *Times* became exclusive, Hirschfeld published in the *World*, the *Brooklyn Eagle*, and other New York newspapers, as well as such leading magazines as *Time*, *Vanity Fair*, and the *New Yorker*. In addition, he illustrated books and designed Hollywood film posters, mostly for Metro-Goldwyn-Mayer.

Hirschfeld's studies in Paris in the 1920s and his taste for travel introduced new cultural influences. In this drawing, the flattened, silhouetted figures, the

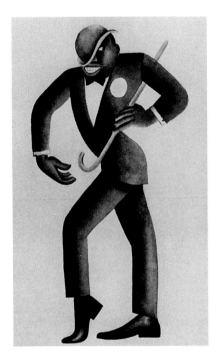

Fig. 48. *Strut* by Miguel Covarrubias (1904–1957). Printed illustration from *Negro Drawings* (New York: Alfred A. Knopf, 1927). Library of the National Portrait Gallery and the Smithsonian American Art Museum, Smithsonian Institution, Washington, D.C.

stylizations, and the elegant interplay of black-and-white patterning recall the art deco aesthetic practiced by French poster and graphic designers. And the artist has credited a trip to Bali, where color was "bleached out" by the intense sunlight, with focusing his attention on line.[346] Despite the prominence of the flattened forms, line plays an important role in the *Hot Mikado* drawing. Hirschfeld employs a complex, highly expressive graphic vocabulary, made up of a remarkable diversity of pen marks. Thin threads, authoritative contours, squiggles, loops, arcs, and white and black stripes all produce different effects in this virtuoso display of the potential of line. The quality of line defines textures, suggests receding space, and contrasts the languid posture of the background figures with the taut attention or arrested movement of the principals. As Lloyd Goodrich has pointed out, the line in Hirschfeld's drawings often seems alive: "It leaps, races around

curves, zooms with whiplash speed . . . and plays its precise part in an over-all linear ballet."[347]

In the crowded field of caricature in the 1920s and 1930s, when New York's many newspapers and busy theaters demanded a quantity of illustration, Hirschfeld's drawings began to emerge as distinctive. He had a remarkable flair for capturing likeness, relying, unlike many other artists, on the full-length figure, body posture, or characteristic pose in addition to facial features.[348] Hirschfeld often mused on the mystery of that "built-in radar," making an approaching friend recognizable long before face or clothing can be identified.[349] His ability to translate that body language into line became a specialty few could emulate. In addition, a discernible, barely balanced tension in his drawings added vitality to the image. The figure of Bojangles is outlined with such extreme angles and stretches that the line seems almost uncontrollable. Hirschfeld called the process one of "anarchic discipline," and spoke of struggling through a "self-made maze of swirling, engulfing lines, taming and bending them to my will, fighting every inch of the way."[350] It is partly this sense of line about to break loose from its restraints that imparts the illusion of liveliness and movement so frequently present in Hirschfeld's drawings.

If Hirschfeld loved to exaggerate line to an extreme, the malicious distortion of faces and figures was not his purpose. His contribution, he claimed, was not to ridicule but to take the theatrical character—"created by the playwright and acted out by the actor—and reinvent it for the reader." Indeed, Hirschfeld's drawings share an elegant exuberance that actually flatters his subjects. As Arthur Miller pointed out, "The sheer tactical vibrance of the lines . . . make you feel that all is not lost . . . that he has found a wit in your miserable features that may yet lend you a style and dash you were never aware of in yourself."[351] In preparation for his drawings, Hirschfeld would often go to rehearsals or attend an out-of-town, pre-Broadway opening. Sketches and written notations ("fried eggs" or "spirals" identified eyes; "corn silk" or "fuzz" described hair) were made in the darkened theater, sometimes supplemented by backstage visits. Notes and sketches served as references for the final composition created back in the studio. Despite his great interest in people, the theatrical likeness was secondary. His principal goal was to produce an image "capable of surviving the obvious fun," a drawing that resolves a complex set of formal problems with black lines on paper.[352]

W.W.R.

342. Robert Coleman, *New York Daily Mirror* [1939], quoted in Jim Haskins and N. R. Mitgang, *Mr. Bojangles: The Biography of Bill Robinson* (New York: William Morrow, 1988), 252.

343. Quoted in Allen Woll, *Black Musical Theatre from Coontown to Dreamgirls* (Baton Rouge: Louisiana State University Press, 1989), 182.

344. James Weldon Johnson, *Black Manhattan* (1930; reprint, Salem, N.H.: Ayer, 1990), 214; Haskins and Mitgang, *Mr. Bojangles*, 162, 194, 214–25.

345. David Leopold, *In Line with Hirschfeld* (New York: Katonah Museum of Art, 1998), 4.

346. Al Hirschfeld, *The World of Hirschfeld* (New York: Harry N. Abrams, 1970), 19.

347. Lloyd Goodrich, introduction to ibid., 9.

348. "Few black and white artists," *ARTnews* reported, reviewing an exhibition of Hirschfeld's work at the Morgan Gallery, "can stand up in so large a showing as Hirschfeld does here" (*ARTnews* 37 [February 4, 1939]: 14). For comparison with other caricature artists, see Reaves, *Celebrity Caricature*, 254–61.

349. Hirschfeld, *World of Hirschfeld*, 12; Al Hirschfeld, *Hirschfeld: Art and Recollections from Four Decades* (New York: Charles Scribner's Sons, 1991), xix.

350. Hirschfeld, *World of Hirschfeld*, 15.

351. Ibid., 30; Arthur Miller, "Al Hirschfeld," *FMR* 15 (October 1985): 41.

352. Hirschfeld, *World of Hirschfeld*, 26, 11.

Joseph Stella
1877–1946

Self-portrait

Gouache, graphite, metalpoint, watercolor, and crayon on prepared paper, 35.8 x 30.7 cm (14$^{1}/_{8}$ x 12$^{1}/_{16}$ in.), circa 1940
NPG.93.368

Joseph Stella's late self-portraits reveal a conflicted personality and complex artistic expression. While his earlier self-portraits suggest an artist simply using himself as a model for a physical presence, the later ones convey his state of mind. Drawing was his preferred medium for the self-portraits, and his profile image in the Portrait Gallery testifies to the power of his draftsmanship. The intricacy of its technique hints at the layers of experience and emotion that weighed heavily on him at the time.

Born in Muro Lucano, near Naples, Italy, Stella enjoyed a classical education in preparation for a professional career. He immigrated to the United States at the age of nineteen, but within a year he abandoned his medical studies and enrolled in art classes at the Art Students League. Uncomfortable with the academic rigidity and arbitrary rules of the school, he left after a few months. He transferred to the New York School of Art, headed by the popular teacher and international celebrity William Merritt Chase, who encouraged his students to study masterpieces of the past. In New York he made frequent trips to the Metropolitan Museum of Art, and in 1909 he returned to Italy to continue his study of Old Master painting and drawing techniques in the museums of Florence, Rome, Venice, and Naples. The profile view he favored for likenesses of his friends and himself recalls the early Renaissance portraits of Pisanello and Piero della Francesca, while the strong outline of the head recalls such masters as Andrea Mantegna.[353]

Stella continued to find inspiration in the works of Renaissance masters throughout his career, but he was equally drawn to modernist abstraction and the study of nature. He is best known as America's leading futurist artist for such monumental abstract paintings as *Battle of Lights, Coney Island,* 1913, *Brooklyn Bridge,* 1919–20, and *The Voice of the City of New York Interpreted,* 1920–22,[354] distinguished by dramatic contrasts of light and color, thrusting

diagonals, and dynamic movement. If Italy represented the grand and noble tradition of the past, America represented the future, and Stella sought to convey its energy and promise in complex, abstract compositions based on urban subject matter and the engineering feats of modern life.

At the same time he was creating these avant-garde works, however, he was drawing exquisite nature studies in the Bronx botanical gardens. Executed in graphite, pastel, colored pencil, watercolor, or metalpoint—or a combination—the drawings ranged from careful, botanically accurate renderings to imaginative creations and groupings of plants that would never grow together naturally. Although most of the sketches were conceived as independent works, he often incorporated the forms into his canvases. During the same years he painted his iconic image of the Brooklyn Bridge, he also created his masterpiece of nature imagery, *Tree of My Life.* With scenes of the Italian countryside in the background and wildly exuberant plant life in the foreground, the painting would appear to be the diametric opposite of *Brooklyn Bridge.* Although each can be characterized as "baroque and operatic," together they seem to represent the conflicting poles of Stella's emotional ties and sources of inspiration.[355]

Stella's self-portrait drawing reflects, on a more intimate scale, many of the conflicts and contradictions that distinguish his artistic development and personal life. Although the profile pose recalls Renaissance classicism, the intensity and complexity of the image belie that tradition. In contrast to his silverpoint portraits of Marcel Duchamp [fig. 49] and Edgard Varèse, or his crayon portrait of Helen Walser, all posed serenely against a blank background, the turbulent pattern and acrid yellow highlights in the background of his self-portrait create a sense of anxiety.[356] The background forms appear to have little relation to the massive head, but the strong area of yellow that abuts the

177

artist's features from his forehead to his chin suggests a shadow profile, a bilious alter ego that hovers behind the artist's more composed external appearance. The touches of red on the lips, eyelid, nose, and fold of the cheek reinforce a sense of discomfort.

The strong outline of the head tends to flatten and abstract its form, as do the prominent white highlights on the forehead and cheekbone, yet the modeling of the face and the details of the features create a fairly realistic image. Stella's wrinkled forehead, furrowed brow, fleshy neck and chin,

Fig. 49. *Marcel Duchamp* (1887–1968) by Joseph Stella (1877–1946). Silverpoint on prepared paper, circa 1920–22. The Museum of Modern Art, New York; Katherine S. Dreier bequest

prominent jowls, thinning hair, and mole or wart on his cheek show no attempt to disguise his less-attractive features. Moreover, the large head sits uncomfortably on the flattened, abstracted shoulders that seem too small to support it. Yet the intensity of his gaze, the flare of his nostril, and the set of his lips convey the headstrong personality of the artist that persists despite the surrounding emotional turmoil.

Although Stella had achieved acclaim early in his career, by the 1930s he was no longer recognized as one of America's leading artists. When he returned from Italy in the mid-1930s, the market for his work had so diminished that he found it necessary to work on a Works Progress Administration easel-painting project. He felt bitter that he had to accept a government check. Lonely, he renewed contact with his wife, Mary French, from whom he had been separated for more than two decades. She had returned to her native Barbados, and Stella visited her several times and brought her medications. She

died in November 1939, and his own health began to deteriorate as well. Toward the end of his life, Stella became more self-centered and narcissistic. He had almost no friends, save his nephew August Mosca, who took care of him during his last years, and his dog. As his body weakened, Stella continued to work, on paper more often than on canvas.

Because the image was made on prepared paper, it probably began as a metalpoint drawing. This painstaking technique requires the preparation of an opaque, liquid solution that, when brushed on the paper, dries to form a ground with a slight texture, or "tooth," that holds minute particles of metal deposited on it when a stylus is dragged along the surface.[357] Unlike drawing with pencil directly on paper, this exacting technique does not allow for erasure or for increased pressure to create darker lines without penetrating the ground and abrading the paper beneath it. To strengthen the outline around the head, Stella drew over it several times, and when that did not suffice, he darkened it further with graphite. Stella added flesh color with crayon and the background yellow with watercolor, repeating the sickly yellow tone in the fleshy neck area. As the final touch, he used white gouache to highlight the forehead and cheekbone and define the shirt. The stark white highlights draw attention to the sitter's furrowed brow, emphasizing the area of his face that most succinctly expresses the sitter's emotional state.

The care and attention that Stella lavished on this self-portrait suggest that he intended it to be a finished work of art rather than a study for a painting. Although he frequently combined more than one drawing technique in one work, he rarely used so many different media to create a single image. Yet the complexity of techniques does not overwhelm the power of the line and the subtlety of the details. Joseph Stella's skill as a draftsman was apparent early in his career, and masterful drawings such as this self-portrait attest that age did not diminish his virtuosity.

J.M.

178

353. Joann Moser, *Visual Poetry: The Drawings of Joseph Stella* (Washington, D.C.: Smithsonian Institution Press, 1990), 8, 10.

354. *Battle of Lights, Coney Island,* and *Brooklyn Bridge* are in the Yale University Art Gallery, and *The Voice of the City of New York Interpreted* is in the Newark Museum.

355. Barbara Haskell, *Joseph Stella* (New York: Whitney Museum of American Art, 1994), 110.

356. For comparison profiles, see Moser, *Visual Poetry,* 15–16.

357. Stella usually used a ground of zinc white gouache thinned to the consistency of light cream.

Beauford Delaney
1901–1979

By Georgia O'Keeffe
1887–1986

Pastel on paper, 48.9 x 32.4 cm (19^1/$_4$ x 12^3/$_4$ in.), 1943
Gift of The Georgia O'Keeffe Foundation
NPG.2002.01

As a gay black southerner, the painter Beauford Delaney faced extraordinary challenges as he strove to establish a coherent artistic identity.[358] Throughout his career his quest for self-expression was impeded by sexual, cultural, and racial stereotyping. He had to take menial jobs to support himself, was sometimes physically assaulted because of his homosexuality, and later in life, beset by inner voices and other psychological problems, attempted suicide. Delaney often alluded to these difficulties in his personal journals. He wrote of the importance of facing "one's destiny, seeing clearly the direction through all the complexities occasioned by struggle, sorrow, enigma" and tellingly recorded his belief that one measure of success was "how many disappointments [he] has withstood."[359] Georgia O'Keeffe's reverent pastel portrait honors Delaney's magnanimity, endurance, and courage—virtues that would eventually garner him international renown as an artist by the time of his death in Paris on March 26, 1979.

The son of a Methodist Episcopal minister, Delaney had a talent for drawing that his mother recognized when he was a child in Knoxville, Tennessee. In 1923 he moved to Boston to further his art studies before settling in New York City from 1929 until 1953. There Delaney forged many friendships within the mostly white bohemian culture near his Greene Street studio in Greenwich Village. He also frequented the gathering places for black artists such as the Artists Guild and the Savage Studio of Arts and Crafts in Harlem, as well as the famous Harlem jazz clubs where he met and drew prominent musicians such as Cab Calloway, W. C. Handy, Ethel Waters, Duke Ellington, and Louis Armstrong. Finally, in addition to contemporary debates concerning the nature of "Negro" art, Delaney became acquainted with the modernist art world through his friendships with the abstract painter Stuart Davis and the photographer Alfred Stieglitz.

Delaney greatly admired all of Stieglitz's varied activities. Soon after his arrival in New York in 1929 he had begun visiting An American Place, Stieglitz's gallery at 501 Madison Avenue. He described its rooms as "white and gray, serene with . . . indomitable spirits" who "live by sheer awareness" and who have "extended the dignity of the American spirit into the consciousness of our times."[360] Emulating American Place's distinctive white walls, he covered the cracked walls of his own studio with white paper, believing that the color was a symbol of pure expression and that its reflected light enlivened his painting. Moreover, Delaney wrote at length in his journal about Stieglitz's photographs and consistently praised his inner circle of artists, including John Marin, Arthur Dove, and O'Keeffe, all of whom he met at the gallery.[361] He found O'Keeffe's paintings "alive and quite amazing" and called Marin's show in 1946 at An American Place "magnificent," noting that he "grows into greater splendor of heights and depths—the unusual spirit pervades his color." When Stieglitz died later that year Delaney observed that he "has left us his mantle and we who are here somehow become more precious to each other."[362]

In 1974, O'Keeffe recalled sketching Delaney alongside her friend the sculptor Mary Callery: "I found that he was a painter and posed for others because he had no heat in his studio and needed to keep warm. He seemed a very special sort of person. I don't remember where I worked on him—maybe at Mary's—maybe at my own place."[363]

Drawing directly from a live model was not O'Keeffe's usual practice. As a young artist visiting Stieglitz's 291 gallery she had been schooled in the modernist belief that abstract symbols and forms rather than physical traits could more cogently describe personality. Rather than portraiture, O'Keeffe instead often employed other genres—abstractions, still lifes, cityscapes, and landscapes—to

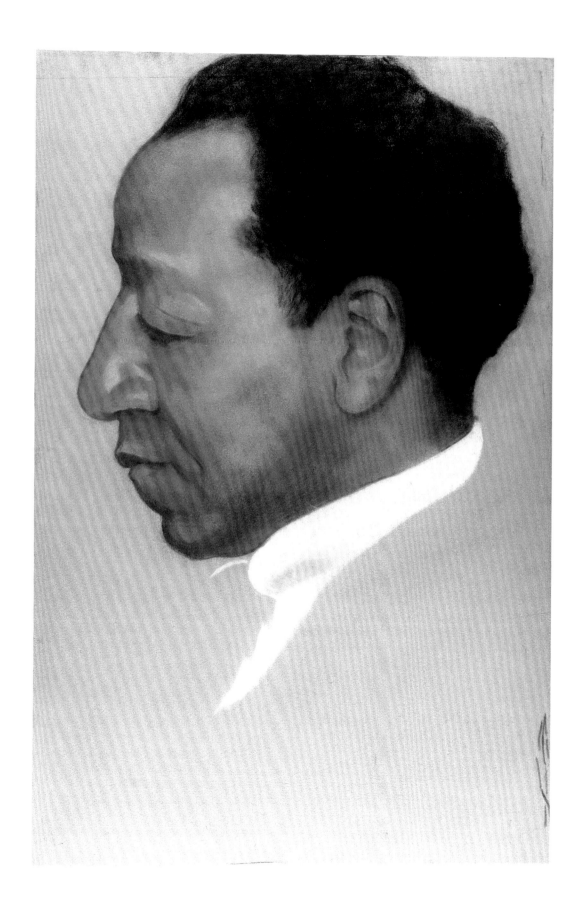

obliquely refer to her subjects. Her three charcoals and two pastels of Delaney, were, in fact, her last traditional portraits and the pastels are the only examples of realistic portraiture in that media in O'Keeffe's entire oeuvre.[364]

Although Delaney was an unusual subject, O'Keeffe rendered him using the same methods and in the same manner as her New Mexico landscapes and desert still lifes of bones, rocks, and flowers from this period. She generally worked in series and in this instance produced five variations, including four frontal views and this single profile study. Also, a

Fig. 50. *My Heart* by Georgia O'Keeffe (1887–1986). Pastel on paper, 1944. The Museum of Texas Tech University, Lubbock

photographic aesthetic had informed O'Keeffe's style ever since her early encounters with the work of Stieglitz and Paul Strand. Here O'Keeffe depicts her subject precisely and objectively, using minute tonal gradations. Isolating Delaney's head against a neutral background, and focusing attention, like a close-up, on the details of the face—the curving surfaces of the ear, nose, eyes, chin, cheek and lips—she draws upon the way photographic vision abstracts forms and manipulates scale. The final result is not unlike her nearly contemporary New Mexico landscape *Black Place*, or the pastel of two stones titled *My Heart* [fig. 50].[365] When considered together, these images suggest how in O'Keeffe's work the traditional genre categories are irrelevant. Her photographic eye elides the differences in scale and form that distinguish a stone from a mountain or a mountain from a face. All are seen as sensuous, undulating topographies capable of registering not only facts but feelings as well.

James Baldwin and Henry Miller were Delaney's two most famous champions and in their writings unabashedly apotheosized the older artist. In 1945,

Miller wrote in *The Amazing and Invariable Beauford Delaney* (part of his novel *The Air-Conditioned Nightmare*): "Beauford sitting at 181 Greene Street . . . sets in motion the universal brotherhood of man, the white sisterhood of doves and angels, and the great serpentine constellation of birds, beasts and flowers, all caracoling towards the sun in color, peace and harmony."[366] Baldwin praised him in similarly lavish terms in his statement for Delaney's solo show in 1973 at the Galerie Darthea Speyer in Paris observing, "It escapes the general notice that he has comprehended, more totally perhaps than anyone in this century . . . the tremendous reality of light which comes out of darkness. If we stand before a Delaney canvas . . . we are liberated into the perception that darkness is not the absence of light, but the negation of it."[367]

O'Keeffe herself contributed a statement to the Galerie Darthea Speyer catalogue, which appeared next to Baldwin's. She wrote, "I knew Beauford Delaney some twenty-six or twenty-eight years ago. He was a very special person—impossible to define. I think of him often as a special experience and always with a feeling that it is fine to know he is living—somewhere—still being his special self—what I do not exactly know, but he is a special kind of thought."[368] In comparison to the passionate, visionary styles of Miller and Baldwin, O'Keeffe's comments are circumspect and guarded. Recalling her spare, restrained visual aesthetic and evoking her own notoriously elusive and private personality, they remind us that, although a great admirer of Delaney, she was never as close to him as Baldwin and Miller were. Nevertheless, in O'Keeffe's pastel, this more distanced, objective approach succeeds in conveying a sadness that was an undeniable part of Delaney's existence. Presenting a subdued, somber, and introspective painter lost deep in thought, with head bowed forward slightly as if in prayer, the sources of his private inner life sacrosanct and inviolable, it corroborates the sobering account of Delaney in the early 1940s offered by his biographer, David Leeming: "Beauford Delaney was not the serene man that Henry Miller saw; he was a man still only recognized as an eccentric 'Negro painter,' and he was a man wracked by poverty and an inner pain that was taking its toll."[369]

C.B.

NOTES

358. For Delaney's biography, see David Leeming, *Amazing Grace: A Life of Beauford Delaney* (New York: Oxford University Press, 1998).

359. Quoted in ibid., 87, 64.

360. Quoted in ibid., 77.

361. Ibid., 63, 53.

362. Quoted in ibid., 78.

363. Georgia O'Keeffe, *Some Memories of Drawings* (New York: Atlantis Editions, 1974), n.p. Although O'Keeffe remembered this episode as their first meeting, it seems likely that she and Delaney had crossed paths sometime during the 1930s, either during one of Delaney's visits to An American Place or perhaps through one of their mutual friends such as the writer Carl Van Vechten. At one point, most likely before 1943, Delaney had inquired at An American Place about a job. O'Keeffe seems to have considered hiring him to work at her Ghost Ranch house in New Mexico. This episode is recounted in an undated letter from O'Keeffe to Louise March in Roxana Robinson, *Georgia O'Keeffe: A Life* (New York: Harper & Row, 1989), 471, in which O'Keeffe refers to Delaney as "very beautiful" and states that she "would take him in a minute if my place were not so far away."

364. See nos. 1041–45 in Barbara Buhler Lynes, *Georgia O'Keeffe: Catalogue Raisonné* (New Haven: Yale University Press, 1999), vol. 2, 654–55. Sarah Greenough has written on the charcoal, no. 1042, in Bruce Robertson et al., *Twentieth-Century American Art: The Ebsworth Collection* (Washington, D.C.: National Gallery of Art, 1999), 199–201.

365. For *Black Place*, 1943, The Art Institute of Chicago, and *My Heart*, see nos. 1058 and 1074, respectively, in Lynes, *Georgia O'Keeffe*, 664, 676.

366. Henry Miller, *The Amazing and Invariable Beauford Delaney* (Yonkers: Alicat Book Shop, 1945), 24.

367. Quoted in *Beauford Delaney* (Paris: Galerie Darthea Speyer, 1973), n.p.

368. Quoted in ibid.

369. Leeming, *Amazing Grace*, 83.

John Marin

1870–1953

Self-portrait

Graphite and charcoal pencil on transparent film, 24.4 x 19.2 cm (9⅝ x 7⁷⁄₁₆ in.), circa 1945
NPG.83.136

John Marin's most celebrated art is about monumental forms and forces: bridges and skyscrapers, mountains and sea, sun and sky. But late in his career Marin discovered a new interest in the human scale of portraiture. In drawings such as this self-portrait, the painter of Maine's rugged coast observed the effects of time and weather on his own distinctive visage.

By the 1940s, Marin's face was one of the best known in the American art world. A *Look* magazine article polling American museum directors, curators, and critics in 1948 named Marin as the number-one artist in America. But art critic Henry McBride described his first meeting with Marin, in Venice in 1907, thus:

> He conformed completely to my idea of an artist though I don't think I should have picked him out as one marked for worldly success. He already had the hatchet-hewn face that has since been made familiar to the world by Gaston Lachaise's portrait bronze. Indeed I have never been able to see the slightest change in his lineaments made by the years and perturbations that have since rolled over our heads. He was born old and has remained young.[370]

As McBride noted, the young Marin seemed unlikely to succeed at anything. After attending the Stevens Institute in his native New Jersey, Marin drifted between jobs, spending a few years as an architectural draftsman and architect before giving up the profession. He studied at the Pennsylvania Academy of the Fine Arts and at the Art Students League in New York, but the academic approach to art did not appeal to him. He much preferred to draw on his own, as he later recalled, "As for making my own pictures . . . I just drew. I drew every chance I got."[371]

By 1905, Marin was wandering the streets of Paris, Amsterdam, and Venice, making popular architectural etchings inspired by James McNeill Whistler's acclaimed prints. Soon Marin began making more experimental etchings and watercolors inspired by the modern art he saw in Paris. When Alfred Stieglitz's European talent scout, painter, and photographer Edward Steichen saw Marin's watercolors at the Salon d'Automne of 1908, he found them so exciting that he shipped a number of them to New York. The following year Marin's show of watercolors at 291 was the first of his many exhibitions at Stieglitz's various New York galleries. Marin found in Stieglitz a devoted advocate who provided annual exhibition opportunities, in addition to consistent moral and financial support. Stieglitz found in Marin his ideal American artist, a sensitive and original individualist inspired by modern art but not adhering to any established art movement. Their warm friendship and business relationship lasted until Stieglitz's death in 1946.[372]

With Stieglitz's financial support, Marin was able to spend his summers on the Maine coast painting seascapes and landscapes, while in the winters he lived in New Jersey, where he concentrated on urban subject matter. Whether painting the watercolors for which he was best known or working in oils, Marin used boldly gestural strokes, rich colors, and a cubist-influenced linear structure to explore the characteristic life and forms of the urban and rural worlds. The human figure formed only a very minor part of his art until the 1930s, when circus performers and women bathing in the sea began to appear.[373]

Marin achieved a new kind of fame in 1931 with the publication of a book of letters he had written to Stieglitz.[374] Marin wrote with eccentric syntax, his long sentences broken up by dashes. Since most of the correspondence was written during the summer, the pages were filled with humorous descriptions of fishing, berry picking, boat repair, and the vivid characters of rural Maine. In magazine stories and his own letters, Marin took on the persona of an innocent and unpretentious New Englander who kept apart from the sophisticated art world of New York.

Of course there was no need for Marin to write to Stieglitz during the winter, when the artist lived in New Jersey and frequently crossed the river to visit 291 and other New York galleries.

When, in 1936, the Museum of Modern Art held the first major retrospective of Marin's work, painter Loren Mozley wrote a "pen-portrait" that captured Marin's public image:

> John Marin is an American original, a curious little man, wiry and frail. His face is incredibly wrinkled and puckers into all sorts of criss-cross lines. His candid eyes peer out brightly and mischievously under an

Fig. 51. *John Marin* (1870–1953), self-portrait. Graphite pencil on tracing paper, 1940–1953. The Phillips Collection, Washington, D.C.; gift of Marjorie Phillips, 1985

> outlandish curling bang. His hair is scarcely streaked with grey . . . a tense grace born of habitual alertness: the axis under control. He is ambidextrous and makes abrupt, nervous gestures with both hands. He seems to lean rather than stoop, his shoulders bent by relentless peering ahead. A strange, honest-to-God sort of man.[375]

Marin's singular face fascinated artists. Alfred Stieglitz, Arnold Newman, Charles Sheeler, and George Daniell photographed Marin. Jo Davidson and Gaston Lachaise sculpted his features in bronze. Isabella Howland and Reginald Marsh drew him. Finally, in his later years, Marin himself began to make portraits of his family, his friends, and himself.

As Ruth Fine has observed, some of the aging Marin's late interest in portraiture seems to have been connected to the loss of his wife, Marie, in 1945, and of Stieglitz in 1946, as well as his own health problems. However, the earliest of the dated late self-portraits is from 1938.[376] Some of these were based upon photographs, but in most he peered into a mirror, unblinkingly recording the asymmetrical,

weathered features reflected there. Sometimes he drew several rough head studies on a single sheet, repeatedly erasing and redrawing his own face, never really satisfied.[377] The Portrait Gallery's undated drawing could have been done at any time between the mid-1940s and the artist's death in 1953. Despite a heart attack in 1946, Marin kept working until the end.[378]

The Portrait Gallery's drawing, informal as it is, is perhaps the most finished self-portrait drawing that Marin made. He depicted himself in his home or studio with a painting on an easel behind him. Directly and honestly he drew his own tousled hair, lined face, rumpled sweater, and leaning shoulders. His lip jutted out as he made faces in the throes of concentration or for his own amusement. Marin's own drawing confirms, perhaps purposely, the eccentricity described and depicted so often by others.

The drawing is on a sheet of transparent plastic. Marin often drew on plastic sheets to make several variations on a theme, tracing or transferring images from drawing to drawing as he tried out different approaches and compositions.[379] The Phillips Collection in Washington, D.C., owns a self-portrait drawing on paper in a more vigorous and less detailed style than the Portrait Gallery's drawing but with a similar basic structure [fig. 51]. It seems likely that the Phillips Collection's drawing was traced from or based on the Portrait Gallery's drawing.

In his last years, Marin continued to look for new ways of seeing the world and making art. For instance, he found that he could use an ear syringe filled with oil paint to draw stronger lines on canvas than he could achieve with a brush.[380] His self-portraits were a similar discovery, giving him new terrain to explore with his established modes of drawing. He described his own wavy hair and lopsided mouth with the same free, vigorous line that he had applied to bridges and skyscrapers, mountains and sea, sun and sky.

A.P.W.

NOTES

370. "Are These Men the Best Painters in America Today?" *Look*, February 3, 1948, 44; quoted in E. M. Benson, *John Marin: Watercolors, Oil Paintings, Etchings* (New York: Museum of Modern Art, 1936), 11–12.

371. Ruth E. Fine, *John Marin* (Washington, D.C.: National Gallery of Art and Abbeville, 1990), 21–28; quoted in Dorothy Norman, introduction to *The Selected Writings of John Marin* (New York: Pellegrini & Cudahy, 1949), ix.

372. For accounts of the relationship between Marin and Stieglitz and Marin's exhibitions at Stieglitz's galleries, see Fine, *John Marin*, 31–45, 75, 289–90; Norman, introduction to *Selected Writings of Marin*, ix–xii; Barbara Rose, *John Marin: The 291 Years* (New York: Richard York Gallery, 1998), 12–18; Homer, *Stieglitz and the American Avant-Garde*, 88–108, 202–8 [see cat. no. 7, n. 74]; Ruth E. Fine, "John Marin: An Art Fully Resolved," in Sarah Greenough, *Modern Art and America: Alfred Stieglitz and His New York Galleries* (Washington, D.C.: National Gallery of Art and Bulfinch Press, 2000), 340–61.

373. Sheldon Reich, *John Marin: A Stylistic Analysis and Catalogue Raisonné* (Tucson: University of Arizona Press, 1970), vol. 1, 206–21.

374. Herbert J. Seligmann, ed., *Letters of John Marin* (New York: An American Place, 1931).

375. Loren Mozley, "Yankee Artist," *Bulletin of the Museum of Modern Art* 4 (October 1936): 2. For another version of Marin's public image, see Matthew Josephson, "Profiles: Leprechaun on the Palisades," *New Yorker*, March 14, 1942, 26–35.

376. Fine, *John Marin*, 249–51. This watercolor is in Yale University's Beinecke Library.

377. Cleve Gray, ed., *John Marin by John Marin* (New York: Holt, Rinehart and Winston, 1970), 31, 37; telephone conversation with Meredith Ward, director, Richard York Gallery, New York, October 12, 1999.

378. When the Portrait Gallery's drawing was in the collection of John Marin Jr., it was exhibited with the date of circa 1950; see *John Marin's Maine: A Tribute* (Addison, Maine: Cape Split Place, 1978). Its similarity to a self-portrait drawing in the artist's estate dated 1945 suggests, however, that it could as easily have been made in the mid- to late 1940s; see Gray, *John Marin by John Marin*, 5.

379. Fine, *John Marin*, 280–82.

380. MacKinley Helm, *John Marin* (Boston: Institute of Contemporary Art and Pellegrini & Cudahy, 1948), 74.

IGOR STRAVINSKY
1882–1971

BY RICO LEBRUN
1900–1964

Charcoal on paper, 50.8 x 43.8 cm (20 x 17$\frac{1}{4}$ in.), 1947
NPG.84.156

Not only were the musical compositions of Igor Stravinsky powerful and even shocking in their time, but the five-foot, three-inch man himself, with his birdlike physiognomy, was a sight to behold. Indeed, everyone who saw him was struck by his appearance, and it is nearly impossible to read about his life and work without coming across a description of his remarkable physique. A close acquaintance wrote, "He is physically so extraordinary . . . that nothing less than a lifesize statue, or scaled to life drawing, could convey his uniqueness: the pygmy height, short legs, fleshlessness, football player's shoulders, large hands, and wide knuckles, tiny head, and recessive frontal lobes. . . . He is so absorbing to look at, in fact, that an effort is required to concentrate on what he says."[381] Rico Lebrun gracefully summarized Stravinsky in this life-size charcoal profile sketch made in Los Angeles when Stravinsky was sixty-five years old. The artists were not intimate friends, but they often saw each other at social events in Los Angeles in the 1940s and shared many interests, including ballet.

Lebrun, who was almost twenty years Stravinsky's junior, was known for his expressionistic drawings, murals, and sculptures. His career encompassed diverse projects, ranging from stained-glass manufacture, commercial advertising, animation for Walt Disney's *Bambi*, set and costume design for ballet performances, and a mural portrayal of the Book of Genesis for Pomona College in Claremont, California. His early career as an illustrator laid the foundation for his future work as a painter and sculptor. In the 1920s he became one of the most highly paid commercial artists of his day, with work appearing in such popular publications as *Vogue*, *Harper's Bazaar*, and the *New Yorker*. In the early 1930s, however, he became frustrated by the pace and nature of periodical illustration and focused his energy on painting. In his paintings and sculptures he tried to keep his imagery from being excessively illustrative and strenuously avoided total abstraction.[382] Central to his work was a monumental interpretation of the human figure charged with a brooding, tragic sense of the human condition.

In this mid-career sketch with its fast yet fluid lines, Lebrun has focused on his subject's vitality and captivating physiognomy. The plentiful white space on the page, without shadow and with minimal detail, gives the impression of the impact Stravinsky made on those around him. Although the effect of the cartoonlike profile might at first be humorous, Lebrun has sensitively captured key aspects of the composer's personality. The artist refers to Stravinsky's determination in his fixed gaze, his dynamism in the vigorous charcoal lines, his nervousness in the frenzy of the lines, and his modernism in the sketch's simplicity.[383] The drawing also summarizes Lebrun's approach to his subjects: working predominantly in black and white in an expressionistic manner with an emphasis on the humanity of his sitter. Stravinsky's naturally exaggerated physiognomy was well suited for Lebrun's vision, for he accomplished all his figurative works with a concentration on the individuality of the various shapes that make up the human form. A great admirer of Lebrun's art, the artist Leonard Baskin once wrote, "His thousandfold of drawings were laced with the linear frenzy of the search for forms: they always opened truth to beauty."[384]

Little is known about the circumstances surrounding the creation of this sketch. Lebrun made a similar drawing of Stravinsky, most likely at the same time, which is now in the Morton Collection at the University of California, Los Angeles [fig. 52]. The drawing was made at an important moment in the careers of both Lebrun and Stravinsky, when the two were involved in similar projects. At the time, each artist was deeply involved in communicating in his art the story of Christ's Crucifixion. Their respective projects would consume them for years. In

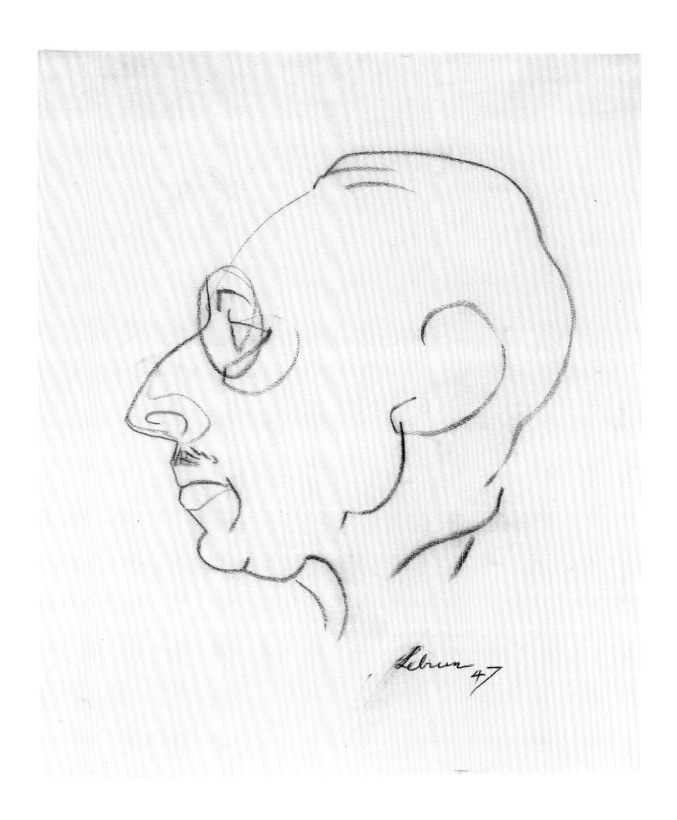

1946, Lebrun's wife died. A year later, in an effort to direct his grief toward creating beauty, he began a Crucifixion cycle based on Matthias Grünewald's monumental altarpiece. He dedicated the next three years of his life to the cycle. Lebrun wrote of this project, "My painter's language is founded on the belief of a traditional function of art, that is, to communicate through dramatic presentation, a legend; a story."[385]

At the same time, beginning in 1944 and continuing through 1948, Stravinsky was working on a mass inspired by Mozart. He wanted it to be not a

Fig. 52. *Igor Stravinsky* (1882–1971) by Rico Lebrun (1900–1964). Pencil on paper, 1941–47. The Morton Collection at the University of California at Los Angeles

concert piece but music to be used within the liturgy of the Catholic Church. A deeply spiritual man, Stravinsky commented to Evelyn Waugh: "My Mass is liturgical and virtually unornamented. Setting the 'Credo' I was simply concerned with adhering to the text; and in a special way . . . the 'Credo' is the longest of the movements. There is a great deal to believe."[386]

Stravinsky, who was born near Saint Petersburg, Russia, became one of the most prominent composers of the twentieth century. He was the protégé of Nikolai Rimsky-Korsakov and a great admirer of Pyotr Ilich Tchaikovsky. His celebrated *L'Oiseau de Feu (The Firebird),* commissioned by Sergei Diaghilev for the Ballets Russes, was among one of his first public challenges and won him great critical acclaim. His forte, as demonstrated for the first time in that piece, was his unusual orchestral innovation, which made harmonic use of a distinctive melodic vocabulary. As his career evolved, he became a leader

in introducing technical innovations. For example, his *Petrushka,* composed in 1911, was influential for its bitonal combination of F sharp against C major. Thereafter, virtually every well-known composer began experimenting with bitonality.[387] Stravinsky's eccentric rhythm that nevertheless maintained unity was especially suited to the ballet and he was ultimately regarded as one of the great composers of ballet music of all time. Although the public was not always receptive to his intellectual and logical compositions, fellow musicians responded enthusiastically and were inspired, looking to him for direction in their own compositions. Early in Stravinsky's career, Claude Debussy praised him for having "enlarged the boundaries of the permissible" in music.[388]

Stravinsky did not move to the United States until 1940, when he settled in Los Angeles. In America and in Europe, he was a symbol of the avant-garde, with his compositions compared by critics to the visual arts of cubism and symbolism. A *New York Times* contributor described his music as getting down to the "essentials: the essentials of religious experience, of dance, of sonata form. Of the baroque, and so on."[389] His approach to music, then, was not unlike Lebrun's manner of drawing and painting in terms of working and reworking individual forms to emphasize the architecture and monumentality of the whole. Stravinsky wrote: "The sensation produced by music is that evoked by contemplation of the interplay of architectural forms. . . . The more art is controlled, limited, worked over, the more it is free."[390]

It is appropriate that Lebrun's description of Stravinsky was one of minimal detail, but with powerful effect, much like Stravinsky's music. Lebrun achieved in this seemingly simple sketch a profound awareness of his subject, which communicates Stravinsky's extraordinary and deeply human qualities in clear and accessible language. His goals for his drawings, as he expressed them the year the portrait was made, are here met with ease: "For me the aim is to participate in the living world of all peoples—to grasp this, its significance, and forge it, draw it, illustrate and give it in terms understandable and, I hope, acceptable to them."[391]

D.M.

NOTES

381. Robert Craft, *Stravinsky: Chronicle of a Friendship* (New York: Alfred A. Knopf, 1972), 4.

382. *Dictionary of American Biography*, s.v. "Lebrun, Federico," supplement 7, 464.

383. Lebrun was not the only artist to rise to the challenge of summarizing Stravinsky in a sketch. Pablo Picasso, who had a profound influence on Lebrun's mixture of abstraction and expressionism, had made such a portrait of the composer in 1920. A straightforward sketch for Picasso, it caused suspicion at the Italian border because the guard felt it to be too exaggerated to be a portrait and accused Stravinsky of carrying a coded, subversive "plan." The sketch had to leave the country in a diplomatic pouch (Donal Henahan, "Igor Stravinsky: An 'Inventor' of Music Whose Works Created a Revolution," *New York Times*, April 7, 1971, from *New York Times Biographical Edition*, s.v. "Stravinsky, Igor," 1118).

384. Leonard Baskin, *Rico Lebrun: Memorial Exhibition, Paintings and Drawings* (New York: American Academy of Arts and Letters, 1965), n.p.

385. Quoted in James Thrall Soby, "Rico Lebrun," *New Art in America: Fifty Painters of the Twentieth Century*, with contributions by John I. H. Baur, Lloyd Goodrich, Dorothy C. Miller, James Thrall Soby, Frederick S. Wight (Greenwich, Conn.: New York Graphic Society, 1957), 172.

386. Quoted in Craft, "Stravinsky," 227.

387. Henahan, "Igor Stravinsky," *New York Times Biographical Edition*, 1116.

388. Ibid.

389. Harold C. Schonberg, "The Symbol of the Avant-Garde," *New York Times*, April 7, 1971, quoted in *The New York Times Biographical Edition*, 1116.

390. Quoted in Henahan, "Igor Stravinsky," *New York Times Biographical Edition*, 1119.

391. Rico Lebrun, "Rico Lebrun," in *1942: Eighteen Artists from Nine States*, ed. Dorothy C. Miller (New York: Museum of Modern Art, 1942), 79.

J. Robert Oppenheimer
1904–1967

By Ben Shahn
1898–1969

Ink on paper, 30.9 x 24.9 cm (12³/₁₆ x 9¹³/₁₆ in.), 1954
NPG.84.192

Ben Shahn was an artist who freely admitted an intense desire to present big and powerful subjects. A lifelong advocate of progressive reform, he believed that the arts community should remain engaged in the political life of the nation.[392] In J. Robert Oppenheimer, he found a perfect subject: one of the most prodigiously intelligent scientists of his day, widely acclaimed as the father of America's atomic bomb. In his encounter with this singular man, Shahn discovered someone who was confronting the same intellectual dilemma that he saw threatening artists at mid-century.

As Shahn described the tension of their time,

> Any citizen who feels his responsibility toward the public good—finds himself caught midway between two malignant forces. To the right . . . the force of reaction . . . [and] to the left . . . the Communist contingent. . . . The accusation of Communism is the most powerful scourge that has fallen into the hands of reaction since heresy ceased to be a public crime. . . . The really shocking fact that we must face is this . . . throughout the country, people of the basest ignorance are sitting in judgment upon the very meaning of thinking itself.[393]

During the Cold War, both Shahn and Oppenheimer became targets of unprecedented societal and political anxiety as America emerged a competitive, but vastly insecure, global superpower. Whereas Shahn had always addressed his commitment to political causes through his often controversial paintings and photographs, Oppenheimer was slower in realizing such a vision. Politically inactive for much of his life, Oppenheimer had busied himself with his studies without the distractions of newspapers or even a telephone in the early 1930s and only voted for the first time in 1936. Yet he came to enjoy—and capably fulfilled—the complex roles of founder and director of the famous laboratory in Los Alamos, New Mexico, where he oversaw the scientific research that would uncover, in the rarified realms of theoretical physics, the

foundations of America's postwar military might.[394] Unable, however, to conform his personal thinking in every way to the emerging orthodoxy of official atomic-energy policies to the complete satisfaction of other players in the political and scientific establishments, he expressed concerns about the development of the hydrogen bomb in the 1950s and quickly became the object of feverish suspicion.

Shahn, who knew Oppenheimer and would himself become a target of anti-Communist suspicions and the House Un-American Activities Committee, was sympathetic to the physicist's cause. During this period, he drew ten or more versions of his Oppenheimer portrait, ranging from cropped heads [fig. 53] to half-length images.[395] One of them was commissioned by the *Nation* and published in the September 25, 1954, issue to accompany Waldo Frank's article on Oppenheimer [see fig. 21]. All the versions reflected the sense of unease that gripped both men. Here, an imposing head looms above a torso caught between rigidly opposing margins while a small book lies open in the hands. The figure seems interrupted from a moment of contemplative perusal. Solemn and intense, the slender figure is depicted with extraordinary verticality. Recalling the often-attenuated figures of saints, martyrs, and mystics that adorned Romanesque cathedrals, the figure exemplifies an artistic program that evolved from portraiture into a kind of propaganda. The ragged, inelegantly labored quality of the line, a torturously sharp-edged, almost painful, presence on the page, takes the image beyond the mere passivity of the unsmiling, distracted visage into an expression of profound distress appropriate for an iconic symbol of troubled humanity.

The contesting forces of the political left and right that came to bear upon Oppenheimer and Shahn in the early 1950s are unseen on the page, but discomfort seems to be an important part of the wide-eyed, tight-lipped figure's meaning.

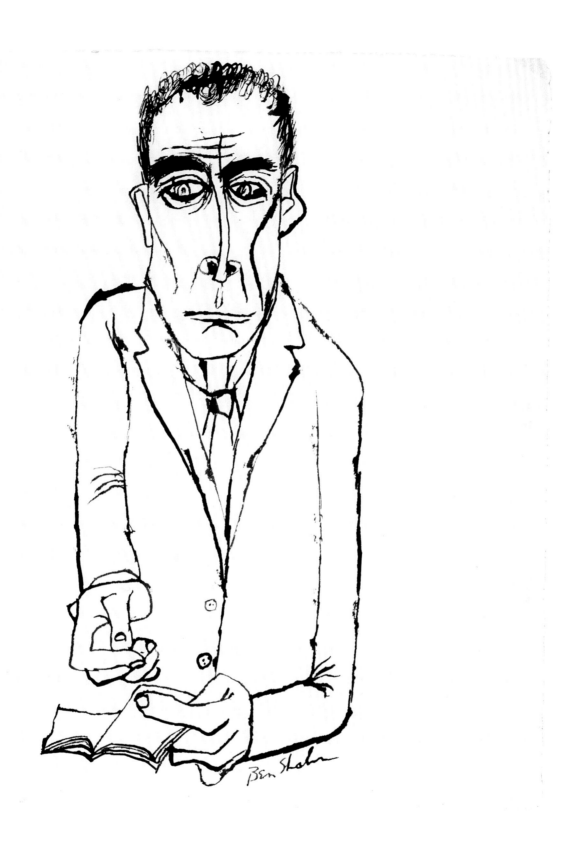

Ben Shahn

Oppenheimer's ambivalence in the face of the destructive power he had helped discover and unleash was well known.[396] In this image, Shahn takes up that theme, enlarging it to include inescapable, difficult questions about the nature and purpose of an individual's consciousness and acquired wisdom. Shahn's art "has never lost its fighting edge," art critic James Thrall Soby wrote, "its profound concern with justice and truth."[397] During this period especially, both men struggled to reconcile the competing aims of frequently hostile social systems in a newly vulnerable world that suddenly seemed to

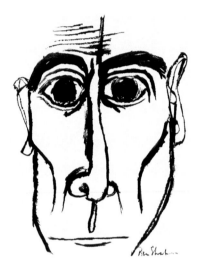

Fig. 53. *J. Robert Oppenheimer* (1904–1967) by Ben Shahn (1898–1969). Ink on paper, 1954. New Jersey State Museum Collection, Trenton

have less room for intellectual and artistic freedom.

Oppenheimer became a convenient symbol of possibly uncontrollable forces, the existence of which disturbed the nation's equanimity as it struggled to cope with the unaccustomed stress of world leadership at a time when former allies were recognized as mortal enemies. Accused of long-standing Communist sympathies and associations and of having opposed the development of the hydrogen bomb for subversive reasons, the New York City–born son of German-Jewish immigrants who had contributed so dramatically to the defeat of fascism submitted to investigation by an American "loyalty board." In 1954, in a poignant moment of Cold War confusions, he was declared by his judges at the Atomic Energy Commission to be both a loyal citizen and a security risk. His security clearance was withdrawn, but nine years later he was, in a gesture of some reconciliation, awarded the commission's highest honor, the Enrico Fermi Award. "Most of us look," he said then, "to the good opinion of our colleagues and to the goodwill and confidence of our

government. I am no exception."[398]

In Shahn's mind, almost a decade before the bestowal of the Fermi, Oppenheimer surely stood as a victim of political hysteria. Having been subject to questions concerning his own allegiances, Shahn was clearly drawn to the brilliant but controversial scientist. Yet he could never have portrayed Oppenheimer's historic stature with gracefully flowing, too obviously artistic lines which, in his youth, he had once supposed superior to his own technique. As Shahn's widow remembered it, although he sought, for a time, to "overcome his habit of digging-in lines, . . . at length, [he] had to come face to face with himself and be resigned to walking inartistically alone."[399] Having done so, Shahn was more than ready to craft his Cold War image of Oppenheimer as the embodiment of genius beleaguered.

H.F.P.

392. James Thrall Soby said that Shahn decided as a young man that his "own instinct was for story-telling and social commentary"; he wanted his art to "mean something in terms of people and their needs" (James Thrall Soby, "Ben Shahn," *Graphis* 4 [1948]: 102–3). Shahn once stated, "Really, everything I do points to Man" (quoted in Bernarda Bryson Shahn, "The Drawings of Ben Shahn," *Image* [Autumn 1949]: 50).

393. Ben Shahn, "The Artist and the Politicians," *ARTnews* 52 (September 1953): 35, 67.

394. Before the work at Los Alamos, while teaching at the University of California at Berkeley, Oppenheimer had already "fashioned a great center for theoretical physics that was to largely transform American physics." Ferociously intelligent and widely read in several fields, he recalled that, although interested in man and his experience, he "had no understanding of the relations of man to his society" during the years of his closest association with "left-wing" individuals and organizations in the late 1930s. At Los Alamos, one aspect of his remarkably successful intellectual leadership was his continuing insistence on the value of weekly sessions in which all the scientists shared the results of their work with one another, a procedure whose openness seemed, to some, to threaten the program's secrecy even as it accelerated its progress (Philip M. Stern, *The Oppenheimer Case: Security on Trial* [New York: Harper & Row, 1969], 13, 14, 73).

395. For various versions of Shahn's *Oppenheimer*, see the Taller Archive, Fine Arts Library, Harvard University.

396. The sight of the first atomic bomb explosion in July 1945 is said to have reminded him of a sacred Hindu text, "I am become Death, the shatterer of worlds" (quoted in *Current Biography Yearbook 1964*, s.v. "Oppenheimer, J[ulius] Robert," 331). In 1948 he was publicly quoted as having expressed the conviction that the physicists responsible for the bomb had experienced an ineradicable sense of "sin" as a consequence of their work (quoted in Stern, *Oppenheimer Case*, 111).

397. Soby, "Ben Shahn," 104.

398. Quoted in *Current Biography Yearbook 1964*, 332.

399. Shahn, "Drawings of Ben Shahn," 45.

JAMES BALDWIN
1924–1987

BY BEAUFORD DELANEY
1901–1979

Pastel on paper, 64.8 x 49.8 cm (25$^1/_2$ x 19$^5/_8$ in.), 1963
Inscription: *recto* Beauford Delaney / Paris France 1963
NPG.98.25

Beauford Delaney's portrait in pastels of his dear friend and protégé the writer James Baldwin is an intensely evocative image, glowing with the golden yellow found in numerous abstract paintings and portraits from this productive period of the artist's life. One of perhaps a dozen portraits that Delaney made of Baldwin over thirty years, it documents their friendship and represents one of Delaney's most expressive efforts. Its subject is both a likeness based on observation and memory, and a study of light. Baldwin wrote about Delaney and light in the introduction to an important exhibition of Delaney's works, held in Paris at the Galerie Lambert in 1964—an exhibition that combined portraits and the artist's brilliantly colored abstractions:

> I learned about light from Beauford Delaney, the light contained in every thing, in every surface, in every face. . . . That life, that light, that miracle, are what I began to see in Beauford's paintings, and this light began to stretch back for me over all the time we had known each other, and over much more time than that, and this light held the power to illuminate, even to redeem and reconcile and heal. For Beauford's work leads the inner and the outer eye, directly and inexorably, to a new confrontation with reality.[400]

James Baldwin visited Paris, where Delaney had lived since the early 1950s, several times in 1963, but only briefly. Baldwin was at the height of his powers as a writer. *Another Country* (1962), his controversial novel of racism and sexuality, was a best-seller, and his important collection of essays, *The Fire Next Time*, had just been published. He was writing *Blues for Mr. Charlie*. Lionel Trilling noted that there was "no literary career in America today that matches James Baldwin's in the degree of interest it commands."[401] At the same time, Baldwin's activities on behalf of the civil-rights movement in the United States were increasing. In 1963 alone, he lectured extensively for CORE (Congress of Racial Equality); appeared on television talk shows; was

featured in an article and on the cover of *Time* magazine for May 17; met with Robert F. Kennedy and a group of civil-rights activists, both black and white, in New York; helped organize the civil-rights march on Washington on August 28; and worked on a voter registration drive in Birmingham, Alabama.[402]

Delaney was a generation older than Baldwin. He was born in Knoxville, Tennessee, where his father was a minister in the Methodist Episcopal church and a barber. Delaney, the eighth of ten children, discovered art at an early age. When he was a teenager, he received lessons in drawing and painting from a local white artist, Lloyd Branson, in exchange for working in Branson's studio. In 1923, Branson helped Delaney move to Boston to continue his art studies. He worked as a janitor, soaked up the cultural life of the city, and tried to find art instruction where he could, including the Massachusetts Normal Art School, the Copley Society, and the Lowell Institute. Delaney concentrated on portraiture and academic drawing. He visited museums, where he was particularly intrigued with the work of the impressionists and their approaches to capturing the effects of light. By 1929, Delaney had moved to New York, where he renewed an acquaintance made in Boston with Countee Cullen and met other important figures in the Harlem Renaissance. He felt most at home in Greenwich Village and lived there for more than twenty years. At first, he concentrated on portrait drawings, including charcoal sketches made of customers at Billy Pierce's Dancing School on West Forty-Sixth Street. He painted portraits as well, with strongly articulated outlines and an almost primitive intensity. By 1930 he had been taken up by art patron Juliana Force, who gave him an exhibition at the Whitney Studio Club.[403] He continued to make portraits, of well-known African Americans and other writers and artists, and his reputation grew. In the mid-1940s, he was exhibiting portraits of Henry Miller and the first of his portraits of Baldwin.

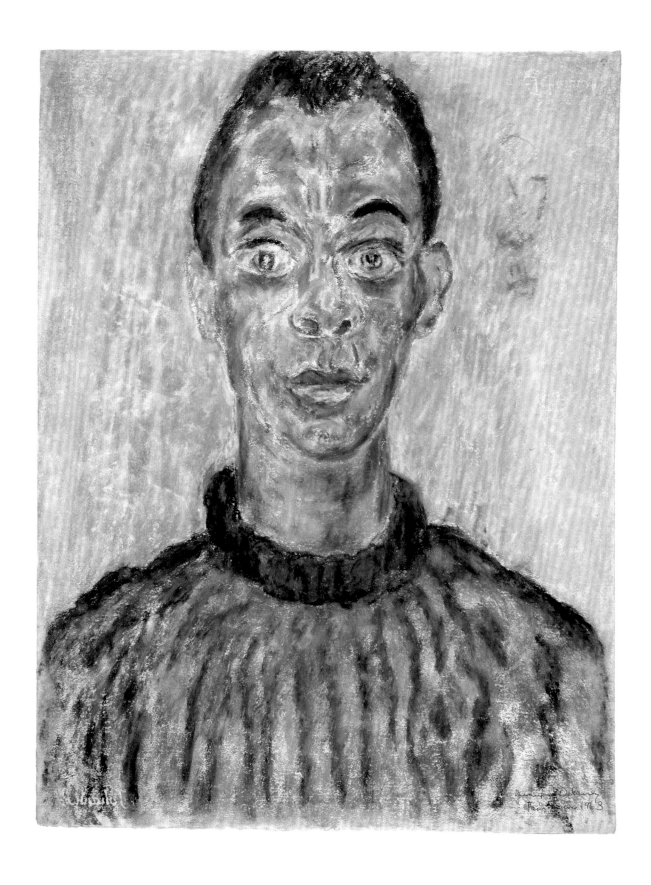

197

Although his financial situation was precarious, he was increasingly well known as a painter of portraits, interiors, and street scenes, all created with expressive brush strokes and colors.[404]

Delaney first met Baldwin in 1940. Sixteen years old and raised in Harlem, Baldwin was struggling with career and personal choices, including whether or not to continue serving as an apprentice preacher in New York. Both men came from similar, economically deprived backgrounds, and both recognized their homosexuality. Delaney praised and supported Baldwin's talents and served as his

Fig. 54. *James Baldwin (1924–1987) with Beauford Delaney (1901–1979) and Lucien Happersberger in Paris, 1953* by an unidentified artist. Photograph from David Leeming, *James Baldwin: A Biography* (New York: Alfred A. Knopf, 1994). Library of the National Portrait Gallery and the Smithsonian American Art Museum, Washington, D.C.

surrogate "father in art."[405] Baldwin counted Delaney as one of the most important people in his life. Delaney loved Baldwin, but they did not become lovers. Their friendship continued, however, until Delaney's death in 1979, in a psychiatric hospital in Paris. Baldwin was inspired by the older artist—by his ideas, his devotion to his work, and his struggles with mental illness and alcoholism.

Delaney had intended to move to Rome in 1953, but a stopover in Paris lengthened, and he soon made Paris his home. Baldwin visited often, and their letters reflect his continuing dependence on, and careful attention to Delaney. Delaney confessed his anxieties to Baldwin as he did to no one else. In 1954 he wrote to Baldwin, "Have been working and living with the many people who make up Beauford . . . and trying to merge them into some sense of composition and a workable form of painting."[406] In Paris, Delaney's painting was transformed. At first, he continued to make expressive, abstract landscapes and street scenes. By the mid- to late 1950s, however, he

began to paint large, nonobjective canvases, often flooded with light and color, particularly the vibrant yellow he associated with Vincent Van Gogh and the color Delaney thought of as particularly his own. He suffered a major mental and emotional collapse in 1961, but by 1962 he had recovered and was entering a period of great productivity.

Delaney's 1963 portrait of Baldwin expresses his long-standing affection for the writer. Delaney wrote to Henry Miller that year that he was "trying to merge color and form into the essences of things felt and remembered," and his portrait of Baldwin is one example of that effort.[407] Although a clearly recognizable likeness, including Baldwin's large, protruding eyes and a characteristic expression found in contemporary photographs [fig. 54], the pastel also depicts a younger man, giving us a sense that Delaney was picturing Baldwin over time.

And yet this is not an image based in nostalgic affection. Delaney's portrait is heated and confrontational; its anxious, kinetic energy is highlighted through the colors chosen by the artist and the roughness of their application to the textured paper. The vibrant yellow that meant so much to Delaney suffuses the background of the portrait as well as the figure and face. It grows more heated and uneven as it nears the contours of the face and neck. Baldwin's dark skin is suggested through dark green contours, defining skin that is marked with strokes of bright color and rubbed areas of brown, green, and ochre. His hair includes rich, dark reds, blacks, greens, and blues.

Years of love and longing are summarized in this portrait, made when Delaney was coherent but still troubled by inner voices and anxieties. Baldwin's likeness was of supreme personal importance for the artist. For us, however, it is a window into the personality of a complex, gifted African American who outlived his mentor by only eight years. Delaney often spoke of his need for light, and for enlightenment. Baldwin recognized the results of that search in Delaney's most successful paintings: "If we stand before a Delaney canvas, we are standing, my friends, in the light." Delaney has made Baldwin into an embodiment of light. It is an image of desire—another theme that his friend Baldwin recognized in the artist's work: "Great art can only be created out of love, and . . . no greater lover has ever held a brush."[408]

B.B.F.

400. James Baldwin, "On the Painter Beauford Delaney" (1965) reprinted in *Collected Essays* (New York: Library of America, 1998), 720–21.

401. Quoted in James Campbell, "James Baldwin and the FBI," *Threepenny Review* (Spring 1999); n.p. See also James Campbell, *Talking at the Gates: A Life of James Baldwin* (New York: Viking, 1991).

402. See David Leeming, *James Baldwin: A Biography* (New York: Alfred A. Knopf, 1994), 216–30.

403. Leeming, *Amazing Grace*, 9–39 [see cat. no. 34, n. 358].

404. Richard A. Long, *Beauford Delaney: A Retrospective* (New York: Studio Museum in Harlem, 1978), n.p.

405. Leeming, *James Baldwin*, 33.

406. Delaney to Baldwin, September 17, 1954, in Leeming, *Amazing Grace*, 125.

407. Delaney to Henry Miller, July 19, 1963, in ibid., 160–61.

408. Statement by Baldwin for Delaney's exhibition at Galerie Darthea Speyer, Paris, 1973, in Long, *Beauford Delaney*; Baldwin, "On the Painter Beauford Delaney," 721.

Truman Capote
1924–1984

By Don Bachardy
born 1934

Graphite on paper, 76.5 x 55.9 cm (30¹/₄ x 22 in.), 1964
Inscription: Truman Capote / October 14, 1964; Bachardy
NPG.97.60

New Orleans–born author Truman Capote first gained national notoriety upon the publication of his debut novel, *Other Voices, Other Rooms,* in 1948.[409] The book relates the experiences of a young boy, presumably Capote himself, who lives in a decrepit Louisiana mansion with his transvestite uncle and a cast of other haunting characters. Its dust jacket included a famous photograph of the author lounging provocatively on a couch wearing a tattersall vest that helped establish a popular notion of Capote as a kind of contemporary Victorian dandy like Oscar Wilde. It was an image Capote came to regret because he believed it distracted critics from more seriously addressing his achievements as a writer. Don Bachardy's arresting, large-scale pencil drawing challenges the stereotype, revealing a more thoughtful and vulnerable side of the author's personality.

Bachardy was born in Los Angeles in 1934. He studied at the Chouinard Art Institute there from 1956 to 1960, then at London's Slade School of Art in the early 1960s. A pure portraitist who "couldn't conceive of doing a landscape," Bachardy has traced his obsession with faces to his early love of movies and the overwhelming impression that closeups of actors made on him when he was a child.[410]

In 1953, Bachardy, then eighteen, met the forty-eight-year-old British American writer Christopher Isherwood [see cat. no. 47] in California, where Isherwood had come after World War II to write movie scripts. They subsequently lived and worked together in Santa Monica until the older man's death in 1986. This close relationship was crucial to Bachardy's development as an artist. Isherwood not only provided Bachardy with the emotional and financial support he needed early in his career to become a full-time portraitist, but he also introduced him to many of the famous Hollywood and literary figures that eventually became his subjects.

Capote had known Isherwood since the late forties and met Bachardy in January 1955. He later posed for the artist on three separate occasions that resulted in four finished drawings: a sketch depicting Capote in a Western shirt and bow tie made at the Connaught Hotel in London in 1961; two drawings, including this image, made on October 14, 1964, at the Bel Air Hotel in Los Angeles; and a final drawing dated November 27, 1973 [fig. 55]. The earlier and later images are defined by Capote's posture and pose and convey a sense of the weight and burden of the body. Rather then confront the viewer, they alternately show the writer looking to the side and staring vacantly into space. In contrast, the 1964 images focus tightly on the eyes and head and bristle with intellectual energy. The Portrait Gallery's drawing, the first of those works, shows Capote wearing a light, informal collarless shirt. He has a lithe, slight build and appears almost gaunt, with the cheeklines omitted entirely. In the second work from the 1964 session, Bachardy dispensed with the torso entirely and focused solely on the head and the hand. In both the viewer directly encounters Capote's penetrating gaze.

The 1964 works illustrate all the basic tenets that have governed Bachardy's portraits. He relishes the pressure, drama, and spontaneity of working closely in the moment with his sitters and never makes preliminary sketches, preferring instead the excitement that results from having "to get it right the first time." Bachardy has always strictly insisted on drawing his subjects from life rather than from photographs or subjectively from memory or the imagination. He believes that the contents of photographs are "predigested" and using them would deprive him "of both the numen and the company of my sitter." Moreover, Bachardy admits candidly, "I can't do it out of my head. I have to have a person there to look at, and I have to be having the experience while I'm recording it. It makes me feel quite obstinate and unimaginative sometimes."[411]

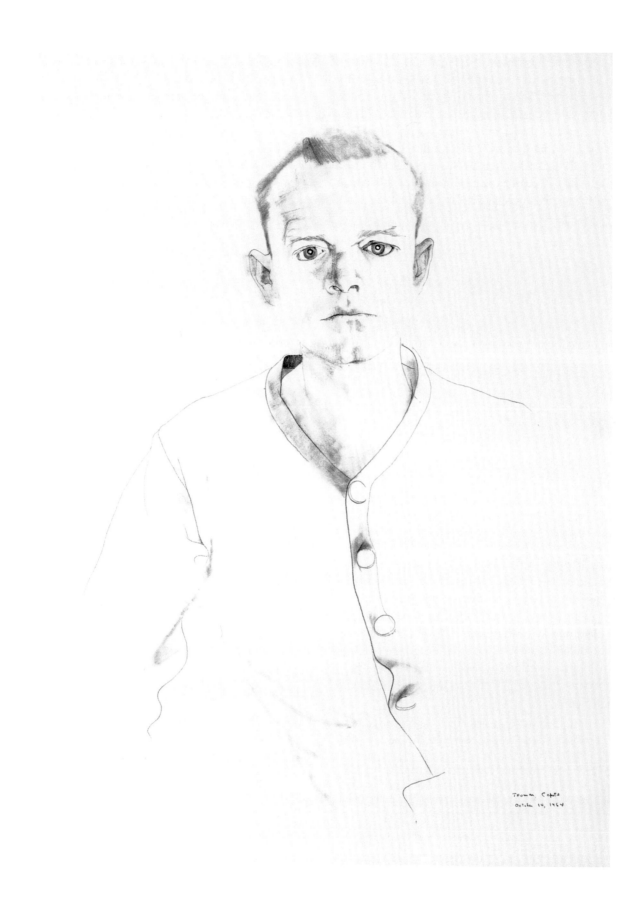

201

The startling clarity and prominence of Capote's pupils are indicative of Bachardy's usual practice of beginning a work by "drawing one eye" so that "everything else depends on the scale and placement of that eye." The "exchange of energy" from such "eye contact" can be so great that Bachardy feels as if his subjects are actually "doing the drawing."[412] Bachardy indeed goes to extraordinary lengths to identify with his sitters. For instance, he has noted how he will contort his face into "expressions that make me feel more like the possessor of the face I am trying to record," thereby enabling him, "as in a self-

Fig. 55. *Truman Capote* (1924–1984) by Don Bachardy (born 1934). Pencil and ink on paper, 1973. Don Bachardy

portrait, to reproduce a likeness from within as well as without." During these empathetic interludes Bachardy is capable of, as he puts it, "slipping into another personality so completely that I sometimes lose my self-awareness for several minutes at a time," an experience he considers "one of the greatest pleasures" of portraiture.[413]

Bachardy believes that the "departure of my sitter is like the breaking of a spell" and, therefore, has always finished his drawings in a single sitting. He explains:

> If the same person comes to my studio the very next day at the same time, I start fresh instead of working on what I did the previous day. Even if the person was in exactly the same mood, which wouldn't be likely, I might be in a different mood. To me, every drawing and painting is a combination of two personalities and those two personalities are changing ever day, every hour. So my work is really kind of a journal of the people I was with on a particular day.[414]

In order that they be explicitly understood as collaborations, Bachardy asks that all his subjects sign and date their portraits as Capote did here.

At the time Capote posed for Bachardy in 1964, he was entering the sixth and final year of a period devoted almost exclusively to writing *In Cold Blood,* his account of the brutal murders of the Clutter family in Holcomb, Kansas, by Richard Hickock and Perry Smith on November 15, 1959. A startling departure for Capote, this "nonfiction novel," as he termed it, represented a conscious effort to distance himself from the highly personal, imaginative techniques and romantic, bittersweet themes of childhood that had characterized his previous fiction and to focus instead on a more objective, documentary depiction of a gritty, real world event. By confronting such a grim subject Capote sought to address those critics who had regarded his previous writings as stylish but not substantial. Previewed in a four-part *New Yorker* series in the fall of 1965, *In Cold Blood* was published in January 1966. Some reviewers, most notably Kenneth Tynan, criticized Capote for exploiting his subject, but others, like Conrad Knickerbocker of the *New York Times,* acknowledged how dramatically he had succeeded in transforming his literary style and reputation: "He has traveled far from the misty, moss-hung, Southern Gothic landscapes of his youth. He now broods with the austerity of a Greek or an Elizabethan."[415]

One reason Bachardy may have been equal to the task of depicting Capote in 1964 was that the goal of his technique of "eye contact" was similar to that of Capote's contemporary experiments with the "nonfiction novel": to achieve, through a relentless, often merciless, attention to objective detail, a high degree of empathy with one's subject. Done just six months after Hickock and Smith were executed for their crimes, the somber tone and searing intensity of this vivid portrait convey a sense of how disturbing and harrowing Capote's experience inhabiting the world of *In Cold Blood* had been.

C.B.

409. For Capote's biography, see Gerald Clarke, *Capote: A Biography* (New York: Simon and Schuster, 1988).

410. Don Bachardy quoted in *Inside/Out, Self Beyond Likeness* (Newport Harbor, Calif.: Newport Harbor Art Museum, 1981), 30. About his early love for films, Bachardy said, "I'm convinced that my interest . . . came directly from gazing, when I was very young and impressionable, at closeups of movie actors several hundred times larger than life." Noting that after "many years of making pictures . . . I still haven't found another subject as varied and challenging," he has wryly observed that he may indeed have "invented the idea of myself as an artist in order to have an excuse for looking at people" (Bachardy, *Stars in My Eyes* [Madison: University of Wisconsin Press, 2000], 3, 12; quoted in M. Stephen Doherty, "Don Bachardy," *American Artist* 49 [September 1985]: 98).

411. Quoted in Bachardy, *Stars in My Eyes*, 8, 4; Don Bachardy, *Christopher Isherwood: Last Drawings* (London and Boston: Faber and Faber, 1990), 117.

412. Quoted in Doherty, "Don Bachardy," 53; quoted in Bachardy, *Christopher Isherwood*, 117.

413. Bachardy, *Stars in My Eyes*, 9.

414. Ibid., 4–5; Doherty, "Don Bachardy," 51.

415. Conrad Knickerbocker, *New York Times Book Review*, January 16, 1966.

LINCOLN KIRSTEIN
1907–1996

BY JAMIE WYETH
born 1946

Graphite and crayon on paper, 41.6 x 18.7 cm (16 3/8 x 7 3/8 in.), 1965
Inscription: *verso* 41 / Frame in work / frame #4185 / Kirstein 19¼ x 19¼ in dark grey 1¼ bar Fein
NPG.97.152

In his foreword for the catalogue accompanying Jamie Wyeth's first solo show, in 1966, Lincoln Kirstein lauded the twenty-year-old artist as the "finest American portrait-painter since the death of John Singer Sargent." In Kirstein's eyes, the young James Browning Wyeth [see also cat. no. 48] was both a "master and a veteran" whose work bespoke an artistic heritage stretching back to Peter Paul Rubens, Anthony van Dyck, and Sir Joshua Reynolds.[416] That Wyeth was precocious is not surprising, given his family name. His grandfather, N. C. Wyeth, was one of the foremost illustrators of his day, and his father, Andrew Wyeth, is one of the nation's leading realist painters, renowned for his haunting portrayals of rural solitude.

Nearly sixty when he sat for Wyeth's portrait, Kirstein was likewise uncommonly gifted at a young age. By the time he was eight, he had created a dramatic club called "Tea for Three," and at sixteen had published a play in the *Philips Exeter Monthly* and purchased his first work of art. His interest in the arts blossomed while an undergraduate at Harvard in the late 1920s, where he co-founded the literary magazine *The Hound & the Horn* and the Harvard Society for Contemporary Art. Both endeavors bore witness to Kirstein's foresight. *The Hound & the Horn* published the radical writings of now-canonized masters T. S. Eliot, James Joyce, and Gertrude Stein, and the Harvard Society for Contemporary Art—the first organization in this country devoted to the work of living artists—was hailed by critics as the "germ of the Museum of Modern Art," which opened its doors nine months after the society's first show.[417]

Gazing into the distance in this study for Wyeth's oil painting, Kirstein appears as if looking out for new challenges to tackle. Taking risks came easily to him. Born into an elite family, he had the financial flexibility to allow his interests to lead him in uncharted directions and "was always told [he] could

do anything."[418] Kirstein published more than thirty books and hundreds of articles on the visual and performing arts, wearing the hats in his long career of writer, scholar, poet, businessman, and impresario. His impact is most felt in the dance world. Electrified by performances of Sergei Diaghilev's Ballets Russes when he was sixteen, Kirstein a decade later brought classical ballet to the United States through the young choreographer George Balanchine, whom he persuaded to move to New York in 1933. The following year, the pair founded the School of American Ballet and the American Ballet Company, with Balanchine as artistic director and Kirstein as director of theatrical sciences and later, in 1940, as director. American Ballet became a resident ballet company for New York City in 1935, but Kirstein's efforts to "further the tradition of classical theatrical dancing" would not rest there.[419] In the latter half of the 1930s and 1940s, Kirstein founded and directed the touring ensemble Ballet Caravan, and co-founded, again with Balanchine, the Ballet Society. This small, subscription-only troupe evolved into the New York City Ballet, one of the most influential ballet companies in the world today.

Kirstein's duties at the New York City Ballet did not preclude his continued involvement in the visual arts. As a member of the Museum of Modern Art's advisory board in 1948, he approved the purchase of Andrew Wyeth's famed painting, *Christina's World*—done that same year—which led to a close friendship between the two that would last until Kirstein's death in 1996. Writing to Wyeth that the painting had "all the lonely dignity, the stoic grandeur that the best American art [had]," Kirstein found the artist's work a refreshing change from the kinds of abstractions then flooding the American art world.[420] His admiration for Wyeth naturally extended to the work of his son, Jamie, which, in the realist vein of his father, is renowned for its intimate and equal treatment of subjects ranging from pigs to

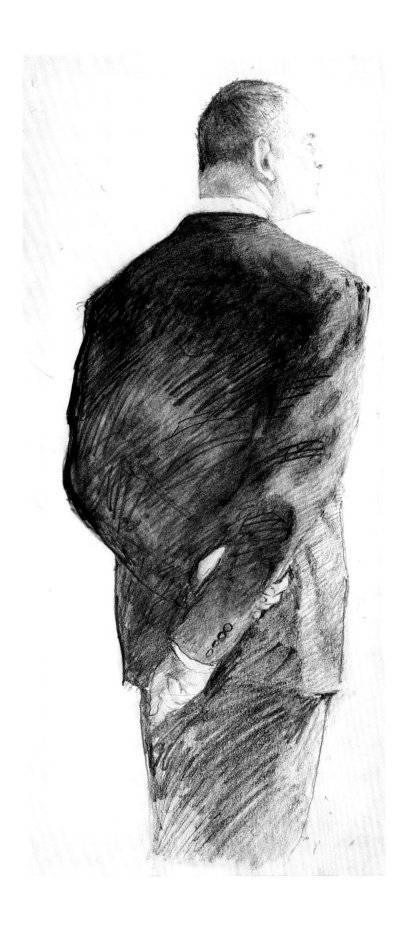

MODERN AMERICAN PORTRAIT DRAWINGS

people, snowy landscapes to hay bales. Jamie considered Kirstein one of his artistic mentors, and Kirstein, for his part, thought of Jamie as a son. He expressed his gratitude to Betsy Wyeth, the artist's mother, saying, "You gave me the only son I ever had."[421]

Portrayed by Isamu Noguchi, Gaston Lachaise, and others, Kirstein was genuinely fascinated by portraiture and the processes of the artist. He must have reveled in watching the nineteen-year-old Wyeth—for whom he spent two hundred hours posing—arrive at and develop a formula for depicting

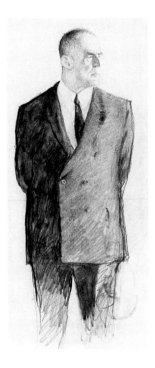

Fig. 56. *Lincoln Kirstein* (1907–1996) by Jamie Wyeth (born 1946). Pencil and crayon on paper, 1965. National Portrait Gallery, Smithsonian Institution

him. The painting that resulted was exhibited at Wyeth's solo show in 1966 and remained in Kirstein's possession, flanking his fireplace, until he bequeathed it to the National Portrait Gallery.

As the youngest member of an artistic dynasty, which included not only his father and grandfather but also his aunts, Carolyn Wyeth and Henriette Hurd, and his uncle, Peter Hurd, Jamie Wyeth was virtually destined to pursue art. He quit school at the age of eleven and was thereafter tutored in the mornings and trained at the easel by Carolyn, his father's older sister, in the afternoons. The Wyeths clearly considered drawing integral to Jamie's artistic development: when Betsy Wyeth discovered a pile of her son's unfinished drawings, she made him sit down to finish each one. In his drawings of Kirstein, Wyeth achieved his aim to make viewers "see the essence" of his subject.[422] Depicting Kirstein in an

aristocratic and thoughtful pose with quick, zigzagging pencil strokes, Wyeth has managed, in both the front [see fig. 56] and back views of his subject, to capture a measure of the impresario's intellectual energy. Perhaps because the details of Kirstein's tie and the buttons of his coat draw attention away from the face in the front view, Wyeth based his painting on the sketch of Kirstein from the back.

The focus of this drawing is not Kirstein's face, however, which is only faintly rendered; his lips are delineated with one thin, short mark and his chin is barely defined. Wyeth's emphasis is, rather, on Kirstein's body, which was "massively built" and "enormous" at several inches over six feet tall.[423] LuLen Walker, a student at the School of American Ballet from 1978 to 1982, suggests that Kirstein may have been self-conscious about his size:

> He always wore the same style suit: black, double breasted as shown in the Wyeth drawing. This uniform and his habitual stance with arms behind his back were probably subconscious efforts to de-emphasize his massive frame. Backstage at Lincoln Center, he would observe the performance from one of the front wings, standing in the same unassuming pose.

To his dancers, Kirstein could be, as Walker notes, a "silent, ominous figure" who "seemed to know instinctively which students were destined for a coveted position in the company."[424] This quiet omnipotence is conveyed in Wyeth's portrait. Modeled by a layer of overall shading with graphite and then by darker, heavier black crayon marks in his middle back and left arm and shoulder, Kirstein appears as a monolithic tower rising up from an unseen foundation. In contrast to the front-view drawing, his legs are undifferentiated and the contours of his suit jacket just barely extend beyond the outlines of his pants. His hands, faintly drawn like his profile, only slightly detract from this impression of monumentality. Akin to Auguste Rodin's commanding sculpture of Honoré Balzac, Wyeth's drawing evokes more the power of Kirstein's spirit than the details of his physical appearance. He has the air, as Christopher Isherwood aptly put it, "of protecting everybody, of holding up the world."[425]

J.A.G.

416. Lincoln Kirstein, foreword to *James Wyeth: Paintings (First Exhibition)* (New York: M. Knoedler, 1966), n.p.

417. See *Encyclopedia of World Biography*, 2d ed., s.v. "Kirstein, Lincoln," 39–40.

418. Quoted in W. McNeil Lowry, "Profiles: Conversations with Kirstein—II," *New Yorker*, December 22, 1986, 50.

419. This, one of the aims of the School of American Ballet, as quoted in *Encyclopedia of World Biography*, 40.

420. Quoted in Richard Meryman, *Andrew Wyeth: A Secret Life* (New York: HarperCollins, 1996), 239.

421. Jack Anderson, "Lincoln Kirstein Remembered for His Lifetime in the Arts," *New York Times Obituaries*, February 20, 1996; Kirstein quoted in Meryman, *Andrew Wyeth*, 275.

422. Meryman, *Andrew Wyeth*, 273. Wyeth said of Jasper Johns that he "takes an object and makes you see the essence of it." "That's what I'm trying to do," he affirmed (quoted in *Current Biography Yearbook 1977*, s.v. "Wyeth, James (Browning)," 446.

423. John Russell, "Lincoln Kirstein: A Life in Art," *New York Times*, June 20, 1982. The close cropping of the paper around the figure conveys some of the girth of Kirstein's frame, which seemed to friends to swallow up the space of most corridors and staircases.

424. LuLen Walker, e-mail statement to Jennifer A. Greenhill, September 27, 2001. Walker, now an art historian and contributor to this catalogue, worked at the National Portrait Gallery at the time this drawing was acquired.

425. Quoted in Nicholas Jenkins, "The Great Impresario," *New Yorker*, April 13, 1998, 52.

ORNETTE COLEMAN
born 1930

BY ELAINE DE KOONING
1918–1989

Graphite on paper, 34.5 x 28 cm (13 9/16 x 11 in.), circa 1965
Inscription: *recto* E de K / Ornette Coleman; *verso* Ornette Coleman #1 / Pencil / P-c. 1965 / 13-5/8 x 11 - / FF 1-I / c. 1965 / 13½ x 11
NPG.96.195

Elaine de Kooning [see also cat. no. 44] said that for her, making portraits was an "addiction" and that as for her subjects, "If it's nobody, I couldn't care less. Anyone can be interesting." But when she drew the jazz saxophone player Ornette Coleman, she didn't have to settle for just anyone. He, like his revolutionary recording *Free Jazz* of 1961, was "exceptional in so many ways that it is hard to know where to begin!"[426] In this portrait, two currents of artistic improvisation and invention had a rich and thoughtful encounter.

While it is not clear where or when the drawing was made, the likeliest meeting point for subject and artist would have been the Five Spot in New York's East Village. Once a neighborhood bar that catered to the "raffish and down-and-outers," in 1957 the Five Spot started bringing in avant-garde jazz bands that attracted the attention of New York's cultural cognoscenti. Soon painters of the New York School, including Willem de Kooning and Franz Kline, began to hang out there. The artists, having finally begun to achieve recognition for their abstract expressionist paintings after a long and hungry struggle, identified with jazz musicians like Cecil Taylor, Charles Mingus, and Thelonious Monk, who were engaged in a parallel fight.[427]

Coleman's sensational New York debut at the Five Spot in 1959 was the culmination of a long war with jazz conventions. He had come from a poverty-stricken family in Texas. When the teenaged Coleman took a succession of menial jobs to bolster the family income, his mother was able to afford an alto saxophone for him but not music lessons. Coleman figured things out on his own as best he could and found instruction where he could. This led to the fundamental misunderstandings of music theory that some authorities credit with helping Coleman achieve creative freedom, while others think he has simply never known what he is doing.[428]

From the start, Coleman was playing something different. He refused to follow swing or bebop conventions of improvisation, ignoring the chord progressions the other musicians followed. He recalled discovering his new method for solos when playing with a dance band in 1948:

> [The band was playing] some standard theme like "Stardust," and it was my turn to solo on the chord changes of the tune. In that situation, it's like having to know the results of the chord changes before you even play them, compacting them all in your mind. So once I did that, and once I had it all compacted in my head I just literally removed it all and just played.[429]

Coleman's unorthodox playing stopped dancers from dancing and other musicians from playing. Even the most advanced bebop musicians couldn't figure out how to deal with his totally unfamiliar approach. Naturally, he found it impossible to stay with any band for long.

In 1953 Coleman moved to Los Angeles, hoping to find more understanding there for his music. But he was soon stranded, jobless, and broke. Bands not only wouldn't hire him, they wouldn't even let him sit in until the wee hours of the morning when they were about to leave the stand. His appearance—with a beard, long hair, and eccentric, homemade clothes—contributed to his status as an outcast.[430] The outlook seemed bleak. But a group of young musicians became enthusiastic about Coleman's unique approach to jazz. They began to practice with him in pianist George Newman's garage. Finally, Coleman was with musicians who knew how to play with him instead of against him. In 1958, Coleman's quintet recorded the sessions that the small record label Contemporary would release as *Something Else!!!! The Music of Ornette Coleman*.[431] Word of Coleman's new approach, known as "Free Jazz," began to get out.

In 1959, Coleman and his trumpet player, Don Cherry, attended the School of Jazz in Lenox, Massachusetts. Coleman's performance in the

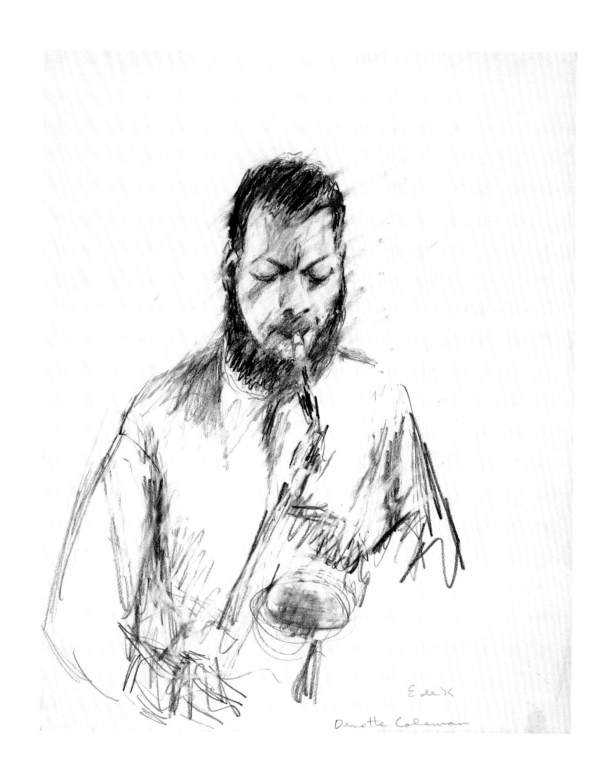

E de K

Ornette Coleman

school's closing concert caught the ears of such influential jazz critics as Martin Williams, who wrote that "I honestly believe . . . that what Ornette Coleman is doing on alto will affect the whole character of jazz music profoundly and pervasively."[432] A press conference preceded Coleman's fateful debut at the Five Spot on November 17, 1959. Reactions ranged from "He'll change the entire course of jazz," to "He's a fake." The controversy attracted such crowds that the two-week engagement stretched to ten weeks. For the next two years, Coleman's band was often at the Five

Fig. 57. *Ornette Coleman* (born 1930) by Elaine de Kooning (1918–1989). Pencil on paper, circa 1965. National Portrait Gallery, Smithsonian Institution

Spot or such fashionable New York jazz locales as the Village Vanguard, or appearing in concerts at New York's Town Hall. Musical giants from John Coltrane to Leonard Bernstein became regulars at Coleman's gigs and eagerly sat in with the band.[433]

It seems impossible that Elaine de Kooning could have avoided hearing and seeing Ornette Coleman during this period of his ascendancy, particularly since the saxophonist collected art works by such audience members as Larry Rivers and Robert Rauschenberg. This portrait drawing, in addition to a sketch showing just part of a frowning face, survive to testify that de Kooning took note of Coleman [fig. 57]. Comparing the subject's full beard, distinctive widow's peak, and slim face to photographs, it appears that the drawings must have been made between 1960 and 1962, when Coleman virtually stopped playing publicly, or perhaps between his reemergence in 1965 and about 1967.[434]

The completed drawing brought together two artists moving in opposite directions. While Coleman tore apart existing jazz forms to create a new freedom bordering on chaos, Elaine de Kooning used the unstructured marks of action painting to re-create the traditional form of portraiture. Her marriage to New York School giant Willem de Kooning established her as a social figure at the center of abstract expressionism, but while at times she painted abstractly, she was basically a representational artist whose work included many portraits.[435]

Most of the abstract expressionists had virtually stopped making traditional drawings. Only for Willem de Kooning and his wife did drawing retain its formative role in the creative process.[436] Elaine Marie Catherine Fried had drawn obsessively when she was a child in Brooklyn, and avidly continued drawing during her training in New York at the Leonardo da Vinci Art School and the American Artists School. When she was just out of high school, she began spending much of her time with Willem in his apartment, where their activities included rigorous drawing exercises.[437] Such instruction continued after the two wed. Thomas B. Hess recalled once seeing Willem start to make a drawing, then reverse his pencil and continue work with the eraser, "not to rub out the lines, but to move them, push them across the paper."[438] Elaine used the same technique in her drawing of Coleman, manipulating the graphite with both eraser and stump to break up the outlines and merge the forms with the background.

The diagonal strokes blurring across the figure parallel the vigorous action of the jagged, repeated pencil lines Elaine drew around the musician's hands to reflect the rapid motion of the fingers shaping a quick succession of notes. In contrast, the more firmly defined face is calm and focused as Coleman directs a stream of breath into his signature small white plastic horn.[439] The different varieties of line suggest Coleman's changing moods as he plays. De Kooning's portraits tellingly condense a range of typical gestures into a single pose that sums up the complexities of a person.[440] For Coleman, de Kooning chose this simple yet revealing posture adopted by the musician as he poured out the sounds of his Free Jazz.

A.P.W.

NOTES

426. Quoted in Gerrit Henry, "The Artist and the Face: A Modern American Sampling and Ten Portraitists—Interviews/Statements," *Art in America* 63 (January–February 1975), 35; Martin Williams, liner notes for *Free Jazz: A Collective Improvisation by the Ornette Coleman Double Quarter*, Atlantic 1364, 1364–2, and 7567–81347–2, reissued by Atlantic Recording Corporation as R2 75208.

427. James Lincoln Collier, "Cecil, Ornette, and the Revolutionaries," in *The Making of Jazz: A Comprehensive History* (New York: Dell, 1978), 159.

428. John Litweiler, *Ornette Coleman: A Harmolodic Life* (New York: William Morrow, 1992), 21–26; Collier, "Cecil, Ornette, and the Revolutionaries," 460–64.

429. Quoted in Litweiler, *Ornette Coleman*, 33.

430. Ibid., 33–48, 47–49.

431. Peter Niklas Wilson, *Ornette Coleman: His Life and Music* (Berkeley, Calif.: Berkeley Hills Books, 1999); Litweiler, *Ornette Coleman*, 51–62.

432. Martin Williams, "Ornette Coleman: Ten Years After," Part 2 in *Down Beat*, January 8, 1970, 35; Wilson, *His Life and Music*, 24–26.

433. Litweiler, *Ornette Coleman*, 78–79, 80–104.

434. Ibid., 82, 105–13. Coleman's inactive period was occasioned by his attempting to demand fees in excess of what club owners were willing or able to pay. Elaine de Kooning, who had been utterly engaged in a commission to make a portrait of President John F. Kennedy, completely stopped painting for about a year following the assassination in November 1963, devoting herself to teaching and sculpture (Lawrence Campbell, "Elaine de Kooning: The Portraits," in Jane K. Bledsoe et al., *Elaine de Kooning* [Athens: Georgia Museum of Art, University of Georgia, 1992], 33).

435. Roberta Smith, "Elaine de Kooning's Telling Portrait Drawings," *New York Times*, August 24, 1989.

436. Theodore E. Stebbins Jr., *American Master Drawings and Watercolors: A History of Works on Paper from Colonial Times to the Present* (New York: Harper & Row, 1976), 366.

437. Eleanor Munro, "Elaine de Kooning," in *Originals: American Women Artists* (New York: Simon & Schuster, 1979), 250–52.

438. Quoted in Thomas B. Hess, *Willem de Kooning Drawings* (Greenwich, Conn.: New York Graphic Society, 1972), 16.

439. Coleman's cheap white plastic saxophone looked to other musicians like a "toy" instrument and was yet another reason many didn't take him seriously (Litweiler, *Ornette Coleman*, 46).

440. Lawrence Campbell, "Elaine de Kooning: Portraits in a New York Scene," *ARTnews* 62 (April 1963): 39.

211

JACOB LAWRENCE
1917–2000

SELF-PORTRAIT

Ink and gouache over charcoal on paper, 48.2 x 30.7 cm (19 x 12 1/16 in.), circa 1965 and 1996
Inscription: *recto* Jacob Lawrence *l*; *verso* SelfPortrait / medium—gouache / Law 0051
NPG.96.190

In about 1965, when Jacob Lawrence began this self-portrait drawing, his face was *the* face of "Negro" art for white America. Through his exhibition at Edith Halpert's Downtown Gallery in New York in 1941, Lawrence assumed a visibility beyond anything ever accorded to an African American artist. His face remained before the nation for decades as he earned continued acclaim. As *Time* magazine's art editor, Alexander Eliot, noted in 1957, "At forty Jacob Lawrence is the world's foremost Negro painter."[441]

Yet until 1965, Lawrence made no surviving self-portraits; he left it to press photographers to deal with his features.[442] From his childhood, faces had attracted him less than the colors and patterns he saw in the vibrant black community of Harlem, where his family moved from Atlantic City around 1930. But he saw formal properties as inseparable from human qualities. He recalled, "Our homes were very decorative, full of a lot of pattern, like inexpensive throw rugs, all around the house. . . . Because we were so poor, the people used this as a means of brightening their life. I used to do bright patterns after these throw rugs."[443] He created these pattern sheets at Utopia Children's House, a settlement house where he also made dioramas of local street scenes.[444] Charles Alston, art teacher at Utopia, also was a mentor to Lawrence at a Works Progress Administration–sponsored art workshop in New York from 1934 to 1937.[445]

Around 1936, Lawrence began to make paintings that combined the Harlem scenes of his dioramas with the primary colors and flat shapes of his pattern sheets.[446] He devised each form and hue for emotional impact, whether it was the black zigzag of cigarette smoke rising in a brothel or the bright red arc of an exhausted mother's dress. Lawrence, whose art training, reading, and museum visits acquainted him with a wide range of Western and non-Western art, freely invented his own forms of perspective and anatomy.[447] The human face, normally subject to

powerful artistic conventions, was to Lawrence just another shape to be simplified or distorted for expression.

Lawrence's art told the human stories that moved him. In African American history he found an array of powerful tales to tell.[448] He made three series of paintings about the lives of Toussaint L'Ouverture, Frederick Douglass, and Harriet Tubman. Lawrence exhibited successfully in African American group exhibitions, but his major breakthrough occurred when the Downtown Gallery showed "The Migration of the Negro" in 1941.[449] This epic cycle told how thousands of black families in the early twentieth century, including Lawrence's, had made the difficult journey from the economically depressed South to the cities of the North. White critics and curators excitedly embraced the unfamiliar narrative and abstract power in Lawrence's series. The Museum of Modern Art in New York and the Phillips Memorial Gallery in Washington, D.C., bought the paintings, which then toured the United States.[450]

Lawrence continued to paint while serving in the Coast Guard during World War II. After leaving the service, he was feted, and his works appeared in prestigious venues. His first teaching position was at the famed Black Mountain College in North Carolina.[451] But Lawrence questioned his own success, wondering why he had been accepted by the white art world while other deserving black artists remained marginalized. Struggling to deal with these stresses, Lawrence entered a psychiatric hospital in October 1949. Used to looking out at the people around him, now he learned to look into himself. He recalled, "I was able to delve into my personality and nature. . . . I think it was one of the most important periods of my life. It opened up a whole new avenue for me."[452] Later, this avenue of frank self-exploration resurfaced in Lawrence's self-portraits.

The Portrait Gallery's self-portrait drawing [fig. 58, seen here before revisions] is one of three related

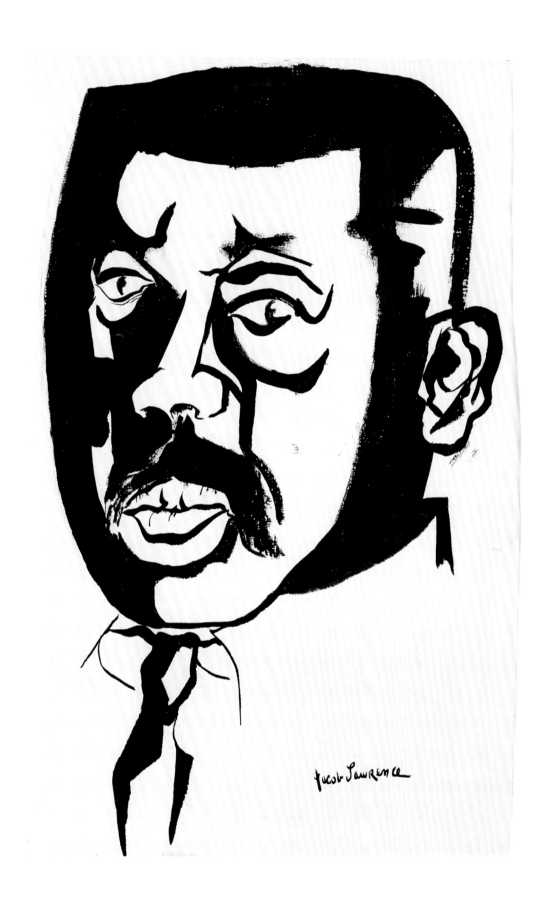

213

drawings—the other two are dated 1965 and are owned by the Butler Institute of American Art in Youngstown, Ohio, and Jacob Lawrence's widow, Gwendolyn Knight Lawrence, respectively. They are Lawrence's earliest surviving self-portraits.[453] Portraits were always rare in Lawrence's work. Expressive composition, color, and action played a larger role in his art than the capturing of the specific detail required for a traditional likeness. In his historical paintings, plot is more important than character, and even the central characters rarely appear in close-up. Why did portraiture come to

Fig. 58. *Jacob Lawrence* (1917–2000), self-portrait in its original form. Ink on paper, circa 1965. National Portrait Gallery, Smithsonian Institution

Lawrence's attention at this late date? Perhaps he was intrigued by the flat patterning of the human face in mid-1960s works by Andy Warhol [see cat. no. 49], Roy Lichtenstein [see cat. no. 45], and other pop artists. Or perhaps Lawrence, who in 1965 was teaching as artist-in-residence at Brandeis University in Massachusetts, was attracted by the intensity of students engaged in the traditional academic exercise of self-portraiture.[454]

Lawrence approached these self-portraits as a probing experiment in self-revelation and design. All of the drawings have the same composition, with the face turned toward the left, while the eyes look uneasily in the opposite direction. The calligraphic descriptions of eyes, ear, nose, lips, and mustache are strikingly similar in their general shapes, but the drawings' variations in detail and proportion bring out different moods. The Butler Institute drawing, showing Lawrence with a short chin and large eyes with prominent circles under them, exudes insecurity and sadness. In contrast, the Portrait Gallery's drawing (even before revision by Lawrence in 1996) had a heavier chin that gave a firm base to the

emphatic dark shapes of hair and mustache to create a more self-confident appearance. The lightly drawn, unevenly set eyes, however, hint at uncertainty.

The drawing returned to Lawrence's attention in 1996 when it was to be exhibited.[455] The aging artist had undergone many changes since 1965, his style having become more varied, with his many new subjects ranging from tools and builders to the bombing of Hiroshima. Since 1971, Lawrence had been a professor at the University of Washington in Seattle.[456] After all of these evolutions in himself and his vision, he decided that the 1965 drawing did not look enough like him, so he reworked it in gouache.[457] Around the eyes, ears, and chin he created solid black shapes by filling in areas between thin outlines. He added strong bands of black around both sides of the face, and molded the complex outline of forehead, cheek, and chin into a single sweeping curve. These changes transformed a lyrical linear drawing into a muscular interplay of contrasting values. The expression of the face acquired some of the strength and wisdom that Lawrence himself had acquired with the years. The extended lines rising from his eyebrows perhaps reflect new anxieties, in addition to advancing age.

Lawrence was used to rethinking and reworking earlier images; during the 1970s, 1980s, and 1990s he designed screen prints based upon his own paintings from the 1930s and 1940s.[458] He freely changed colors, textures, and shapes to achieve fresh effects, like a jazz musician improvising on an old melody. The new face of the old drawing recalls the formal vocabulary of a 1993 ink self-portrait that reduces all forms to geometric black blocks.[459] This bold but elegant approach to drawing—silhouetting black forms against white—had been a part of Lawrence's art beginning with the illustrations he made in 1948 for Langston Hughes's book *One-Way Ticket*.[460]

Lawrence's fascination with composition and pattern was indeed the formal root of all his art and controlled his approach to the human face. He said, "I look around this room . . . and I see pattern. I don't see you. I see you as a form as it relates to your environment."[461] This is the way he saw himself: as a series of forms. His self-portrait is a taut interplay of black and white planes and patterns; yet, like every part of Lawrence's art, it is a moving record of the man.

A.P.W.

441. Diane Tepfer, "Edith Gregor Halpert: Impresario of Jacob Lawrence's *Migration* Series," in *Jacob Lawrence: The Migration Series*, ed. Elizabeth Hutton Turner (Washington, D.C.: Phillips Collection and Rappahannock Press, 1993), 129–39; Alexander Eliot, *Three Hundred Years of American Painting* (New York: Time, 1957), 261.

442. See the photograph of Lawrence in Alain Locke, " . . . And the Migrants Kept Coming," *Fortune* 24 (November 1941): 102.

443. From a conversation between Lawrence and Ellen Harkins Wheat, quoted in Wheat, *Jacob Lawrence, American Painter* (Seattle: Seattle Art Museum and University of Washington Press, 1986), 29.

444. Alice B. Saarinen, *Jacob Lawrence* (New York: American Federation of Arts, 1960), 7; Wheat, *Jacob Lawrence*, 29.

445. Elizabeth Hutton Turner, "The Education of Jacob Lawrence," in *Over the Line: The Art and Life of Jacob Lawrence*, ed. Peter T. Nesbett and Michelle DuBois (Seattle: Jacob and Gwendolyn Lawrence Foundation and University of Washington Press, 2000), 97.

446. Wheat, *Jacob Lawrence*, 32.

447. Ibid., 36–39.

448. Deborah Willis, "The Schomburg Collection: A Rich Resource for Jacob Lawrence," in *Jacob Lawrence: The Migration Series*, 33–39.

449. Wheat, *Jacob Lawrence*, 34–48.

450. For the history of the exhibition, see Tepfer, "Edith Gregor Halpert," 129–39. For the historical content of the "Migration" series, see Lonnie G. Bunch III and Spencer R. Crew, "A Historian's Eye: Jacob Lawrence, Historical Reality, and the *Migration* Series," in *Jacob Lawrence: The Migration Series*, 23–31.

451. Wheat, *Jacob Lawrence*, 69–76.

452. Quoted in ibid., 33–39, 101–2.

453. See reproductions in Peter T. Nesbett and Michelle DuBois, *Jacob Lawrence: Paintings, Drawings, and Murals (1935–1999), a Catalogue Raisonné* (Seattle: Jacob Lawrence Catalogue Raisonné Project and University of Washington Press, 2000), entries D65–10 and D65–11. In 1977, Lawrence painted two self-portraits, *Self-Portrait* (National Academy of Design, New York) and *The Studio* (Seattle Art Museum, Washington).

454. Wheat, *Jacob Lawrence*, 114, 203.

455. *Jacob Lawrence: Drawings, 1945–1996* (New York and Little Rock: D C Moore Gallery and the Arkansas Arts Center, 1996).

456. Wheat, *Jacob Lawrence*, 141–92; *Jacob Lawrence: The Builders: Recent Paintings* (New York: D C Moore Gallery, 1998).

457. Before the changes he made in 1996, Lawrence was not satisfied with this drawing and did not exhibit it (Bridget Moore, D C Moore Gallery, to Wendy Wick Reaves, February 17, 1997, National Portrait Gallery curatorial files).

458. Peter Nesbett, ed., with an essay by Patricia Hills, *Thirty Years of Prints (1963–1993): A Catalogue Raisonné* (Seattle: Francine Seders Gallery and University of Washington Press, 1994), 10–13.

459. Collection of Ruth Bowman.

460. *Jacob Lawrence: Drawings*, 3–4, 12–17.

461. Jacob Lawrence, transcript of tape-recorded interview by A. Jacobowitz, in "Listening to Pictures" program of the Brooklyn Museum, 1968, 15; Jacob Lawrence Papers, AAA; quoted in Hills, "Jacob Lawrence's Paintings During the Protest Years of the 1960s" in Nesbett and DuBois, eds., *Over the Line*, 183.

STOKELY CARMICHAEL (KWAME TURE)
1941–1998

BY JACOB LAWRENCE
1917–2000

Ink, gouache, and charcoal on paper, 57 x 37 cm (22⁷/₁₆ x 14⁹/₁₆ in.), circa 1966
Inscription: 7 1/16" [with arrows on each side pointing away from inscription]
NPG.91.145

The cry for "Black Power" rang out across America in 1966, when Jacob Lawrence went to the headquarters of the Student Nonviolent Coordinating Committee (SNCC) in Atlanta to draw this portrait of its chairman, Stokely Carmichael, for the cover of *Time* magazine. Carmichael, a major spokesman for Black Power, defined the concept in positive terms as "black people coming together to form a political force."[462] Many, black and white alike, however, heard anti-white racism and violence in the words.[463] Lawrence portrayed Carmichael preaching the Black Power gospel, with the expansive gesture of his hand emphasizing his articulate and independent black voice.

The panther that Lawrence drew leaping over Carmichael's shoulder was the symbol of the Lowndes County Freedom Organization (LCFO). Carmichael and other SNCC workers helped blacks in Lowndes County, Alabama, to found this independent political party. African Americans made up 81 percent of the county's population, but as of March 1965 not a single black was registered to vote. In 1966, despite white efforts at intimidation, the LCFO registered thousands of black voters. Although the LCFO won no races in the 1966 election, it emerged as a legitimate political force. When the Black Panther Party for Self-Defense, later known simply as the Black Panthers, was founded in California in October 1966, it took over the LCFO's symbol.[464]

Carmichael's experience in Lowndes County was only part of the harrowing realities he had faced as a civil-rights activist and a black person.[465] A native of Trinidad, Carmichael moved to the United States in 1952. Coming from a place where the black majority dominated elected offices and other important positions, he was shocked to find in Harlem a black community where money and power were in white hands. Carmichael attended the Bronx High School of Science, where he was taken up by a circle of

affluent young white intellectuals.[466] He chafed at his role as token black and was embittered by the struggles of his parents, a maid and a carpenter. In 1967 he told photographer and journalist Gordon Parks,

> In 1960, when I first heard about the Negroes sitting-in at lunch counters down South, I thought they were just a bunch of publicity hounds. But one night when I saw those kids on TV, getting back up on the lunch counter stools after being knocked off them, sugar in their eyes, catsup in their hair—well, something happened to me. Suddenly I was burning.[467]

While earning a bachelor's degree in philosophy at Howard University in Washington, D.C., Carmichael faced terrifying mob violence and police brutality when he participated in the Freedom Rides organized by the Congress of Racial Equality (CORE) and SNCC to challenge segregated interstate travel. Carmichael had become a field worker for SNCC and by 1965 was a nationally known figure in the civil-rights movement.[468]

Carmichael ignited the campaign for Black Power with a fiery speech to the crowds who gathered in June 1966 for the "March Against Fear" from Memphis, Tennessee, to Jackson, Mississippi. James Meredith had begun the march alone but was shot before he could complete it.[469] *Time* magazine's lead article on July 1, 1966, said that "Already Negro hotheads have set up a political party in Alabama (the 'Black Panthers') that spurns whites." Carmichael was quoted as saying, "I have never rejected violence." In the wake of the violent Watts race riots of August 1965, whites read those words with fear, while civil-rights leaders like Martin Luther King Jr. worried that Carmichael was driving whites away from their cause.[470]

Time, in line with its new policy of matching cover artists with their subjects, searched for an able black artist to draw civil-rights leaders such as Carmichael.[471] Ignoring politically and aesthetically

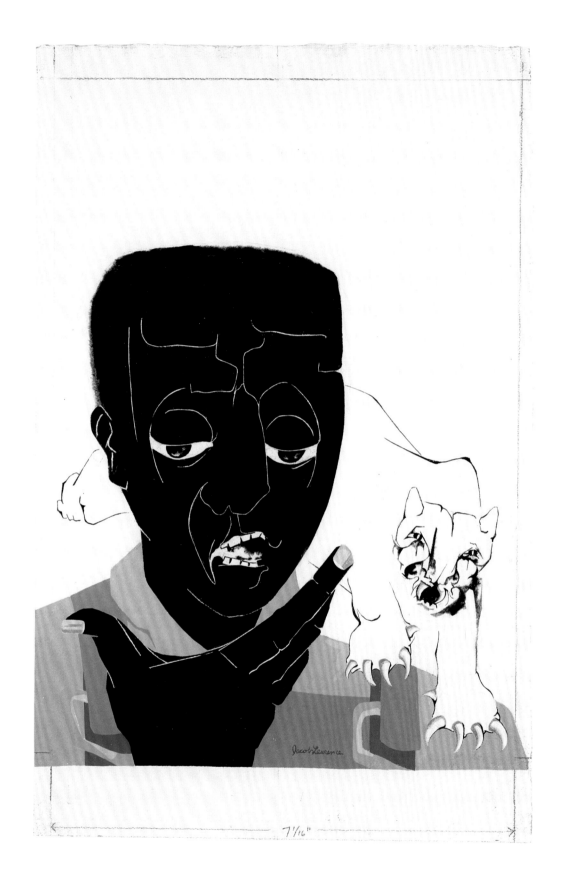

217

radical young black artists, the magazine considered only the few artists who had made a name in the mainstream, white art world. On July 7, 1966, cover coordinator Rosemary Frank wrote a memo to Assistant Managing Editor Henry Grunwald stating, "Jacob Lawrence is apparently the leading, established, Negro artist at present, but he is the first to point out that he doesn't do much portraiture." To prove his ability in the area, Lawrence sent the magazine the only portrait he had on hand, a self-portrait drawing, which was probably either the Portrait Gallery's drawing [see cat. no. 42] or one of

Fig. 59. *Struggle II— Man on Horseback*, by Jacob Lawrence (1917–2000). Brush, ink, and gouache on paper, 1965. The Seattle Art Museum, Washington; gift of anonymous donors in honor of the Museum's fiftieth year

two similar works. Frank's memo noted, "Lawrence lives in New York City . . . and could probably go right to work."[472] Rushing to keep up with events, *Time* hired him to travel to SNCC headquarters in Atlanta and draw Carmichael. The artist stayed several days while he observed Carmichael and made drawings from life. Lawrence later recalled his subject as "fiery, very active, and very much in command."[473]

Gordon Parks noted that Carmichael adapted his presentation to whatever audience he addressed, wearing, for example, a suit to speak in Harlem. Lawrence depicted him in the southern persona Parks described—"in bib overalls, [as] he tramped the backlands of Lowndes County, Alabama, urging Negroes, in a Southern-honey drawl, to register and vote."[474] Carmichael's drooping eyelids evoke slow southern speech, but his bared teeth and his fingernails, rendered in the same pink as the claws of the panther, leave no doubt that he is ready for action. Lawrence, who as a child made African-inspired masks, rendered Carmichael's face with an abstract formal impact like that of an African mask.[475] Lawrence divided the striking black shape

into assertive arcs and bands set off by narrow white lines. To create the complex of white lines within the black shapes, the artist painstaking painted, as he said, "on either side of the line," as he often did in rendering black faces.[476] The tense play of enveloping white field, strong black masses, and defining white lines transcends formal design to take on social implications.

In Lawrence's series of paintings about major narratives of African American history, most panels show small, abstracted figures enacting the dramatic events. The only faces Lawrence individualized were those of great freedom fighters such as Frederick Douglass and Toussaint L'Ouverture. This drawing added Stokely Carmichael to the pantheon.[477] Although Lawrence resisted making specific and overt political statements in his art, during the 1950s and 1960s he made powerful paintings and drawings about the struggle for civil rights. His "Struggle" drawings of 1965 and his drawing of Carmichael brought Lawrence's depictions of African American history up to his own time [fig. 59].[478]

Time probably intended to run Lawrence's drawing on the cover of the July 15, 1966, issue, when Carmichael led the national news coverage as he promoted Black Power in his keynote speech at a national meeting of CORE. The event polarized civil-rights activists: at a simultaneous meeting, leaders of the National Association for the Advancement of Colored People (NAACP) decried the Black Power slogan as divisive. Yet for the cover, *Time* chose to run an image of Indonesian leader General Raden Suharto, who was featured in the international lead story; it ran a small black-and-white photograph of Carmichael inside the magazine.[479] *Time* possibly considered Lawrence's drawing too positive a rendering of so controversial and potentially dangerous a figure as Carmichael, or perhaps the panther symbol of the LCFO cast Carmichael in too local a light to accord with his status as a national civil-rights leader.

Later in 1966 and 1967, *Time* articles reviled Carmichael for stirring up black mobs and telling African Americans not to fight in Vietnam when they had battles to fight at home.[480] In 1969 the ever more radical Carmichael, having broken with the SNCC and later with the Black Panthers over their willingness to cooperate with white liberals, moved to Guinea. There, under the name Kwame Ture, he worked as an advocate of Pan-Africanism until his death in 1998.[481] No picture of Carmichael ever appeared on the cover of *Time* magazine.

A.P.W.

462. Quoted in Gordon Parks, "Stokely Carmichael," *Life,* May 19, 1967, 82. Black Power was a complex, controversial, and rapidly evolving idea. For Carmichael's ideas on Black Power, see Stokely Carmichael, "What We Want," *New York Review of Books,* September 22, 1966, 5–8, and Kwame Ture [Stokely Carmichael] and Charles V. Hamilton, *Black Power: The Politics of Liberation* (1967; revised reprint, New York: Random House, 1992).

463. Michael T. Kaufman, "Stokely Carmichael, Rights Leader Who Coined 'Black Power,' Dies at 57," *New York Times,* November 16, 1998, B10, col. 1.

464. Ture and Hamilton, *Black Power,* 98–120; *Microsoft Encarta Africana,* 3d ed., p. 1, s.v. "Black Panther Party." Lawrence drew the panther as white, but it might have been intended to be printed in a solid, darker color on the actual magazine cover.

465. Kaufman, "Stokely Carmichael."

466. Robert Penn Warren, "Two for SNCC," *Commentary* 39 (April 1965): 43–45.

467. Quoted in Parks, "Stokely Carmichael," 80.

468. Warren, "Two for SNCC," 46–47, 38–48.

469. Henry Hampton and Steve Fayer with Sarah Flynn, "The Meredith March, 1966: 'Hit Them Now,'" in *Voices of Freedom: An Oral History of the Civil Rights Movement from the 1950s through the 1980s* (New York: Bantam Books, 1990), 283–95. Meredith had gained national fame as the first black student to attend the University of Mississippi, an event that had required the intervention of federal troops. See "James Meredith Enters Ole Miss, 1962: 'Things Would Never Be the Same,'" ibid., 115–22.

470. "The Nation: Civil Rights," *Time,* July 1, 1966, 11.

471. Frederick S. Voss, *Faces of Time: 75 Years of Time Magazine Cover Portraits* (Boston: National Portrait Gallery, Smithsonian Institution, and Bulfinch Press, 1998), 39–40.

472. Memo from Rosemary Frank to Henry Grunwald, Re: "Negro Artists," July 7, 1966, *Time* Collection Archives, National Portrait Gallery.

473. Telephone conversation between Jacob Lawrence and Frederick S. Voss, curator of the National Portrait Gallery's *Time* cover collection, November 8, 1991, National Portrait Gallery curatorial files. Jacob Lawrence did not remember exactly when he had drawn Carmichael.

474. Parks, "Stokely Carmichael," 78.

475. Jacob Lawrence, interview by Carroll Greene for the Archives of American Art (transcript on-line at archivesofamericanart.si.edu/oralhist/lawren68.htm).

476. Jacob Lawrence, interview by Elizabeth Steele, Seattle, March 5, 1999, in Steele, "The Materials and Techniques of Jacob Lawrence," in Nesbett and DuBois, eds., *Over the Line,* 256.

477. Lawrence continued this tradition with his 1970 *Time* cover drawing of civil-rights leader Jesse Jackson, *Time* Collection, National Portrait Gallery.

478. Wheat, *Jacob Lawrence,* 104–6, 111–15.

479. "The Nation: Civil Rights," *Time,* July 15, 1966.

480. "Races: Mind over Mayhem," *Time,* June 23, 1967; "Cities: Recipe for Riot," *Time,* June 30, 1967, 20; "Stokely's Spark," *Time,* September 16, 1966, 37; "Races: The Road to Hell," *Time,* December 15, 1967, 28.

481. Kaufman, "Stokely Carmichael."

HAROLD ROSENBERG
1906–1978

BY ELAINE DE KOONING
1918–1989

Ink wash on laid paper, 37.5 x 24.8 cm (14³/₄ x 9³/₄ in.), 1967
Inscription: Elaine de Kooning '67
NPG.89.160

Elaine de Kooning knew the contours of Harold Rosenberg's face intimately. By 1967, when she made this drawing, they had been close friends for years. Elaine, nearing fifty, was feisty, charismatic, and good-looking, as well as an alcoholic and constant smoker. She was painting, writing about art, and beginning a series of intermittent teaching situations in university art departments. Her financial position was precarious, as it had been since her separation in 1957 from her husband, artist Willem de Kooning. Rosenberg was nearly sixty, a hulk of a man once described as a "philosophical eagle that had just finished feasting on bear meat,"[482] and a formidable art critic, famous for his astute and passionate writing about the New York School of abstract expressionist painters, including Willem, who was included, by implication, in Rosenberg's seminal essay, "The American Action Painters," published in *ARTnews* in December 1952. Elaine and Bill de Kooning and Harold Rosenberg had known each other since the late thirties, and their lives were inextricably linked.

Harold Rosenberg was a lifelong New Yorker. Born in Brooklyn and educated at City College, he studied art and literature, and obtained a law degree from Saint Lawrence University in 1927. A fine writer and critical thinker, he served as editor of the American Guide series produced by the Works Progress Administration from 1938 to 1942, and worked in the Office of War Information during World War II. One contemporary biographer situated Rosenberg as one of "that generation of socially-conscious Greenwich Village intellectuals whose ideas were shaped most conspicuously by Marx and the Depression."[483] Rosenberg taught in a variety of institutions, but was best known for his books and articles on art, literature, and society, including the pieces written as art critic of the *New Yorker*, from 1967 until his death, which brought his ideas before a much broader audience.[484] Elaine once noted of

Rosenberg's interest in art, "When I first knew Harold . . . he was interested in politics and in poetry. And then he began to see that art was a kind of politics and a kind of poetry. And then he realized that he could think poetry and write politics by writing about art. It was just a natural thing for him to do."[485] And he did it with passion and commitment to the artists of the New York School, including Jackson Pollock, Franz Kline, Robert Motherwell, and Willem de Kooning. His most influential collection of essays, *The Tradition of the New* (1959), included his famous "action painters" essay, in which he affirmed the importance of the process of painting:

> At a certain moment the canvas began to appear to one American painter after another as an arena in which to act—rather than as a space in which to reproduce, re-design, analyze or "express" an object, actual or imagined. What was to go on the canvas was not a picture but an event.[486]

Rosenberg continued to champion these artists through articles and reviews published in *ARTnews*, the *New Yorker*, and elsewhere; many of these were included in other collections, such as *The Anxious Object* (1964), *Artworks and Packages* (1969), and *The De-Definition of Art* (1972).

Elaine de Kooning is known today primarily for her portraits—often of important figures within the New York art world, and for her writing. Elaine Marie Catherine Fried was a native of the New York area, where, dropping out after one year at Hunter College, she began to study art. Soon thereafter, she met Willem, whom she married in 1943. They both maintained studios, and lived in a cold-water flat. To make extra money, Elaine began, in 1948, to write short pieces on a variety of artists for *ARTnews*. These were often incisive and precise accounts of painters and paintings, with a keen eye to process and detail. She formed a strong friendship with the editor of *ARTnews*, Thomas B. Hess. Both Hess and Harold Rosenberg spent hours with de Kooning, drinking

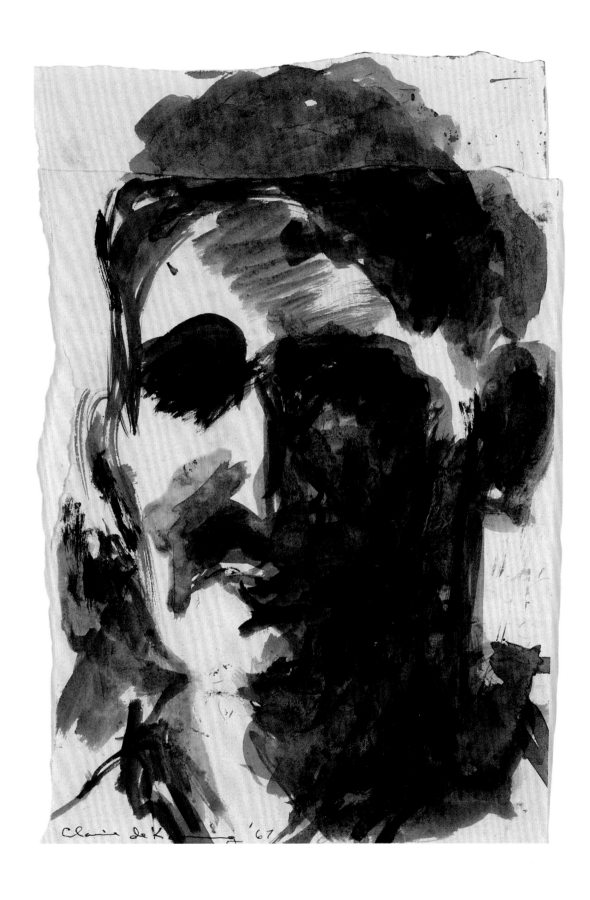

and talking.[487] These two close friendships had a profound effect on Willem's nascent reputation, for she promoted his work to them, and they, in turn, championed it in print. Other friends remembered that it was Elaine who taught Rosenberg to look at paintings. As she recalled, "He knew almost everything . . . everything except how to look at a painting. He would stand in front of a painting—Bill's painting, Franz's painting, anybody's painting—and talk about great ideas."[488]

Rosenberg and Hess did not promote Elaine's art in the same way that they did her husband's. She did

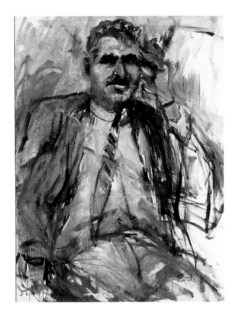

Fig. 60. *Harold Rosenberg [#2]* (1906–1978) by Elaine de Kooning (1918–1989). Oil on canvas, 1967. Estate of Elaine de Kooning

achieve a certain success, however, and always considered herself to be a painter rather than a writer, creating portraits and other figural subjects in a freely brushed, gestural, "abstract expressionist" style. She exhibited her work in a number of solo shows in New York galleries. In 1962 she was commissioned to paint a portrait of President John F. Kennedy for the Harry S. Truman Library in Independence, Missouri. De Kooning traveled to Florida, where she painted and drew the President from life for several weeks in December 1962 and January 1963. She produced a number of paintings from the sittings and was still working on them when Kennedy was assassinated in November 1963. Afterward, she did not paint for nearly a year.

The Kennedy commission was rare for de Kooning in that she preferred to choose her sitters from among her friends and family—poet Frank O'Hara, choreographer Merce Cunningham, Tom Hess, and Rosenberg. Most of her portraits were of men. She

often worked on several canvases and/or drawings of her subjects at one time. She sought the essence of the sitter's individuality not only in facial likeness, which was sometimes nearly or completely absent, but also in the particularity of the body's shape and posture. She noted in 1959:

> Portraiture has always fascinated me because I love the particular gesture of the silhouette (for portraits or anything else), the instantaneous illumination that enables you to recognize your father or a friend three blocks away or, sitting in the bleachers, to recognize the man at bat. Working on the figure, I wanted paint to sweep through as feelings sweep through.[489]

Elaine had painted Rosenberg several times. One canvas, from 1956, is a full-length seated portrait now in the collections of the National Portrait Gallery [fig. 10], and another, from 1967, a half-length portrait [fig. 60]. Her bold ink sketch from the same year is not a direct study, in the traditional sense, for the latter painting, but the two are related. In both images, Rosenberg's deep-set eyes, prominent eyebrows, and full, dark mustache are dominant. His face, fuller with age, is still marked by the prominent nose visible in earlier images made by Elaine, and in contemporary photographs. The gestural brushwork, seemingly uncontrolled and exuberant, captures Rosenberg's features, creating form and mass from dark pools and strokes of ink. The drawing is made up of two sheets of paper; the second sheet is attached just above the subject's hairline. The black and gray washes are overlapping in some areas; others are much darker and dense with pigment. The effect is much like a Rorschach ink blot. The form that emerges is unambiguously Rosenberg, and yet a reference to the psychological and perceptual is telling, for it underscores the depth of identification of the artist with her subject.

B.B.F.

222

NOTES

482. "Harold Rosenberg Is Dead at 72, Art Critic for the New Yorker," *New York Times,* July 13, 1978.

483. *World Authors, 1950–1978,* s.v. "Rosenberg, Harold," 1225.

484. "Harold Rosenberg Is Dead at 72." One of the most interesting and informative tributes to Rosenberg to be published after his death was written by his friend Saul Bellow ("Harold Rosenberg," in *Abstract Expressionism, A Tribute to Harold Rosenberg: Paintings and Drawings from Chicago Collections* [Chicago: David and Alfred Smart Gallery and Department of Art, University of Chicago, 1979], 9–12).

485. Quoted in Lee Hall, *Elaine and Bill, Portrait of a Marriage: The Lives of Willem and Elaine de Kooning* (New York: HarperCollins, 1993), 72.

486. Harold Rosenberg, "The American Action Painters" (1952), reprinted in *The Tradition of the New* (New York: Horizon Press, 1959), 25.

487. In Lee Hall's biography of Elaine and Bill, she states that Elaine's close relationship with Rosenberg and Hess were, at least occasionally, sexual. Others have downplayed this aspect of these friendships. See, for example, two typical reviews of the biography: Grace Glueck, "Elaine and Bill in the Match Made in Heaven," *ARTnews* 92 (Summer 1993): 129–30, and Eric Gibson, "Lives of the Artists," *New Criterion* 12 (January 1994): 69–73. Elaine's papers, including her diaries, are still in private hands and inaccessible to scholars.

488. Quoted in Hall, *Elaine and Bill,* 75.

489. Elaine de Kooning, statement in *It Is,* ed. Philip Pavia (Fall 1959): 29–30, reprinted in *Elaine de Kooning: June 21–September 6, 1994,* n.p., catalogue for exhibition at the Federal Reserve Board Building, Washington, D.C. See also, for Elaine de Kooning's life and career, Jane K. Bledsoe et al., *Elaine de Kooning* (Athens: Georgia Museum of Art, University of Georgia, 1992), and Elaine de Kooning, *The Spirit of Abstract Expressionism: Selected Writings,* ed. Rose Slivka and Marjorie Luyckx (New York: George Braziller, 1994).

ROBERT F. KENNEDY
1925–1968

BY ROY LICHTENSTEIN
1923–1997

Felt-tip markers over graphite with adhered paper corrections on paper-faced mat board, 60.7 x 47.3 cm (23 7/8 x 18 5/8 in.), 1968
Inscription: *recto* BLACK ONLY, WORK IN / COMBINATION WITH OVERLAY No. 1 / BUT DELETE LINES AS SHOWN ON / BLACKSTAT;
verso 2- 51 X 5 + Super negs.
Gift of *Time* magazine
NPG.78.TC492

The Democratic presidential primary of 1968 was a tense contest in a year darkened by the assassination of Martin Luther King Jr., the ensuing race riots, and protests against America's involvement in the Vietnam War. After President Lyndon Johnson withdrew from the race, the Democratic candidates were Senator Eugene McCarthy, Vice President Hubert H. Humphrey, and Senator Robert F. Kennedy. During the spring, the energetic younger brother of slain President John F. Kennedy took the lead in the race, sweeping state primary after primary and attracting screaming crowds of supporters who shared his bold opposition to the war and his advocacy of racial equality.[490]

To depict Kennedy on the May 24 cover, *Time* magazine's editors chose Roy Lichtenstein [fig. 61]. Like Bobby Kennedy, Lichtenstein was famous, controversial, and exciting. Beginning in 1961, he had shocked the sensibilities of the art world by closely basing his pop art paintings upon low-culture comic-book illustrations and advertisements. A 1964 article in *Life* magazine asked, "Is he the worst artist in the U.S.?"[491]

Time publisher James R. Shipley commented:

Pop Artist Roy Lichtenstein, who painted this week's cover, says that Kennedy is one of the very few real people he has ever portrayed. The 44-year-old artist usually turns out comic-strip-style superheroes with square jaws and their girl friends with superperfect coiffures. What he liked most about Kennedy, he says, was his "lively, upstart quality and pop-heroic proportions as part of a legend."[492]

The cover was actually a lithograph, not a painting, and Lichtenstein portrayed not superheroes in tights and capes but comic-book versions of World War II pilots and weepy women in search of love.[493] Painted in a giant version of the crudely dotted tints and bright colors of commercial printing, Lichtenstein's early 1960s comic-book images had made

headlines as they crossed the boundaries of fine art. But by 1968 the comic-book imagery had vanished from his work, replaced by art deco–derived compositions using the same bright commercial printing process colors and Benday dot patterns.

Shipley had some facts wrong about Lichtenstein's art but was right on target about America's image of Robert Kennedy as a young hero who had taken up the standard of his fallen brother. Lichtenstein certainly realized that *Time* wanted him to return to his earlier mode to portray the candidate as a political superhero. In this drawing, which is the color separation for the black elements in the final print, as well as the key drawing used as the basis for the red, yellow, and blue color separations, the artist set forth his vision of Kennedy.[494] Lichtenstein interpreted him as the handsome, upward gazing people's champion of truth and justice. The candidate, in reality often exhausted and haggard from the rigors of the campaign, appears in Lichtenstein's cartoon style as bright and vital, his white teeth flashing.[495] The Kennedy charisma and glamour are working full force. There is nothing here of the dark reputation for ruthlessness that had dogged him since his crime-fighting days as attorney general.[496] The innocent child's comic-book style exposed the simplified fantasies of those who saw Kennedy as a flawless hero ready to save the country.

In creating the *Time* cover print, as in designing his paintings, drawing was the central process for Lichtenstein.[497] He began with an image or combination of images that interested him. In this case he worked from photographs.[498] The artist transmuted the photographs into a cartoonlike image in his usual palette of black, red, blue, and yellow on white with a pattern of red Benday dots representing the color of Kennedy's face. Lichtenstein made a small sketch in colored pencil to lay out his initial ideas for the composition and color. With an

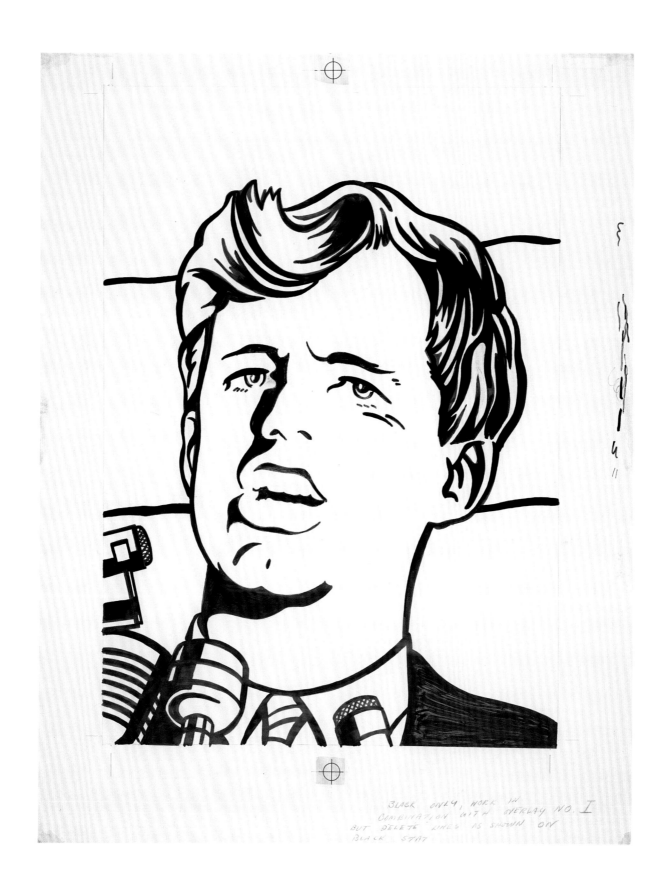

BLACK ONLY, WORK IN
COMBINATION WITH OVERLAY NO. I
BUT DELETE LINES AS SHOWN ON
BLACK STAT

overhead projector he enlarged and traced the sketch in pencil onto a large piece of artist board.[499] The resulting product became the key drawing.

In the key drawing, we clearly see the artist's hand at work behind the finished print. Over the traced pencil lines, Lichtenstein redrew the design in black marker. The brands of marker he used at different times have aged to various shades that allow the viewer to follow the artist as he filled in solid areas and moved, added, and extended lines. To create a stronger white angle extending from above Kennedy's right ear, Lichtenstein covered up a black

Fig. 61. *Robert F. Kennedy* (1925–1968) by Roy Lichtenstein (1923–1997). *Time* cover, May 24, 1968. TimePix

line there by attaching a piece of white paper. He took particular care in elaborating the flowing pattern of Kennedy's signature long, wavy hair.

The final printmaking was only the formal realization of the visual ideas conceived and developed in the drawings. Lichtenstein never kept his painstaking graphic development a secret from the public. The same 1964 *Life* magazine article that questioned whether Lichtenstein was the nadir of American art included a photograph and description of his working method.[500] In an interview in 1991 he explained,

> Redrawing . . . is something I like to do. . . . I try to draw it again, trying not to copy the projection but to kind of resense it. . . . I redraw the position of each line. I know approximately where it's going to be. Then I redo that. I semi-erase the whole thing, and I draw it again. I'm trying to make the drawing as powerful as possible.[501]

During this process of careful composition, free redrawing, and precise amendment, Lichtenstein combined precision with expression. His original comic-book–based works of the early 1960s had

emphasized the clumsy harshness of commercial graphic work, while the Portrait Gallery's work from 1968 superimposes a new decorative elegance, perhaps related to the art deco designs he was painting at that time.

The background of the print began as a pattern of wide stripes of red, white, and blue, as outlined in the drawing. In the final version, Lichtenstein added an irregular yellow radiating shape behind the head to suggest, with the yellow stripe over the face, a flashbulb illuminating the candidate. The brilliant flash could suggest, as well, Kennedy's powers as a heroic speaker. The yellow shape, with its sharp extended points, was also uncomfortably like the shapes Lichtenstein and his comic-book sources used to indicate explosions and bursts of machine-gun fire. Among Kennedy's supporters and campaign staff there were growing fears that the candidate, like his brother, would be assassinated.[502] These fears were tragically borne out on June 5, when Kennedy, as he was giving a speech after winning the California primary, was killed by an assassin's bullet. In retrospect the gold flash could now be read as the shining halo of a martyred saint.

Two weeks after the assassination, *Time* published another Lichtenstein print on the magazine's cover. This new cover made the viewer look down the barrel of a smoking gun. The carefree cartoon style of the second cover, and its kinship to Lichtenstein's previous cover of the recently slain Kennedy, provided its own commentary on the grim questions of gun control debated in the magazine's lead article.[503]

A.P.W.

490. Campaign workers were often disconcerted by the wild enthusiasm of the crowds who supported Kennedy, screaming and tearing at his clothing when they could get near him. Arthur M. Schlesinger Jr., *Robert Kennedy and His Times* (Boston: Houghton Mifflin, 1978), 861–65.

491. Dorothy Seiberling, "Is He the Worst Artist in the U.S.?," *Life,* January 31, 1964, 79–83.

492. James R. Shipley, "A Letter from the Publisher," *Time,* May 24, 1968, 19.

493. For a discussion of the type of comic-book images Lichtenstein used as the basis for his paintings and how he transformed those images, see Kirk Varnedoe and Adam Gopnik, *High and Low: Modern Art, Popular Culture* (New York: Museum of Modern Art, 1990), 194–208.

494. As in commercial printing, to make a color print an artist creates color separations, with one plate for each color.

495. James Stevenson described the exhausted candidate: "He rubs his face. He has pushed himself to the limit, but he does not mention his weariness. His face is gaunt, weathered; his eyes are sunken and red. He rubs his hand over his face again, as if to tear away the exhaustion" (Stevenson, "Notes and Comment," in "The Talk of the Town," *New Yorker,* June 15, 1968, 23).

496. Schlesinger, *Robert Kennedy,* 805, 808, 877.

497. Bernice Rose asserts that "drawing is both the core of his aesthetic and an essential part of the making of his art" (Rose, *The Drawings of Roy Lichtenstein* [New York: Museum of Modern Art and Harry N. Abrams, 1987], 15).

498. Henri Zerner, *The Graphic Art of Roy Lichtenstein* (Cambridge, Mass.: Fogg Art Museum, 1975), 13–14.

499. John Coplans, "Talking with Roy Lichtenstein," in *Roy Lichtenstein* (New York and Washington: Praeger, 1972), reprinted from *Artforum* 5 (May 1967): 34–39; Rose, *Drawings of Roy Lichtenstein,* 28–29.

500. Seiberling,"Is He the Worst Artist in the U.S.?," 80–81.

501. Quoted in Milton Esterow, "Roy Lichtenstein: 'How Could You Be Much Luckier Than I Am?,'" *ARTnews* 90 (May 1991): 87.

502. Schlesinger, *Robert Kennedy,* 900–901.

503. *Time* cover, June 21, 1968, and "The Gun under Fire," 13–19.

Rico Lebrun

1900–1964

By Leonard Baskin

1922–2000

Ink on paper, 56.4 x 77.6 cm (22³/₁₆ x 30⁹/₁₆ in.), 1968
NPG.77.233

In a tribute he wrote soon after Rico Lebrun's death, Leonard Baskin noted of his teacher, mentor, and friend, "Nothing human was alien to Lebrun's vision."[504] In his drawings, paintings, and sculpture, Lebrun worked and reworked the human form, fragmenting and distorting the body. His images are imbued with such urgency and drama that any moment of rest seems impossible. It was Lebrun's sustained passion for the human figure that most profoundly moved Baskin and informed his own work.

Baskin's deeply felt posthumous portrait of Lebrun poetically captures the fine line between figuration and abstraction, between absence and presence. It also points to the dichotomy between the fragility of the human spirit and the "fiery forge" of the human form to which both artists' work was dedicated. Baskin frequently made portraits of dead artists whom he admired as a way of "reinforcing help and fighting strength, for justification, for reassurance."[505] Among the many artists he memorialized in this way were William Blake, Honoré Daumier, Thomas Eakins, and Andrea Mantegna. Only two years before he died, Lebrun described Baskin's pictures of dead artists as capable of overwhelming the subject of death.[506] In this case, Baskin's great kinship with his subject amplified his depth of feeling.

Lebrun and Baskin were committed to figuration throughout the 1950s and 1960s, when abstract expressionism was the dominant American modernist aesthetic. Their lifelong mutual affection was fueled by their solidarity in resisting the contemporary trend of total abstraction. Lebrun once told a critic, "'With the abstract expressionists I feel that in spite of a tremendous presence of freedom there is an amorphousness and similarity in their work which proves that, in the long run, they are cultivating sterile rather than fertile ground.'"[507]

In describing his spiritual and artistic dependence on Lebrun, Baskin expressed the sense of loss he felt at the time he made Lebrun's portrait: "Whatever the reality, I feel, since the death of Rico Lebrun, entirely alone, as if drifting in an unknown, alien sea. I do not feel weak or even threatened, but I do feel alone. No living artist allegorically shares with me the long and silent hours in my studio."[508] These words are echoed in the artist's technique. A skilled printmaker, Baskin often made drawings that referred to prints. Here, the attenuated head is balanced by drawn lines that appear to be etched; they move quickly yet deliberately from the profile onto the background, teasing the perception of three-dimensionality. This technique in turn questions the tensions between abstraction and figuration while allowing figuration to prevail. On another level, the "etched" lines—as possible representations of breath, speech, aura— create the impression of a person whom the artist has been watching and studying but who has suddenly disappeared, leaving the onlooker with a fresh memory of the visage. The unfinished outline of Lebrun's shirt reinforces this lonely gulf between absence and presence, death and life.

The placement of the drawing at the left of the composition, leaving the right side of the page completely blank, suggests a kind of voyeuristic view of the profiled subject with space that allows close looking without confrontation. This position gives the viewer time to study the lines and flecks of the sitter's sagging chin and cheeks, creased forehead, and downcast, moist eyes. The emptiness of the page reinforces the intimate nature of the drawing.

Lebrun, who was born in Naples, came to the United States in 1924. He first worked in Illinois as a designer and foreman in a stained-glass factory, and then found success in New York as a commercial artist and later as an instructor at the Art Students League. After a period of study in Italy on a Guggenheim Fellowship, he was hired in 1935 as a muralist for the Works Progress Administration.

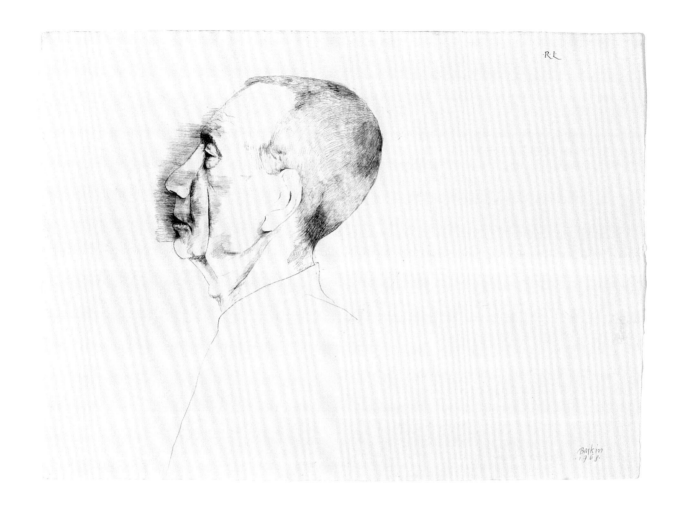

MODERN AMERICAN PORTRAIT DRAWINGS

Though his early years thrust him into the New York art world, the majority of his career was spent in California. While there, he felt that drawing was unequal to the task of achieving monumental representations of the human form, and he turned to sculpture.

A sensitive and intelligent humanist, Lebrun read incessantly and wrote beautiful, powerful prose often emulating the styles of his favorite writers, Emily Dickinson and Herman Melville.[509] Art historically, he was fascinated by subjects treating the anguish of the human condition found in the work of Baroque masters and their nineteenth-century successors in Romanticism. He "revised" the works of Francisco José de Goya y Lucientes, depicted the horrors of Nazi concentration camps, illustrated Dante's *Inferno* as well as Bertolt Brecht's *Threepenny Opera,* and made a Crucifixion cycle after Matthias Grünewald. Among his most ambitious projects was a mural portraying the Book of Genesis for Pomona College in Claremont, California.

Like Lebrun, Baskin was completely and obsessively involved in his projects, and while much of his work dealt with spiritual themes, it was not without an element of social commentary. Predominantly a sculptor, he was profoundly aware of the technical challenges posed by his diverse media, which included ink, bronze, plaster, and watercolor.[510] Also like Lebrun, Baskin was a prolific writer. His many musings on art and life expressed his dramatic vision exemplified in his oft-quoted statement, "Our human frame, our gutted mansion, our enveloping sack of beef and ash is yet a glory. Glorious in defining our universal sodality and glorious in defining our utter uniqueness. The human figure is the image of all men and of one man. It contains all and can express all."[511]

At the time this drawing was made, Baskin's work was being exhibited extensively and was critically acclaimed in this country and abroad. His work figured prominently in the exhibition "New Images of Man" at the Museum of Modern Art in 1959 and in the biennial exhibitions in São Paulo in 1961 and Venice in 1969. Aside from exhibiting his work in major national and international exhibitions, he taught at Smith College and worked prolifically in his Northampton, Massachusetts, studio, often hosting studio visits with prominent art critics. Although Lebrun's work was well known in Los Angeles, where he lived, taught, and painted, it never reached the level of international critical acclaim that Baskin's did. This disparity deeply troubled Baskin, who wrote,

That he [Lebrun] has not risen to universal esteem and admiration is undiluted evidence of the dire disjointedness of our time, the hideous miasmal blindness that an entrenched avant-garde, buttressed by an endlessly powerful vested interest, can cast over our society. . . . "The human form is a fiery forge," wrote William Blake, and Lebrun is inseparable from his work. Bound together and forever are the tempest, the fire and the fury of his dedicated, deeply human achievement.[512]

The words of John Donne, which Lebrun quoted in a brochure published in conjunction with an exhibition of Baskin's work at Bowdoin College in Brunswick, Maine, in 1962, perhaps best summarize the two artists' communion of vision and mind:

Then, as all my souls bee,
Emparadis'd in you, (in whom alone
I understand, and grow and see,)
The rafters of my body, bone
Being still with you, the Muscle, Sinew, and Veine,
Which tile this house, will come againe.[513]

D.M.

504. Baskin, *Rico Lebrun: Memorial Exhibition* [see cat. no. 36, n. 384].

505. Baskin often quoted William Blake's famous line, "The human form is a fiery forge," when writing about Lebrun's work. For example, see Leonard Baskin, *Iconologia* (New York: Harcourt Brace Jovanovich, 1988), 1, 24.

506. Rico Lebrun, *Leonard Baskin* (Brunswick, Maine: Bowdoin College Museum of Art, 1962), n.p.

507. Quoted in Henry J. Seldis, "Artists on the West Coast: A Family of Painters," *Art in America* 44 (Fall 1956): 37.

508. Baskin, *Iconologia*, 1.

509. Leah Ollman, "Reworking a Portrait of the Artist," *Los Angeles Times*, April 27, 2001, 57.

510. On the verso of the drawing is a curious pen-and-ink sketch of an unidentified nude man in profile wearing only a helmet and a belt with a pouch on it. The drawing is reminiscent of Baskin's sculptures from this period in the militaristic subject matter and the figure's exaggerated, unidealized form.

511. Quoted in Robert Smith, "Leonard Baskin Dies at 72: Sculptor of Stark Memorials," *New York Times*, June 6, 2000.

512. Baskin, *Iconologia*, 8.

513. Quoted in Lebrun, *Leonard Baskin*.

231

CHRISTOPHER ISHERWOOD
1904–1986

BY DON BACHARDY
born 1934

Ink wash and graphite on paper, 60.9 x 47.8 cm (24 x 18¹³/₁₆ in.), 1976
Inscription: Christopher Isherwood Dec 17 1976 / Bachardy
Gift of the Mildred Andrews Fund
NPG.80.133

This incisive drawing is a brilliant example of an extensive series of portraits by Don Bachardy [see also cat no. 39] depicting his lover and companion, the British-American writer Christopher Isherwood, that together, as Bachardy has noted, "encompass the full range of my work as an artist and for me represent my best effort."[514] Documenting their thirty-three-year relationship and signed in almost every instance by both men, the series is a moving testament to the history of the lives of two artists that, more generally, illuminates the collaborative nature of portraiture and creativity.

Collaboration had always been paramount to Isherwood, as evidenced by his earlier relationship with the English poet W. H. Auden, but had taken on new meanings for him around the time he met Bachardy in 1953.[515] Approaching fifty, Isherwood had begun to see his earlier work revived in different guises. In 1946, the year he became a naturalized United States citizen, the novels of his bohemian youth in prewar Berlin, *The Last of Mr. Norris* (1935) and *Goodbye to Berlin* (1939), were reissued together as *The Berlin Stories*. And then in 1952 the play *I Am a Camera*, set in Berlin and starring Julie Harris as the expatriate American music-hall performer Sally Bowles (a role later made famous by Liza Minnelli in the 1972 movie *Cabaret*), won the New York Drama Critics Award.

In response to these events, Isherwood began to reflect upon the many ways that his art had begun to complicate his identity. In his July 1954 foreword to a new edition of *The Berlin Stories* he recalled his reaction to confronting his past in the persona of Harris's Bowles: "I was dumbfounded, infatuated. Who was she? What was she? How much was there in her of Miss Harris[?] . . . How much of the girl I used to know in Berlin, how much of myself? It was no longer possible to say." Isherwood also mused about how, in the making of the play, his invented past had supplanted reality:

Indeed, it had now become hard for me to remember just how things really had happened—that is to say, how I had made them happen in my stories. And so, gradually, the real past had disappeared, along with the real Christopher Isherwood of twenty years ago. . . . Watching my past being thus reinterpreted, revised and transformed by all these talented people upon the stage, I said to myself: "I am no longer an individual. I am a collaboration."[516]

It was partly in that spirit of collaboration that the forty-eight-year-old Isherwood embarked upon his relationship with the eighteen-year-old Bachardy. Isherwood, who famously described himself as a "camera with its shutter open," confirmed Bachardy's own "instinctive urge to record" and by providing the younger man with financial and emotional support, as well as being his most cooperative and convenient subject, "willed me to be an artist,"[517] as Bachardy later put it. As a portraitist, Bachardy learned to lose himself in the characters of his sitters, just as Isherwood had in the characters of his novels. With both artists so adept at the art of transcending any simple notion of identity, the poet Stephen Spender observed that their relationship became "multiple": "They were lovers, father and son, teacher and pupil, and colleagues." In addition to their portrait series, Isherwood and Bachardy eventually went on to work together on a play, a movie, and a book.[518] Moreover, their intriguing partnership became a subject that fascinated and inspired other notable artists such as David Hockney [see fig. 62].

Bachardy and Isherwood's portrait sittings were dramatic, often difficult, encounters. Isherwood, who viewed himself as "patient, lazy but persistent" and Bachardy as "all impatience, energy, aggression," noted: "Don often describes his work as a confrontation. He himself, with a pen gripped in his mouth ready for use when it is needed instead of a brush, reminds me of a pirate carrying a dagger

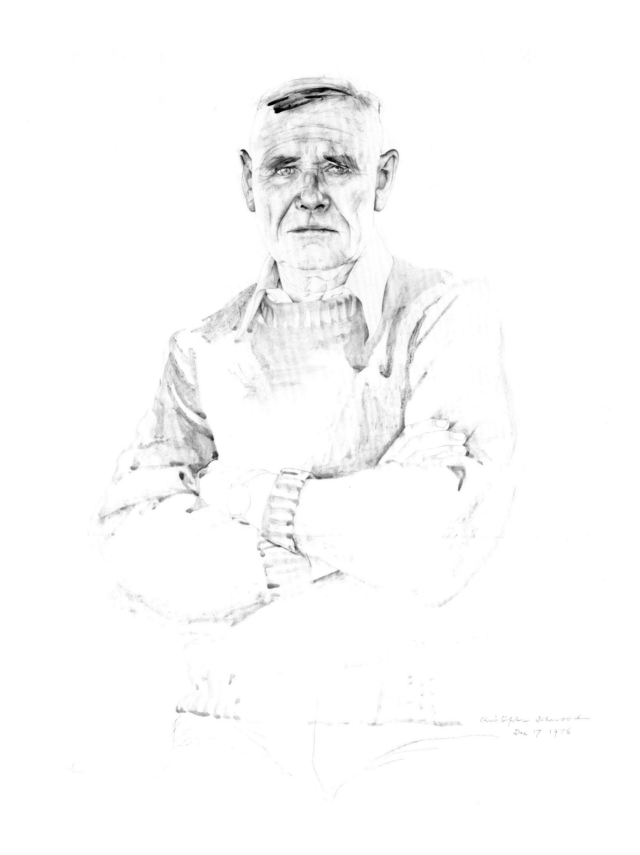

Christopher Isherwood
Dec 17 1976

between his teeth while boarding the enemy. He seems to be attacking the sitter." Bachardy never shied away from presenting his sitters with "a version of themselves which they would almost certainly think unflattering, and maybe cruel or even sadistic." Regarding his last sessions with Isherwood, Bachardy even acknowledged that he may have been "tormenting" his sitter and surmised that it was "an extension of something basic in our interaction."[519]

If at one level these works are tense, cruel records of fact, they are also infused with a rich, emotional warmth that speaks to the closeness of the

Fig. 62. *Christopher Isherwood* (1904–1986) *and Don Bachardy* (born 1934) by David Hockney (born 1937). Acrylic on canvas, 1968. The David Hockney No. 1 U.S. Trust

relationship. The critic John Russell has noted: "So far from being an inert, discouraged, unresponsive sitter, Isherwood . . . comes across as a marvel of steadiness and co-operation who revealed his every shift of feeling without pathos or pretense." Russell commented further that "Isherwood worked together wholeheartedly" with Bachardy and recalled how Isherwood referred to his younger partner as the "ideal companion to whom you can reveal yourself totally and yet be loved for what you are, not what you pretend to be." In the final analysis, the drawings must then be seen, as Spender succinctly said, as "both merciless and loving."[520]

This image of the seventy-two-year-old Isherwood indeed evinces the unusual mixture of realism and sentiment that Spender spoke of. Bachardy's "cruelty" is evident in the unflinching way the effects of age—the sagging cheeks, the fleshy nose, the creases and lines around the eyes—are all carefully recorded. Simultaneously, the folded arms,

the clarity of Isherwood's eyes, and the tenacity of his gaze speak to Bachardy's admiration for the older man's unfaltering strength of spirit. Bachardy's affection is further conveyed by the way Isherwood's body, in contrast to the sharp pencil lines of the face, is clothed in a sweater rendered in broad, soft ink washes.

The watch Isherwood wears is featured in a number of the portraits and alludes to how conscious Bachardy was of the various ways in which the series recorded the passage of time. Because each of the drawings was done in a single sitting, Bachardy thought of them collectively as a "kind of pictorial diary." Another temporal analogy was suggested by films: "Since I am obsessed by time it has occurred to me that my drawings can be comprehended as spans of time, even measurements of time or, in movie terms, as long takes."[521] Finally, and most poignantly, the watch eventually came to assume a more traditional symbolic function as a memento mori following Isherwood's diagnosis with terminal cancer in 1981.

Bachardy drew Isherwood through every phase of his illness and sketched the corpse shortly after death. He has written that Isherwood during this difficult period "continued to participate in my development as an artist as though it really was what he repeatedly claimed it was, one of the greatest sources of satisfaction he'd known in his life." The extent of this final collaboration was so great that Bachardy came to feel that "dying was something which we were doing together." Although cognizant of the cumulative power of their work together, Bachardy was still startled to discover how his drawings alone continued later to palpably evoke Isherwood's presence: "They almost seemed to me supernatural. Somehow, I'd caught a spirit in them. A couple of times, I felt him almost talking to me— from my own pictures of him! That stunned me. It never occurred to me that, by doing those pictures, I was setting up a communication with him after he was gone."[522]

C.B.

514. Bachardy, *Stars in My Eyes*, 13 [see cat. no. 39, n. 410].

515. See Norman Page, *Auden and Isherwood: The Berlin Years* (New York: Palgrave, 1999).

516. From foreword to Christopher Isherwood, *The Berlin Stories* (New York: New Directions, 1954), vii–viii.

517. Christopher Isherwood, "Goodbye to Berlin," in Isherwood, *Berlin Stories*, 1; Bachardy, *Stars in My Eyes*, 3; Bachardy, *Christopher Isherwood*, 119 [see cat. no. 39, n. 411].

518. Quoted in Bachardy, *Christopher Isherwood*, 115; The other Bachardy/ Isherwood collaborations were a 1979 play based on Isherwood's book, *A Meeting by the River* (1967); *October* (Los Angeles: Twelvetrees Press, 1981); and the 1973 movie *Frankenstein: The True Story*.

519. Isherwood and Bachardy, *October*, 42, 11; Bachardy, *Stars in My Eyes*, 10; Bachardy, *Christopher Isherwood*, xiv.

520. Quoted in Bachardy, *Christopher Isherwood*, ix, xii.

521. Bachardy, *Stars in My Eyes*, 3; Bachardy, *Christopher Isherwood*, xiii.

522. Bachardy, *Christopher Isherwood*, xiv, 119.

Andy Warhol
1928–1987

By Jamie Wyeth
born 1946

Gouache, watercolor, and graphite on illustration board, 40.6 x 40 cm (16 x 15 3/4 in.), 1976
Inscription: J. Wyeth
Gift of Coe Kerr Gallery
NPG.77.32

In November 1975 a New York society columnist hinted at James Browning Wyeth's future plans: "Jamie Wyeth expects to spend more time than usual in New York this winter. He is toying with the possibility of two portraits. . . . One . . . is Andy Warhol, whose child face, as innocent as unscribbled white paper, presents a real challenge, he says."[523] The following spring, Wyeth executed this mixed-media portrait drawing in gouache, watercolor, and graphite on illustration board. It is one of several portraits that Wyeth made of Warhol during an intense three-month collaboration at the Factory, Warhol's studio.[524] While Wyeth sketched and painted Warhol, the older artist made his own silkscreen portraits and drawings of Wyeth, based on the Polaroid photographs he repeatedly snapped.[525]

The results of this "narcissism thing," as Wyeth playfully termed it, were exhibited with great fanfare in a joint exhibition hosted by the Coe Kerr Gallery.[526] "Warhol has a strong claim to being the leading portraitist of our era," proclaimed one reviewer.[527] Wyeth, only twenty-nine, already enjoyed a strong reputation as a portraitist in his own right, having painted many notable individuals, including John F. Kennedy and Lincoln Kirstein [cat. no. 40]. But the show's real interest was its juxtaposition of competing styles—Warhol's pop art versus Wyeth's traditional American realism. As one critic put it succinctly: "The twain meet."[528]

Although the photographer Peter Beard introduced Warhol and Wyeth during the 1960s, it was not until 1975 that Wyeth approached the older artist about creating a portrait. Wyeth explained,

> I simply saw Andy Warhol as someone who I wanted to paint. . . . I think that he is such a fascinating looking person, almost infinitely more interesting than his work. . . . So I went to Andy and asked him if he would consider posing. Then he came up with the idea Well, you do one of me and I'll do one of you. Really it was a joint effort.[529]

Working side by side with Warhol, Wyeth saw his subject at close range, a necessity for him. He explains, "To paint a person, I practically go to bed with him. . . . Through osmosis I become the object. I just stay with the person, I follow him around for days." Warhol made no demands, telling one critic, "I wasn't concerned about how he would paint me. . . . I love his work." Wyeth reveled in his freedom: "The great thing about painting another artist is that he doesn't dictate to you to take off a pound or two here [around the chin] to flatter him."[530] Like the drawing, Wyeth's finished oil portrait of Warhol was far from flattering, accentuating his blemished skin and rumpled clothing [fig. 63]. The drawing even includes Warhol's protruding belly. In the oil painting, Warhol's abdomen is exposed, revealing the scar that resulted from his shooting in 1968 by the radical feminist Valerie Solanis.

Wyeth's portrait played into Warhol's own strategies of self-representation. Warhol advocated flaunting one's beauty flaws, rather than hiding them, and claimed he tried to make himself unattractive to preserve his privacy.[531] Indeed, Warhol participated in Wyeth's construction by posing in the glare of bright light. According to Wyeth, "He was sitting for me with this strobe light in his face, which not only is rather warm after a while but also shows up every little detail." Warhol later acknowledged: "I could see him using pimple colors when I posed, so I knew what he was doing."[532]

Warhol's disheveled appearance in the drawing corresponds to contemporary descriptions of the artist. "Warhol's face is . . . paler than Wyeth's [oil] portrait," observed Martha Espedahl, who encountered Warhol at a private preview of the portraits. "With his shock of straight white hair in front (it's dark in the back) and the flesh-colored eyeglass frames, he's wearing jeans, the tie that inevitably seems to gravitate off center, and a jacket.

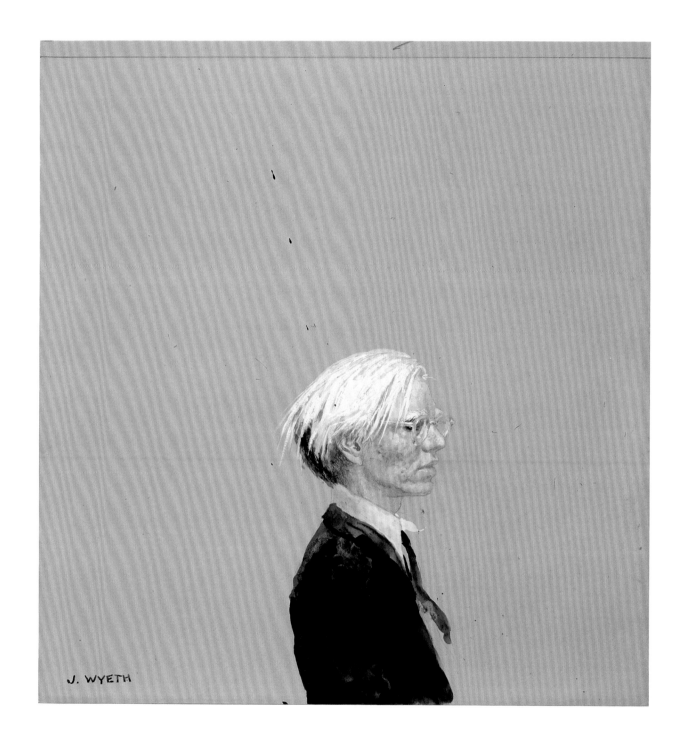

MODERN AMERICAN PORTRAIT DRAWINGS

. . . His voice is barely audible but has a decided note of refinement. He is visibly nervous." The placement of Warhol's figure on the illustration board magnifies his awkwardness. We see only the upper half of his torso, and the artist's right arm seems pinned by his side, with no hands visible. An expanse of open space presses down upon the diminutive creature, who once claimed: "That could be a really American invention, the best American invention—to be able to disappear."[533]

Yet this mixed-media drawing of Warhol's skin and torso has a visceral quality, honed by Wyeth's

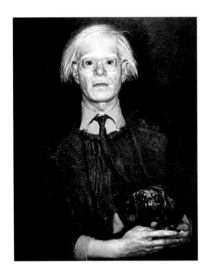

Fig. 63. *Andy Warhol* (1928–1987) by Jamie Wyeth (born 1946). Oil on panel, 1976. Cheekwood Museum of Art, Nashville, Tennessee

study in New York City's morgue.[534] The raised texture of the hair invites the touch. Indeed, the artist's fingerprints are visible on the subject's shoulder and neck. To paint Warhol, Wyeth used "palette, brush, fingers, everything—and a lot of white paint," evident in both the artist's hair and skin tones.[535] The image's sensual physicality is accentuated by the splashes of black paint that rain down upon Warhol's head and extend to the bottom of the paper. The watercolor and gouache often stray boldly from the still-visible pencil lines underneath, as in the rendition of Warhol's collar and tie.

The physicality of the drawing suggests that it may be more than just a preparatory sketch, as has been commonly assumed.[536] In 1981, Wyeth explained: "Unlike my father, I don't make a lot of preparatory studies before I paint on canvas. I do make a lot of sketches, but many of these are done after the painting. I decide there's really more to a subject than I put on the canvas, so then continue with more drawings."[537] Warhol's own drawings of Wyeth were executed after his silkscreen portraits.

Warhol's drawing of Wyeth [cat. no. 49] is

opposed in almost every respect to this one. Based on a Polaroid snapshot, it is large and glamorous. Indeed, it may have been the very differences in their approaches that encouraged this artistic "odd couple" to work together. As Wyeth recalled at the time of Warhol's death:

> I think he was fascinated by the way I paint because it's so alien to the way he works. If anything, I had a great envy of the way Andy worked. I'd be working away for hours on my portrait of him. With him it was just "click, click" and that was it. I wonder if Andy's hand ever even touched that piece of canvas. I really think there *is* a validity to the way he works. . . . It was the antithesis of my work.[538]

Yet despite these differences, the reciprocal portraits of Wyeth and Warhol indicate a strong bond, the significance of which is not well appreciated. In Warhol, Wyeth found an unlikely friend, capable of appreciating his love of animals, toys, and Americana.[539] In Wyeth, Warhol found a supporter capable of defining himself against Warhol's idiosyncrasies rather than giving way to them. It may be that each artist recognized in the other something distinctly American, a quality with which each artist has identified himself—Warhol through his repetition of democratic, iconic images, and Wyeth through his realist, even deliberately naive, style. As Espedahl observed in 1976, "The obvious question is, 'Why Andy Warhol?' Jamie's reply is the same to all. 'To me he was representative of New York and I love New York.'"[540]

A.C.G.

523. Eugenia Sheppard, "The Lady Is a Pig," *New York Post*, November 14, 1975, 45.

524. John N. Buckland, "The Brandywine Tradition Meets the Big Apple," *Delaware Today* (August 1976): 17. Buckland's account of the collaboration, in conjunction with others, suggests that this project took place between February and April 1976 (cf. Martha E. Espedahl, "Jamie Paints Warhol, and Vice Versa," *Sunday News Journal* [Wilmington, Delaware], April 25, 1976, 17). Tape recordings made by Warhol confirm that he and Wyeth were together in February and March 1976 (Joyce Hill Stoner, "Andy Warhol and Jamie Wyeth," *American Art* 13 [Fall 1999]: 83, nn. 24, 29, and 31).

525. Espedahl, "Jamie Paints Warhol," 17; Buckland, "Brandywine Tradition," 17; Judy Kessler, "Wyeth and Warhol: A Portrait of the Artist by a Good Friend, Warts, Eyeshadow and All," *People* 5, no. 16 (April 26, 1976): 22.

526. Espedahl, "Jamie Paints Warhol," 17. The exhibition was titled "Andy Warhol and Jamie Wyeth: Portraits of Each Other," and ran from June 3 to July 9, 1976. Buckland reports that the show included a total of thirty-six works, consisting of six silkscreens and five sketches by Warhol and one oil portrait and twenty-four sketches by Wyeth (Buckland, "Brandywine Tradition," 19). Gerrit Henry specifies that the show included eight mixed media drawings by Wyeth (Gerrit Henry, "Andy Warhol and Jamie Wyeth: Portraits of Each Other," review, *ARTnews* 75 [September 1976]: 120).

527. Noel Frackman, "Andy Warhol and Jamie Wyeth," *Arts Magazine* 51 (September 1976): 15.

528. Buckland, "Brandywine Tradition," 17.

529. Stoner, "Andy Warhol and Jamie Wyeth," 61; quoted in Buckland, "Brandywine Tradition," 17.

530. Quoted in Stephen Gayle, "Daily Closeup: Portrait of Jamie," *New York Post*, November 16, 1974, 41; quoted in Kessler, "Wyeth and Warhol," 22; quoted in Espedahl, "Jamie Paints Warhol," 17.

531. Andy Warhol, *The Philosophy of Andy Warhol (From A to B and Back Again)* (London: Cassell, 1975), 65 and 113–14.

532. Quoted in Espedahl, "Jamie Paints Warhol," 17; quoted in Kessler, "Wyeth and Warhol," 22.

533. Espedahl, "Jamie Paints Warhol," 17; Warhol, *Philosophy of Andy Warhol*, 113.

534. This quality was also observed by Noel Frackman (Frackman, "Andy Warhol and Jamie Wyeth," 15).

535. Quoted in Kessler, "Wyeth and Warhol," 22.

536. On Wyeth's love of the physicality of oil paint and surface texture, see Joyce Hill Stoner, "Jamie Wyeth: Proteus in Paint," *Traditional Fine Arts on Line, Inc.* [TFAOI.com] (November 18, 1998): 1–2 and 5.

537. Quoted in M. Stephen Doherty, "Jamie Wyeth's Studio Retreat," *American Artist* 45 (February 1981): 59.

538. Jamie Wyeth, statement in Robert Becker, "A Portrait of Andy," *Parkett*, no. 12 (1987): 96.

539. On the importance of their collaboration and relationship, see Stoner, "Andy Warhol and Jamie Wyeth," 58–83, 72–75, and 78–81, and Wyeth, statement in Becker, "Portrait of Andy," 96.

540. Mario Amaya, "Artist's Dialogue: A Conversation with Jamie Wyeth," *Architectural Digest* 38 (May 1981): 204–6; Espedahl, "Jamie Paints Warhol," 17.

JAMIE WYETH
born 1946

BY ANDY WARHOL
1928–1987

Graphite on paper, 103.5 x 71.2 cm (40³/₄ x 28¹/₁₆ in.), 1976
NPG.98.121

"The Patriarch of Pop paints the Prince of Realism and vice versa," the *New York Times* exclaimed after the June 1976 opening of Andy Warhol and Jamie Wyeth's mutual portrait exhibition. A celebrity-studded crowd of 2,240 had thronged the Coe Kerr Gallery, anxious to see how these two seemingly antithetical artists portrayed each other. "Not since Gainsborough painted 'The Blue Boy,'" gallery owner Fred Woolworth exulted, "has portraiture created such a stir."541 This graphite portrait as well as Wyeth's gouache of Warhol [cat. no. 48] were both included in the exhibition of drawings, studies, and paintings the two had made of each other. Warhol's contribution included six variously colored silkscreen-and-acrylic paintings of Wyeth in a dreamy, contemplative three-quarter pose with chin resting on one hand [fig. 64]. Like the Portrait Gallery drawing, they were all based on one of the many Polaroids that Warhol had shot during the three months or so that Wyeth had spent painting at the Factory, the older artist's famous studio.542 Warhol created a glamorized pop icon, the critics agreed, while Wyeth had produced a meticulously realist grotesque; the exhibition was, in Hilton Kramer's words, a "curious all-male version of Beauty and the Beast." But Kramer, writing for the *New York Times*, considered both approaches vulgar and vacuous, appealing to cheap, popular taste.543

The two artists had anticipated the publicity and the furor. By 1976, Warhol and Wyeth, who met in the 1960s, had formed a lasting friendship.544 Both artists were nationally famous, but each had borne his share of critical fury. Wyeth—not only scion of a famous artistic family but also wealthy, handsome, and precociously proficient—had become the poster boy of the realist tradition at a young age, attracting a broad popular following. To an art establishment still largely wedded to abstract expressionism, however, he had been anathema. Warhol, emerging in the 1960s as a celebrity symbol of the pop art

movement, was equally reviled for his banal, commercial subject matter, his slick, anti-art style, and his emotional neutrality. The joint exhibition, Bob Colacello asserted, alienated Warhol even further from critics like Clement Greenberg and Harold Rosenberg.545 Nonetheless, by the 1970s, a new generation had bestowed its critical acclaim upon Warhol's embodiment of pop culture. His various art enterprises were thriving, including films, printmaking, a burgeoning portrait business, and his magazine, *Interview*. Warhol had proposed the idea of the exhibition and undoubtedly relished the publicity.

The paintings of Wyeth at the 1976 exhibition exemplified Warhol's familiar approach to celebrity portraiture, but the five monumental drawings on display, made after the painted portraits were finished, struck some commentators as especially notable.546 Ambitious, hand-drawn works of art must have seemed a new direction for an artist famous for banishing all authorial gestures and handmade qualities. Noel Frackman considered them a "challenging" aspect of Warhol's portraiture. "They are line drawings of total assurance," he wrote in *Arts Magazine*, "the result of an educated hand and much closer to drawings by Matisse or Picasso than to what we think of as Pop Art." The drawings even intrigued the otherwise critical Hilton Kramer, who found them more interesting than the paintings; to him they recalled "Jean Cocteau's pastiche of Picasso's neoclassical style."547

Although Warhol's reputation rests more on his prodigious output of paintings and screen prints, he was an inventive and original draftsman, and drawing played a definitive role in his early New York successes and subsequent development.548 In his commercial work and self-published books and portfolios from the 1950s, Warhol employed an elegant outline style that recalled Henri Matisse. In a manner variously charming or provocative, Warhol

combined his thin, decorative line with whimsical humor, naive distortion, and erotic subject matter. Rainer Crone related his early style to children's art, folk art, nonsense humor, satirical cartoons, and popular prints and broadsides, all of which embody anti-academic approaches to drawing.[549] Warhol's *Wyeth*, while retaining that iconoclastic spirit and outline format, reflects as well the thicker, coarser lines he introduced to his drawings of the 1960s. Early in the decade Warhol had begun drawing over photographic images projected onto sheets of paper, the same method he would use in his Wyeth

Fig. 64. *Jamie Wyeth* (born 1946) by Andy Warhol (1928–1987). Synthetic polymer paint and silkscreen on canvas, 1976. Cheekwood Museum of Art, Nashville, Tennessee

drawing.[550] Jagged lines and shapes often resulted as he traced, in an almost topographical manner, the highlights and shadows of features. He also started adapting newspaper pages and magazine covers, using thick, messy hatched lines to convey a sense of unartistic, cheaply reproduced pictorial journalism. In 1962, Warhol produced many pencil drawings incorporating this harsher, inelegant approach, including portraits of such movie icons as Joan Crawford and Ginger Rogers taken from fan magazines.[551] Drawings always helped him think through new approaches to art.

Warhol refined his graphic technique further in an series of large, ambitious graphite portraits of the 1970s and early 1980s, merging his outline style with an assertive, zigzagging line. Preoccupied with his other enterprises, Warhol made few drawings from 1962 to 1972. But after Richard Nixon's trip to China, he created about forty drawings of Chairman Mao, independent of the paintings and silkscreens.[552] This *Wyeth* is one of a number of monumental graphite portraits that Warhol drew subsequently, all starting with a photographic image projected onto a large sheet of paper.[553] The jagged line in many of these portraits relates to the finger-painted scribbles in such paintings as *Julia Warhola* and *Ivan Karp*

from 1974, which animate shapes in a similar way.[554] But without the moderating influence of decorative color, those nervous wiggles create in the drawings a stronger, edgier effect.

Critics had considered the paintings of Wyeth a Hollywood-style idealization.[555] But the enormous drawn version from the same Polaroid is a complex Warholian exercise in subverting expectations. The handsome features and withdrawn pose are both negated by sharp, zigzagging lines. Insistent and ungraceful despite their thick, lush texture, they fill the drawing, replacing contemplative elegance with electrifying confrontation. The dialectic between the mechanical and the hand-crafted, always resonant in Warhol's art, adds to the tension. The hand-drawn image, historically based on the artist's immediate observation, is traced instead from a photographic source. On the other hand, the unstable, wiggling lines challenge any firm sense of contour, destroying the "authenticity" of the camera's eye. The whole image mocks the directness of drawing. What Auguste Rodin had called the "flow of my feelings . . . from my eye to my hand" is not only interrupted but sabotaged.[556] Warhol had frequently used mechanical means—movie cameras, Polaroid cameras, and printing techniques—to distance himself from a portrait subject. Here, ironically, he achieves the same goal through the most direct of media. The mammoth head of Wyeth, posed close to the picture plane and brutally cropped across the top of the scalp, accosts the viewer in an exciting but unsettling confrontation. Subverting beauty, spontaneity, and intimacy, it expresses a distanced monumentality more searing than the painted icon. Bantering with reporters at the opening, Warhol claimed that what he hoped to reveal in the paintings was "Jamie's cuteness."[557] In this drawing, he implies instead a complexity and depth of character his painted portraits did not convey.

The concepts explored in these high-impact graphite works reconnected Warhol to the drawn line, which would play a prominent role in his paintings and silkscreens. Linear, hand-drawn overlays appeared frequently in subsequent images, often outlining photographic features [see fig. 14].[558] The powerful Wyeth portrait thus reminds us of the central role of drawing in Warhol's art. With its large scale and witty, anti-art graphic inventiveness, it also redefines the nature of drawing, signaling new directions and ambitions for works on paper.[559]

W.W.R.

541. Judy Klemesrud, "At Gallery, the Crowd Was Ogling Itself," *New York Times*, June 6, 1976; quoted in *Washington Post*, May 18, 1976.

542. "He never turned off the tape [recorder] while we were working," Wyeth told a reporter, "and while I was painting he would be taking Polaroids of me" (quoted in Espedahl, "Jamie Paints Warhol"). According to another report, Warhol took 150 Polaroids (Kessler, "Wyeth and Warhol," 22). Although plans for the portrait sessions evolved over a number of months and the friendship and visits continued after the exhibit, Wyeth seems to have spent an intensive period of about three months working at the Factory (Buckland, "Brandywine Tradition," 17).

543. Hilton Kramer, "Art: Warhol Meets Wyeth," *New York Times*, June 4, 1976.

544. Stoner, "Andy Warhol and Jamie Wyeth," 58–83. Warhol and Wyeth, one reporter noted, "joke together and each has a tremendous understanding of the other that is immediately apparent" (*Sunday News Journal*, April 25, 1976).

545. Bob Colacello, *Holy Terror: Andy Warhol Close Up* (New York: HarperCollins, 1990): 266.

546. Some of these drawings were based on another Warhol Polaroid, a full-face, frontal pose. See, for example, Stoner, "Andy Warhol and Jamie Wyeth," 63.

547. Frackman, "Andy Warhol and Jamie Wyeth," 15; Kramer, "Art."

548. Mark Francis and Dieter Koepplin's *Andy Warhol, Drawings, 1942–1987* (Boston: Little, Brown, 1998) provides a pictorial overview of Warhol's drawings accompanied by Koepplin's extensive essay translated from the German. As Koepplin relates, Warhol always loved to draw and would come to the studio to draw on Sundays when few people were there (pp. 15, 19).

549. Rainer Crone, *Andy Warhol: A Picture Show by the Artist* (New York: Rizzoli, 1987), 18–21, 55–62.

550. David Bourdon, *Warhol* (New York: Harry N. Abrams, 1989), 70–72.

551. Ibid., 114, 118–19.

552. Crone, *Picture Show*, 78; Francis and Koepplin, *Drawings*, 17, 44.

553. Henri Zerner, *Andy Warhol: Portrait Drawings* (New York: Brooke Alexander, 1998), 12–15. This series of large-scale drawings included, together with celebrity subjects, portraits of transvestites from his "Ladies and Gentlemen" series. See also Francis and Koepplin, *Drawings*, 45–46.

554. Henry Geldzahler and Robert Rosenblum, *Andy Warhol: Portraits of the Sixties and Eighties* (London: Thames and Hudson, 1993), 148, plates 6, 7.

555. In the words of Gerrit Henry, Wyeth was given the "Liz Taylor treatment" (Henry, "Andy Warhol and Jamie Wyeth," 121). Even Wyeth's wife remarked when she first saw the painting, "Jamie, what a romantic look" (*Sunday News Journal*, April 25, 1976).

556. Quoted in Judith Brodie and Andrew Robison, eds., *A Century of Drawing: Works on Paper from Degas to LeWitt* (Washington, D.C.: National Gallery of Art, 2001), 32.

557. Quoted in Buckland, "Brandywine Tradition," 19. That evening, when he was informed that at least half of the show was sold, Warhol quipped, "I think it's because Jamie looks like a soup can" (quoted in Stoner, "Andy Warhol and Jamie Wyeth," 70).

558. Warhol himself disguised the seriousness of such techniques with typical obfuscation: "I would really rather do just a silkscreen of the face without all the rest, but people expect just a little bit more. That's why I put in all the drawing" (quoted in Barry Blinderman, "Modern 'Myths': An Interview with Andy Warhol," *Arts Magazine* 56 [October 1981]: 145).

559. Zerner, *Portrait Drawings*, 15.

MARK STRAND
born 1934

BY PHILIP PEARLSTEIN
born 1924

Watercolor on paper, 74.6 x 52.7 cm (29³/₈ x 20³/₄ in.), 1983
Gift of Mark and Julia Strand
NPG.91.38

Philip Pearlstein, who is best known for large paintings of nudes, has also created a number of portraits, some commissioned, and others made for friends. This watercolor of poet Mark Strand is similar to others by Pearlstein in its size, the close cropping of the face and body, and its emotional detachment. It marks a point in their friendship when the poet and artist had collaborated in the creation of a book about contemporary figurative painters. *Art of the Real* (1983), organized and edited by Strand, featured autobiographical essays and images of the work of nine painters, including Pearlstein.

Mark Strand thought about being a painter before turning to poetry. After graduating from Antioch College in Ohio, he went to Yale to study art with Joseph Albers, like a number of the painters featured in *Art of the Real*. During those two years, however, he turned increasingly to poetry. This change "wasn't a conscious thing." According to Strand, "I don't think these kinds of lifetime obsessions are arrived at rationally." It was an auspicious choice, however. Strand has taught at a number of colleges and universities, and has published nine volumes of poetry, including *Blizzard of One*, which won the Pulitzer Prize for poetry in 1999. "A Piece of the Storm," from that collection exemplifies the focus of much of Strand's work and his interest in the "amazement of the vivid moment."[560]

Strand gained a national reputation through two collections of verse published around 1970, and received the fellowship of the American Academy of Poetry in 1979. Around 1980, however, with the publication of *Selected Poems*, Strand turned away from poetry for a few years in favor of short stories and art criticism. It was during that time that he edited *Art of the Real*, and also wrote texts for books on two other painters included in that compendium, William Bailey and Neil Welliver. By 1985,

Strand was again publishing poetry. In 1987 he received a MacArthur Foundation "genius" grant, and served as poet laureate of the United States in 1990–91. In 1993, he was awarded Yale's Bollingen Prize in Poetry.

Philip Pearlstein attracted Strand's attention as one of a group of figurative painters, raised on modernism and in the wake of abstract expressionism, who express within their work, as Strand put it, "that our relationship to the physical world, a relationship that is perpetually in danger of being destroyed by inattention, can be salvaged."[561] Although he painted abstractions early in his career, Pearlstein began his studies of art in a figurative mode, and eventually, in the early 1960s, returned to figuration with large-scale paintings of nude figures, male and female, painted directly from the model. His models are posed against simple backgrounds, with unusual rugs and furniture and sometimes draped in highly patterned kimonos. Through the 1960s and 1970s, Pearlstein also experimented with portraiture. By the early 1980s his work was almost evenly divided between work in oils and watercolor, and while focused on figures, it also included some landscapes.[562]

One of the leading figurative painters of the last forty years, Pearlstein has emphasized technical excellence, achieved within a circumscribed subject matter. He first studied art at the Carnegie Institute of Technology in Pittsburgh. In 1949 he moved to New York, with Dorothy Cantor, whom he married in 1950, and with Andy Warhol, fellow classmates at Carnegie Tech. Pearlstein continued to paint, but also earned a master's degree in art history from the Institute of Fine Arts at New York University. He traveled in Italy, where he had served during World War II, on a Fulbright grant in 1958 and 1959. Upon his return to New York, he began an association with the Allan Frumkin Gallery, where his paintings were

shown for many years; in 1963, he joined the faculty at Brooklyn College, where he is currently professor emeritus.

Pearlstein explained his approach to painting:

> [I decided] to develop every part of the painting, no matter how unimportant it seemed, as fully as possible. . . . The large size of my figure painting came about simply because I needed the space in which to develop each detail. I was never interested in trompe l'oeil. I wanted only to carry the work to a uniform level of finish, and I ask of myself only that every work I make be a thoughtful response to my visual experience.[563]

Fig. 65. *Mark Strand* (born 1934) by Jack Beal (born 1931). Charcoal on paper, not dated. Indiana University Art Museum, Bloomington

Pearlstein knew Strand for a number of years before making his portrait. Strand's head and shoulders fill the pictorial space; the top of an Adirondack rocking chair that appears in a number of Pearlstein's paintings from this period is behind his head. His clothing—the soft textures of the mushroom and brown tweed jacket and well-worn dark gray turtleneck, thinly striped with purple—enhances the sense of quiet lassitude that fills the image. The watercolor is both harsh in its revelation of the artist's scrutiny and delicate in execution and detail. Strand's likeness reveals no emotion other than pensiveness. Critic Hayden Herrera noted the expression found in this and other portraits by Pearlstein:

> Their glazed eyes look not at us but at the artist, or are vacant. Some expressions have the mixture of wariness and apathy with which one might look at an expert dentist. . . . Posing repeatedly for long hours, sitters lose the muscular and mental set with which they normally face the world and which distinguishes personality from mere features. Muscles go slack around the mouth; eyes grow dim. . . . This is one of Pearlstein's most important

strategies for abstracting. . . . He splits physiognomy and personality, implicating the viewer in an act of willed dispassion.[564]

The portrait was made as a gesture of friendship—a traditional gift from one artist to another. And yet, even Strand admitted that his likeness was "sacrificed a bit for Pearlstein effects."[565] Jack Beal, whose works were also included in *Art of the Real*, made another portrait of Strand, several years before the book was compiled [fig. 65]. A charcoal drawing, it has the strong contrasts of light and dark typical in Beal's work, but it is not abstracted. The portrait expresses a stalwart intensity that allows the viewer to take away a sense of the sitter's intelligence. Pearlstein, however, gives us every plane of Strand's visage, and every carefully coiffed strand of hair, but true to his style and mission, we do not see clues to the sitter's personality.

B.B.F.

560. Quoted in Jonathan Aaron, "About Mark Strand: A Profile," *Ploughshares* (Winter 1995–96): n.p.

561. Mark Strand, introduction to *Art of the Real: Nine American Figurative Painters*, ed. Mark Strand (New York: Clarkson N. Potter, 1983), 9.

562. On Pearlstein, see his statements in *Art of the Real*; Russell Bowman et al., *Philip Pearlstein: A Retrospective* (New York and London: Alpine Fine Arts Collection for the Milwaukee Art Museum, 1983); and Hayden Herrera, "Pearlstein: Portraits at Face Value," *Art in America* 63 (January–February 1975): 46–47.

563. Philip Pearlstein, foreword to John Perreault, *Philip Pearlstein. Drawings and Watercolors* (New York: Harry N. Abrams, 1988), 13.

564. Herrera, "Pearlstein: Portraits at Face Value," 46.

565. Telephone interview with Mark Strand by LuLen Walker, undated notes (before November 1999), National Portrait Gallery curatorial files.

Glossary of Drawing Media

ROSEMARY FALLON
AND EMILY JACOBSON

CHARCOAL

Charcoal is one of the oldest drawing materials. Used in cave drawings and throughout the centuries, it continues in use today. In a beginning drawing class, vine charcoal is usually the first medium that is introduced. It can be easily erased from the paper surface with a chamois cloth so the student can make adjustments and reuse the surface. The two most common types are stick and compressed charcoal. Stick, or vine, charcoal is made by heating small, thin sticks—traditionally made from vine, beech, or willow—until only dry carbon remains. Compressed charcoal is ground into a powder and mixed with a binder. It can also be made into pencils of varying degrees of hardness. Charcoal is frequently used on drawing paper with a pronounced tooth, or texture, which grabs the particles as they splinter.

COLLAGE

Collage is a French term for an arrangement of two-dimensional items, usually paper, that are adhered to a flat surface to create an artistic composition. Collage as an art form had its beginnings in the early twentieth century.

CONTÉ CRAYON

Nicholas Jacques Conté invented conté crayon in the late eighteenth century. It was made of powdered graphite and clay encased in wood, when pure graphite was in short supply. Contemporary conté crayon is composed of semi-hard chalk and an oily binder. It is manufactured in sticks with different degrees of hardness and comes in several colors, most commonly black, red, white, and brown.

CRAYON (WAX)

Wax crayons are colored drawing sticks composed of wax, pigment or dye, and stearic acid, with tallow as the binder. They can be made with a mold or by extrusion. Many of the colors are sensitive to fading from exposure to light.

FELT-TIP MARKER (FIBER-TIPPED PENS OR POROUS-TIP PENS)

These pens have been commercially produced beginning in the mid-twentieth century. Many are formulated with water or solvents with fugitive or soluble dyes delivered through a fibrous tip. Although generally highly light sensitive, some are more stable than others.

GOUACHE

Gouache is similar to watercolor in that it is composed of finely ground pigments mixed with gum arabic as a binder. Gouache, however, has a higher percentage of binder and the addition of a white pigment (zinc white, titanium white, or chalk) to make its appearance opaque. Gouache tends to form a thick paint layer and does not appear as transparent as watercolors.

GRAPHITE PENCIL

Pencils were originally made of pure graphite and introduced as a drawing medium in the mid-seventeenth century, thus replacing the lead stylus. The mixture of graphite (a crystalline form of carbon) and clay was invented in the late eighteenth century. Modern pencils are powdered graphite mixed with various amounts of clay to make them harder and softer, and sheathed in wood. Drawings made with soft graphite pencil can be as friable as charcoal, whereas drawings created with hard graphite pencil can be quite stable. The metallic sheen makes graphite easily identifiable.

INK/INK WASH:

Drawing inks have been used since the seventeenth century. Liquid, carbon-based ink (India ink) can be water soluble or mixed with shellac or glue to be made waterproof upon drying. Ink can be diluted with water to create a wash with a range of grays.

LITHOGRAPHIC CRAYON

The lithographic crayon was originally formulated in the 1790s by Aloys Senefelder, the inventor of lithography. It is a wax-based drawing stick made of lampblack and multiple ingredients, including tallow and olive oil, available in hard and soft grades. Soft grades can be greasy and easily smudged, and they leave an oily halo over time.

METALPOINT

Metalpoint tools are styluses made from metals or metal alloys, such as silver, lead, copper, gold, brass, bronze, or tin. As with a pencil, stroking the tool across paper deposits a line of metal on the paper, with different metals imparting varying tones. To make the paper smoother and more receptive to the metalpoint, it is often coated with a ground layer, usually composed of white lead or bone dust mixed with water and a glue or gum adhesive.

PASTEL

Pastels are colored drawing sticks composed of finely ground pigments and a small amount of a binder, traditionally gum tragacanth. Other materials used as binders have included oils, resins, waxes, sugars, and glues. Pastels were originally made by hand but became available commercially by the late nineteenth century. To make pastels, pigments are ground in water, the binder is added, and the stick is formed by rolling and drying. When drawn on paper, pastel is friable—that is, susceptible to flaking and smudging—owing to its small amount of binder.

WATERCOLOR

Watercolors are composed of finely ground pigment particles suspended in a solution of gum arabic. Upon drying, the gum acts as the binder for the pigment. Glycerin is occasionally added to increase moistness, and a wetting agent is added to improve the flow of the watercolor on the paper. The resulting media tends to appear transparent, like a stain on the paper support. Watercolors were originally sold as dry cakes but today can be bought in pans or tubes of moist paint. The pigments used in watercolors can vary widely in their stability when exposed to light.

249

Bohan, Ruth L. *American Drawings and Watercolors, 1900–1945: The Saint Louis Art Museum Summer 1989 Bulletin.* Saint Louis: Saint Louis Art Museum, 1989.

Bolger, Doreen, et al. *American Pastels in the Metropolitan Museum of Art.* New York: Metropolitan Museum of Art, 1989.

Borzello, Frances. *Seeing Ourselves: Women's Self-Portraits.* New York: Harry N. Abrams, 1998.

Brilliant, Richard. *Portraiture.* Cambridge: Harvard University Press, 1991.

Brodie, Judith, and Andrew Robison, eds. *A Century of Drawing: Works on Paper from Degas to LeWitt.* Washington, D.C.: National Gallery of Art, 2001.

Carr, Carolyn Kinder, and Ellen G. Miles. *A Brush with History: Paintings from the National Portrait Gallery.* Washington, D.C.: National Portrait Gallery, Smithsonian Institution, 2001.

Cogniat, Raymond. *Twentieth-Century Drawings and Watercolors.* Translated from the French by Anne Ross. New York: Crown, 1966.

Corn, Wanda M. *The Great American Thing: Modern Art and National Identity, 1915–35.* Berkeley: University of California Press, 1999.

Cummings, Paul. *American Drawings: The 20th Century.* New York: Viking, 1976.

————. *The Changing Likeness: Twentieth-Century Portrait Drawings.* New York: Whitney Museum of American Art, 1986.

De Salvo, Donna, et al. *Face Value: American Portraits.* Southampton, N.Y.: Parrish Art Museum, 1995.

Elderfield, John. *The Modern Drawing: 100 Works on Paper from the Museum of Modern Art.* New York: Museum of Modern Art and Thames and Hudson, 1983.

Fine, Ruth, et al. *O'Keeffe on Paper.* Washington, D.C.: National Gallery of Art and Harry N. Abrams, 2000.

Glueck, Grace. "Revival of the Portrait." *New York Times Magazine,* November 6, 1983, 52–57+.

Goldstein, Nathan. *Figure Drawing: The Structure, Anatomy, and Expressive Design of Human Form.* 5th ed. Upper Saddle River, N.J.: Prentice-Hall, 1999.

Gottlieb, Carla. "Self-Portraiture in Postmodern Art." In *Sonderdruck aus dem Wallraf-Richartz-Jahrbuck.* Cologne: Dumont Buchverlag, 1981.

Greenough, Sarah, et al. *Modern Art and America: Alfred Stieglitz and His New York Galleries.* Washington, D.C.: National Gallery of Art and Bulfinch Press, 2000.

Henry, Gerrit. "The Artist and the Face: A Modern American Sampling and Ten Portraitists—Interviews/Statements: Chuck Close, Elaine de Kooning, Alex Katz, Alfred Leslie, Alice Neel, Philip Pavia, George Schneeman, George Segal, Sylvia Sleigh, Hedda Sterne." *Art in America* 63 (January/February 1975): 34–41.

Johnson, Una E. *Twentieth-Century Drawings.* 2 vols. New York: Shorewood Publishers, 1964.

Kushner, Marilyn. *The Modernist Tradition in American Watercolors, 1911–1939.* Chicago: Mary and Leigh Block Gallery, Northwestern University, 1991.

Leymarie, Jean, Geneviève Monnier, and Bernice Rose. *History of an Art: Drawing.* New York: Rizzoli, 1979.

McCarthy, Cathleen. "About Face." *Art and Antiques* 20 (Summer 1997): 56–63.

McGrath, Robert L. *The Face of America: Contemporary Portraits in Watercolor.* Old Forge, N.Y.: Arts Guild of Old Forge, 1994.

Mendelowitz, Daniel M. *Drawing.* New York: Holt, Rinehart and Winston, 1967.

Pilgrim, Dianne H. "The Revival of Pastels in Nineteenth-Century America: The Society of Painters in Pastel." *American Art Journal* 10 (November 1978): 43.

Porter, Fairfield. "Speaking Likeness." In *Narrative Art,* edited by Thomas B. Hess and John Ashbery. New York: Macmillan, 1970.

Rawson, Philip. *Drawing.* 2d ed. Philadelphia: University of Pennsylvania Press, 1987.

Reed, Sue Welsh, and Carol Troyen. *Awash in Color: Homer, Sargent, and the Great American Watercolor.* Boston: Museum of Fine Arts and Bulfinch Press, 1993.

Reich, Sheldon. *Graphic Styles of the American Eight.* Salt Lake City: Utah Museum of Fine Arts, 1976.

Rose, Barbara. "Self-Portraiture: Theme with a Thousand Faces." *Art in America* 63 (January–February 1975): 66–73.

———. *Drawing Now.* New York: Museum of Modern Art, 1976.

Sachs, Paul J. *Modern Prints and Drawings: A Guide to a Better Understanding of Modern Draughtsmanship.* New York: Alfred A. Knopf, 1954.

Sadik, Marvin, and Harold Francis Pfister. *American Portrait Drawings.* Washington, D.C.: National Portrait Gallery and Smithsonian Institution Press.

Stebbins, Theodore E., Jr. *American Master Drawings and Watercolors: A History of Works on Paper from Colonial Times to the Present.* New York: Harper & Row, 1976.

Steiner, Wendy. "Postmodern Portraits." *Art Journal* 46 (1987): 173–77.

Varnedoe, J. Kirk T. Introduction to *Modern Portraits: The Self & Others.* New York: Wildenstein Gallery, 1976.

Wadley, Nicholas. *Impressionist and Post-Impressionist Drawing.* New York: Dutton Studio Books, 1991.

Woodall, Joanna, ed. *Portraiture: Facing the Subject.* Manchester: Manchester University Press, 1997.

Yau, John. "The Phoenix of the Self." *Artforum* 27 (April 1989): 145–51.

212–15, 216–19; *Self-Portraits,* *213, 214*; *Stokely Carmichael (Kwame Ture), 42, 217*; *Struggle II—Man on Horseback, 218*

Lebrun, Rico, 28, 188–91, 228–31, *229*; *Igor Stravinsky, 27, 189, 190*

Le Gallienne, Eva, 21, 100–103, *101, 102*

Lescaze, William, 98

Leslie, Alfred, 26

Lewis, Sinclair, 36, 104, 156

Leyendecker, F. X., 37

Lichtenstein, Roy, 43, 214, 224–27; *Robert F. Kennedy, 21, 28, 28, 43, 225, 226*

Life magazine, 18, 56, 90, 100, 104, 162, 226

Lipchitz, Jacques, 11; *Gertrude Stein, 12*

Lippman, Walter, 38

Locke, Alain, 108, 110

Luks, George, 60, 62

Man Ray (Emmanuel Rudnitsky), 26, 98

Manship, Paul, 96

Marin, John, 20, 21, 180, 184–87; *Self-Portraits, 185, 186*

Marlowe, Julia, 16, 62

Marsh, Reginald, 84–87, 186; *Thornton Wilder, 85*

Massachusetts Normal Art School, 144, 196

Masses, the (journal), 18, 128, 134

Matisse, Henri, 13, 20, 21, 36, 37, 114, 170; *Nude with Bracelets, 21*

McBride, Henry, 20–21, 102, 184

McKay, Claude, 108

metalpoint, 164, *165,* 166, 178

Meyer, Agnes, 14, 72, 80–83, *81, 82*

Millay, Edna St. Vincent, 92–95, *93*

Miller, Henry, 182, 196, 198

Miller, Kenneth Hayes, 64, 84

Monet, Claude, 48, 54

Moore, Marianne, 96

Motherwell, Robert, 220

Nast, Thomas, 39

Nation, the (magazine), 41, *42,* 192

National Academy of Design, 52, 94, 134, 172

National Portrait Painters Association, 150

Neagle, John, 33

Neel, Alice, 22, 23, 24, 26; *Virgil Thomson, 24*

Negro Drawings (Covarrubias), 102, 172, 174

Newman, Arnold, 186

Newman, Barnett, 22, 168, 170

New Masses, the, 134

New Negro, the, 108, 110

New Yorker, 18, 39, 40, 104, 134, 202, 220

New York Herald, 38

New York Herald Tribune, 172

New York School of Art, 60, 64, 176

New York Times, 134, 172, 174, 240

New York World, 60, 68, 70, 72

Noguchi, Isamu, 206

Nolde, Emil, 41

O'Hara, Frank, *26,* 222

O'Keeffe, Georgia, 14, 20, 37, 38, 180–83; *Beauford Delaney, 181*; *My Heart, 182*

O'Neill, Eugene, 92, 94, 104, 132

Oppenheimer, J. Robert, 28, 41, *41,* 192–95, *193, 194*

Pach, Walter, 102

Parks, Gordon, 216, 218

pastel, 17, 19, 60, 80, 110, 148, 150; examples of, *61, 81, 109, 149, 181, 197*

Pearlstein, Philip, 26, 244–47; *Mark Strand, 22, 25, 27, 245*

Pennsylvania Academy of the Fine Arts (Philadelphia), 48, 60, 62, 184

Perkins, Francis, 16, 148–51, *149, 150*

photography: as art, 19–20; manipulation of, 12, 28; and portraiture, 36–37, 182

Picabia, Francis, 14, 26, 36, 72, 74, 82; *Ici, C'est Ici Stieglitz Foi Et Amour, 14*

Picasso, Pablo, 14, 20, 80, 112, 114, 116, 118, 130; *Daniel-Henry Kahnweiler, 36, 36*; *Gertrude Stein, 11, 13, 13*

Pollock, Jackson, 22, 220

pop art, 26, 27–28, 43, 224, *225,* 226, *226,* 236, 240; examples of, *27, 28, 43, 225, 226*

Porter, Fairfield, 22

portraiture: abstract and symbolic, 14–15, 25–26, 36, 222; in mass-media communication, 15–16, 17–18, 34, 37–40, 43

poster art, 68, 142, 174

Prendergast, Maurice, 156

Rauschenberg, Robert, 25–26, 210

Redon, Odilon, 72

Reiss, Winold, 17, 108–11; *Countee Cullen, 109*

Renoir, Auguste, 48, 114

Rhoades, Katharine, 82

Richards, Alan: *J. Robert Oppenheimer, 41*

Rivers, Larry, 22, 25–26, 210; *O'Hara Reading, 26*

Robeson, Paul, 40, 104, 110, 132–35, *133, 134*

Robinson, Bill ("Bojangles"), 20, 172–75, *173*

Robinson, Theodore, 52, 54

Rodin, Auguste, 20, 37, 72, 206, 242; *Nude, 20*

Roosevelt, Theodore, 17, 18, 37, 38, 56–59, *57, 58*

Rosenberg, Harold, 24, *24,* 220–23, *221, 222,* 240

Roszak, Theodore, 22, 136–39; *Self-Portraits, 137, 138*

Rothko, Mark, 22, 168, 170

Sargent, John Singer, 11, 19, 33, 35, 76, 204; *Henry James, 78*; *Mrs. Joshua Montgomery Sears, 33*

Schoukhaeff, Basil, 158

Scribner's magazine, 17, 18, 37, 38, 41, 56

Segal, George, 26

self-portraiture, 36, 48, 50, 60, 62, 64, 66, 104, 106, 136, 138, 164, 170, 176, 178, 186, 214; examples of, *49, 61, 65, 66, 105,*

IMAGE CREDITS